MASCULINITIES IN VICTORIAN PAINTING

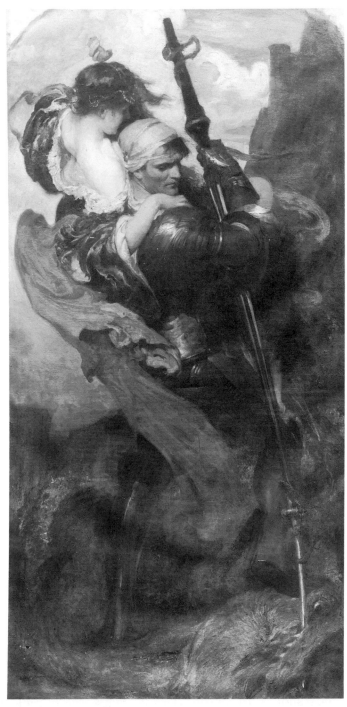

Solomon J. Solomon: *St George*, 1906; 83½ × 41½; Royal Academy of Arts, London.

Masculinities
in
Victorian Painting

Joseph A. Kestner

Ashgate

Aldershot • Brookfield USA • Singapore • Sydney

Published by
Ashgate Publishing Limited
Gower House
Croft Road
Aldershot, Hants
GU11 3HR
England

Ashgate Publishing Company
Old Post Road
Brookfield
Vermont 05036
USA

Ashgate website: http://www.ashgate.com

Reprinted 1999

British Library Cataloguing-in-Publication data.
Kestner, Joseph
 Masculinities in Victorian Painting
 I. Title
 759.2
Library of Congress Cataloging-in-Publication Data
Kestner, Joseph A.
 Masculinities in Victorian painting / Joseph A. Kestner.
 p. cm.
 Includes bibliographical references and index.
 ISBN 1–85928–108–7
 1. Painting, British—Themes, motives. 2. Painting, Victorian—Great Britain—Themes, motives. 3. Masculinity (Psychology) in art.
 I. Title.
 ND487.K47 1995
 757'.3'094109034—dc20 94–31199
 CIP

ISBN 1 85928 108 7

Typeset in Times by Photoprint, Torquay and printed in Great Britain at the University Press, Cambridge.

Contents

v

For Joseph Wiesenfarth

The Nineteenth Century

General Editors' Preface

The aim of this series is to reflect, develop and extend the great burgeoning of interest in the nineteenth century that has been an inevitable feature of recent decades, as that former epoch has come more sharply into focus as a locus for our understanding, not only of the past but of the contours of our modernity. Though it is dedicated principally to the publication of original monographs and symposia in literature, history, cultural analysis, and associated fields, there will be a salient role for reprints of significant texts from, or about, the period. Our overarching policy is to address the spectrum of nineteenth-century studies without exception, achieving the widest scope in chronology, approach and range of concern. This, we believe, distinguishes our project from comparable ones, and means, for example, that in the relevant areas of scholarship we both recognize and cut innovatively across such parameters as those suggested by the designations 'Romantic' and 'Victorian'. We welcome new ideas, while valuing tradition. It is hoped that the world which predates yet so forcibly predicts and engages our own will emerge in parts, as a whole, and in the lively currents of debate and change that are so manifest an aspect of its intellectual, artistic and social landscape.

Vincent Newey
Joanne Shattock

University of Leicester

Plates

Acknowledgements

This book could not have been written without the cooperation of many individuals, libraries, dealers and institutions and the access provided to their collections of paintings and documents. The author wishes to express his gratitude for the invaluable assistance rendered by these individuals and institutions.

The author is particularly grateful to Joanne Shattock, Director of the Victorian Studies Centre of the University of Leicester, who invited him to be a Fellow at the Centre in 1992. In lectures and seminars during that time, many of the ideas in this book were presented and researched. The congeniality, colleagiality, and resources at the Centre were invaluable in advancing this project.

The author is indebted to Peter Harrington, Curator of the Anne S.K. Brown Military Collection at Brown University, for crucial assistance at every stage of the development of this manuscript. The opportunity to conduct research at the Anne S.K. Brown Military Collection on a fellowship provided much of the material which comprises the fifth chapter of the book. Mr Harrington's willingness to share his vast files of material was invaluable in pursuing information about Victorian battle art.

Much valuable information and assistance was supplied by Jenny Spencer-Smith of the National Army Museum in London, whose work on Lady Butler was a model of scholarly exactitude.

Richard Humphreys of the Tate Gallery in London was exceptionally helpful in providing access to its resources. The opportunity to lecture at the Tate on this subject was also greatly appreciated.

The author wishes to thank Alex Robertson of the City Art Gallery, Leeds, for inviting him to lecture during an exhibition of paintings from the FORBES Collection. The opportunity to discuss the material in Chapter Four with so informed an audience was a privilege.

An invitation from the Victorian Society of Sheffield to lecture at the Mappin Art Gallery provided an occasion of exceptional challenge and enjoyment. Anne Goodchild of the Graves Art Gallery and Ruth Harman of the City of Sheffield Archives provided much important advice and material during my visit to Sheffield.

The opportunity to lecture on the subject of Frank Dicksee at Leighton House, London, was an exceptional occasion to discuss ideas in this book. The author wishes to thank Joanna Banham for her support and also for crucial access to the Leighton House collections. Her work on the chivalric revival in Victorian Britain has been of immense value to this research, especially for Chapter Three of this book.

Alex Kidson of the Walker Art Gallery, Liverpool, was extraordinarily helpful in providing access to the Walker's outstanding collection of Victorian paintings. His willingness to assist at every stage of this project was decisive in its completion.

Helen Valentine of the Royal Academy of Arts, London, has been wonderfully helpful in providing access to its library's vast collection of documents relating to Victorian painting. Her willingness to provide access to the Academy's collection of paintings has been crucial.

In the United States, the author wishes particularly to thank Susan P. Casteras, the Curator of Paintings at the Yale Center for British Art, for unfailing support, advice and information at every stage of this project. Her vast grasp of the subject of Victorian painting and her own outstanding books have been invaluable for this research.

The author would like to thank the following individuals for their most important assistance: Christopher Wood, London; Roy Miles, London; Julia Findlater of Leighton House, London; John Corr, Tate Gallery, London; Major A.G.B. Cobbold of the Royal Anglian Regiment; Major D.J. Thorogood, Regimental Secretary of the Royal Anglian Regiment; Joanne Irvine of the Walker Art Gallery, Liverpool; Robyn Tromeur of the FORBES Collection, New York; Philip Jago of the National Gallery of Victoria, Melbourne; Sarah Colgrave of Sotheby's London; Brian Allen, Director of Studies, Paul Mellon Centre for Studies in British Art; Nicole Tetzner of the Royal Collection; Shearer West and Alison Yarrington of the Department of the History of Art, Leicester; Francis W. Greenacre of the Bristol Museum and Art Gallery; Neil Wilson, Christie's London; Neil Walker of the Castle Museum, Nottingham; Elizabeth Gombosi of the Fogg Art Museum, Harvard University; Lord Faringdon; Vivien Knight of the Guildhall Art Gallery; Richard Jefferies of the Watts Gallery, Compton; Graham A. Coombe, Archivist, Baden-Powell House; Kate MacDonald Buchanan of Sotheby's London; Robert Ferguson, United Distillers, Edinburgh; John Stevens, The Naval and Military Club, London; George Church, The Cavalry and Guards Club, London; D.W. Scott of the Rotherham Department of Arts; Julie F. Codell, Editor of *The Journal of Pre-Raphaelite Studies*; Robert Spoo, Editor of the *James Joyce Quarterly*; Jody Lamb, President of the Society of Historians of British Art; Debra N. Mancoff of Beloit College; Donald Lawler, Editor of the *Victorians Institute Journal*; Adrienne A. Munich, co-editor of *Victorian Literature and Culture*; Suzanne O. Edwards, editor of *Nineteenth Century Studies*; Charles Segal of the Department of Classics, Harvard University

(with whom the author participated in two NEH seminars); Roger T. Stearn; Camilla L. Aiken; Thomas A. Horne; Mary Jo Lindsay and Joseph A. Kestner, Jr.; Lee M. Edwards; Roger L. Brooks, Director of the Armstrong Browning Library, Baylor University; Gordon O. Taylor; Garrick Bailey; Terri Nickel; Vibeke Petersen; Karl Schaefer; James G. Watson; and John Halperin, Centennial Professor of English, Vanderbilt University.

The author expresses his gratitude to Her Majesty Queen Elizabeth II for permission to reproduce paintings in The Royal Collection.

Portions of this book were presented and discussed at valuable scholarly conferences, including the Interdisciplinary Nineteenth-Century Society; the College Art Association; the Northeast Victorian Studies Association; the Midwest Victorian Studies Association; the American Council of Irish Studies; and the Pre-Raphaelite Conference at the Armstrong Browning Library, Baylor University. The author thanks the organizers for this congeniality and support.

Portions of this book have appeared in another form in the following journals, for which the author expresses his gratitude to the respective editors: *Victorians Institute Journal, Journal of Pre-Raphaelite Studies, Victorian Literature and Culture, Nineteenth Century Studies,* the *James Joyce Quarterly* and *Annals of Scholarship.*

The author is grateful to the University of Tulsa for the academic leave which permitted the consolidation of this research.

This book would not have been completed without the extraordinary expertise of surgeon John W. Phillips, Jr., whose exceptional diligence, encouragement, authority and friendship enabled the author to surmount major medical difficulties during the writing of this book. His support can never be repaid.

The author is indebted to Ellen Keeling, senior editor at Scolar Press, for her exceptional professionalism at every stage of the production of this book.

The author is grateful for the conscientious support of his editor at Scolar Press, Alec McAulay.

The author can never sufficiently thank his secretary, Sandra L. Vice, for her outstanding care and concern during the writing, revision, and completion of this manuscript. Her unfailing cooperation, goodwill and expertise were decisive in the completion of this project.

Anna H. Norberg has been a strong and loving source of support during the writing of this book.

In the galleries, the legend for each plate includes artist, title, date, medium (if other than oil on canvas or panel or board), dimensions in inches, height before width (if known) and provenance (if known). Where the provenance is unknown or private, the source of the plate is identified. The abbreviation *RAP* indicates the Cassell series *Royal Academy Pictures*.

1

Artistic Representation and the Construction of Masculinity

During 1992–1993, the Tate Gallery held the exhibition 'Visualising Masculinities' which displayed 14 canvases painted during the nineteenth and twentieth centuries, ranging from works by Sargent, Millais and Hicks to contemporary depictions by Hockney, Kitaj, Spencer and Longo. Andrew Stephenson commented that the purpose of the exhibition was to examine

> the display and meanings of the male body in art since the mid-nineteenth century. It . . . recognises the important role that visual culture has played in circulating, often in a celebratory way, images of male power and the norms of manliness. . . . The display is based on three interrelated assumptions. Firstly, that 'masculinity' is a historical construct changing from period to period, and as a category is neither 'natural' nor culturally innocent. Its meanings and significations are always structured in relation to wider social beliefs, political ideologies and sexual identities. Secondly, that histories of 'masculinity' relate in a complex and unequal way with histories of 'femininity' as its 'Other' and with representations of sexual difference. Thirdly, that 'masculinity' interweaves lived experience with imagined fantasies and desires. ('Visualising Masculinities', exhibition brochure, n.p.)

Stephenson's premises for this exhibition are those which summarize key theses of the theory of masculinity in the twentieth century: that masculinity is constructed by culture; that it defines itself by opposition to 'femininity' as the Other; that it is part of ideologies of power and control; and that, in the arts, visual imagery serves crucial purposes in constructing masculinity in culture. As Stephenson indicates, 'masculinity' is a composite expression embracing a range of categories of the masculine – categories which may be designated 'masculinities' as in the exhibition – for the expression 'masculinity' during the nineteenth century and later has been inflected by factors of race, sexual preference, class, occupation, economic status and

1

ethnicity, which compel a recognition of the multiple varieties of the male as subject and of male subjectivity. Adams contends: 'The play of difference *within* as well as across genders and sexualities [is] an insistence that is central in constituting the study of masculinity' (1993: 208). The Tate Gallery exhibition 'Visualising Masculinities' was unique, not only in its recognition of 'masculinities' but also in demonstrating the impact of recent theory on the study of art, as Adams observes: 'Although norms of masculine identity are a long-standing preoccupation of anthropologists and sociologists, only in the past fifteen years or so has the idea of masculinity come to be studied across the human sciences as a central problematic of cultural formation and change' (207).

If masculinity has only recently been studied as 'a central problematic of cultural formation', however, it may be because, as Middleton observes, 'the concept of masculinity is a modern invention, a somewhat mysterious one, a new invention' (154), a product of the modern, that is, the post-eighteenth-century revolutionary world:

> Modernity is a description usually applied not just to the twentieth century but the great period of modernization and social change since the industrial and political revolutions of the eighteenth century. The impact of this social transformation on men's lives is obvious. If men have largely dominated the means of production and the public sphere, they have in turn been changed by that involvement. Men have been affected by universal conscription and total war, by the technologization of their work, the almost complete division of work and home, and their mass organization in work, culture and politics. Men's dominance has also been challenged, and at times diminished, as women have gained the vote, entered the workplace in large numbers, gained access to education, and slowly improved their legal status. (154)

To study the construction of masculinity during the nineteenth century, therefore, is to analyse its modern formation. Masculinity as a concept, Middleton continues, presents its own challenge:

> Masculinity is similarly hard to grasp. Is it a discourse, a power structure, a psychic economy, a history, an ideology, an identity, a behaviour, a value system, an aesthetic even? Or is it all these and also their mutual separation . . .? I believe modern masculinities are misrepresented when they are described solely in terms of sexuality, power or identity. . . . Masculinity has been left behind the scenes, writing the scripts, directing the action and operating the cameras, taken for granted and almost never defined. Its relation to other nouns like male, man, manhood, manliness and virility is far from obvious. As adjective, the term 'masculine' moves between the identification of a person's sex as male and socially validated norms of acceptable behaviour for males. As noun, its referent will depend on what assumptions about subjectivity and society determine its context. For some sociologists masculinity is a role, for some poststructuralists it is a form of representation. Central to all the usages seems to be an element of acculturation. Masculinity is socially constructed. (152–153)

It is during the nineteenth century, therefore, that these connotations of masculinity assume a contemporary structure, configured by the construction of masculinity and its cultural transmission and imprinting of the 'validated norms' of male gender.

During the nineteenth century, the rubric 'manliness' was used to connote the hegemonic form of masculinity and its ideal paradigm, as Mangan observes:

> Central to the evolution of the male image was the Victorian ideal of 'manliness'. . . . as embracing qualities of physical courage, chivalric ideals, virtuous fortitude with additional connotations of military and patriotic virtue. In the second half of the nineteenth century . . . the concept underwent a metamorphosis. To the early Victorian it represented a concern with a successful transition from Christian immaturity to maturity, demonstrated by earnestness, selflessness and integrity; to the late Victorian it stood for neo-Spartan virility as exemplified by stoicism, hardiness and endurance. . . . 'Manliness' symbolised an attempt at a metaphysical comprehension of the universe. It represented an effort to achieve a *Weltanschauung* with an internal coherence and external validity which determined ideals, forged identity and defined reality. (1–3)

Mangan adds that this second stage of evolution of masculinity was to have global repercussions: 'a neo-Spartan idea of masculinity was diffused throughout the English speaking world with the unreflecting and ethnocentric confidence of an imperial race' (3). The concept of masculinity that evolved during the nineteenth century in Britain, therefore, had repercussions far beyond the island of Great Britain itself. Norman Vance, in his pioneering *Sinews of the Spirit*, had affirmed about manliness:

> 'Manliness' has almost always been a good quality, the opposite of childishness and sometimes of beastliness, counter not so much to womanliness as to effeminacy. . . . The manly man may be patriotic, generous, broad-minded, decent, chivalrous and free-spirited by turns. . . . 'Manliness' can be summarized as physical manliness, ideas of chivalry and gentlemanliness, and moral manliness, all of which tend to incorporate something of the patriotic and military qualities which 'manliness' may also connote. (8, 10)

Vance traces the origin of such ideas of manliness to the heroic exploits of Nelson and Wellington during the Napoleonic Wars, with the militaristic aspect given additional credence as a result of Balaclava. The ideologies of chivalry and of the gentleman, negotiated in everything from *Idylls of the King* to *Great Expectations*, contributed to the formation of manliness, which Charles Kingsley and F.D. Maurice, with their concept of Muscular Christianity, forged to link gendered behaviour with organized religion, lending the weight of divine sanction to secularized attitudes. The advocacy of 'hero-worship' by Thomas Carlyle in his lectures of 1840–41, clearly inspired by such events as the Napoleonic campaigns, transformed men like Oliver Cromwell into paradigms of gendered behaviour for males during the century.

Noting the importance of an individual such as Carlyle in the construction of masculinity, Michael Roper declares:

> Masculinity underpins social life and cultural representation. . . . Masculinity has always been defined in *relation* to 'the other'. . . . Making men visible as gendered subjects has major implications for all the historian's established themes . . . the historical diversity of masculinity. . . . Masculinity (like femininity) is a relational construct . . . and . . . it is shaped in relation to men's

social power. . . . We now have a reasonably clear impression of a marked shift in the codes of manliness current among the governing and professional classes during the latter half of the nineteenth century – from the moral earnestness of the Evangelicals and Dr Arnold to the respect for muscle and might so prevalent at the close of the Victorian era . . . the diversity and mutability of masculinity over time. . . . (1–3)

Roper stresses that this shift in the definition of masculinity during the century was integrally involved with 'the politics of masculinity':

Codes of manliness served as gender boundaries. . . . Understanding what 'masculinity' is requires that we firmly locate the differences between men in the context of sexual politics: men's power over women, the power of older over younger men, and – during the last hundred years – power of heterosexual over homosexual men. (4)

Roper emphasizes 'the costs to men of patriarchy' as a result of 'the mutations of male dominance over time and their relation to other structures of social power, such as class, race, nation and creed' (4). If masculinity consists, for Roper, in the codes of male behaviour in culture, then patriarchy, which inscribes masculinity in situations of power, signifies the element of dominance in ideologies of maleness. These forms of empowerment meant that 'the achievement of manhood depended on a disparagement of the feminine without and within' as well as the maintenance of 'dominant ideologies of masculinity . . . through asserting their difference from – and superiority to – other races' (13).

The term 'masculinity' itself, as Arthur Brittan has argued in *Masculinity and Power*, is both problematical and yet crucial. He states:

This assumption – that we can know and describe men in terms of some discoverable dimension is problematic – because it suggests that masculinity is timeless and universal. . . . My position is that we cannot talk of masculinity, only masculinities. This is not to claim that masculinity is so variable that we cannot identify it as a topic. . . . Any account of masculinity must begin with its place in the general discussion of gender. . . . While it is apparent that styles of masculinity may alter in relatively short time spans, the substance of male power does not. (1–2)

Brittan argues that images are a key element in this negotiation of power vis-à-vis gender:

The fact that masculinity may appear in different guises at different times does not entitle us to draw the conclusion that we are dealing with an ephemeral quality which is sometimes present and sometimes not. In the final analysis, how men behave will depend upon the existing social relations of gender. . . . Masculinity, therefore, does not exist in isolation from femininity – it will always be an expression of the current images that men have of themselves in relation to women. And these images are often contradictory and ambivalent. (2–3)

It is one of the premises of this study of Victorian painting that the images constructed by visual representation are part of this repository of images which contribute to the formation of male subjectivity. Brittan distinguishes masculinity from what he denominates as masculinism: masculinity he

defines as 'those aspects of men's behaviour that fluctuate over time' while masculinism is 'what remains relatively constant in the masculine ideology' (3). The latter is 'the justification and naturalization of male power' (3). He continues:

> Those people who speak of masculinity as an essence, as an inborn characteristic, are confusing masculinity with masculinism, the masculine ideology. Masculinism is the ideology that justifies and naturalizes male domination. As such, it is the ideology of patriarchy. Masculinism takes it for granted that there is a fundamental difference between men and women, it assumes that hetero-sexuality is normal, it accepts without question the sexual division of labour, and it sanctions the political and dominant role of men in the public and private spheres. Moreover, the masculine ideology is not subject to the vagaries of fashion – it tends to be relatively resistant to change. In general, masculinism gives primacy to the belief that gender is not negotiable – it does not accept evidence . . . that the relationships between men and women are political and constructed. (3–4)

Brittan's distinction between masculinity and masculinism, however, while sharpening one's awareness that male subjectivity is constructed, intro-duces a differentiation in terminology which may not be necessary, as he seems to recognize:

> I am not for one moment suggesting that the connection between masculinism and masculinity is tenuous. . . . I realize that there are problems in talking about masculinism as a dominant ideology. To assume this is to accept without reservation that a dominant group's ideology is inevitably imposed upon everybody else. . . . The proposition that masculinism is the ideology that justifies and naturalizes male domination needs to be qualified. Granted that men collectively do not form committees to ensure their continued domination, and that men themselves are exploited and dominated by other men, we can nevertheless still speak of a set of gender relations in which the power of men is taken for granted, not only in the public but in the domestic sphere as well. Masculinism is reproduced and reaffirmed in the household, in the economy and in the polity. . . . The masculine ideology remains intact. (4–6)

It would seem useful, therefore, to deploy the term 'masculinity' as Roper suggests, not restricting it as does Brittan to 'those aspects of men's behaviour that fluctuate over time' but rather to describe the codes of male behaviour in culture, *including* those that construct male dominance in the process of constructing male subjectivity; in other words, to incorporate the power relations central to masculinism as part of the process of encoding and imprinting male gender. Separating the idea of power from the concept of masculinity is to draw an artificial distinction. Rather, the term 'masculinity' refers to the constructed ideologies defining male subjectivity, including those establishing male dominance, masculine hegemony and patriarchy. The term 'masculinities' recognizes that the term 'masculinity' cannot be monolithic or essentialist in the sense of applying to all males, which would be to ignore differences among men of class, race, sexual orientation, ethnicity or nationality. The term masculinity in this subsequent discussion will therefore include the practice

of reifying male power as well as the other constituent elements (for example, sexual or economic or physical or civic) basic in the cultural construction of male subjectivity.

As Brod observes (*Making*), masculinity as a construction is one of 'the social processes of engenderment' (4), involving not a simplistic '*the* male sex role' but rather 'the multiplicity of male roles' (7), which range over race, class, ethnicity and nationhood. The dominant, hegemonic masculinity is constituted by 'the institutionalized codes that embody these concerns, govern and restrict all men's lives, and give some men power over others' (12). The presence of a range of behaviours compels one to 'think of masculinity not as a single object with its own history but as being constantly constructed within the history of an evolving social structure, a structure of sexual power relations' as Carrigan observes (Brod 88–89). Relations of power mean that masculini*ties*, the varieties of masculine behaviour from the inflection by differences (of race, creed, ethnicity, sexual orientation or nationhood) become as key a focus as masculinity. R.W. Connell's structure of a hierarchy of masculinities clarifies these degrees of empowerment: 'hegemonic masculinity, conservative masculinities (complicit in the collective project but not its shock troops) and subordinated masculinities' (110). These classifications, as will be demonstrated in the subsequent analysis of Victorian painting, could be fluid: a white private in the ranks, subordinated by class at home, could assume hegemonic status as part of the colonial forces on the Indian sub-continent or in Africa, where his race would confer superiority.

One's awareness of masculinity as constructed in culture has been greatly sharpened by the advent of Men's Studies. As Kimmel notes (1987), 'men have been the normative gender', but only with the advent of Men's Studies has the 'study [of] men as men . . . masculinity [as] the object of inquiry' become focused: 'men's studies takes masculinity as its problematic' (11). This problematic is challenging since 'the social construction of masculinity varies along class, race, age, and ethnic lines, even if masculinity is always constructed in relation to femininity' (21–22). As Stearns remarks, 'manhood is an evolving social construct reflecting some continuities but many more changes. In talking about manhood, we are inevitably talking about history' (3). The influence of culture in this process prompts Stearns to assert that 'manhood in any organized society flowed more from the culture than from innate gender characteristics' (11). For Stearns, there was 'basic change in the canons of manhood during the nineteenth century' (11–12), which makes its transitional status particularly crucial in investigating Victorian culture.

The repercussions for men in the nineteenth century resulted from the transitional status of the culture prompted by the Industrial Revolution. Stearns summarizes some of these consequences:

> Industrialization moved the process of work outside the home. . . . Fatherhood was radically transformed. . . . Industrialization challenged patriarchy . . . by

separating work from home, reducing traditional contacts between boys and adult males. . . . For in linking manhood and work, men not only won for themselves a greater share of economic power than had been characteristic of ordinary families in the past, when both husband and wife contributed to the family economy. They also reserved for themselves attributes different from those of women. And they gained a new basis for family authority. . . . In its relaxation of community controls, the nineteenth century in fact provided more outlets for diverse male behavior than had been possible for the general run of men in preindustrial society. But this only increased the rigor with which most men, in working class and middle class alike, held to basic notions of what a real man should be. . . . [Men] tended to assume a distinctive gender personality that could enhance a sense of masculinity. . . . There was a self-conscious assertiveness about nineteenth-century masculinity that deserves notice' . . . (49, 67, 71, 78)

As Doyle summarizes, 'the nineteenth-century industrial revolution did more to affect men's lives than almost any other social change in history' (11).

The impact of historical change may be considered if one examines certain specific moments during the century which began to transform the social contexts in which masculinity was constructed. Political transformations were effected by a series of acts that specifically intervened in the marriage relationship, for example: the 1844 Matrimonial Causes Act mandated that a man could not force his wife to return home; the 1857 Marriage and Divorce Bill established civil courts to grant separation and divorce, and the 1858 Amendment Act made divorce less expensive and thus more accessible to the middle class. The Married Women's Property Act of 1870 transformed the economic situation of married women by granting them equitable property rights and permission to retain earnings after marriage. In 1878 abused wives could get separation orders and maintenance. The 1882 Married Women's Property Act gave women the right to independent ownership of property, that is, the same property rights as unmarried women. Such legislative intervention in the marital relationship began to rectify the imbalance of power within marriage – male as paterfamilias by legal provision. How symbolic as well as real such legislation could be is indicated by the 1884 action of Parliament which abolished imprisonment as a penalty for denying a spouse conjugal rights.

Legislation alone could not alter the role of males in marriage. Science and medicine began to transform sexual knowledge and practice. In 1843, for example, the vulcanization of rubber made the cervical cap popular, while the condom became less expensive. By 1877, the year of the Bradlaugh-Besant trial, the middle classes were definitely employing birth control for limitation of family size. The Contagious Diseases Acts of 1864, 1866 and 1869, which mandated that a woman suspected of prostitution could be subjected to a pelvic examination – a major example of the sexual double standard – were repealed in 1886. While education for men, rather than both sexes, was still the norm in the nineteenth century, women nevertheless began to become better educated, with the founding of

Queen's College in 1848, the Nightingale School of Nursing in 1860, Girton College in 1869 and Newnham College, Cambridge, in 1871. By 1878, women were admitted to all degrees at the University of London. The Reform Bills of 1832, 1867 and 1884 failed to grant women's suffrage, however, thereby assuring male hegemony for the duration of the nineteenth century. As Kimmel (1987) has observed, there was a 'crisis of masculinity . . . a powerful organizing concept in the late nineteenth century' (280), much of it due to this transformation of the feminine as the century advanced. Brod (in Kimmel 1987) summarizes:

> The 1890s were widely perceived as embodying an acute 'crisis of masculinity.' Articles abounded in the popular press of the time and instructional manuals aiming to solve male problems proliferated. Many factors contributed to the male malaise, among them the waning of Victorianism, the emergence of the 'New Woman,' the continuing impact of industrialization, urbanization. (267)

These changes meant that standards of masculinity, like many other dimensions of Victorian culture, were in a state of transition.

It is this transitional nature of masculinity in the nineteenth century which makes maleness during this period of special importance for the study of gender. Stearns notes that 'male family styles also displayed considerable continuity from nineteenth-century forms' into the twentieth century (220–221). He concludes:

> For men, the twentieth century has witnessed a complex juggling act designed to preserve certain masculine personality traits inherited from the nineteenth century or before, while at the same time adapting to important new pressures toward greater surface friendliness or selective emotional openness. . . . Overall, the basic trends toward reducing gender distinctions, while not eliminating either the distinctions themselves or some of their nineteenth-century manifestations, applied both to developments in actual male roles and to the styles men were urged to adopt in enacting these roles. . . . The new male standards touched base with Victorian traditions in urging restraint in normal emotional expression, but the foundations had shifted, and so, in all probability, had the actual emotional experience of many men. . . . Male traditions did shift, but they maintained contact with reactions that had seemingly worked well in the nineteenth century. (224, 227, 226, 232)

The endurance of nineteenth-century paradigms, however, meant that masculinity was defined by its differences from femininity. Such differences were sharply marked in the nineteenth century, as Stearns comments about the middle-class male:

> The decline of property in the middle class did more than modify the bases of paternalism. . . . [There arose] the need to associate economic manhood with claims to a specialized knowledge. . . . This process . . . required a claim that the new expertise fit the special mental qualities of men. . . . The downgrading of women played a role in gender battles in some of the professional fields. . . . but it was more broadly necessary to bolster masculinity itself. . . . Women were claimed to be irrational, and thus unqualified to receive the new professional knowledge . . . the deeply felt need for rhetorical vigor in separating men from women. . . . Schools . . . not only reflected but actively promoted the gender stereotypes of the day. (134–136)

This establishing of differences – from racial/sexual/national Others – was crucial in forming the masculine codes of the nineteenth century. Part of this emphasis on difference and constructing the Other was the result of a central element in the construction of masculinity during the era, as Stearns observes: 'Manhood is a solemn thing. It is not purely natural, for like most of the attributes of civilized society it has to be taught' (248). The nineteenth century produced famous teachers, or sages, who constructed through their discourses paradigms of masculinity by reiterating and focusing on differences. These 'instructors' of masculinity formed the intellectual environment in which, and by which, males constructed their masculinity.

Of particular significance in this construction was Thomas Carlyle, whose 1840 lectures *On Heroes, Hero-Worship, and the Heroic in History* were published the following year. It goes without saying that for Carlyle the heroic impulse was indisputably of the male gender: his heroes are Odin, Mahomet, Dante, Shakespeare, Luther, Johnson, Cromwell and Napoleon, among others. Such individuals are marked by their galvanizing energy, vitality, sincerity, intensity, fearlessness, self-reliance, earnestness, valour and silent confidence. 'Universal History, the history of what man has accomplished in this world, is at bottom the History of the Great Men who have worked here. They were the leaders of men, these great ones,' Carlyle declares (239), distinguishing heroes not only from the anonymous, the classless and women, but also from males unlike themselves. Carlyle constructs a history of masculinity and a paradigm of it:

> Society is founded on Hero-worship. All dignities of rank . . . are what we may call a *Hero*archy (Government of Heroes), – or a Hierarchy, for it is 'sacred' enough withal! . . . The History of the World, I said already, was the Biography of Great Men. . . . (249, 251)

Carlyle appropriates to masculinity the tolerance of force and even violence in this process of self-realization: 'Divine *right*, take it on the great scale, is found to mean divine *might* withal!' (429). Those who disagree with the hero are labelled 'quacks' and often rise through democratic reform, which Carlyle despises: 'Why, the insincere, unbelieving world is the *natural property* of the Quack. . . . By ballot-boxes we alter the *figure* of our Quack; but the substance of him continues' (442). The force of *On Heroes, Hero-Worship* in the construction of paradigmatic masculinity in the nineteenth century is summarized in Carlyle's observation: 'Virtue, *Vir-tus*, manhood, hero-hood, is not fair-spoken immaculate regularity; it is first of all, what the Germans well name it, Tugend . . . Courage and the Faculty to do' (443). Despite the fact that Carlyle suggests heroism is accessible to all, the clear agenda of these lectures is that it is not. In this famous sentence, Carlyle equates *virtue* with *manhood* with *herohood* in an incontrovertible paradigm, from his perspective, of maleness.

The demarcation of maleness from femininity was advanced by John Ruskin in his lecture *Of Queens' Gardens* in 1864, published the following

year in *Sesame and Lilies*. Ruskin distinguished men from women as clearly as possible in his contentions:

> The man's power is active, progressive, defensive. He is eminently the doer, the creator, the discoverer, the defender. . . . But the woman's power is for rule, not for battle, – her intellect is not for invention or creation, but for sweet ordering, arrangement, and decision. . . . Her great function is Praise. . . . [Home is] the woman's true place and power . . . infallibly wise – wise, not for self-development, but for self-renunciation: wise, not that she may set herself above her husband, but that she may never fail from his side . . . with the passionate gentleness of an infinitely variable, because infinitely applicable, modesty of service – the true changefulness of woman. (18.121–123)

As Pearsall notes, 'men read and listened to Ruskin because this was what they wanted to have confirmed' (*Worm* 109). Pre-eminent as critic of art and society, the case of Ruskin compels one to confront 'the relationship of discourse about art to the exercise of social and political control' (Roskill 89). It is striking the manner in which Ruskin's distinction between men and women reinforces Carlyle's construction in *On Heroes, Hero-Worship*: the emphasis on leading, action, engagement is common to both. Carol Christ argues that 'the ideal of the angel in the house should tell us at least as much about the Victorian man as about the Victorian woman', and while her claim that woman 'represents an ideal freedom from those very qualities [man] finds most difficult to accept in himself' (147) would be considered false by many nineteenth-century males, it is nevertheless true that Coventry Patmore's *Angel in the House* (1854) still emphasizes 'woman's lack of desire to act' as the basis of her virtues (149). Patmore's poem and Ruskin's treatise advanced gender differences by confirming the doctrine of separate spheres for nineteenth-century culture.

Elizabeth Fee has documented the manner in which early anthropologists contributed to the construction of masculine superiority over women by emphasizing difference. John McLennan, author of *Primitive Marriage* (1865) and *Studies in Ancient History* (1876), believed that 'women were less useful to society than were men' (Fee) (37). 'For [John] Lubbock [author of *Primitive Times* (1865)] and doubtless many of his contemporaries, the essence and beauty of the male–female relationship resided in inequality' (32). For Herbert Spencer, evolution indicated that 'feminism appeared distinctly reactionary' (37). The result of these theories was that 'patriarchalism was . . . inextricably linked with the progress of civilization' (38). The amalgamation of several elements of nineteenth-century thought led to Social Darwinism, one of whose ideas was that women and members of other races were less evolved than Caucasian males. For example, George J. Romanes noted that 'the average brain-weight of women is about five ounces less than that of men', a condition which led to 'a marked inferiority of intellectual power' in women (654–655). He concluded that 'it must take many centuries for heredity to produce the missing five ounces of the female brain' (666). Herbert Spencer in 1873 in *The Study of Sociology*

wrote that there had been 'a somewhat earlier arrest of individual evolution in women than in men' (340). Male superiority was confirmed and constructed by the emphasis on the inferiority and differences of women and of other races.

Victorian theories of race contributed to this construction of Caucasian male superiority, especially by advancing agendas whose principal thesis was 'racial determinism' (Biddiss 12). Disraeli's *Tancred* in 1847 included the observation that 'All is race; there is no other truth' (149), and Robert Knox declared:

> That race is in human affairs everything is simply a fact, the most remarkable, the most comprehensive, which philosophy has ever announced. Race is everything: literature, science, art – in a word, civilization – depends on it. (*Images* 12)

Biddiss notes several elements which were used in the process of differentiation: 'gradations of skin pigmentation', 'the colour and texture of hair', the 'developing science of comparative anatomy', 'prognathism and orthognathism', 'phrenology' and the 'cephalic index' (15–16). All of these contributed to the formation of a concept of 'innate differentiation' revolving around the competing theories of racial monogenesis (all humankind comprised of one race) and polygenesis (the races as separately derived). Alfred Wallace's essay 'The Origin of Human Races' in 1864, for example, advanced a polygenicist argument while glancing at a remote monogenesis. The following year, Francis Galton in 'Hereditary Talent and Character' contended that intelligence and other desirable traits were inherited, which meant that 'Darwin's law of natural selection acts with unimpassioned, merciless severity' (*Images* 64). In 1866, Charles Mackay published 'The Negro and the Negrophilists' which emphasized blacks' innate inferiority:

> It will be admitted, that in his native Africa the negro has never emerged out of primitive barbarism. . . . The great Caucasian stock, spreading from Asia westwards and southwards, has peopled Europe, America, and Australia with bold enterprising and progressive men. . . . But during this time the negro has done nothing. . . . There is an antipathy of race, against which all argument is powerless. . . . The antipathy of the Anglo Saxon against people of a different colour from his own springs, in the first place, from a desire to rule and to possess. . . . The inferior race provokes aggression, even when the superior would gladly do no more than banish it beyond the boundaries of civilisation. (97, 102)

Mackay's essay inscribes not only the dominance of the white male over all other human beings but also provides a platform for the justification of imperialism, an exploitation posited on assumptions of racial determinism. Frederic Farrar in his 'Aptitudes of Races' in 1867 declared that 'mental faculties seem to be deficient in all the dark races' (*Images* 151). The epitome of this racist programme is of course Carlyle's *The Nigger Question* published in 1849 and revised in 1853. Carlyle established that if a

black did not act according to white prescription, he must be forced to so act: 'compel him, since inducing will not serve, to do the work he is fit for . . . but if your Nigger will not be induced? In that case, it is full certain, he must be compelled' (10).

Carlyle's *Nigger Question* links Caucasian racial superiority to an explicit formation of an ideology of manliness; the essay constructs masculinity as precisely as the essays comprising *On Heroes, Hero-Worship*. Carlyle asserts the right to govern belongs to Anglo-Saxons:

> Up to this time it is the Saxon British mainly; they hitherto have cultivated with some manfulness; and when a manfuler class of cultivators, stronger, worthier to have such land . . . shall make their appearance, – they . . . will be declared by Nature and Fact to *be* the worthier. . . . That is the law. . . . Till the white European first saw them [blacks], they were as if not yet created. . . . [The gods] wish . . . that manful industrious men occupy their West Indies, not indolent two-legged cattle. . . . Before the West Indies could grow a pumpkin for any Negro, how much European heroism had to spend itself in obscure battle . . . heroic white men, worthy to be called old Saxons. . . . Decidedly you have to be servants to those that are born *wiser* than you, that are born lords of you; servants to the Whites, if they *are* (as what mortal can doubt they are?) born wiser than you. That, you may depend on it, my obscure Black friends, is and was always the Law of the World, for you and for all men. (27, 28, 30, 32)

Although John Stuart Mill recognized in his rejoinder to Carlyle that his essay was racist and imperialist and colonialist, the force of Carlyle's essay in constructing white male superiority cannot be underestimated. Its basic tenets coincided with ideas expressed by other theoreticians of race and by anthropologists during the era, confirming white male superiority over other males, races and women.

This emphasis on the Anglo-Saxon heritage became integrated with Victorian ideas about Aryans. Léon Poliakov emphasizes the importance of Tacitus's *Germania* in forming ideas about a superior racial type, which reached a climax in the 1840s with the emphasis on Teutonism of such figures as Thomas Arnold, Carlyle, and Edward Bulwer-Lytton, and given fictional impetus by works such as Walter Scott's *Ivanhoe*, which commends Anglo-Saxon over Norman blood and lineage. Faverty comments that Thomas Arnold was 'a fervent admirer of the Germanic races, the most moral that the world had known . . .; he came to be known as 'that Teuton of Teutons, the Celt-hating Dr Arnold' (76). This position was similarly important in the formation of ideologies of masculinity, for such ideas are 'following the belief widely current in the nineteenth century that the most virile, the most regenerative ingredient in modern western civilization was the Teutonic' (97).

This emphasis on the Teutonic and Anglo-Saxon was given pictorial construction in Frank Dicksee's *The Funeral of a Viking* of 1893 (Plate 1–1), which depicts a Nordic world of phallocentrism, warfare, heroism and death. Henry Blackburn observed in *Academy Notes*:

A scene which is a whole Saga in itself. The dead Viking is bound on his last voyage over the sea to Walhalla. Norse warriors are launching the galley which is also to be a funeral pyre. Contrast between the dying twilight and the gaining flames at the prow, with their orange reflections in the surf. The old king, saluted for the last time by his stern bronze-clad followers, rests at full-length on a wild animal's skin as he starts on his final cruise. A Jarl, in splendid battle array, has lit the framework of the doomed vessel, and, with sorrowful gaze, uplifts his right hand as a last tribute of respect to his war-lord. A strong wind blows off shore, fanning the flames. (9)

Both the figure of the lord and of his thane with the torch are associated with solarism: the lord wears a gold helmet (with swan's wings) and holds a bronze shield reflecting the glow of the fire; the thane in dark red cloak has a helmet and breastplate that appear gold in the firelight, accented by the gold bracelet on his left arm. The uplifted swords of the retainers echo Jacques-Louis David's *Oath of the Horatii*, linking maleness to civic virtue. As notes in the Manchester City Art Gallery files suggest, the period of the canvas is between 789 and 912 AD; the Vikings are part of the ancient lineage of Britain inasmuch as 'the first raid by Vikings in England was in A.D. 789, when they appeared off the Dorset coast and appeared again in 793, followed by many other raids' (unpublished). Dibdin notes that the canvas 'was hung in the place of honour at Burlington House, a distinction it well deserved', adding that the chief is a 'hero' (12) in an echo of Carlyle. The artist himself in a letter of 1928 declared that the Viking would 'enter Valhalla' (Manchester City Art Gallery Archives). The *Magazine of Art* in its review of the canvas felt compelled to emphasize its masculine qualities, for it is 'far more virile and solid than any painting Mr. Dicksee has painted for some years' (258).

As a construction of masculinity, *The Funeral of a Viking* is a key document of gender differentiation and imprinting during the era. Dicksee's nude drawing (Plate 1–2) for one of the retainers hauling the boat, emphasizes the significance of the male body in this construction of masculinity. This psychological imprinting occurs as the male observer gazes at the canvas. Stearns notes about sporting events that 'one of the functions of male spectatorship . . . was to allow men some symbolic expressions through watching the intensities of others' (226), a function equally of the male gaze directed at a canvas like *The Funeral of a Viking*. Hatt argues convincingly that 'the stability of masculinity depends upon the visibility of the male body; to be learnt or consolidated, masculinity requires a visual exchange between men' (63). A painting such as *The Funeral of a Viking* or its preliminary study reinforces Hatt's belief: 'Authority demands recognition; in order to function, it needs to be looked at' (65). This act of looking is common to both literary and artistic discourses. It is of particular interest with regard to Dicksee's canvas that it was exhibited in the British fine art section of the Festival of Empire exhibition at the Crystal Palace in 1911, for *The Funeral of a Viking* functions as an ideological construction of empire, in its hierarchical

authority, its militarism, its Caucasian emphasis and its valour. In this respect, it intersects with a text such as H. Rider Haggard's *King Solomon's Mines* of 1885, in which Sir Henry Curtis, fighting renegade blacks, reveals his Viking ancestry:

> His long yellow hair streamed out in the breeze behind him. There he stood, the great Dane, for he was nothing else, his hands, his axe, and his armour all red with blood, and none could live before his stroke. Time after time I saw it sweeping down, as some great warrior ventured to give him battle, and as he struck he shouted, '*O-hoy! O-hoy!*' like his Bersekir forefathers, and the blow went crashing through shield and spear, through head-dress, hair, and skull, till at last none would of their own will come near the great white 'tagati' (wizard), who killed and failed not. (226)

The fact that Haggard dedicated his novel 'to all the big and little boys who read it' assured that its imprinting of Viking norms would pave the way for the reception of *The Funeral of a Viking*.

This canvas in turn may well have inspired Henry Newbolt's *The Viking's Song* of 1900, which establishes conquest of land as the epitome of male desire:

> When I thy lover first
> Shook out my canvas free
> And like a pirate burst
> Into that dreaming sea,
> The land knew no such thirst
> As then tormented me.
>
> Now when at eve returned
> I near that shore divine,
> When once but watch-fires burned
> I see thy beacon shine,
> And know the land hath learned
> Desire that welcomes mine. (89)

Written during the Boer War, such a poem legitimizes conquest, just as Dicksee's glorification of Viking heroism does. In such a manner, art becomes, along with literature, part of the discourse constructing masculinity for the nineteenth-century male. In fact, it was even possible to assimilate the Vikings in Christian paradigms, as the presence of the monks in Robert Gibb's *The Last Voyage of the Viking* (1883) attests. In a painting which might well have influenced Dicksee's *The Funeral of a Viking*, a ship is being rowed across a tranquil surface as the monks recite the funeral service around the bier of the dead Viking and his retainers lament. Thus, the masculinity of the Viking paradigm could be adapted to either pagan/heroic or Christian constructions of male subjectivity.

This construction of male subjectivity via *The Funeral of a Viking* endured beyond its exhibition at the Festival of Empire in 1911. In his 1925 address to the Royal Academy as its president, Dicksee clarified its imperialist agenda by declaring the racism of his ideology:

> There is another limit by which we of the western races must be bound. Our ideal of beauty must be the white man's; the Hottentot Venus has no charms for

us, and the elaborate tattooing of the New Zealand Maoris does not, to our thinking, enhance the beauty of the human form; so, in spite of some modern tendencies, if we have to bear 'the white man's burden,' in Heaven's name let us at least keep his ideals! (13)

In this address Dicksee associates this sense of 'ideals' with Matthew Arnold's *Literature and Dogma* (1873) by citing 'the enduring power, not ourselves, that makes for righteousness' (13). After expressing this imperialist political attitude, Dicksee proceeds to apply such ideas to a Social Darwinist theory of art:

> The hoarded memory of the race [has] been passed down and become[s] an instinct in each member of it. . . . For him another veil has been lifted, and on him has been bestowed that rare and fateful gift which we term genius: one more step has been won in the ascent of man. But it must be admitted that there are others who show evidence of what in breeding parlance is called a 'throwback,' that is to say, that for some unknown reason they have failed to inherit the whole of the hoarded memory of which I have spoken. The earlier part, which has just emerged from the darkness of the cave-dweller, they retain; but the later ideals of the race they have not the power to assimilate. (14)

This statement, linked with the alignment of Caucasian racial superiority immediately preceding it, creates a Darwinist theory of art: those who do not follow prescribed racial/aesthetic/masculine traditions are evolutionary atavisms. Dicksee advises his audience of art students: 'You of the British race, do not consent to be dragged by the heels behind continental decadents' (16). Dicksee was to paint a canvas, *The Ideal* (Plate 6–10) in 1905, of a nude Aryan male, which conjoined the masculine body with these racist and imperialist 'ideals'. He exhorts his students in a peroration:

> Be up and doing, unfurl your banner and call up your reserves. Let your consciousness become, as it were, a saturated solution of ideas, experiences, visions, harmonies. . . . And then, if there be fresh worlds to conquer, who would be better equipped for the venture than you? (17)

Dicksee's discussion of form, colour, and other painterly concerns is merged in this ideology of imperialism, racism and masculinism. Dicksee appropriated this same language in his 1927 address to the students of the Royal Academy. After invoking chivalric and imperialist codes as a model for students, he observed:

> The old standards of beauty are abandoned and a new order founded on a negroid or other barbaric type usurps their place, and as the old-fashioned idea of beauty is associated with health, so *that* also must be shunned, and samples of disease in ample variety are paraded for the public eye. . . . The music of this new dispensation must be borrowed from the syncopated patter of the negro population of America. (14)

The African associations of Cubism and jazz are equated with the disease of the postwar world. Throughout this lecture, expressions like 'miasma', 'contamination', 'unnatural madness', 'this distraught world' and 'malign

influence' are interspersed to coerce the art students into believing that anything other or different – including women and/or colonials – is to be appropriated by a supremacist, Caucasian, masculinist force, embodied in art. The proto-Fascist salute in *The Funeral of a Viking* anticipated Dicksee's politics in the twentieth century, as Gladys Storey recorded in 1929:

> He told me he was an admirer of Mussolini, and was himself a Fascist – 'though I am too old to take an active part': nevertheless, a few months later he was (at the age of seventy-one) elected to the Presidential Chair of the Royal Academy, which office he filled with dignity; his height, good looks, and charm of manner made him an attractive and popular figure. (208)

As president of the Royal Academy from 1924 to 1928, Dicksee embodied, encoded and represented – both in actuality and in his oeuvre – an ideology about art, gender, race, imperialism, and authority that, originating from Victorian bases, demonstrates the practice by which artistic representation constructs male subjectivity.

Carlyle in *Heroes* emphasized the importance of the Teutonic, for example in discussing Luther: 'No more valiant man, no mortal heart to be called *braver*, that one has record of, ever lived in that Teutonic Kindred, whose character is valour' (36). Charles Kingsley in *The Roman and the Teuton* (1864) stressed the superiority of the Teutonic Aryan:

> 'The Teuton sat, yet a child, unknown and naked among the forest beasts . . . for the child was of a royal face, and destined to win glory for all time to come.' . . . To the strange and complicated education which God appointed for this race; and by which he has fitted it to become, at least for many centuries henceforth, the ruling race of the world. . . . While the Red Indians have been, ever since we have known them, a decreasing race, the Teutons have been a rapidly increasing one. . . . The Teuton morals were above those of a Sioux or a Comanche. . . . Happy for us Englishmen, that we were forced to seek our adventures here, in this lonely isle; to turn aside from the great stream of Teutonic immigration; and settle here, each man on his forest-clearing, to till the ground in comparative peace, keeping unbroken the old Teutonic laws, unstained the old Teutonic faith and virtue. (5, 8, 9, 13)

In his preface to the third lecture comprising *The Roman and the Teuton*, Kingsley establishes as 'an ethnological fact' the superiority of 'a hereditary aristocracy' by recounting its originating moment in a dialogue:

> The golden-haired hero said to his brown-haired bondsman, 'I am a gentleman, who have a "gens," a stamm, a pedigree, and know from whom I am sprung. I am a Garding, an Amalung, a Scylding, an Osing, or what not. I am a son of the gods. The blood of Asas [the first Aryan] is in my veins. Do you not see it? Am I not wiser, stronger, more virtuous, more beautiful than you? You must obey me, and be my man, and follow me to the death.' . . . As a fact, that is the method by which the thing was done. (49)

The linguist and sponsor of the solar theory of language, Max Müller, in his preface to the 1881 edition of *The Roman and the Teuton*, linked Kingsley's

lectures with masculinity, praising Kingsley's 'manly features' and 'chivalry' (v, vi). The belief that the Aryans migrated from central Asia following the path of the sun was to underlie the affiliation of maleness with the sun in Victorian culture, linking masculinity with the god Apollo, as George Eliot does through her character Will Ladislaw in *Middlemarch*. As Poliakov has observed, the result of this Teutonic/Aryan concept was evident in the manner in which it constructed the idea of masculinity in the nineteenth century: 'On close inspection the true Aryan appeared to be a Westerner of the male sex, belonging to the upper or middle classes, who could be defined equally by reference to coloured men, proletarians or women' (272). Horsman observes that 'a belief in Anglo-Saxon freedom . . . had by the middle of the nineteenth century been transformed into a rationale for the domination of peoples throughout the world' (387). The attitudes expressed in Victorian theories of race intersected with ideologies of masculinity in the memorable euphemism for the penis employed by Robert Baden-Powell in his advanced-Scout handbook *Rovering to Success*: 'the racial organ' (111).

The penis as signifier in the nineteenth century was fundamental to the concept of hegemonic masculinity during the Victorian period. Carrigan *et al.*, observe that 'the political meaning of writing about masculinity turns mainly on its treatment of power' (64). Masculinity is a 'political order, and the question of what forms of masculinity are socially dominant or hegemonic has to be explored' (64). While the idea of maleness has been governed for much of the nineteenth and twentieth centuries by the concept of role, the idea fails to convey the 'sense of a power relation between men and women' (66–67). Criticizing Parsons, the authors comment that 'the underlying structural notion in his analysis of gender is always differentiation, not relation' (68), a statement applicable to much nineteenth-century construction of gender, which posited Caucasian maleness by differentiating it against the Other, whether that Other was racial, sexual, ethnic, or based on class or nationality: 'masculinity exists as a power relation' (74). While the theory of 'role' in the twentieth century has been critiqued by authorities such as Pleck, Carrigan *et al.*, correctly note that the problem with this rubric is that 'the very idea of a "role" implies a recognizable and accepted standard. . . . It does not actually describe the concrete reality of people's lives' (77). During the nineteenth century, however, at least until the final decades of the century, a paradigmatic concept of 'role' was legitimized in the discourses configured by Carlyle, Kingsley, Thomas Arnold, Ruskin, and many others. During the nineteenth century, to paraphrase Carrigan, *relations were* interpreted as differences (75). The consequences of hegemonic masculinity are several:

> First, hegemony means persuasion . . . images of masculinity are constructed and put to work. . . . Second, hegemony closely involves the division of labor. . . . Third, the negotiation and enforcement of hegemony involves the state. . . . [It] creates economic incentives to conform to the hegemonic pattern. . . .

> Our knowledge of the biological dimension of sexual difference is itself
> predicated on the social categories. (94–95)

The architects of masculinity in the nineteenth century – under the press of
feminism, imperialism, anthropology, and other movements – constructed
a masculinity which Carrigan *et al.*, illuminate. The possession of the penis
became inscribed into the dominant, patriarchal order as the phallus which
constitutes law, governance, control of others and surveillance.

'The notion that there is a simple continuity between biology and the
social has been very powerful as ideology' writes Carrigan (75), referring to
Lionel Tiger's *Men in Groups* (1969). In his treatise, Tiger contended that
biology was behind the fact that men congregate in groups, the basis of
male bonding in culture. Tiger differentiated between male bonding and
male aggregation:

> Bonding can be distinguished from male *aggregation*, a pattern generally
> associated with male dominance. . . . Aggregation simply involves the banding
> together of all males of appropriate age; there is no selection involved, no
> apparently significant ordering of preferences for particular individuals by other
> individuals. . . . Bonding [is] related to 'achieved status' and aggregation [is]
> related to ascribed status. In other words, a male will not bond with just any
> member of his ethnic religious, familial, or social-class group; he will bond with
> particular individuals. . . . Aggregation involves no process of choice. (20–21)

The repercussions of bonding, however, are discriminatory:

> Males dominate females in occupational and political spheres. This is a
> species-specific pattern. . . . Males bond in a variety of situations involving
> power, force, crucial or dangerous work, and relations with their gods. They
> consciously and emotionally *exclude* females from their bonds. . . . Male
> dominance and bonding are features of the human 'biogram'. (112)

The emphasis in Victorian art, literature and culture on male groups –
public school, regiment, social club, college – is evident from such
documents as Thomas Hughes's *Tom Brown's Schooldays* (1857). How-
ever, in the nineteenth century, this male bonding was also the means of
enforcing dominance, so bonding was in fact a form of aggregation, that is,
the male group constructed an ideology of masculinity sufficiently coercive
that to succeed one had to accept its norms. Activities ranging from sport
to war to fagging to ritual initiations were posited on the exclusionary
premise of male bonding for aggregating purposes.

Inevitably, maleness and male bonding catalyse aggression, which may
or may not be manifest in violence; team sports, war, imperialism and
organizational competition are forms of such aggression. Such groups
construct a power hierarchy, and the idea of the heroic becomes key to its
maintenance. 'The function of the death of heroes in establishing or
reaffirming social bonds is clear', Tiger remarks (173). The group enforce-
ment of a hegemonic paradigm of masculinity is central to the ideology of
maleness:

Typically, maleness involves physical bravery, speed, the use of violent force, etc. . . . When the masterful activity is undertaken by a group of men, the pressures for bravery, toughness, self-proof, etc., are normally increased. . . . The process of male bonding [serves] the validation of social males . . . [the] need to be a man among men. (182, 198)

In the nineteenth century, pictorial art existed in culture in a complex relationship with masculine ideologies. Just as Dicksee's *The Funeral of a Viking* constructs the death of a hero noted by Tiger, the portrait of a living hero can also construct ideology, as in James Tissot's *Colonel Frederick Gustavus Burnaby* (Plate 1–3) painted in 1870 at the beginning of the phase of expansionism traditionally called the New Imperialism. As Ash notes, Burnaby 'was one of the great heroes of the Victorian age, a larger-than-life figure noted for his strength and intrepid overseas adventures' (n.p.). Burnaby constructed his own legend through his 'accounts of his exploits', such as *A Ride to Khiva* (1876), *On Horseback through Asia Minor* (1877) and *A Ride Across the Channel* (1882). The map of the world behind the suave, elongated figure signals his cosmopolitanism and imperialism, while the helmet and breastplate use armour to signify his masculine heroism, as in *The Funeral of a Viking*. Burnaby was 6'4" tall, and the red diagonal stripe of his trousers introduces a tension, but also a threat of force, into the portrait. As Andrew Wilton notes, Burnaby 'was very much a type of the Imperial period, and foreshadows in some respects the adventures of Lawrence of Arabia' (186). Burnaby's death at the battle of Abu Klea, part of the Gordon Relief Expedition, elevated him into the Victorian equivalent of Dicksee's Valhalla. Masculinity and its authority are thus visualized and transmitted. 'The audience's recognition of the hero's prowess is as much an acknowledgement of the power of their own gaze' (Hatt 63).

During the era, the representation of males in art both constructed the paradigm of masculinity and interrogated it/conflicted it by proposing inadequacies, fissures, inconsistencies and incommensurabilities in the prevailing paradigm of masculinity, that of the white Caucasian, middle-class male. Power was a central part of the Victorian art world, manifest in myriad aspects: the all-male composition of the Hanging Committee at the Royal Academy; the fact that no woman attained the status of academician during the century; the control of galleries and exhibitions by men; the overwhelming presence of males in art reviewing and art journalism; the different modes of education for male and female art students; the fact that males had access to the highest forms of painting, particularly historical/mythological subject matter; and the fact that women were construed as lacking the perseverance needed to become accomplished painters. The Victorian art world bears out the importance of bonding among males, and the Royal Academy itself indicates, by its all-male composition, the exclusionary function of such male alliances.

The reason to investigate the function of the representation of males in art is clarified by Roper:

> Men's behaviour – and ultimately their social power – cannot be fathomed merely in terms of externally derived social roles, but requires that we explore how cultural representations become part of subjective identity. . . . Masculinity is never fully possessed, but must perpetually be achieved, asserted, and renegotiated. (*Manful*, 15, 18)

An analysis of the construction of masculinity in Victorian painting reveals the processes by which male subjectivity was both configured and achieved during the era. Graham Dawson affirms the decisive function of such iconography:

> Masculine identities are lived out in the flesh, but fashioned in the imagination. This 'imagining' of masculinities is not simply a matter of defining those roles, traits or behaviours considered normal or appropriate for 'men' in any particular cultural context. Rather, it indicates the process by which such norms are subjectively entered into and lived in, or 'inhabited', so as to enable a (relatively) coherent sense of one's self as 'a man' to be secured and recognized by others. An *imagined identity* . . . has real effects in the world of everyday relationships. (118)

Iconography does not only construct such an identity. As an image, through processes of reproduction, it circulates not only a content but also a message: that is, one must ask not only what a canvas is of, but what it is about, the cultural ideology inseparable from its construction. Dawson elaborates:

> A necessary distinction must be made here, however, between the representation of masculinities in images and narratives, and the complexities of any such identity as it is lived out amidst the contradictory demands and recognitions generated by any actual social relations. Representations furnish a repertoire of cultural forms that can be drawn upon in the imagining of lived identities. These may be aspired to, rather than ever actually being achieved, or achievable. . . . The forms furnished by representations often figure ideal and desirable masculinities, which men strive after in their efforts to make themselves into the man they want to be. . . . The history of masculinities must therefore include within its scope the tracing of those many and varied historical imaginings which have given shape, purpose and direction to the lives of men. It must concern itself with questions about identities and cultural difference. (118 119)

It is through these representations that male subjectivity has been constructed.

The discourse of masculinity constructed by such representations during the nineteenth century was predominantly a hegemonic form, although alternative, 'marginal' masculinities were not totally excluded. As Kimmel and Messner observe: 'We cannot speak of "masculinity" as a singular term, but must examine masculinities: the ways in which different men construct different versions of masculinity' (8). They theorize:

> Men are not born . . . to follow a predetermined biological imperative. . . . To be a man is to participate in social life as a man, as a gendered being. Men are not born; they are made. . . . The meaning of masculinity varies from culture to culture. . . . Men's lives also vary within any one culture over time. . . . The resulting matrix of *masculinities* is complicated and often the elements are cross-

cutting. Men are divided along the same lines that divide any other group: race, class, sexual orientation, ethnicity, age, and geographic region. (8-10, 17)

This construction of masculinities, as Carrigan *et al.*, argue,

obliges us to think of masculinity not as a single object with its own history but as being constantly constructed within the history of an evolving social structure, a structure of sexual power relations . . . in which there is a continuing process of mobilization, marginalization, contestation, resistance, and subordination. (88 89)

Nevertheless, during the nineteenth century, it is possible to discern what Carrigan calls 'hegemonic masculinity . . . a particular variety of masculinity to which others [including some males] . . . are subordinated' (86):

In the case of men, the crucial division is between hegemonic masculinity and various subordinated masculinities. . . . Masculinities are constructed not just by power relations but by their interplay with a division of labor and with patterns of emotional attachment. . . . The differentiation of masculinities is psychological . . . but it is not only psychological. In an equally important sense it is institutional, an aspect of collective practice. . . . Social definitions of masculinity [are] embedded in the dynamics of institutions. . . . The ability to impose a particular definition on other kinds of masculinity is part of what we mean by 'hegemony'. (90, 91, 92)

Brod (in Kimmel 1987) notes that 'men's history reveals that constructs of masculinity have always resulted from conflicting pressures' (267), economics being an especially powerful one coercing males to conform to hegemonic masculinity. It is possible to argue that 'rituals of manhood are principally aimed at the social control of *men*: although men can dominate women, they require strenuous norms of manhood to sustain themselves in a perpetual struggle against regression' (Adams 210).

Indeed, Kimmel (1987) contends that 'men have, as a group, benefited from the sex-role paradigm [since] it uses masculinity as the normative standard of reference and maximizes the distance between the two genders' (14). Brod (1987) argues that 'the concept of "hegemonic masculinity" connects the themes of pluralities of masculinities and the power imbalance between men and women by understanding both as contested, interactive historical practices' (17). Thompson and Pleck distinguish between 'descriptive norms (the characteristics individual men are perceived as actually having) and sociocultural norms (the attributes and behavior men should have ideally)' (in Kimmel 1987, 25–26). Artistic representation was a catalyst in constructing the latter. Kimmel argues (in Hearn and Morgan) that 'masculinity needs constant validation' (100), a function that art engaged in during the nineteenth century.

It is crucial to note that even when certain kinds or classes of males were under- or non-represented in art, the force of the paradigmatic masculinity was nevertheless legitimated. Carrigan *et al.*, contend about the hegemonic paradigm:

An immediate consequence of this is that the culturally exalted form of masculinity, the hegemonic model . . . may only correspond to the actual

characters of a small number of men. . . . There is a distance, and a tension, between collective ideal and actual lives. . . . Yet very large numbers of men are complicit in sustaining the hegemonic model. . . . The overwhelmingly important reason is that most men benefit from the subordination of women, and hegemonic masculinity is centrally connected with the institutionalization of men's dominance over women. (92)

Even if the under- or non-represented male could only vaguely actualize the masculine paradigmatic representation, therefore, he would still, by virtue of being male, construct a superiority posited on gender differences. As Stearns summarizes, 'male imagery could have a definite reality' (110).

Michael Hatt writes about nineteenth-century America in a statement equally relevant to Britain:

The words 'manhood' and 'manliness' recur repeatedly in nineteenth-century American discourse, shaping debates on such diverse topics as religion and aesthetics. However, the concepts of gender they represent are never fully defined. Instead, the idea of masculinity is apparently self-evident, a set of behaviours and values that needs no further elaboration. . . . Of course, this lack of definition is a necessary absence, allowing a number of different gender identities and roles to be validated; if there is any sense in which these identities and roles might be contradictory or incompatible, those contradictions can be disavowed through their subsumption by the undifferentiated notion of 'manhood'. Masculinity can thus be deployed as a unified field rather than as a set of diverse gender positions. But although at any given historical moment we are dealing with the issue of masculini*ties* – of male gender as a field of difference – certain definitions may predominate, being cited more frequently as the masculine exemplar. (57)

One might dissent from this statement to the extent that in fact gender did require elaboration through a variety of discourses. However, as Hatt notes, even if there were 'different masculinities . . . they were mutually inflecting, different discourses overlapping' (58). In Victorian Britain, the models of the classical hero, the knight, the soldier, and the paterfamilias, studied in this book, did mutually inflect one another and overlap.

Several key standards of masculinity, all involving varieties of this manliness or manhood, were particularly significant and also amenable to transposition in artistic representation; for example, the concept of a 'gentleman' was much debated during the century. Norman Vance establishes that part of this project was 'to democratize and domesticate the traditional notion of chivalry':

The knight of mediaeval chivalry and the gentleman of earlier times had fused in the popular imagination into a conventional moral ideal democratically applicable to all classes of society. . . . The shift of meaning of both terms [knight and gentleman] from description of military and social status to ideal of conduct conveniently allowed virtue to retain something of the dignity and glamour of high social standing. . . . The classless and timeless moral possibilities of true knightliness and true gentility were particularly useful to the preacher and the moralist. It was natural that they should pass into the preaching of attractively manly Christianity. (*Sinews* 17)

Everything from Walter Scott's *Ivanhoe* (1820) to Kenelm Digby's *The Broad Stone of Honour* (1822) to Charlotte M. Yonge's *The Heir of Redclyffe* (1855) contributed to this linkage of gentlemanliness with chivalry. The traditional idea of the gentleman, as defined by inherent prerogatives of birth and land, yielded to the idea of the gentleman as defined by standards of moral rectitude. Disraeli's project of 'Young England' as enunciated in *Coningsby* (1844) led to a redefinition of the gentleman which yielded Charles Dickens's intense interrogation of its various significations in *Great Expectations* (1860–61), even as Dinah Mulock Craik in *John Halifax, Gentleman* (1856) had assimilated the ideology of self-help to that of the gentleman. As Vance comments, the end of *Great Expectations* 'outlines an alternative moral gentlemanliness based on an ethic of unselfishness, generosity and patient hard work' (25).

In painting such an ideal, it was often useful to evoke a previous era, as in chivalric iconography (discussed subsequently). A possible alternative was to deploy 'history' as a means of interrogating masculinity and gentlemanliness, as in Ernest Crofts' *At the Sign of the Blue Boar, Holborn* of 1883. Here a royalist messenger confronts Cromwell and Ireton, who have discovered a letter he was carrying from Charles I to the queen involving the assistance of the Scots in overthrowing Cromwell and restoring the monarchy. Two ideas of gentlemanliness confront one another, that of the self-made Cromwell and that of the loyal royal retainer, whose elaborate costume associates fidelity to a cause with flair and glamour. The famous *And When Did You Last See Your Father?* of 1878 by William Frederick Yeames also depicted the Civil War. Here, a parliamentary officer is interrogating the son of a royalist household, with the dress of the young man again evoking the tenacious honour of gentlemanly fidelity. At the same time, however, as Edward Morris and Frank Milner note, 'the parliamentary soldiers are portrayed as rather kind and considerate men with one comforting the weeping girl by putting his arm around her' (87). True to the tradition of the Victorian 'problem picture', the viewer will never know the youth's response. The canvas juxtaposes the democratic and the aristocratic definitions of 'gentleman' as a subject for investigation during the nineteenth century.

Such pictures derive from Carlyle's championing of Cromwell in *On Heroes, Hero-Worship* and also complement his lectures by presenting an attractive dimension of the royalist ideal of loyalty. Both paintings construct masculinity within politically inflected contexts. In each canvas, variants of masculinity are represented: in Crofts, that of the dashing royalist with his lighter hair and silk clothes against the earthbound stolidity of the darker-haired Cromwell; in Yeames, the flaxen-haired youth in blue silk against the drab parliamentarians. These masculinities conflicted by politics are likewise allusive to conflicting sexualities. The youth with silken hair reappears in William Powell Frith's *Varnishing Day at the Royal Academy, 1881*, exhibited in 1883, the same year as Crofts' *At*

the Sign of the Blue Boar, Holborn. (In 1881 Gilbert and Sullivan had presented their satire of aestheticism, *Patience*.) In Frith's canvas, one of a group of women surrounding Oscar Wilde places her hand on the shoulder of a boy in 'Fauntleroy' dress who echoes the boy in Yeames's canvas. During his career Wilde's clothing (pantaloons) and long hair echoed those of the royalists, suggesting that in Yeames and Crofts there exist not only alternative politics but alternative sexualities. In both canvases the main subject becomes the exchange of male gazes, signifying a range of conflicting masculinities: political (parliamentary/royalist), sexual (heterosexual/homosexual), and behavioural (aristocratic vs. democratic ideas of the gentleman). Such representations demonstrate the manner in which fine art during the era constructed masculinity and engaged its conflicted nature.

The representation of males in nineteenth-century British iconography was decisive in the formation of ideologies about masculinity. London asserts the importance of

> the historical specificity of the construction of masculinity . . . that masculinity, as much as femininity, is created by cultural negotiations and contestations. . . . It brings to light the constitution and distribution of the male body in the making of cultural identity. . . . Male spectacle is an integral part of masculinity. (261)

The representations of the male on canvas mean that the male and the male body become the spectacle. The image of the male constructs a discourse negotiating difference, power and surveillance in culture. Writing of 'Masculinity as Spectacle', Neale discusses cinema in terms applicable to the pictorial representation of males in the nineteenth century, emphasizing

> how heterosexual masculinity is inscribed and the mechanisms, pressures, and contradictions that inscription may involve. . . . Identification [with such imagery] is never simply a matter of men identifying with male figures on the screen. . . . [It] draws on and involves many desires, many forms of desire. And desire itself is mobile, fluid, constantly transgressing identities, positions, and roles. Identifications are multiple, fluid, at points even contradictory. . . . A series of identifications are involved, then, each shifting and mobile. Equally, though, there is constant work to channel and regulate identification in relation to sexual division, in relation to the orders of gender, sexuality, and social identity and authority marking patriarchal society. (9–11)

The spectacle of the male on canvas fosters cultural absorption for males through an idealized paradigm, whether or not individual men may be able to actualize that model.

The process of empowerment through identification, even if it entails elements of contradiction, is determined by the act of seeing, of confronting the spectacularity of the male on canvas. In representations of the male, the implied or explicit male gaze transcends the manifest subject to become the representative of the discourse of male gender and empowerment. In her landmark essay 'Visual Pleasure and Narrative Cinema', Laura Mulvey argues that the male gaze serves two ends: first, scopophilic,

that is, 'pleasure in looking at another person as an erotic object', containing a strong element of male voyeurism which emphasizes a 'woman's to-be-looked-at-ness'; second, narcissistic, serving 'ego libido . . . identification processes' (815). In this gaze, there is considerable cultural gynephobia, since 'woman as representation signifies castration'; 'her lack . . . produces the phallus as symbolic presence. . . . Woman then stands in patriarchal culture as signifier for the male other' (815, 803–804). Males viewing the representation of males contemplate the phallus as the symbolic presence, the visible mark of gendered empowerment: whether women are present or absent in such canvases, their lack of the penis, signifying castration, and producing male anxiety, also empowers males as women become the Other. The male body on the canvas, particularly in canvases of all-male subjects such as war, reaffirms the patriarchal legitimation of the phallic order, particularly when the male image is engaged in heroic, chivalric, paternal or martial action and is undamaged. The 'determining male gaze' means that 'pleasure in looking has been split between active/male and passive/female' in Mulvey's terms (808); art is 'coded into the language of the dominant patriarchal order' (805). The gaze is both 'controlling and curious' (806): the male is empowered through contemplation of heroic imagery or idealized masculine represen-tation, with the canvas even becoming the representative of the patriarchal super-ego. In her paper 'Afterthoughts', Mulvey describes her original essay of 1975 as concentrating on 'the "masculinisation" of the spectator position' (12). If males contemplate females on canvas, the woman as object, a marked 'dominance–submission' pattern becomes operative (Kaplan 27). For males contemplating males on canvas, the paramount result is a narcissistic ego reinforcement:

> As the spectator identifies with the main male protagonist, he projects his look on to that of his like, his screen surrogate, so that the power of the male protagonist as he controls events coincides with the active power of the erotic look, both giving a satisfying sense of omnipotence. A male movie star's glamorous characteristics are thus not those of the erotic object of the gaze, but those of the more perfect, more complete, more powerful ideal ego conceived in the original moment of recognition in front of the mirror. (Mulvey 810)

Neale notes another crucial element of the power of pictorial imagery, its silence: 'this absence of language can further be linked to narcissism and to the construction of an ideal ego' (12); the 'narcissistic male image' is 'the image of authority and omnipotence' (13).

This process of imprinting and modelling authoritative masculinity through the male gaze at a canvas can be illustrated by John Everett Millais's *The Boyhood of Raleigh* of 1870 (Plate 1–4). Based on J.A. Froude's *England's Forgotten Worthies* (1852) and painted on the Devon coast, the canvas shows two boys listening to a Genoese sailor recount his exploits. One of the boys, holding his knees, represents the future hero Sir Walter Raleigh, who himself came from Devon. The canvas represents a

summons to imperialism, as the sailor gestures over the sea. The birds winging over the sea parallel and symbolize the hero's desire. Details, such as the toy ship on the left, the anchor on the right, and the mackaw, construct the exoticism, daring and valour of the imperialist mission. The toy ship will soon be cast aside for the actual adventure. How closely this conforms to governing ideologies during the period may be illustrated by considering the imperialistic rhetoric of Ruskin's Slade lecture delivered in the same year, 1870, as the exhibition of Millais's canvas:

> There is a destiny now possible to us – the highest ever set before a nation to be accepted or refused. We are still undegenerate in race; a race mingled of the best northern blood. We are not yet dissolute in temper, but still have the firmness to govern, and the grace to obey. . . . And we are rich in an inheritance of honour, bequeathed to us through a thousand years of noble history, which should be our daily thirst to increase with splendid avarice, so that Englishmen, if it be a sin to covert honour, should be the most offending souls alive. . . . Will you, youths of England, make your country again a royal throne of kings; a sceptred isle, for all the world a source of light, a centre of peace? . . . 'Vexilla regis prodeunt' There is indeed a course of beneficent glory open to us, such as never was yet offered to any poor groups of mortal souls. But it must be – it *is* with us, now, 'Reign or Die'. . . . This is what she must either do, or perish: she must found colonies as fast and as far as she is able, formed of her most energetic and worthiest men; – seizing every piece of fruitful waste ground she can set her foot on, and there teaching these her colonists that their chief virtue is to be fidelity to their country, and that their first aim is to be to advance the power of England by land and sea. . . . If we can get men, for little pay, to cast themselves against cannon-mouths for love of England, we may find men also who will plough and sow for her . . . and who will gladden themselves in the brightness of her glory. . . . The England who is to be mistress of half the earth, cannot remain herself a heap of cinders. . . . She must guide the human arts, and gather divine knowledge, of distant nations, transformed from savageness to manhood, and redeemed from despairing into peace. (20, 41–43)

As Edward Said comments about Ruskin's statement: 'England is to rule the world because it is the best; power is to be used; its imperial competitors are unworthy; its colonies are to increase, prosper, remain tied to it. . . . the political and imperial aspect enfolding and in a sense guarantee[ing] the aesthetic and moral one' (104). For young men, Millais's *The Boyhood of Raleigh* constituted a formative icon. The spirit of *The Boyhood of Raleigh* was embodied in such institutions as the Boys' Brigade of 1883 and publications like the *Boy's Own Magazine* (1856–74), *Boy's Own Paper* (1879–1967) and the novels of G.A. Henty.

The recurrence of images of the male as heroic, chivalric, paternal or martial recognizes, as Jeffords claims, 'the importance of repetition as reproduction' of the masculine code as well as 'repetition as self-reproduction' (247–48), whereby the male engages in continuous acts of self-affirmation through the empowering gaze; masculinity becomes a process of 'sequential self-extension' (255). While this process of empowerment is not devoid of anxiety, or even masochism produced by a sense of personal inadequacy in confronting the ideal, the act of gazing at the male

representation empowers males with assurances of control, affirmation, hierarchy and surveillance during the nineteenth century. Baden-Powell knew the effect of such imagery when he incorporated images of St George and of Raleigh (the latter specifically from Millais's canvas) into editions of *Scouting for Boys* (283, 300). John Berger notes the 'density of visual messages' and the way 'they stimulate the imagination by way of either memory or expectation' (129), a powerful function of the representation of the male in the Victorian period.

Such representation exists to enforce what Silverman, in *Male Subjectivity at the Margins*, describes as the dominant fiction of masculinity, 'the commensurability of penis and phallus' (15); that the male by virtue of possession of the penis is part of the hegemonic patriarchal order symbolized by the phallus/Law of the Father. Silverman's argument is crucial for recognition of the ideology inscribed by the gaze of the male at the male subject of representation:

> [The] 'dominant fiction' or ideological 'reality' solicits our faith above all else in the unity of the family, and the adequacy of the male subject.
>
> If ideology is central to the maintenance of classic masculinity, the affirmation of classic masculinity is equally central to the maintenance of our governing 'reality.' Because of the pivotal status of the phallus, more than sexual difference is sustained through the alignment of that signifier with the male sexual organ. . . . Hegemony is keyed to certain privileged terms . . . [the] dominant fiction [of] the phallus/penis equation. . . . Ideology is sustained through the maintenance of *collective* belief. . . . The subject of ideology can attribute actuality to mere representation. . . . Only by successfully defining what passes for 'reality' at the level of the psyche [can] ideology . . . be said to command the subject's belief. . . . Successful interpellation means taking as the reality of the self what is in fact a discursive construction . . . claiming as an ontology what is only a point of address. . . . The members of a group come to accept the same ideological representations as 'true'. . . . Hegemony hinges upon identification. . . . Rancière . . . sees [hegemony] as 'a reserve of images and manipulator of stories for the different modes of configuration (pictorial, novelistic, cinematic, etc.).' . . . The dominant fiction consists of the images and stories through which a society figures consensus. . . . [The] dominant fiction is above all else the representational system through which the subject is accommodated to the Name-of-the-Father. Its most central signifier of unity is the (paternal) family, and its primary signifier of privilege the phallus. . . . The Name-of-the-Father is also lived by the boy as the paternal legacy which will be his if he renounces the mother, and identifies with the father. . . . Our dominant fiction calls upon the male subject to see himself, and the female subject to recognize and desire him, only through the mediation of images of an unimpaired masculinity . . . believing in the commensurability of penis and phallus, actual and symbolic father. (15–16, 34, 40, 42)

Silverman's argument is crucial for recognizing the function of representations of the male: such images reinforce the dominant fiction by the collective belief catalysed by the male gaze at such representations. The imagery of classical hero, medieval rescuer, paternal guide or martial warrior sustains belief in the commensurability of penis and phallus, actual and symbolic order. In this respect, the reproduction and circulation of

images becomes the means of reinforcing the message of the dominant fiction.

Silverman contends that the dominant fiction serves to conceal the fact that the penis/phallus equation is fundamentally vulnerable and even fragile, that many males (homosexual, de-classed, marginalized, colonized) are in fact not part of the dominant fiction even though they possess the penis. She observes:

> Conventional masculinity can best be understood as the denial of castration, and hence as a refusal to acknowledge the defining limits of subjectivity. . . . It is imperative that belief in the penis/phallus equation be fortified . . . for it represents the most vulnerable component of the dominant fiction. (46, 47)

Following the ideas of Serge Leclaire, Silverman contends that males are in fact castrated, that is, disempowered, marginalized, excluded, even though they believe the penis is representative of the phallus and thus inscribes them into hegemonic structures. This would apply even to white Caucasian males as well as racial, ethnic or national Others. The dominant fiction, therefore, rests upon this key *méconnaissance* or misrecognition: the male believes in the penis/phallus equation even though it is not fundamentally valid. '*Méconnaissance*' is 'so crucial to belief in the phallus/penis equation' (45):

> The phallus/penis equation is promoted by the dominant fiction, and sustained by collective belief. . . . A given symbolic order will remain in place only so long as it has subjects. . . . It relies for that purpose upon the dominant fiction, which works to bring the subject into conformity with the symbolic order by fostering normative desires and identifications. (44, 50)

Silverman's contention elucidates the marginalization of lower class, racial, sexual, ethnic or national Other males by the dominant fiction: such men, although possessing the penis, were effectively excluded from the dominant patriarchal order during much of the nineteenth century.

Nevertheless, the nineteenth century maintained an ideology of masculinity to which males, regardless of actual exclusion from power, subscribed. While the fact that the penis/phallus equation may have been unrealizable and unsustainable, in imagination it could exist unquestioned because possession of the penis itself empowered men over the most threatening Other, the female. Thus, even if males experienced the fissure of the equation, ideologically the representation of the dominant fiction of masculinity could be sustained by collective male belief. Silverman admits that 'the dominant fiction neutralizes the contradictions which organize social formation by fostering collective identifications and desires, identifications and desires which have a range of effects, but which are first and foremost constitutive of sexual difference' (54); she grants that 'although the phallus is not the penis, it nonetheless derives its material support from that organ' (153). Males confronting images of women would be empowered through the voyeuristic component of the male gaze.

The process of reinforcing the dominant ideology through continuous

reinscription is indicated by Millais's *The North-West Passage*, exhibited in 1874 (Plate 1–5), four years after *The Boyhood of Raleigh*. The canvas was exhibited with a quotation, 'It might be done, and England should do it', which exactly complements Ruskin's Slade lecture of 1870. Here, an old explorer, modelled by Captain Edward John Trelawny (1792–1881), contemplates a chart and dreams of finding a passage through the open Polar Sea, for commercial and imperialistic purposes. Millais constructs here an aspiring masculinity to reinforce the era of the New Imperialism. The telescope, the sea view outside the window, the small oil study of icebergs, the Union Flag, and the logbook in the foreground all reinforce this agenda. The military print, of Nelson, on the wall is especially significant in constructing an idea of heroic masculinity. In his poem *Admirals All* of 1892, Newbolt writes in its first stanza:

> Effingham, Grenville, Raleigh, Drake,
> Here's to the bold and free!
> Benbow, Collingwood, Byron, Blake,
> Hail to the Kings of the Sea!
> Admirals all, for England's sake,
> Honour be yours and fame!
> And honour, as long as waves shall break,
> To Nelson's peerless name! (31)

Newbolt links the Nelson of *The North-West Passage* with the Raleigh of *The Boyhood of Raleigh*. (Nelson appeared in other poems by Newbolt such as *The Quarter-Gunner's Yarn* and *The Hundreth Year*.) The specific function of imprinting masculinity in *The North-West Passage* is marked if one notes that in its original design there was to be a male child looking at a globe incorporated into the composition. In his biography of his father, J.G. Millais wrote of *The North-West Passage*:

> [It] was perhaps the most popular of all Millais's paintings at the time, not only for its intrinsic merit, but as an expression more eloquent than words of the manly enterprise of the nation and the common desire that to England should fall the honour of laying bare the hidden mystery of the North. (2.48)

Millais records that he saw a print of his father's painting in the hut of a Hottentot shepherd while hunting in the Great Karroo of South Africa (55), so the dissemination of the image was remarkable and wide-ranging. The fact that the adventurer Trelawny, an intimate friend of Byron and Shelley, was the model for the captain in *The North-West Passage*, aligned heroism with the Napoleonic period and the victories of Nelson and Wellington. Furthermore, the fact that Robert Louis Stevenson selected 'Trelawney' for the name of the treasure-hunting squire of *Treasure Island* (1883) contextualizes the canvas in a continuum of constructions of heroizing masculinity, the male as *homo newboltiensis*.

Confronting images of men, the narcissistic component of the male gaze reinforced collective belief in the code of classic masculinity. Although failure to achieve the masculine ideal might appear to be masochistic, even

in this instance the male may engage in a reflexive masochism, as Silverman notes of T.E. Lawrence, 'occupying the sadistic and masochistic positions *simultaneously* rather than *in turn*' a 'sadism . . . directed against himself' so that 'the reflexive masochist suffers/enjoys pain without renouncing activity' (*Male Subjectivity* 324). This reflexive masochism may, in fact, be a means by which males sustain the code of masculinity:

> Because reflexive masochism does not demand the renunciation of activity, it is ideally suited for negotiating the contradictions inherent in masculinity. The male subject can indulge his appetite for pain without at the same time calling into question either his virility or his paternal lineage. Indeed, reflexive masochism . . . promotes the illusion of a contained and autonomous self. . . . Reflexive masochism, in its maintenance of the active, masculine position . . . is compatible with – indeed, perhaps a prerequisite for – extreme virility. . . . A man can be virilized, and even constituted as the leader of a group, through what is ostensibly self-sacrifice. . . . To place oneself in the position of winning . . . by multiplying and deepening one's own suffering . . . is always to aggrandize the self. (326–327)

The dominant fiction of classic masculinity may be sustained even in the midst of contradiction or exclusion, because to endure the pain that results is itself a constituent part of the code. As Silverman notes: 'Reflexive masochism poses no threat to masculinity, and . . . it may even represent a necessary component of virility' (328). Thus, even if one considers the 'masculinities' of the excluded or marginalized, these are not to be considered apart from the dominant masculine order and ideology. First and foremost is the differentiation of the masculine from the feminine. The male body on canvas is part of a key drive of the semiotics of masculinity. Thomas Laqueur details the 'dramatic reinterpretation of the female body in relation to that of the male' which occurred in the later eighteenth century:

> A new model of incommensurability triumphed over the old hierarchical model in the wake of new political agendas . . . [a] grounding [of] the social and cultural differentiation of the sexes in a biology of incommensurability. (17–19)

Thus, the crucial factor in the nineteenth century is that, even if one perceived the vulnerability/fragility of the commensurability of penis and phallus (and the majority of males did not), the necessary element was to accept the incommensurability of the male and female bodies. For the male gazing at the representation of the male in art, there was no doubt of the commensurabiltiy of himself with the physical body *per se* on the canvas.

Belief in the dominant fiction, therefore, was sustained in the nineteenth century by a male collectivity. Lionel Tiger's thesis in 1969 of 'men in groups' and the biological–social context of male bonding has been recently theorized by Sedgwick in *Between Men* as 'male homosociality', in this instance 'social bonds between persons of the [male] sex' (1). Male homosociality represents the entire continuum of 'the *structure* of men's relations with other men', including 'male friendship, mentorship, entitlement, rivalry, and hetero- and homosexuality' (2, 1). She asserts that 'the shapes of sexuality, and what *counts* as sexuality, both depend on and

affect historical power relationships' (2). Such homosociality is integral to the power relationships in culture in such a manner that one must investigate 'the politics of male homosociality', for there is 'the distinctive relation of the male homosocial spectrum to the transmission of unequally distributed power' in culture (17, 18). For Sedgwick, there are 'crucially important male homosocial bonds . . . such as the institutional, bureau-cratic, and military' (19), to which one might add the artistic as well:

> In any male-dominated society, there is a special relationship between male homosocial (*including* homosexual) desire and the structures for maintaining and transmitting patriarchal power: a relationship founded on an inherent and potentially active structural congruence. (25)

The institutions by which males were acculturated and incorporated into the dominant fiction stressed this homsociality: 'school itself was . . . a crucial link in ruling-class male homosocial formation' (176). Male domi-nance was per force a consequence of much of this homosociality, 'the enforcement of women's relegation within the framework of male homo-social exchange' (120), as in Tennyson's *Princess*. Sedgwick contends that homosexuals were excluded from much of the construction of masculinity by hegemonic heterosexuality, but it is key to remember, as Sedgwick notes, that 'most Victorians neither named nor recognized a syndrome of male homosexuality as our society thinks of it' (174). Such examples as intense male friendships, common during the period (as reflected in Tennyson's *In Memoriam*, for instance), reveal that the eroticism of such relationships was repressed or unacknowledged. The triangulation of male–male desire through a woman, for instance, which Sedgwick estab-lishes as frequent, meant that many men were 'deluded' in their very involvement with other men about the genuine nature of their attraction. Sedgwick notes that a man's 'delusion is, however, often indistinguishable from real empowerment' (179), which reflected 'the impossibly but compulsorily self-ignorant terms of masculinity, of male homosocial desire, in English culture' (199). At the end of the century, J.A. Symonds, Havelock Ellis, Edward Carpenter and others theorized about the 'inter-mediate sex' or the 'third sex' that homosexuals might be.

It seems clear, however, that while the male gaze directed at males in paintings was both erotic/scopophilic as well as narcissistic, the erotic component was repressed or even unacknowledged. Men, instead, dis-placed this potential homoeroticism and transmuted it to identification as emulation, accommodating such desire to the coercive demands of the dominant fiction. Neale calls this 'repressed homosexual voyeurism' (13):

> The narcissistic male image – the image of authority and omnipotence – can entail a concomitant masochism in the relations between the spectator and the image, and further . . . the male image can involve an eroticism. (13)

Male homosociality, therefore, constituted the collectivity which sustained belief in the dominant fiction. Much of the representation of males in

Victorian art involves such homosocial groups, including regiments, chivalric troops, schoolfellows and comrades. Hatt observes:

> A division between heterosocial and homosocial [spaces] is both far more useful and more accurate [in describing the nineteenth century]. The crucial difference is that some of these spaces only men . . . may enter. Moreover, it is in the homosocial realm that young men are inculcated with the ideals of their gender roles. . . . The transmission of masculinity is dependent on the visual economy of these spaces. (62)

The emphasis on school is expressed in a range of poems, as in Newbolt's *Ionicus*, which celebrates the imprinting/modelling function of William Cory, a schoolmaster:

> Beyond the book his teaching sped,
> He left on whom he taught the trace
> Of kinship with the deathless dead,
> And faith in all the Island Race.

The fact that Cory was sacked for homosexuality did not prevent Newbolt from celebrating his function in this poem of 1896. *The Schoolfellow* and *The Best School of All* convey this educative role of the homosocial school environment and its value; in the latter 'the round world shall ring of it' (92). Alfred Rankley's canvas *Old Schoolfellows* (1854) particularly emphasizes the value of this homosocial bonding. A now wealthy school-fellow visits the garret home of his writer friend, who has fallen ill and is thus unable to provide for himself and his wife; she stands at the side viewing the two men embracing each other on the sickbed, while the friend prepares to give her a banknote. The key to the canvas, however, is the book on the floor, Cicero's *De amicitia*, which the two men probably read as boys at school.

Rankley's painting and the poems by Newbolt demonstrate 'the diffusing power of the public school ethos' (Best 130), embodied in Thomas Hughes's *Tom Brown's Schooldays*, published anonymously in 1857 as 'By an Old Boy'. Vance (in Simon) notes that in this novel Hughes 'combined manliness and hero-worship . . . the sturdy variety of manliness' (120). The link with militarism was sanctioned by 'Wellington's supposed comment about Waterloo [which] has immortalised the playing fields of Eton' (117). Many critics have examined the school ideology and its affiliation with constructions of gender, ideology of comradeship, and philosophy of imperialism (for example, James, Worth, Bristow, Honey). In an address Hughes delivered at Newbolt's school, Clifton College, he specifically designated the English schools as 'miniature Englands' (84). The manliness constructed in *Tom Brown's Schooldays* received divine authorization when Hughes published *The Manliness of Christ* in 1879, linking the self-denial, courage, fortitude and integrity of the Victorian youth with that of Jesus himself.

Vance (in Simon) states that a Victorian schoolmaster would have 'at least four basic types' of manliness in mind: 'the chivalric, the sentimental-

benevolent, the sturdy English, and the moral' (115). The chivalric embraced 'courage, loyalty, self-sacrifice, stainless integrity and protection of the weak' (114), embodied in the Prince Consort, who also was paradigmatic of the second kind of manliness, the benevolent, involving 'the practice of loving his neighbor and generally improving society' (116). The third kind of manliness, the sturdy, involved physical prowess and 'vigorous cricket' (117), the preliminary, if Wellington is to be believed, to military triumph. The fourth kind of manliness, the 'moral manliness' (117), Vance rightly links to the Evangelical revival and above all to the figure of Arnold of Rugby, the 'exponent of moral manliness' who 'insisted that manliness was moral maturity' (118). If the rubric Muscular Christianity was a term disliked by Hughes, it nevertheless consolidated several of these types of manliness. H.H. Almond of Loretto School 'inaugurated a "Sparto-Christian" ideal of temperance, courage and *esprit de corps*' (124) that represented this consolidation of Christian with Greco-Roman concepts of masculinity. It was an attempt to consolidate varieties of manliness which led to Newbolt's most famous poem, *Vitaï Lampada* of 1892:

> There's a breathless hush in the Close to-night –
> Ten to make and the match to win –
> A bumping pitch and a blinding light,
> An hour to play and the last man in.
> And it's not for the sake of a ribboned coat,
> Or the selfish hope of a season's fame,
> But his Captain's hand on his shoulder smote –
> 'Play up! play up! and play the game!'

In the second stanza, Newbolt applies the ideology of gamesmanship to survival in a colonial campaign, where 'the voice of a schoolboy rallies the ranks' with the refrain to 'play up'. In the final stanza, Newbolt summarizes the idcology:

> This is the word that year by year,
> While in her place the School is set,
> Every one of her sons must hear,
> And none that hears it dare forget.
> This they all with a joyful mind
> Bear through life like a torch in flame,
> And falling fling to the host behind –
> 'Play up! play up! and play the game!' (38–39)

Vitaï Lampada consolidates various types of manliness: the physicality and *esprit de corps* of the sturdy variety; the courage and loyalty of the chivalric; the concern for one another marking the benevolent; and a suggestion in the final stanza that even evokes Christ and moral manliness. That Newbolt was a friend of Douglas Haig, who had to issue the famous 'Backs to the Wall' Order of the Day in 1918, demonstrates that the manliness of *Vitaï Lampada* was 'passed on' as the final lines suggest from one generation to another, whether in the school or in the trenches. Lytton Strachey's biographical sketch of Dr Arnold in *Eminent Victorians* (1918),

while denigrating its subject, could not eradicate the manliness of school ideology.

Homosocial bonding among men could operate in both same-sex and heterosexual situations within the same common denominator, as in the 'rescue' compulsion of Victorian males, frequently depicted in representations of male activity. Construing the rescue compulsion in an erotic, heterosexual manner, Freud wrote in 'A Special Type of Choice of Object Made by Men' that some men felt a strong compulsion to rescue women. The conditions were: 1) that the woman be attached so there could be an injured third party; 2) the woman be sexually experienced; 3) the attachment be compulsive; and 4) that the woman be in some distress and require rescue. In Victorian society, the examples of Millais and Ruskin's wife, or Browning and Elizabeth Barrett, or Gladstone's schemes for the reclamation of prostitutes, verify the intensity of this rescue compulsion during the period. Frequently the subject of art during the era involved representations of rescues, as in the many canvases of Perseus and Andromeda, of St George and the dragon, of a knight and an assaulted woman. The rescue compulsion structures the empowerment of the male rescuer. Rescue, however, could also occur in male homosocial situations, such as battle imagery, where one comrade aided another or one gallant rescued a fallen regimental friend. The rescue drive, therefore, could exist in both heterosocial and homosocial contexts. Richards remarks that 'close noble friendships were encouraged until the 1880s as an antidote to "beastliness"' (117), but were discouraged by the increasing awareness of homosexuality later in the century, by such legislation as the Labouchere amendment of 1885, and by the Wilde trials in 1895. On the other hand, such bonding was facilitated by the expansion of the empire, as Tosh observes:

> The Empire now also occupied an unprecedented place in the masculine imagination; in the work of popular writers like Kipling and Henty it had become an imaginative space where male comradeship and male hierarchies found their full scope, free from feminine ties. (67–68)

Such unanimity along the spectrum of male homosociality was decisive in reinforcing and enforcing the codes of classic masculinity.

The penis/phallus equation of classic masculinity limns the fact that the possession of the penis is the irreducible common element among males. The consequence is that for men male sexuality, however expressed in maturity as adults, is problematic, challenging and conflicted as the male matures. 'Norms of masculinity [are] sites of profound internal stress and instability. . . . The understanding of "manhood" depends importantly on the analysis of transgression, as a dynamic which defines and energizes the authority of the norm' (Adams 208). During the nineteenth century, males confronted an array of theories about their sexual maturation. Many of these were not conducive to the formation of strongly self-confident notions about possession of the penis. The penis *apart* from the ideology of

the phallus could cause great anxiety in the medical climate of the nineteenth century. As Brittan contends:

> The valorization of the penis is a requirement of various norms of masculinity, not of the penis. . . . The 'overburdened penis' . . . is precisely the point. It cannot carry the load of cultural prescription. (57)

The codes of classic masculinity needed the penis/phallus equation to allay anxiety about male sexuality *per se*, not only castration anxiety. The dominant fiction allowed males to emphasize the empowering dimensions of their sexuality – the phallus camouflaging the anxiety the vulnerable, fragile, small penis by itself might instill. The dominant fiction inscribed standards of maleness – courage, assertiveness, loyalty, leadership, strength, heroism, gentlemanliness, self-reliance – that the possession of the penis alone could not or would not sustain.

Part of the regulation and control of sexuality and manliness was necessary to allay, refute or conceal the intimidating discourses about male sexuality that circulated during the nineteenth century, particularly about such male experiences as masturbation, nocturnal emissions and venereal diseases. The reiteration of masculine codes in Victorian art, while problematizing masculinity in some representations, predominantly reinforced classic masculinity. The refusal to paint the penis itself is highly indicative of male anxiety, for the concealment of the organ is not due to codes of modesty so much as to a sense that the organ itself would appear inadequate and unequal to the demands made by virtue of phallocratic culture. Surrogates for the penis – lances, clubs, spears, armour – aggrandized the penis symbolically to assure its commensurability with the demands of the phallus/Law of the Father and its aggregation of superiority, power and authority. Some attention to a few of such discourses about male sexuality indicates their drive to induce rather than reduce anxiety in young males.

John and Robin Haller note about the nineteenth century:

> Physicians and purity writers gloried in the added responsibility of elevating each new generation above the last. They placed themselves at the center of national life, claiming to be the moral vortex of the century's power. . . . They promised continual victory for every challenge met. . . . The white man's burden became the young man's burden, and on his slender shoulders the young male Caucasian had to carry the weight of the century's ideals, hopes, and goals. . . . The Victorian man-child felt himself watched, encouraged, cautioned, and threatened by every social force to achieve those values which were deemed necessary to his future manhood, and to eschew those which were either harmful or of no value in his struggle to become the fittest man. Few dreamed of complaining or resisting. (191–192)

This policing of young men by the phallic order indicates the fragility of masculinity dependent on the possession of the penis alone. Medical attention focused on semen, and it was particularly concerned for its loss in any form, even in intercourse, for physicians believed 'that the semen of a continent male was absorbed by the blood stream and circulated through

the body to produce the deeper voice, beard, muscles, and temperament of a truly manly adult' (200). Writers stated that 'the healthy male could live until marriage without the loss of a single drop of seminal fluid' (201), and some physicians even contended that a man should not have seminal emissions. The result was great fear induced about the loss of semen in any form, whether from intercourse, masturbation, or nocturnal emissions, as Barker-Benfield analyses (337–344). This loss of semen was declared an immense hazard for young males:

> Of all diseases or derangements which affect or which can affect the generative organs, there is none equal nor half so bad as Spermatorrhoea. All others together, or one after another, in a continuous round, are not capable of producing – and never have and never can produce – half so much mischief, derangement and ruined health, as this one evil of Spermatorrhoea or involuntary emission of Semen! It is a direct draft upon the vital energies of life itself, destroying both body and mind as it goes! And the longer it continues, the more difficult it becomes to overcome. [Bigelow, *Sexual Pathology* (1875), cited in Haller 190]

Loss of semen from masturbation or nocturnal emissions was thought to be a harbinger of insanity, derangement, mental instability or physical debilitation and therefore produced great anxiety: 'Distraught males, believing themselves victims of the dreaded disease [of spermatorrhoea] after having a single wet dream, wrote impassioned letters to medical men' (214), leading to a period of 'medical terrorism' (216) of men during the nineteenth century.

There has been considerable debate about the effect of William Acton's *The Functions and Disorders of the Reproductive Organs in Youth, Adult Age and Advanced Life, Considered in their Physiological, Social and Psychological Relations*, first published in 1857 (for instance, Hall, Weeks, Haller and Haller, Peterson, Marcus). The book is notorious for the fact that it devotes a mere two passages to female sexuality. Its concentration on male sexuality is extraordinary and revelatory, but the title of the work itself is its meaning: that the penis must be regulated in order to assure the stability of the phallus/phallic order. The Hallers make clear what is suggested in Acton's title:

> [The male] had also to absorb the woman's deficiencies, for in her weakness lay a need for his strength, and the Victorian male acted in full knowledge that he bore the burden for both sexes as he struggled to ever higher planes of evolution. Beset on all sides by evidence of civilization's past achievements, he knew that any slight failing on his part would reflect upon his family, nation, and race in the struggle for survival of the fittest; he could admit of no weakness, for to do so would deny his very role and stigmatize him as less than a 'fittest man'. . . . The young Victorian [male] struggled against impossible ideals, and when he stumbled, he carried both the onus of personal failure and the knowledge that he had failed to carry forward the torch of his civilization. (234)

Hall notes that for Acton, 'sex was a dangerous force which had to be held in check. . . . He warned against the waste of vital spermatic fluid by

whatever means' in a treatise marked by 'shock-horror warnings' (17). About young boys, Acton observed:

> The tendency of all irritation or excitement of the generative system . . . is to induce the youngest child to stimulate the awakened appetite. . . . Its victims, begetting precocious desires, too often gratified, [give rise] to the meanest and most debasing of all vices . . . this melancholy and repulsive habit [masturbation or 'self-abuse']. (24)

Acton praises one of the architects of Victorian masculinity, Thomas Arnold of Rugby, for instilling principles into his charges, characterizing it as 'this manful *meeting* of temptation' which is achieved by 'cultivating a boy's faculty of self-restraint' (41).

For Acton, 'continence and chastity are stellar virtues in males' (53), and he does allay anxiety about nocturnal emissions in the context of preserving male chastity:

> The occasional occurrence of nocturnal emissions or wet dreams is quite compatible with and, indeed, is to be expected as a consequence of continence, whether temporary or permanent. It is in this way that nature relieves herself. (52)

Acton's treatise is significant in the formation of ideologies about maleness, as his section devoted to 'Virility' reflects. Citing Claude Lallemand's definition of virility – 'Virility, derived from the Latin word, *vir*, a man, is the distinctive characteristic of the male; it is the condition upon which essentially depends the preservation of the species' – Acton declares that 'this feeling of virility is much more developed in man than is that of maternity in women' (123). Acton proceeds to stress the power of the man's sexual instinct and confirms that women have little or no sexual response; Acton advises men to have sex 'not more frequently than once in seven or ten days' (145). He assures males that '*size* . . . is no sign of vigor' (208), but the tendency of the book is to arouse rather than allay anxiety about the penis while simultaneously making males responsible for civilization. The link is evident as the rubric of 'virility', first introduced in the context of sexual desire, is transformed into the basis of the phallic order:

> [Virility] seems necessary to give a man that consciousness of his dignity, of his character as head and ruler and of his importance, which is absolutely essential to the well-being of the family, and through it, of society itself. It is a power, a privilege, of which the man is, and should be, proud. (125)

As Marcus comments however, 'this power is as precarious as ever' (25).

Peterson establishes that a physician such as James Paget was a powerful force against the terrorizing of a man like Acton: 'Paget considered masturbation no more dangerous to health than partnered sex' (580) she observes, and he specifically repudiated men like Claude Lallemand, upon whom Acton drew for much of his theory. Peterson indicates that Acton's work was internally contradictory, unoriginal and exploitative. Hall notes that Havelock Ellis similarly exploded 'many of the contemporary myths

surrounding auto-erotic practice' (23). Still, males were bombarded with anxiety-producing information about sexuality. Hall notes:

> There is little ground for believing that contracting venereal disease was a venial matter for a man in Victorian Britain. . . . Many voluntary hospitals would not admit patients suffering from them. . . . The stigma associated with these diseases affected male sufferers. (34)

The discovery of Salvarsan for the treatment of syphilis did not occur until 1909. Baden-Powell in *Scouting for Boys* warned against masturbation, albeit not in so strident a fashion as Sylvanus Stall's *What a Young Man Ought to Know* of 1897, which was 'Dedicated to the young men who should be pure and strong' and accompanied by testimonials from ministers and even a journalist, William T. Stead, author of 'The Maiden Tribute of Modern Babylon'. Cominos asserts that sexuality became governed under the rubric of Respectability as the century progressed:

> The perfectly continent, the completely sublimated sensual man, represented the Respectable or normative standard of gentlemanly sexual morality. . . . Continence in sex and industry in work were correlative and complimentary virtues. (31, 37)

'Thrift in semen' incorporated sexuality into 'the economic and social system' (233). The heroic doctrines of courage, self-reliance and fortitude, represented in many images of males in Victorian art, were attained by the sublimation of potentially anarchic sexual energy into causes advancing the phallocentric agendas of economics, imperialism and control.

To reinforce this ideology, painters scarcely ever depicted the penis, preferring that it be incorporated into the ideology of the phallus. This attribute of Victorian depictions of the male body, explored subsequently, correlates with the coercion to sublimation advocated by the culture at large. As Lehman (1991) notes, 'the representation of the male body involves the problematic relationship between the penis and the phallus' (54). Much of the imagery discussed in this book, therefore, 'foregrounds the display of the male body while protecting it from view' (51) as Lehman has noted 'of cinema' (51):

> The awe we attribute to the striking visibility of the penis is best served by keeping it covered up – that is, invisible. . . . Even when no nudity is involved, posing the male body as spectacle has always been a problem. (46, 56)

Preservation of the mystery of the penis enabled the penis/phallus equation of the codes of masculinity to develop in the nineteenth century. It became another mode of gendering difference, for as Lehman notes, Freud not only remarked that a girl notices she has no penis, he emphasized its visibility and size:

> Little girls . . . notice the penis of a brother or playmate, strikingly visible and of large proportions, at once recognize it as the superior counterpart of their own small and inconspicuous organ. (44)

Freud thus distinguished the penis not only by its physical fact but also by

its size and concomitant visibility. Even jokes by women about penis size do not disabuse males, for 'the jokes affirm the importance and centrality of the very thing they seem to question. . . . These women simply tell men what they have always told themselves about the importance of the penis' (58). The concealment of the penis in Victorian art constitutes a form of sublimation appropriate to masculinity because it allays anxiety, preserves the mystique, and anchors male superiority. This practice by artists was central to their incorporation into the ideologies of masculinity during the century. In 'The Meaning of the Phallus' Lacan declares:

> The phallus is the privileged signifier of that mark where the share of the logos is wedded to the advent of desire. . . . It is the equivalent in that relation [the real of sexual copulation] of the (logical) copula.

The crucial fact, however, is his key addendum: 'The phallus can only play its role as veiled' (82). As Gallop and Bernheimer have argued, however, the phallus cannot be separated absolutely from the penis (see Chapter Six). Thus, concealment of the penis in depictions of the male body, even literally with a 'veiling' of drapery, enables the entire male body to be the signification of the phallic order/logos/Law of the Father/dominant fiction in representations constructing male subjectivity.

The role of the male artist *qua* male in the nineteenth century is fundamental to his function of contributing to the construction of masculinity during the era. The representations of men in Victorian painting are overwhelmingly by male artists and a particularly significant element of their construction is the explicit or implicit male self-fashioning which is negotiated in these canvases. Male artists in their representations, therefore, constructed not only an ideology about masculinity but also their own place and status in Victorian phallic culture; they constructed both the subjects to be seen to reinforce the masculine ideology as well as their legitimation as its constructors and representatives. There were two necessary reasons for this process: first, the problematical status of the artist during the era; second, the question of the degree of masculinity associated with art itself.

As Gillett observes, 'artists shared the general belief in the Great Man' (9), linking themselves with the Carlylean conception of the hero. English painters had to confront their 'peripheral status' and attempt to transform it (1):

> Photographs taken of painters in their studios during the last three decades of the century show how enduring was the concern to erase residual memories of their artisan–tradesman past: impeccably dressed, they stare imperiously into the distance. . . . The level of public interest in art that began at mid-century and continued well into the eighties was unprecedented. (12)

Painters were photographed like gentlemen in private clubs in an attempt to establish professional status and exemplify Victorian acquisition of wealth, possible during the third quarter of the century when artists

enjoyed 'high incomes' (16). The Carlylean doctrine of work, enunciated in 'Signs of the Times' (1829), 'Characteristics' (1833) and *Chartism* (1839), was followed by male painters and contributed to their incorporation into the dominant ideology. Painters drew on Ruskin's elevation of the morality of art to establish their claim to moral respectability, which then translated into 'social respectability' (29). Carlyle and Ruskin, therefore, two constructors of masculinity in the period, were also key elements in the construction of the male artist as a representative of masculinity. The 'noble image of the artist' (31) presented in Ruskin's writings was transferred to contemporary practitioners. Above all, the artist became the bearer of the idea of the gentleman, a social–moral construction that was key to establishing claims of respectibility and legitimation in Victorian society. With the 'redefinition of the concept of gentility' during the 1840s, 'it followed that the painter must be a gentleman' (36, 37). Painting was listed as a profession in 1861, verifying the status of the artist.

This status was reserved for men, for women who aspired to professional status were constructed as amateurs and consigned to the lesser forms of art – miniature, landscape, watercolour. 'History' painting, mythological or historical subject canvases, was established as the province of males. Myriad other means were devised at the Royal Academy to reinforce art as 'masculine': the exclusion of women from membership, the fact that the hanging committee was all-male; the prohibition against women attending the RA banquet; the fact that non-members' wives were not permitted to accompany them to the Conversazione. If one recalls that 355,000 was 'the average [attendance] during the eighties and nineties' (193) at the annual exhibition, the exclusion of women meant that the RA was a classic male club where bonding/homosociality constructed gendered difference inimical to women while confirming masculine prerogatives.

The construction of gendered difference within the art establishment during the nineteenth century contributed an additional element to the construction of masculinity in culture: the exclusion of women from the homosocial male art world was necessary to establish that the artist was masculine. June Wayne argues that:

> society unconciously perceives the artist as a female and . . . artists act out the feminized stereotypical patterns projected onto them. . . . Although there have always been artists of both sexes, only males have survived into art history. Yet even for male artists one is more apt to believe that Leonardo and Michelangelo were homosexual than that Peter Paul Rubens was a diplomat. For the ancient but still powerful demonic myth prepares us to accept the warped and bizarre personality as an indicator of talent, even as proof of genius. . . . So profound is the stereotype of the artist as the inchoate, intuitive, emotional romantic that both the public and the artists themselves find it difficult to imagine that we can be anything else. . . . Obviously the artist makes art and the woman makes babies, but the word *create* is commonly used to describe both processes. That the will and the brain are said to be unnecessary and even antithetical to the function of women and artists encourages the elision of the male artist into being perceived as a female by the public. . . . It is profitable to some people that

artists remain demonized – that is, feminized – that is, lobotomized. (270, 271, 274)

Herbert Sussman (*Victorian Studies*) has recently contextualized this problem of the gender of the artist specifically to the nineteenth century in his analysis of the 'problematic of a male poetic' in his study of Browning's 'Fra Lippo Lippi' (185). Sussman contends that Browning's text constructed the artist as 'a constellation of male sexual energy, commercial success, and artistic potency that seems to reconcile artistic achievement with entrepreneurial manhood' in an attempt to efface a 'feminized romantic' conception of poetic identity:

> the project of situating the source of poetry not in those qualities of isolation and emotional intensity associated with the feminine, but rather in the attributes of entrepreneurial manhood itself, in commercial engagement, energetic activity, and phallic sexuality. (186–187)

Sussman concludes that, despite the insistent heterosexuality of 'Fra Lippo Lippi' and 'Andrea del Sarto', Browning's artists fail to realize this poetic of 'the truly manly artist' (199).

A nineteenth-century artist particularly preoccupied with self-representation and self-fashioning was Frederic Leighton, who became president of the Royal Academy in 1878. Drawing on Vasari's *Lives of the Artists*, Leighton constructed a male homosocial world and pedigree for his artistic ancestors in such canvases as *Cimabue Finding Giotto in the Fields of Florence* (c. 1848–50), *The Death of Brunelleschi* (1852), and *Michael Angelo Nursing His Dying Servant* (1862). In the first of these Cimabue finds Giotto drawing a sheep; Giotto is conceived as a natural genius to be taken up by the older artist and cultivated in his male world. In *The Death of Brunelleschi* Donatello cradles the dying Brunelleschi's head. There is a view of the dome of the Florentine cathedral in the distance. In both these paintings, the male bonding of Cimabue/Giotto and Donatello/Brunelleschi enforces the idea of art as a closed male fraternity. In the last canvas, Michelangelo's dying servant Urbino leans against Michelangelo's shoulder, a scene at once professional and private of two men in the studio of the artist. In contrast to the private all-male world of this canvas, Leighton's *Cimabue's Celebrated Madonna* of 1855 shows Cimabue leading Giotto as his canvas of the Madonna is carried in a celebratory advance through the streets of Florence. Here, the male homosociality of the two artists is displayed for the civic public. Leighton's canvases of Giotto also reflect the other empowering myth of the artist, 'that a master's genius already strives for expression in childhood' (Kris and Kurz 28), a motif contributing to the ideology of the artist as divine. In all four of these canvases, Leighton constructs an image of the art world as masculine, civic, powerful and exclusive. The fact that Queen Victoria purchased *Cimabue's Madonna* lent official blessing to this representation. When Leighton painted his own *Self-Portrait* in 1881 (Plate 1–6), he represented himself seated like Zeus before casts of the Panathenaic Frieze of the Parthenon.

With his hair in a fringe over the forehead and his distinctive beard, Leighton's head suggests the more stylized late-Archaic bronze *Olympian Zeus* discovered in 1877. Kris and Kurz note that art history endows the painter with godlike status, 'the artist as *alter deus*' (49), very much the objective of Leighton's *Self-Portrait*. When a president of the Royal Academy constructs himself in this fashion, he is asserting his full inscription into the masculine order of superiority, power and genius.

Casteras has argued that canvases such as Leighton's construct the notion 'giftedness as sexed', particularly in depictions of

> gifted boys whose place in history was already guaranteed. . . . Artists could literally embody the myth of genius and point, as well, to the future growth and greatness of the empire . . . [by depicting] the childhoods of gifted men. (*Rewriting* 117, 120, 122)

In such paintings in Victorian culture 'the realm of art is completely male. . . . The identification of genius with the male sex is total' (125). Equally important, she argues, is the idea of 'male bonding' (125) in such paintings. In addition, some canvases link 'genius and nationalism' in contrasts of racial type (as in Millais's *The Boyhood of Raleigh*). She concludes:

> These various strands of imagery – coupled with the overriding male cultural supremacy – all confirm . . . [that] Victorian art projected a misogynistic myth about male genius in line with prevailing beliefs about giftedness. In these visual representations of inequality, females have no autonomy or control over events, and the clear demarcations of role, intellectual abilities, and separate spheres are strikingly mirrored in countless paintings. . . . The iconology of genius thus remains a lasting metaphor – not only of male cultural supremacy, but also as almost a propagandistic emblem of British culture, and, by extension as a tribute to the entire nation and empire . . . manifestos of masculine virtues. (142–143)

This gendered empowerment of the artist and his elevated status is constructed in Edwin Long's *The Chosen Five* of 1885, which shows the five models selected to pose for the painter Zeuxis of Crotona for his depiction of Helen in the Temple of Hera. The model for the upper torso stands with arms raised, while the remaining four models await their turn to pose for the artist. Long's canvas constructs a classical prototype for the Victorian artist, enhancing his profession by this ancestry. The objectification of the female and her submission to the hegemonic authority of the male gaze is explicit in this representation. In constructing their iconography of masculinity, therefore, male artists legitimatized their profession, their status, their practice and, above all, their gender.

This book analyses the construction of masculinity by investigating five pivotal representations of males which evolved a paradigmatic masculinity for nineteenth-century British culture: the classical hero, the medieval knight, the challenged paterfamilias, the valiant soldier and the male nude. As Paul Smith argues:

> not only [can] male sexuality be understood in or as its cultural manifestations, but importantly . . . these representations involve and are part of personal agency too insofar as they address the experience of living a male body. (90)

The second chapter examines the male in classical-subject iconography, painting accorded the highest status in the hierarchy of pictorial genres during the period, requiring that artists had a strong knowledge of (and even identification with) the cultures of Greece and Rome. Painters such as Leighton, Poynter, Waterhouse, Draper and Burne-Jones, for example, constructed a paradigm of male heroism in their depictions of mythological males such as Odysseus and Perseus. The third chapter investigates the male in Victorian 'medievalizing' imagery, concentrating on the role of the knight and of the chivalric code, crucial in the construction of the idea of the gentleman. Artists such as Dicksee, Pettie, Watts and others are located in the context of cultural documents ranging from Carlyle to recruiting posters to *Scouting for Boys*. The idea of St George, the concept of rescue, and the prominence of armour in these representations configured an empowering masculinity for males. The fourth chapter discusses the configuration of the paterfamilias, the male in sexual and domestic relations in depictions of contemporary Victorian society. Unlike the homosocial contexts of much of the imagery involving the classical hero or the knight, the context of this chapter is more insistently heterosocial. Subjects such as the male as family man, the male and prostitution, and the male in emigration are analysed in the work of artists like Holl, Herkomer, Walker and Orchardson. The focus of the fifth chapter is the idea of militarism in Victorian art, concentrating on battle imagery and its contexts of imperialism, racism, class division, and the representation of cultural otherness. Like the paradigms of the classical hero and the knight, the representation of the soldier exists in an inflected homosocial context. Fripp, Wollen, Woodville, Lady Butler and Giles, among others, are studied to explore the function of the soldier in sustaining the dominant fiction. The sixth and final chapter concentrates on the male body as constructed in images of the male nude as a summation of arguments about masculine representation, and examines such elements as athleticism, homoeroticism and ephebic initiation in works by such artists as Tuke, Wetherbee, Leighton, Richmond and Walker. An evaluation of these five paradigms advances 'an understanding of masculine identity as an intersection of numerous and often-conflicting contexts and axes of meaning, of which sexuality is but one' (Adams 213). This study also details 'the complex imbrication of institutions, practices, desires, ideologies, beliefs, and representations that must be made to cohere in order to sustain even the most commonsensical notions of what men are – or more importantly, notions of what men should be' (Cohen 217).

This analysis of masculinity in Victorian painting is concerned with the construction of male subjectivity in art, especially in the art that constructed the reigning ideologies/dominant fiction of masculinity during the period. The artists who painted these canvases were almost exclusively middle class as well as male. Their representations were in turn exhibited before and purchased by members of this class. Their construction of such

imagery, therefore, reinforced the classic masculinity espoused during the Victorian period. This is not to say that such imagery is beyond conflict: some of these canvases contest and conflict the representation of the masculine even as they negotiate and inscribe the controlling masculinity of the era. As Sedgwick observes, ' "patriarchy" is not a monolithic mechanism . . . it is a web of valences and significances' (*Between* 141). Marginalized masculinities – those different by virtue of class, sexual preference, race or ethnicity – appear in these canvases, but primarily as a way of contrasting the constructed legitimacy of the dominant masculinity. By the end of the century, with the rise of increasing democracy, the insistent presence of feminism and the New Woman, the problematical involvement in empire and the resulting confrontations, this dominant masculinity was contested. The 'concomitant difficulties subtending the nexes of "masculinity"' began to be exposed (Cohen 215). Nevertheless, the effects of this construction endured far into the twentieth century, for this paradigm of masculinity remained the hegemonic model for decades after the death of Victoria. Peter Lehman (1988) observes:

> Masculinity is not simply a position of power that puts men in comfortable positions of control. If we ignore studying images of the male body, we are likely to think of masculinity as an ahistoric, powerfully secure, monolithic position. (108)

This study examines the formation of masculinity during the nineteenth century through the investigation of representations which contribute to the construction of maleness and male subjectivity during the era. In the formation of this ideology within a specific period of history, it becomes possible to delineate the formation of what Fasteau designates as 'the fact of masculinity itself' (59).

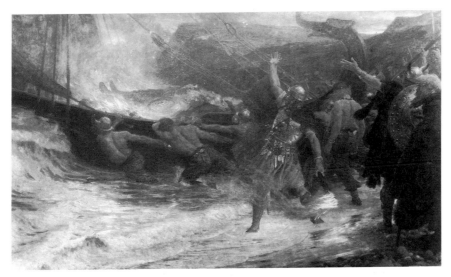

1–1. Frank Dicksee: *The Funeral of a Viking*, 1893; 73 × 120; Manchester City Art Galleries.

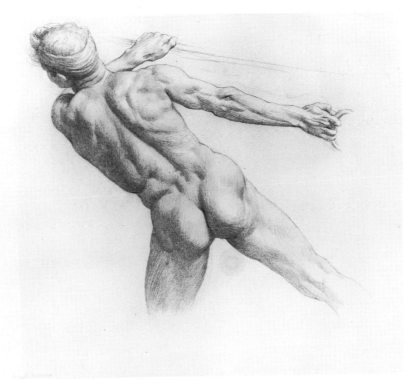

1–2. Frank Dicksee: Sketch for *The Funeral of a Viking*, c. 1893; pencil on paper; 17 × 19; Manchester City Art Galleries.

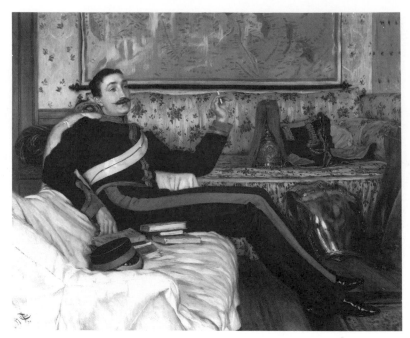

1–3. James Tissot: *Colonel Frederick Gustavus Burnaby*, 1870; 19½ × 23½; National Portrait Gallery, London.

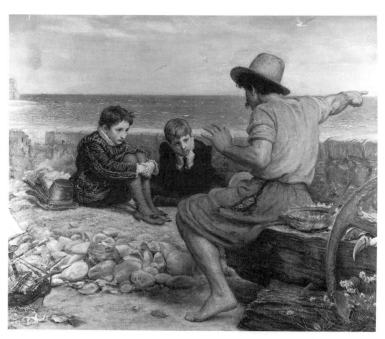

1–4. John Everett Millais: *The Boyhood of Raleigh*, 1870; 47½ × 56; Tate Gallery, London.

1–5.　John Everett Millais: *The North-West Passage*, 1874; 69½ × 87½; Tate Gallery, London.

1–6.　Frederic Leighton: *Self-Portrait*, 1881 (studio replica); 30⅛ × 25¼; Leighton House Museum, London.

2
The Classical Hero

The construction of masculinity that came most readily to the minds of Victorian artists was that derived from the mythology of Greece and Rome. The classical world and its literature had created paradigms of male behaviours which the world of nineteenth-century Britain was able to remould, refashion and reconstruct for the purposes of advancing the masculine ideologies of Victorian culture. In developing the codes of male behaviour, classical myth provided – in the tales of Theseus, Perseus, Hercules, Apollo, Jason, Achilles, Odysseus, Orpheus and Pygmalion, to name the most prominent of these narratives – paradigms of masculinity which the culture appropriated because of its own strong affinities with classicism and its strong belief that in its imperial objectives and its aesthetic aspirations it was the legitimate successor to, respectively, Rome and Greece. Thinkers from Thomas Arnold to John Stuart Mill to Matthew Arnold to Walter Pater informed the culture that its most crucial prototypes rested in the cultures of Greece and Rome. Adding to this strong inclination towards the classical world were modes of acculturation and education that favoured classical texts and attitudes, whether these were in the political, marital, commercial or martial sphere. It is against the background of these discourses that artists constructed an ideology of masculinity that concentrated on the classical/mythical hero as a paradigm of nineteenth-century masculinity.

A variety of thinkers regarded the age as in part a palimpsest with that of Greece or Rome. Shelley's declaration in the preface to *Hellas* (1812) asserted: 'We are all Greeks – our laws, our literature, our religion, our arts have their roots in Greece' (477). Thomas Arnold declared: 'Aristotle, and Plato, and Thucydides, and Cicero . . . are most untruly called ancient writers; they are virtually our countrymen and contemporaries' (Jenkyns, *Victorians* 62). Christopher Wood comments that Victorian 'colonial administrators . . . saw themselves as Roman proconsuls, or even generals' (*Victorian Parnassus* 2). Mill declared: 'The battle of Marathon, even as an

event in English history, is more important than the battle of Hastings' (*Works* 11.273), and in *On Liberty* in 1859, Mill linked Britain with Greece and Rome: 'The struggle between Liberty and Authority is the most conspicuous feature in the portions of history with which we are earliest familiar, particularly in that of Greece, Rome, and England' (3). In the pages of the *Edinburgh Review*, when he appraised the second volume of de Tocqueville's *Democracy in America*, Mill lauded the literatures of Greece and Rome as revealing two cultures which, while flawed, nevertheless exhibited:

> human nature on a grander scale [than his own] – with less benevolence but more self-control; if a lower average of virtue, more striking individual examples of it; fewer small goodnesses but more greatness and appreciation of greatness; more which tends to exalt the imagination, and inspire high conceptions of the capabilities of human nature. (*Ethical Writings* 153)

Of particular interest in this last statement is that it constructs qualities – self-control, greatness, patriotism, virtue – which were central to the definition of masculinity in the nineteenth century. Mill also points to the key component such narratives supplied in this construction: they acted as a catalyst in the creation of works which would 'inspire' readers or observers. Artists of classical-subject canvases in the nineteenth century constructed, through their recourse to classical legend, masculine heroism, political allegiance, physical prowess, moral rectitude and daring individuality. Matthew Arnold in *Culture and Anarchy* (1869) declared that 'it is a time to Hellenise', and the inspiration for this venture was Greek art: 'Greek art . . . Greek beauty, have their root in the same impulse to see things as they really are, in as much as Greek art and beauty rest on fidelity to nature, – the *best* nature' (147). In looking towards Rome, and especially to Greece, the male culture embraced a strongly patriarchal paradigm. Lord Acton declared in 1859: 'Two great principles divide the world and contend for mastery, antiquity and the Middle Ages. These are the two civilisations that have preceded us, the two elements of which ours is composed' (Richards in Mangan, 1987, 93). As Ogilvie observes: 'There was enough in the resemblance between the situations of England and Athens to tempt the Victorians into feeling a spiritual kinship' (108).

Males intending to participate in government came from a system of classical education that not only favoured the classics but privileged works that constructed male heroizing ideologies. As Warner notes, 'The *Iliad* . . . became a handbook of ethics, not just in Great Britain, but over a wide swathe of Europe, from the end of the eighteenth century onwards' (103). These texts from the classical world elevated the male over the female, even to the point of inculcating a misogynistic or gynephobic system of beliefs that constructed masculinity in an intransigent form. In Plato's *Timaeus*, for example, one could read the following: 'The better of the two [sexes] was that which in future would be called man. . . . Anyone who lived well for his appointed time would return to his native star and

live an appropriately happy life, but anyone who failed to do so would be changed into a woman at his second birth' (57–58). Arnold stated in his preface to *Poems* in 1853: 'Achilles, Prometheus, Clytemnestra, Dido – what modern poem presents personages as interesting, even to us moderns, as these personages of an "exhausted past"? . . . Why is this? Simply because . . . the action is greater, the personages nobler, the situations more intense' (*Poetry and Criticism* 206). His selection of male and female characters is striking: the two males are militant saviours of their culture; the two females are empowered women ultimately destroyed by males. Classical heroism as constructed in art of the nineteenth century was directed towards empowering males, although this emphasis was not so pervasive as to make the representation unproblematical or unconflicted.

In this construction of masculinity, artists were inspired by the debates about mythography and its value during the period. Max Müller, the theorist of the solar theory of linguistics, declared in *Comparative Mythology*: 'Nothing is excluded from mythological expression; neither morals, nor philosophy, neither history nor religion, have escaped the spell of that ancient sybil' (178). A.H. Sayce observed that myths are not only inherited but also reconstructed and added to by succeeding interpreters: 'The myth takes its coloring from each generation that repeats it, and clothes it with the passions and the interests and the knowledge of the men in whose mouths it lives and grows' (Munich 4). In 1876, Pater developed a tripartite model for interpreting myth. In his essay 'The Myth of Demeter and Persephone', Pater distinguished three levels of meaning in a myth: the natural, the literary and the ethical:

> In the story of Demeter . . . we may trace the action of three different influences . . . in three successive phases of its development. There is first its half-conscious, instinctive, or mystical phase . . . primitive impressions of the phenomena of the natural world. We may trace it next in its conscious, poetical or literary phase. . . . Thirdly, the myth passes into the ethical phase, in which the persons and incidents of the . . . narrative are realised as abstract symbols, because intensely characteristic examples, of moral and spiritual conditions. (*Greek Studies* 91)

If one selected the tale of Jason's quest for the golden fleece, the three levels might be the following: the first sense, the conquest of day (golden fleece) over night (Medea/witchcraft/darkness); the second sense, the importance of duty; the third sense, the value of strength of heroic conviction and self-assertion. Ruskin in *The Queen of the Air* in 1869 made a similar formulation: 'In nearly every myth of importance . . . you have to discern these three structural parts – the root and the two branches: – the root, in physical existence, sun, or sky, or cloud, or sea: then the personal incarnation of that . . . and, lastly, the moral significance of the image, which is in all the great myths eternally and beneficently true' (19.300).

The reconstruction of myth could involve not only processes of education but also those of indoctrination. A key text in such a process was a book

such as Charles Kingsley's *The Heroes* of 1855, which promulgated the heroic idea to children by studying three males heroes, Perseus, Jason and Theseus. Lady Diana Cooper recalled being raised 'on a book of Flaxman's drawings for the *Odyssey*, followed by Church's *Homer* and Kingsley's *Heroes*' (Ogilvie 142). Kingsley began *The Heroes* by confirming the classical tradition for the Victorian age:

> You can hardly find a well-written book which has not in it Greek names, and words, and proverbs; you cannot walk through a great town without passing Greek buildings; you cannot go into a well-furnished room without seeing Greek statues and ornaments, even Greek patterns of furniture and paper . . . We owe to these old Greeks . . . the beginnings of our geography and astronomy; and of our laws, and freedom, and politics. (10–11)

To Kingsley heroes are 'men who were brave and skilful, and dare do more than other men' (17). Kingsley states that boys and girls alike may strive for the heroic, yet his illustrations are exclusively male.

To Kingsley, Perseus is 'brave and truthful, gentle and courteous' (25). The fear engendered in the Perseus legend is soon confronted: 'As Perseus looked on it [the Medusa head] his blood ran cold. It was the face of a beautiful woman; but her cheeks were pale as death. . . . Vipers wreathed about her temples. . . . Day and night Perseus saw before him the face of that dreadful woman, with the vipers writhing around her head' (28–29). The salient fact of the Perseus legend as retold by Kingsley is that woman's beauty is fatal, for when Perseus sights Medusa, 'for all her beauty, she was as foul and venemous as the rest' (46). Kingsley advances male-superior agendas in his construction of the Jason/Medea encounter: 'He looked at Medea cunningly, and held her with his glittering eye, till she blushed and trembled' (117), scarcely credible if one follows any of the ancient sources. The plight of Jason is that he 'had taken a wicked wife. . . . Jason could not love her, after all her cruel deeds. So he was ungrateful to her, and wronged her; and she revenged herself on him' (159). Medea later is called the 'dark witch-woman' (189). Kingsley's reading of myth is a selective one, a distortion or simplification of the sources in Euripides or Apollonius Rhodius in the case of Medea, but his intention is to inculcate heroic paradigms. The result for males was the use of classical myth – through a relentless emphasis on classical heroism – to construct paradigms that empowered them in the culture. Ogilvie notes: 'The Edwardian age has all the marks of an heroic or Homeric age. . . . [A man] had to show himself to be strong, brave, and courageous. . . . The Homeric world of the heroes has other resemblances. There is the same attitude to wealth, the same regard for other heroes' (54). Hercules, Jason, Theseus, Perseus, Apollo, Odysseus were the mythological males elevated in classical-subject masculinizing constructions, an extension of the hero worship initiated by Carlyle in his lectures in 1840. As Hatt observes, 'the classicising vocabulary . . . inscribes a history of masculinity as an unchanging ideal, naturalising it as an essential and ahistorical category' (66). For nineteenth-century British

painters, therefore, classical mythology and its heroes constituted a source of paradigms with which to construct masculinity.

Mario Praz has affirmed a marked 'virility complex' in nineteenth-century society, a disposition he defines as 'an anxious desire to appear masculine' (238). This 'virility complex' contributed to the strategy of invoking mythical conceptions of masculinity in Victorian art. There were six dimensions involved in this process: 1) the myth chosen (Jason's quest for the golden fleece, for example); 2) the particular episode (the retention of the fleece); 3) the elements implied by the representation (male heroism and valour); 4) the use of typological detail (Jason's powerful physique); 5) the repetition of a certain myth (Jason as archetypal male hero); and 6) the omission of other narrative elements (Jason's abandonment of Medea). One of the greatest of classical-subject canvases during the period, and one that concentrates on the Jason narrative, is Herbert James Draper's *The Golden Fleece* (1904) (Plate 2–1), derived from Euripides, Ovid, Apollonius Rhodius and probably Kingsley. The canvas concentrates on two dimensions of the tale: Jason's obtaining and holding on to the golden fleece and, à la Kingsley, the venality of Medea. Jason flaunts the fleece and shakes his fist as Medea prepares to cast her brother Absyrtus into the ocean to delay pursuit by her father. The boy grasps Medea's gown, his left hand hovering over her naked breast to suggest her anti-maternal tendencies, which will find fruition when she slays her children by Jason. Jason appears as the Apollonian, Aryan, light-bearing hero, not only because of the golden sheen on his helmet but also because of the way the golden fleece has become a second skin, endowing him with an identity as solar hero. His tanned body is accentuated in contrast to the fleece in order to suggest his fierce mariner's personality and endurance. In further contrast, Medea's black hair (connoting her affiliation with night) and the red border of her drapery and costume signify her bloody and dangerous personality, which will transform her into a woman who slays her children. The painting therefore constructs masculinity in an empowering manner by contrasting it with vengeful female venality. However, any observer of the canvas would recall the end of Jason after Medea has destroyed his children and his fiancée. Thus, the canvas constructs a masculine heroism that nevertheless would be stronger if dangerous women were not present.

Medea's costume and sex isolate her from the all-male world of the ship. Draper thus delivers both a hero and an admonitory cultural message in the painting. His preferred woman is the one depicted in *Day and the Dawn Star* in 1906, which shows a dark-skinned angelic male (Day) lifting up a pale female (the Dawn Star). The association of the male with solarism and light is confirmed, and the absorption of the Star by male power is the substance of the canvas, with the male empowered as his superior position in the design verifies. The passive figure of the Dawn Star is one of two polarities chosen by the patriarchy to construct

femininity, the other being the femme fatale, as represented by Medea in *The Golden Fleece*. In *The Golden Fleece*, Draper demonstrates the process by which narratives of classical heroes were constructed to encode ideologies of masculinity during the nineteenth century.

Another important representation of Jason and Medea is by John William Waterhouse (1907) (Plate 2–2). In this depiction, Jason watches while Medea – the venal sorceress – concocts a potion. The canvas is particularly interesting because at first it would appear as if Jason were dependent on Medea. If one examines the canvas, however, this is not the case. In reality, it attributes vengeance and violence to the woman, even though Medea concocted her lethal poisons for her lover. Jason is shown detached from the very devices which aided his quest. Waterhouse emphasizes his power, in fact, by the spear, which is so long it disappears over the edge of the canvas – a powerful aggrandized penis encoding masculinity. Both Draper and Waterhouse construct the Jason narrative in a way that empowers male heroism.

Just as Jason was used to construct a version of the explorer/adventurer in the masculine code, another mythological figure – Hercules – was also of great importance in the formation of the masculine paradigm. As Walters contends:

> Hercules . . . is masculinity incarnate. He is the archetypal hero, who ventures out alone to do battle with his enemies. In the most literal sense of the word, he is the type of *virtu*, embodying the courage proper to a man; and like so many proper men, he was finally done for by the gullibility and jealousy of his wife. . . . At the beginning of the fifteenth century, the Florentine chancellor Salutati wrote a treatise on his ethical and political significance; he was to be exploited for centuries as a symbol of courage by republican, monarch and emperor. (118)

Walters affirms it is the *vir* in virile that Hercules connotes for mortals, especially since he himself began as a mortal and was elevated to divine status as reward for his heroism, a quality making him peculiarly attractive as a paradigm for mortal males. Hercules also embodied an intense veneration of phallicism, noted by Walters:

> The nude gods of the Greeks, for all their naturalistic anatomy and neat unobtrusive penises, continue to derive much of their authority from being identified with this archaic but still vital phallic symbolism. The whole body may come to represent the phallus; Hercules is the archetypal phallic nude. He is the epitome of muscular masculinity, a strongman whose bodily exploits win him fame and finally the status of a god. One of the most popular of all ancient heroes, he survived to be Christianized into an emblem of fortitude. The Renaissance employed him as an all-purpose symbol of manhood (*virtu*) and political power. (9)

If Hercules's body was a phallus, his hypermasculinity could be further signified by his phallic club, which increased the maleness of his representation. In all the dimensions of phallic heroism, Hercules embodied their essence: a mortal man who was made divine; a male whose phallic strength was unavailable to women; a man who was killed by the actions of a foolish

woman and thus became a candidate for apotheosis; a god sanctioned by both the pagan and Christian traditions.

For these reasons, the representation of Hercules in Victorian art is particularly significant for the construction of male heroism. In 1871, Leighton exhibited his canvas *Hercules Wrestling with Death for the Body of Alcestis* (Plate 2–3). It is designed as a triptych: mourners of the 'dead' Alcestis on the left; the heroine herself in the centre; and Hercules and Death wrestling on the right. Pauline Viardot had sung an aria from Gluck's *Alceste* at a party Leighton gave in April 1871, and Browning was to praise this canvas in *Balaustion's Adventure*, published in July of the same year. William Morris had also treated the idea in *The Earthly Paradise*, drawing on the key source, the drama by Euripides. Both Leighton and Browning had attended a performance of Gluck's opera in 1871. Leighton aggrandizes the nude Hercules by echoing famous sculptural predecessors: the head of Hercules is bound with a fillet similar to that in the *Diadumenos* of Polykleitos, with the same raised foot, and the statue of the *Borghese Warrior* supplied the paradigm of the god's combat stance. The association of heroic action with sculptured models also had an additional significance, as Hatt declares: 'The depiction . . . of the body as sculptural was a way of stabilising the male nude and mitigating the threats it posed, as well as denying the weakness of the male flesh' (68). Hercules has the force of the lion whose skin he wears. The restoration of Alcestis to her cowardly husband Admetus in the drama represents the reconfinement of the woman to the *oikos*, so the heroic deed of Hercules, encoded by his nudity, serves to reinforce the patriarchy in Leighton's construction. The male nude signifies empowered masculinity, stressed here by the fact that the nude is a mortal man become a divinity. Leighton emphasizes his heroic masculinity by his tanned skin colour, which also connotes the rigour of his life, comprised of the twelve labours amidst much else. Leighton's structure in a triptych design augments the hero's distinction, isolating his combat with Death as a discrete unit of the canvas.

The modelling of Leighton's Hercules after the *Borghese Warrior* is also part of the cultural representation of the male body in the nineteenth century, not only in art but in the physical culture movement. For example, one of the greatest proponents of physical culture at the end of the century was Eugen Sandow, who, as Kershner demonstrates, was 'initially inspired by the sight of classical statues in Rome' (668). As his career evolved, Sandow posed 'as a model for a painting of a Roman gladiator' (669) and participated 'wearing bronze makeup and striking a series of classical poses' (669) on the stages of theatres. Noting the 'classical resonance' of Sandow's exhibitions of his near-naked body in the 'nineteenth-century tradition of the *pose plastique* or *tableau vivant*' (676–677), Kershner contends:

> Sandow's name was synonymous with physical strength and fitness, but, in the aesthetic nineties, it was also synonymous with male beauty . . . [demonstrating]

Sandow's emergence as a cultural icon. . . . The key to [Sandow's] social positioning was precisely the *spectacle*, founded upon strength, and observed in the dispersal of his advertised image through countless commodities and numerous abstract attributes – beauty, health, science, art, masculinity, respectability. (677, 683)

Sandow's body becomes part of 'the incessant circulation of signs' (683) of masculinity during the era, much as a canvas could be reproduced and circulated as a construction of masculinity. Sandow posed as the *Dying Gaul*, the *Illisos*, and the *Discobolos* as a model to males of physical and aesthetic perfection, part of the ideology constructed about the male body in Leighton's canvas, which joins classical sculpture, the male body, the physical culture movement, and heroism in a powerful ideogram of male subjectivity. 'This idea of athletes as living statuary survived all the way into the 1950s' (Chapman 7).

In 1882, William Blake Richmond exhibited *The Release of Prometheus by Hercules* (Plate 2–4) at the Grosvenor Gallery. The *Art Journal* clearly understood the gender modelling encoded in the canvas, which was more than 11 feet high:

Hercules, poised on a rock in strong relief against the sky, with life and energy in every line of his virile body, is shooting a last arrow at the vanquished eagle, whose presence is indicated by a feather floating down. Prometheus, a no less fine figure, but cramped from his bonds, lies in an uneasy attitude on the rock below, as if half fearing to rise lest his deliverance should not be really accomplished. (Lascelles 17)

The Victorian art world perceived the equation of masculinity with the naked male body as depicted by Richmond. The evolution of the canvas is particularly interesting in this respect, since a sketch (Stirling 431) shows that while Prometheus remained in the position originally conceived, Richmond at first portrayed Hercules from the side, instead of the frontal view of the final canvas. To increase the intensification of the male body as masculine paradigm, Richmond altered the design to the frontal view, thrusting the force of the hero's power directly at the viewer. It is not accidental that Thomas Hughes, in an address to the students of Clifton College in 1879, exhorted them 'to live a brave, simple, truthful life', a desirable ideology which 'is no modern, no Christian experience, this': 'The choice of Hercules, and numberless other Pagan stories, the witness of nearly all histories and all literatures, attest that it is an experience common to all our race' (83). After exhibiting *The Release of Prometheus by Hercules*, Richmond toured the islands of the Aegean during 1882–83, confirming his conception at the source. The promontory on which the rescue occurs adds to the impression the scale of the canvas must have made on the viewer. Here scale itself becomes a mode of masculine ideology and advocacy.

Prominent among legends supporting male superiority and constructing male heroism were those involving the 'rescue' compulsion, by which men

rescued women, sometimes later subjugating them in marriage. Hercules and Alcestis, Perseus and Andromeda, and Orpheus and Eurydice are three relationships that illustrate the rescue compulsion, the mythological prototype of the rescue societies and missions established in the nineteenth century to help the destitute (often envisioned solely as females). Rescue missions and societies, frequently with men as their founders or heads, particularly devoted their attention to dealing with vagrant women (that is, prostitutes) or redundant women (seamstresses, for example). One might note the examples of Urania Cottage (1846), the House of Mercy at Windsor (1849) and the Female Temporary Home (1852). There is no doubt that such rescue societies had an altruistic goal. The men who sponsored and directed them sincerely desired to remedy the condition of women. It must be recognized, however, that males were the authorities behind many of these plans, a consequence being the reinforcement of male superiority and confirmation of female passivity and helplessness. The rescue myths of the Greco-Roman pantheon reinforced the idea of woman as supplicant and man as heroic rescuer. In his 1910 essay 'A Special Type of Choice of Object Made by Men', Sigmund Freud described a pathology that clarified the attraction to rescue experienced by males. Freud describes four conditions necessary for the activation of the desire to rescue: 1) the woman be attached, so there can be an injured third party; 2) the woman be sexually experienced; 3) the attachment be compulsive; and 4) the woman be in need of rescue, in sum, that the woman be attached, sexually tarnished, irresistible and imperilled. In nineteenth-century society, this compulsion is illustrated by Gladstone with his nocturnal perambulations to reclaim prostitutes, and by organizations like the Salvation Army, founded by William Booth in 1878. While not all classical narratives contain all of these conditions, the fact that mythological prototypes existed assisted the encoding of rescue as a dimension of heroic masculinity, not only in the culture but also in the fine arts.

One of the most alluring of the rescue myths was that of Orpheus and Eurydice. Allen Staley summarizes the attraction of the legend to Victorian artists:

> Orpheus, the artist who conquered death by the beauty of his music and reclaimed his wife from the underworld, lost her because of his inability to resist the temptation to look back at her. Subsequently, he was destroyed by the Thracian women, but his severed head continued to sing after his death. The myth had a profound attraction for many later nineteenth-century painters, for whom it embodied a metaphor of the immortality of the artist. (*Victorian High Renaissance* 75–76)

The myth conveyed two ideas essential to the construction of masculinity: power (illustrated here by the conquest of death and the rescue) and the invariability of heroism (the deed immortalizes the actant). The myth in the works of male artists conveys via a meta-artistic device the heroizing of the artist himself, as well as associating the artist with Christ, who also

overcame death. In an 1862 version by Edward Poynter, a young, almost ephebic poet leads Eurydice from Hades. Eurydice's dependence on him is connoted by the fact that both her hands grasp his right arm. His left hand, in contrast, holds his lyre. The serpents on the ground recall the cause of her death and suggest the fatal conclusion of this rescue. Since this rescue ultimately led to disaster, the point of these canvases is the heroic effort made in spite of the disastrous outcome. Leighton's treatment of the subject differs considerably from Poynter's. His canvas appeared at the Academy in 1864, accompanied by a text from Browning; another source was Gluck's opera, which Leighton had gone to Paris to hear in 1860. In this construction, Orpheus is depicted pushing Eurydice aside, his expression denoting disgust with her for breaking the condition of her release. In this representation, Leighton distorts the legend, in which Orpheus was to blame for gazing back at Eurydice, in order to shift the blame to Eurydice. Leighton's version of the heroism is more admonitory than laudatory: he advises artists that women destroy the lives of artists (as in his friend Browning's 'Andrea del Sarto'). The contrast of flesh tones, and the difference in the colouring of the costumes, emphasize the gendered difference Leighton wishes to confirm here. The lyre and laurel crown are attributes of Orpheus that, in Leighton's conception, differentiate the artist from other men and from women, for whom sexual passion is a natural mode of expression. For the artist, however, it is a delusion and a snare.

G.F. Watts takes the completely opposite attitude in his *Orpheus and Eurydice*, the first version of which he completed in 1860. Here the sexual passion is overwhelming: the poet cannot refrain from looking back at his wife; the lyre which was between them is ignored; his hand reaches passionately to her breast. It is possible that Watts's canvas is a response to Leighton's, which 'suggests repulsion and conflict between the two . . . Watts's picture conveys the deepest tenderness' (Staley 76). Solomon J. Solomon exhibited his *Orpheus* (Plate 2–5) in 1892, one of the more unusual constructions of the legend. The title emphasizes the hero alone, preparing to lead the shade of Eurydice out of Hades. Solomon sets the canvas in Hades to further increase the heroism of the poet, who appears as a young rhapsode/ephebe in his nudity and laurel crown. Solomon's allegiance to the classical tradition was beyond question. He asserted:

> Art reached its highest expression in the hands of the Greeks. Their mythology, so rich in imagery, so inspiring to the artist, so beautiful from the aesthetic side, could not fail in the course of time, among a race so sensitive, to produce the wonders both of sculpture and architecture that are unsurpassed and unsurpassable. (Olga Phillips 70)

Despite his youth in the canvas, Solomon constructs Orpheus as the paradigm of the heroic male artist. Solomon does not show the fatal backward glance, as had Watts and Leighton, in order to confirm the heroism rather than the disaster.

Two final constructions of the Orpheus legend demonstrate the range of alternatives available in its representation. John William Waterhouse's *Nymphs Finding the Head of Orpheus* of 1901 shows the disastrous aftermath of the legend, when the poet's body had been dismembered by bacchants: his decapitation, a symbolic castration, shows the destructiveness of women. The Maenads of Thrace had destroyed Orpheus because after losing Eurydice he despised all women, so their action is revenge for the poet's misogyny. In Waterhouse's conception, his hair still is entwined in the floating lyre. Nevertheless, the fact that the poet's head continued to sing confirms his survival, even though the canvas has a strong component of the admonitory to males to avoid sexual passion for the sake of art. Waterhouse's canvas may be construed as a conflicted representation of the heroism of the legend, as he completely omits the rescue to dwell on the more difficult and disturbing conclusion of the myth. In contrast to this configuration, however, one may note William Blake Richmond's *Orpheus Returning from the Shades* of 1900 (Plate 2–6), deposited by the artist as his Diploma Work. The canvas shows a naked male emerging from the darkness, his drapery swirling, his lyre raised triumphantly in his left hand. Not even a suggestion of Eurydice appears in the canvas, which celebrates the supremacy of the male and of the masculine in art. The construction of the canvas advances a Pindaric conception of the male body as spiritually heroic, similar to the intention of displaying Hercules's body in *The Release of Prometheus by Hercules* in 1882. Richmond in both instances deploys heroic nudity in a rescue context to construct masculinizing paradigms.

Two important canvases by Lawrence Alma-Tadema demonstrate that the allegiance to classical texts was a mark of masculinity, even among painters. In *Sappho and Alcaeus* of 1881, the artist represents the poetess Sappho on the island of Lesbos in the seventh century BC leaning on a lectern to listen to the recitation of her compatriot Alcaeus, who recites to the music of a kithara (the instrument of Apollo), which he plays with a plectrum in his right hand. The *thiasos* or sacred sorority of Sappho's followers sits on an exedra in the open air, the Greek locale suggested by olive trees behind it; their names are carved on the seats. The heroizing of the male poet, in this case, is emphasized by a number of details: the wreath on the lectern; the winged Victory at the base of the lectern proffering a wreath; the inlaid mother-of-pearl scene on the kithara of Apollo and his sister Artemis. Aristotle recorded in *Rhetoric* I.9 that Alcaeus and Sappho were in love, and he may be declaring his love here; he might also be trying to include her in his political affair. In either case, Alma-Tadema constructs an image of the heroic artist/singer gazed upon by an adoring group of women. The association with Apollo, the gold band in Alcaeus's hair, and the plein-air locale all link Alcaeus to solarism, and thereby to masculinity according to nineteenth-century conceptions. In 1885 Alma-Tadema pursued this masculine heroizing of ancient texts in *A Reading from Homer* (Plate 2–7). Here a rhapsode (a professional reciter),

wrapped in a tunic, holds a scroll with lines from Homer, which he recites to his audience; his crown of bay leaves elevates his status, already suggested by the exposure of his body. As in *Sappho and Alcaeus*, details support the heroizing of the male: there is a winged Victory on the left side of the kithara next to the seated male; the Victory holds out a wreath, as on the lectern in *Sappho and Alcaeus*, heroizing both Homer and the rhapsode; Homer's name is carved above the head of the rhapsode; on the right of the kithara is a winged male figure, with the letters *Ka[l?]os* above him, the word for beautiful and often attributed to ephebes. The audience is more varied than in *Sappho and Alcaeus*: here a shepherd is stretched on the floor, a diagonal leading the viewer's eye towards the rhapsode; the man on the left is crowned with a coronal; and a seated couple consists of either another rhapsode or the rhapsode's attendant (the case for the lyre rests next to it); the woman holds a tambourine on which are a dancing figure and a flute player, both associated with Dionysiac ritual. The woman is gendered with the tambourine as a devotee of Dionysus, while the males are associated with the artistry and rationalism of the god of light, Apollo.

This construction, whereby classical texts were gendered masculine and for a masculine audience, is particularly significant for the strong interest in Homeric texts and especially the *Odyssey* in the nineteenth century. Writers during the period, such as Tennyson with his *Ulysses* in 1842 or Arnold with *The New Sirens* of 1849, deployed dimensions of the Homeric narrative for their own cultural purposes, in the first instance to critique the Victorian doctrine of progress and in the second to examine the allure of self-indulgent Romanticism. Arnold was to take the Homeric question into the realm of cultural formation with his four lectures *On Translating Homer* delivered as Professor of Poetry at Oxford in 1860 and 1861. These lectures formed ideas which were later enunciated in additional essays, such as the concept of Homer's direct style constituting a touchstone for the evaluation of subsequent writers. Arnold's preoccupation with Homer led to a renewed emphasis on Homeric texts and particularly the *Odyssey*. For art, the consequence was a considerable body of iconography involving the *Odyssey* and its hero. Not all episodes from the *Odyssey* were represented; for example, there appear to be no canvases about Nestor, Proteus, Oxen of the Sun, Eumaeus, Telemachus or Wandering Rocks. On the other hand, Calypso, Circe, Nausicaa, Penelope, the Sirens, and the Lotus Eaters were powerfully figured in Victorian canvases, as were numerous episodes from the life of Odysseus, some not even included in the Homeric poem. In this concentration on Odysseus, Victorian classical-subject painters constructed an enduring paradigm of masculine behaviour. In doing so, these painters had the precedent of Turner's 1829 *Ulysses Deriding Polyphemus*, considered by Ruskin 'the central picture in Turner's career'. Turner draws on *Odyssey* 9 for the incident but elaborates it with details such as the representation of the Trojan Horse in the rigging flag. Ruskin's review, however, indicated an additional reason for

Turner's attraction to the subject, its potential allegory of the artist confronting a hostile, Philistine environment:

> He had been himself shut up by one-eyed people, in a cave 'darkened with laurels' . . . he had seen his companions eaten in the cave by the one-eyed people – (many a painter of good promise had fallen by Turner's side in those early toils of his); at last, when his own time had like to have come, he thrust the rugged pine-trunk – all ablaze – . . . into the faces of the one-eyed people, left them tearing their hair in the cloud-banks – got out of the cave in a humble way, under a sheep's belly . . . and got away to open sea as the dawn broke over the Enchanted Islands. (13. 136–137)

There can be little doubt that artists of the period, all of whom would have known this review, recognized in this allegory of Turner's career much of their own circumstances. Ruskin equates the painter with the defiant and struggling and enduring Homeric protagonist, a masculine model for the age. The Homeric paintings followed the major events of Odysseus's life in constructing this paradigm.

Some of the episodes were more favoured than others. In 1895 Herbert Draper exhibited *The Youth of Ulysses* (Plate 2–8) showing the young, ephebic hero being watched over by Athene. The large scale of the goddess suggests the threatening role of women in Homer's narrative, whether embodied in Calypso, the Sirens or Circe. In Homer, however, Odysseus is always the favourite of Athene, and Draper reflects this solicitude in the canvas. Odysseus's dark colouring already suggests the rugged mariner. In the *Odyssey* it is Athene who will send Nausicaa to the shore (Book 6) to assist the mariner and who will intervene in the final conflict between the relatives of the slaughtered suitors and Odysseus to establish peace (Book 24). Draper's canvas remains the only depiction of the young Odysseus; the episode does not show the heroic male in action but only in training. The canvas, nevertheless, enforces a dominant masculinity because Athene, as she declares at the conclusion of Aeschylus's *Oresteia*, is male-identified, having sprung not from woman but from the head of her father Zeus.

Classical subject artists particularly gravitated to Odysseus's retrospective account of his wanderings, *Odyssey* 9–12, not only for the rich anecdotes but also for the gendered modelling contained in these episodes, constructing male heroism and female venality. One of the earliest adventures entails the encounter with the Lotus Eaters in *Odyssey* 9, a subject rarely treated by an artist but depicted in Hugh Riviere's lost *The Lotos Land* of 1898, showing a group of mariners languishing on the shore. The impression made by the canvas when exhibited must have been considerable because of its large size, and when contrasted with the Victorian ethos of progress embodied in Tennyson's *Ulysses* the painting, with its wearied explorers, can well represent a critique of those who failed to attain masculine goals.

No subject from the *Odyssey* so engrossed these artists as Odysseus's

encounter with Circe in Book 10. In examining these treatments, however, one should note that Circe was a code word in Victorian journalism for female venality and prostitution. When he argued for the Contagious Diseases Acts, William Acton, for example, stated:

> Prostitution ought to be an object of legislation. . . . Kings, philosophers, and priests, the learned and the noble, no less than the ignorant and simple, have drunk without stint in every age and every clime of Circe's cup. (Murray 427)

In literature, Hardy deployed Circe and the males turned into swine in his creation of Arabella Donn in *Jude the Obscure*. Among the most famous of the constructs of Circe was *Circe Offering the Cup to Ulysses* by John William Waterhouse of 1891. Waterhouse shows some of the mariners already transformed into swine as Circe offers the goblet to Odysseus, seen in the mirror behind Circe's throne, and in fact a self-portrait of the artist. Waterhouse specialized in the figure of the *jeune fille fatale* represented by this Circe. By this device, he increased her malign nature, for it is important to remember that by the time Odysseus encountered Circe on the island of Aeaca she had murdered her husband. The sinister essence of Circe is enhanced by the Medusa head at the base of her throne, while the lionesses on the throne associate her sexuality with bestiality, a corollary of her ability to transform men into swine. Circe's magic wand becomes a phallic symbol threateningly stolen by the sorceress's wiles from the transformed men. The most sinister element of this depiction is the structuring of the canvas, whereby, reflected in the mirror, Odysseus is seen close to Circe's left breast, almost cradled in her arm, a deceptive maternal image exposing the calculated nature of her sexuality. (Waterhouse also painted a canvas of Circe poisoning a rival in love in the 1892 *Circe Invidiosa*.)

Probably inspired by the Waterhouse canvas, Thomas Spence exhibited *The Temptation of Odysseus by Circe* in 1897 (Plate 2–9). Here, Odysseus sits on Circe's throne as the goddess haughtily offers the cup. The mariner appears older and more world weary than in Waterhouse's construction. The threatening nature of women is conveyed not only by the fact that Circe is standing, but by the enormous throne, which diminishes the mariner. Much as Kingsley's construction of Jason warned males against predatory women, so too does the design of Spence's canvas. In Arthur Hacker's *Circe* of 1893 (Plate 2–10), the goddess's venality is linked inextricably with the female body, which she displays to Odysseus as his men, transformed into swine, swarm around him. The brazen nude and dazed hero leave no doubt that Odysseus will spend a year with the goddess, albeit he does escape in the end. This emphasis on female venality is reified in the numerous representations of the goddess alone, sometimes holding the fatal cup, as in George Storey's 1909 canvas or Alfred Drury's 1894 sculpture; sometimes after transforming the men into swine, as in Briton Riviere's 1871 canvas; occasionally surrounded by wild

beasts, as in canvases by Arthur Wardle in 1908 or Wright Barker in 1912; and once Circe on a promontory watching as a shipload of mariners arrives on her island coast, by George Wetherbee in 1911. Such canvases are constructions of female venality as a sign to men to guard against female passion by heroic resistance. Connected to the discourse about prostitution in the nineteenth century, this iconography genders the double standard and warns men against women's irrational but magical and secret powers. The representation of the goddess with beasts was related to the patriarchal belief that woman's nature was less evolved than men's on the evolutionary scale, that woman might be an evolutionary atavism and thus closer to bestiality.

Although Circe drew the greatest amount of attention from Victorian mythological artists, other components of the Homeric text were of considerable interest, especially the Sirens from *Odyssey* 12. Like the episode involving Circe, the Sirens episode warns males against female sexuality; in this instance, however, Odysseus resists their song, a paradigm of male repudiation of female allure. The representation of the Sirens has a long history in Victorian art. For example, William Edward Frost, who specialized in painting the female nude, exhibited his *Sirens* in 1849: no men are present but the central figure plays her lyre as another gazes directly at the viewer. Earlier, in his 1837 *The Sirens and Ulysses*, William Etty, who also specialized in the nude, presented lethal evidence of the dangerous women. Etty includes the decaying bodies of dead mariners in the foreground of the canvas, visible to the observer but not to the mariners on the ship in the middle distance, which shows Odysseus bound to the mast. In Victorian social discourse (Kestner 1989 *passim*), the Siren, like Circe, was prototypical of prostitutes and venal female sexuality. In 1843, William Bevan published a study of prostitution in Liverpool, noting the danger a young tradesman might encounter: 'He lounges in lassitude about the neighbourhood. He is allured by a syren voice that charms but to destroy. . . . He yields and is undone'. Female nature is unpredictable and delusory:

> On they come in countless myriads, to swell that tide of corruption which is sweeping away into one common, nameless grave the noblest and most promising of England's sons. The 'helpmeet' is transformed into the guilty tempter; the 'woman' of Eden loses her identity in the syren of the streets. . . . Alas, how fallen! (Nead 1982, 11)

It is estimated that there were 8,000 known prostitutes in London around 1850, with more than 50,000 in the United Kingdom. By 1858, it is estimated that one-sixth of unmarried women between 15 and 50 were prostitutes, that is, around 83,000 women. In 1856 three hospitals in London treated some 30,000 cases of venereal disease, and half the outpatients at another fell into this category (Chesney 355).

The two major canvases of Odysseus with the Sirens are by Waterhouse and Draper. In *Ulysses and the Sirens* of 1891 (Plate 2–11), Waterhouse

designs the canvas using his trademark of an encircling group of dangerous women surrounding the hero's ship. Here the atavistic nature of the female is emphasized, as the Sirens have birdlike bodies and predatory claws. Waterhouse is particularly inventive in having some of the creatures hovering in the air, prepared to pounce on the unwary. Hobson details the means by which Waterhouse achieves his effects:

> In the final picture, the ring of Sirens echoes the arc of the sail as they bend their beautiful but terrible eyes upon the bound figure of Ulysses. The whole effect is menacing: the only vertical line is that of the mast, the only classical shape the circle of the predatory bird-woman. All the rest is disturbance; diagonals everywhere; and, in the startling realism of paint, the high cliffs, the hurrying sea and the final frightening touch of the Siren clawed on to the gunwale, transfixing the cowering oarsman with a baleful gaze. . . . Like Homer himself, the artist evokes a real world in which dire and sometimes supernatural events occur. (Hobson 1989, 49)

Additional details increase the threat posed by the women and the valour of male resistance: 'the menacing ring of Sirens facing him [Odysseus] and us'; 'the size and proximity of this creature [the Siren on the gunwale] compared directly with the oarsman'; 'the light ellipses of stern and sail match the threatening ring of bird-women' (Hobson 1980, 72). In early sketches for the canvas, Waterhouse showed the entire vessel; in the final canvas, the truncation at the right of the canvas incorporates the viewer's space into the menacing ellipse of women, while the elevated stern post is silhouetted against the cliffs in such a way as to mimic male and female genitalia.

In 1909 Herbert Draper exhibited his *Ulysses and the Sirens* (Plate 2–12), a construction reinforcing the male prerogatives and imprinting of Waterhouse's canvas but with a different strategy. Like Waterhouse, Draper truncates the vessel, but the view of Odysseus is now frontal rather than the rear view in Waterhouse. Odysseus strains forward to catch the song, unlike the more stoic posture of Waterhouse's treatment. Two of the Sirens are young females, the third a mermaid, suggesting female atavism and bestiality. These Sirens are particularly insidious because, although unwinged, they prowl the sea rather than remain on an island. The oar piercing the oarlock of the gunwale imitates sexual penetration and the objective of the Sirens. Tied to the mast, Odysseus symbolically protects his phallic/erectile power from the depredations of the women. Some nineteenth-century mythographers believed that the Sirens destroyed men to avenge the abandonment of Ariadne by Theseus. The icon in Waterhouse and Draper thus amalgamates female sensuality with vindictiveness. The faces of the mariners are clearly visible, as they are not in the Waterhouse. While the one in the foreground stares resolutely at the Sirens, his counterpart opposite recognizes his chief straining at the song and wonders about his resistance, introducing an element of doubt about Odysseus's endurance.

During the century, Sirens were occasionally painted without explicit presentation of Odysseus, as with Waterhouse's *The Siren* of 1900, showing a young woman luring a drowning sailor to his death; or Henrietta Rae's *Sirens* of 1903, where a female artist daringly paints three nudes on a coastal shore. Dante Gabriel Rossetti finished a pen and ink *Boatmen and Siren c.* 1853, showing a man reaching for a female in a bark and restrained only by a companion from certain destruction. Frederic Leighton painted *The Fisherman and the Syren* in 1858, showing a fisherman, in a cruciform posture, being dragged into the sea by a mermaid. Hacker's *Sea-Maiden* of 1897, Draper's *Sea-Maiden* of 1894, and Waterhouse's *A Mermaid* of 1901, the last deposited as his Diploma Picture, reflect this interest in female atavistic behaviour. Burne-Jones painted not only the unfinished *The Sirens* of 1870 but also *The Depths of the Sea* of 1886, the latter showing a mermaid dragging a naked sailor into the depths, while Edward Matthew Hale in *Mermaid's Rock* of 1894 designed a ship imperilled by intimidating dangerous females. Mermaids, because of their phallic tails, were particularly conceived as threatening, as in the Siren-mermaid of Draper's canvas, implying that castrating women had appropriated phallic power. When Edward Armitage painted his *Siren* in 1888, he placed a nude female body in the foreground of the canvas, gazing from a promontory onto the comparatively small vessels below. These depictions of female marine predators all contribute to the formation of male heroism by warning men of the dangers of female sexuality, preparing them to be defensive.

Other components of the Odyssean narrative were less frequently depicted than either the Sirens or Circe. In 1885 Harrington Mann exhibited *Ulysses Unbinding the Sea Nymph's Veil* from *Odyssey* 5, showing the mariner naked on the shore of Scheria, the land of the Phaeacians, just prior to his discovery by Nausicaa, daughter of Alcinous, the King. The mariner's naked body valorizes his masculinity, and yet his destitute outcast status at this point in the narrative is again cautionary. The episode will continue to illustrate the hero's resourcefulness, but Homer recognizes the constantly tested, contingent nature of masculinity in such an episode. (Leighton in 1878 and Poynter in 1878 painted Nausicaa, without Odysseus being visible in the pictures.) John Linnell exhibited *The Return of Ulysses* in 1849, a canvas obviously inspired by Turner. Here the Phaeacians (*Odyssey* 13) deposit the sleeping Odysseus on the shore of Ithaca at dawn, unloading his gifts around him. Since the hero is asleep, the role of aggrandizing the heroism is left to the rising sun, itself representative of male solar power and promising the fulfilment of the mariner's heroism in the combat with the suitors and the reconquest of Ithaca.

Waterhouse completed a representation of *Penelope and the Suitors* in 1912, showing Penelope weaving as the suitors importune her. Penelope is the archetypal Angel in the House, constructed for the nineteenth century

as the model of the woman who waits, dependent on male rescue despite her resourceful strategem of the loom. For Ruskin and others she is the preferred domestic female, particularly because throughout the *Odyssey* she is contrasted with the vengeful Clytemnestra, who awaited her husband Agamemnon to destroy, not embrace, him. When the work was purchased for Aberdeen, the responsible committee stated its grounds for acquiring the work:

> It was never suggested that Mr Waterhouse had produced a mere reconstruction of an actual scene of Homeric times . . . a diagrammatic illustration suitable for a classical dictionary. . . . What Mr Waterhouse has done is to take a classic myth . . . he has infused into his presentation of it . . . that individual point of view which we look for in the work of a great artist. (Hobson 1989, 96)

The intention of interrogating masculinity in the canvas is superbly realized. Waterhouse shows several suitors leaning in through the windows of Penelope's house; one offers a bouquet, which bridges the male and the female spaces of the design. These men, crowned with vine leaves, languorous and self-indulgent, are contrasted with the mural beneath them, showing warriors in combat. Thus, the rejected image of the male interested only in sexuality is juxtaposed with the preferred all-male world of the regiment in aggressive warfare. By this construction, Waterhouse inscribes both the preferred and the repudiated masculine paradigms. The hero's end is depicted in William Blake Richmond's *The Death of Ulysses* of 1888 (Plate 2–13), showing the hero supine as the faithful Penelope takes his hand. The symbols of Odysseus's heroism and masculinity – helmet, breastplate and shield – rest beside him. Richmond's canvas, with its pietà connotations, summarizes the intricate construction of masculinity during the nineteenth century by the strategizing of the narrative of Odysseus, re-configuring the myth to conform to patriarchal ideas of female venality and male heroism. The Homeric text, made a part of Victorian culture by Arnold, Tennyson, and others, also provided a palimpsest for the formation of masculinity by classical-subject artists. In his resourcefulness, endurance, cleverness, intelligence, defiance, resistance and valour, Odysseus embodied for the era, especially in its reconstruction of the legend, the qualities of masculinity privileged by its male paradigmatic codes. (See Kestner, 'Before *Ulysses*', for reproductions of 31 of these canvases relating to Odysseus.)

The Odysseus legend undoubtedly was one of the most important examples of the classical hero used to model gender in Victorian England. The most powerful myth of heroism in the culture, however, was that of Perseus, the slayer of Medusa and the rescuer of Andromeda, a narrative of heroism, female venality, and rescue that was pervasive in the culture (Kestner 1987; Kestner 1989; Munich 1989). Drawing on Ovid's *Metamorphoses*, writers like Browning, Morris and Kingsley dealt with the myth of Perseus as hero and rescuer. Browning wrote *Pauline* during 1832–33 with an engraving of Caravaggio's *Andromeda* over his desk; in 1846 he

even became Perseus when he rescued Elizabeth Barrett. In *The Ring and the Book*, Browning transmuted this rescue in the story of Pompilia's rescue by Giuseppe Caponsacchi from the coils of the dragon Guido Franceschini. Morris developed the Perseus legend as *The Doom of King Acrisius* for *The Earthly Paradise* in 1868. As Munich notes, Kingsley's ambitious poem *Andromeda* 'praises Victorian domesticity, the Christian Socialist's adaptation of chivalric code' (55), using hexameters 'imitative of Homer's epic meter' (51–52). This text parallels Kingsley's celebration of the deeds of Theseus, Jason and Perseus in *The Heroes* in 1855. Gerard Manley Hopkins wrote his sonnet 'Andromeda' in 1879 as an allegory in which 'Perseus is Christ, Andromeda is the Church, and the Dragon is contemporary wickedness' (74). The myth of Perseus, Medusa and Andromeda, with the story of Perseus's mother Danaë, was presented with startling frequency on the walls of the Royal Academy, the New Gallery and the Grosvenor Gallery as the century progressed.

The Perseus myth is composed of two central actions, the slaying of the threatening Medusa and the rescue of the imperilled Andromeda. At the galleries, where males dominated selection committees and administration, painters and sculptors presented the public with an image of the imprisoned and then abandoned Danaë, the chained Andromeda, and the rescuer Perseus arriving to save her, carrying with him the head of the slain Medusa. Perseus is the paradigm of the masculine hero even as Danaë, Medusa and Andromeda reflect the ambiguity of the Victorian male's construction of woman, that she is debased in her sexuality, threatening in her secret power, and helpless in her innate weakness. The particular details of the Perseus myth rendered the legend especially cogent. Perseus's mother Danaë was imprisoned in a tower by her father for fear her offspring would supplant him. Zeus penetrated the tower and Danaë in the form of a shower of gold. In this construction, where semen becomes gold coin, the story of Danaë becomes the archetypal myth of prostitution. (The anonymous protagonist of *My Secret Life* believed that he was rescuing women from starvation by paying them for sex, semen and gold: semen as gold.) In the imprisoning of Danaë one sees a prototype of the incarceration of women by the Contagious Diseases Acts of 1864, 1866 and 1869. In the Danaë myth, female sexuality is constructed as dangerous and therefore it must be contained. (The fact that pregnancy was described as 'confinement' reflects this male anxiety, which Otto Rank later identified as the birth trauma.) The slaying of Medusa and the rescue of Andromeda, both manifestations of male heroism, reveal attitudes towards female sexuality. By her fearful power of petrifying the viewer into stone, Medusa embodies male apprehension of castration (as seen in her beheading) as well as fear that the female might appropriate the penis and its erectile, stiffening power. Freud posited that the severed head of Medusa symbolized the female genitalia, particularly the vagina dentata. In the legend, Perseus must avoid her gaze, although he can petrify enemies by the

Medusa head. As Goux states, furthermore, the slaying of Medusa demonstrates 'the initiatory function of symbolic matricide (taking on the mythic aspect of monstricide) which . . . constitutes the principal bloody trial at the heart of the itinerary towards nuptiality' for the male subject. 'The murder of the female monster provides access to non-incestuous marriage' (63). In the legend of Perseus is the mythic rite of passage of the male to mature masculinity through marriage.

The hair of snakes that characterizes Medusa indicates this dual anxiety of appropriating the penis and castrating the male, with the multi-phallic serpents endowing the woman with male powers. (Medusa's hair is one component of the preoccupation with woman's hair in Victorian culture, analysed by Gitter.) Medusa and Andromeda represent the two polarities of female sexual dichotomizing by patriarchy: the *femme fatale* endowed with male-destroying power and the enchained helpless female awaiting rescue. Andromeda, as well, reveals the imperialist basis for interest in the legend. She is 'a captive of racist and colonial fantasies, she is an Ethiopian or Arabian princess'; 'Kingsley thought of Andromeda as a racial allegory, setting the dark "Aethiop" race against the light, and a gender allegory, setting a woman against a man . . . an allegory about the enlightenment of an inferior race [by which he] assimilates the racial story into the gender story' (Munich 12, 63–64). In addition, the idea that Andromeda is a prize for the hero's exploits confirms the commodification of women as items of exchange among men, especially as a reward for phallic heroism. The imperialist, racist, colonialist, and gendered significances of the Perseus legend made it the most powerful classical myth to strategize masculinity in Victorian culture.

It is of particular interest that the legend attracted artists from the beginning of Victoria's reign through to the early Edwardian period. During the 1830s, William Etty painted several representations of the legend. In the *Andromeda*, completed in the 1830s, Etty shows a bust half-portrait of Andromeda, with chains beneath her large breasts. As Munich affirms, this canvas 'represents the lost breast in conjunction with the feelings of revenge at its loss. The chains wound around the breasts and the woman's travail figure that revenge' (47). In the 1840 *Andromeda – Perseus Going to Her Rescue*, Etty depicts in the foreground an Andromeda shackled to the rock, caught in the coils of the dragon as Perseus hastens to her rescue. Etty in this canvas emphasizes the woman's helplessness as much as the male's rescue. In the *Perseus and Andromeda* (post 1840), Andromeda is shown again in the foreground as Perseus displays the Medusa head to the dragon, which is about to petrify and turn to stone. Etty includes a group of naked women in the distance, presumably future prey for the dragon if it had not been destroyed. Etty poses Andromeda against a red robe not only to emphasize the sanguinary nature of her plight but also the idea, as Munich notes, that the rescue entails 'the loss of female virginity' (92) when the hero weds Andromeda. Various other

canvases depicting Andromeda were exhibited by William Edward Frost in 1846 and 1850 and by Richard Jeffray in 1846.

The Perseus legend, inherently of considerable interest because of its gender-modelling qualities, gained additional force during the nineteenth century in Britain because some of the greatest artists of the period depicted incidents from the narrative, often more than once. These included two future presidents of the Royal Academy, Frederic Leighton and Edward Poynter, as well as a complete cycle of canvases by Edward Burne-Jones. Poynter was deeply engaged with the two depictions he made of the legend. In 1869 he completed a nude Andromeda, which he exhibited in 1870. Here the woman is shackled, captive, awaiting the rescuer; the female body displayed before the male gaze is the object of both desire and power: to possess it is to become empowered through conquering. Andromeda appears as the prize exemplifying the commodification of women. Poynter's nude is shown full front, with a swirling blue drapery behind her. Having agreed to undertake the decorative murals for the Earl of Wharncliffe's billiard room at Wortley Hall, in August 1871 Poynter traveled to Wortley to meet his patrons and discuss subjects for the proposed four murals. The subject chosen for the first mural was Perseus rescuing Andromeda from the dragon/monster. In designing the canvas, Poynter was particularly concerned with the representation of the female nude; he wrote to Lord Wharncliffe on 18 December 1871:

> One point I would like to make sure of before going further – that is, whether you think you will find any objection to the naked figure of Andromeda now you [know?] the size it will be. I myself not only think there is nothing objectionable, but much prefer not covering any of it with drapery, as the composition would lose greatly by this figure being cut in two – but it has occurred to me that when you saw how large a space this figure covers and how conspicuous it is, you might think I had made too much of it. Certainly I have every intention of getting the picture done for the Academy. Though there is not much done on this canvas the studies are well advanced, & I have got just the action I want for the figure of Perseus. (*Wharncliffe Muniments*, Sheffield)

Perseus and Andromeda (Plate 2–14) was exhibited in 1872. The nude Andromeda, hands bound behind her as in the 1869 canvas, stands forth; to the left is a pharos behind which dawn is breaking. To the right are the grim monster and the armoured and armed Perseus, thrusting a falchion down the creature's throat. To the rescuer's left, the town and citizens are seen awaiting the outcome.

In contrast to the 1869 single-figure Andromeda, the rescue itself is depicted in the larger, mural-sized composition. Poynter strategizes the scale of a mural to aggrandize the male heroic rescue. The subject of rescue was singularly appropriate, for 'the billiard room, the game itself redolent of sexual symbolism, became the male preserve, asserting its masculinity. . . . The billiard room . . . represents sexual separation through domestic aesthetics' (MacKenzie in Mangan, 180–181). The rescue ideology of the legend constructs masculinity in this masculine space. The fact that the

Medusa head appears nowhere in the canvas removes the femme fatale element and increases the heroism of the male, who does not, as in Etty, use the head to conquer the beast. Poynter's erasure of the Medusa head may be prompted, as well, by the Greek meaning of her name, 'ruler'. Here only Perseus may rule and have the empowering gaze. Poynter showed continued concern for the nude Andromeda after the exhibition. On 18 May 1872 he wrote to Lord Wharncliffe:

> I am so far satisfied as I suppose an artist can be with his own work, except on one point which was never right from the beginning, I mean the face of Andromeda; & I intend to set it right before I send it home to you. I think the head is a little too small which has the effect of making her rather too tall, but in any case that is a fault on the right side.

On 6 September 1872, he noted: 'I have only just been successful in getting Andromeda's face into shape, & I am touching up the Beast a little. . . . I have had a good deal of trouble with Andromeda' (*Wharncliffe Muniments*). Surviving studies, one in charcoal, the other in oil, show the dynamism of the canvas. Andromeda's drapery is now vermilion rather than blue as in the 1869 canvas; Perseus's cloak is red, and the contrast of flesh tones – white for the woman, dark for the male – is employed as it had been in Leighton's *Orpheus and Eurydice* or Poynter's own canvas on the same theme. Munich notes that the placement of Andromeda indicates she 'is identified with what is outside culture, a wild, uncontrollable, natural beauty' (28), thus making the male representative of culture as the woman is of nature, according to nineteenth-century patriarchal configuration.

Frederic Leighton himself completed two canvases on the Perseus theme, the 1891 *Perseus and Andromeda* and the 1896 *Perseus on Pegasus Hastening to the Rescue of Andromeda*, the latter in tondo format. In the first canvas (Plate 2–15), the hero, mounted on Pegasus, is shooting an arrow at the dragon, who covers the chained Andromeda with one of its wings. Leighton's conception is unusual in that Perseus is not traditionally associated with Pegasus. Instead, Pegasus was tamed by Bellerophon, who rode him to slay the Chimaera, a female monster. According to legend, the bow and arrow in the painting also properly belong to Bellerophon. Leighton thus telescopes two rescues (Perseus, Bellerophon) to reinforce the male heroic rescue. Perseus in this canvas, by being placed in a sunburst, becomes a solar hero. The idea of the solar hero, derived from Max Müller's idea that all myth was a disease of language and that the primary subject of myth was the conquest of night by day, was instrumental in associating males with the sun, women with darkness. This in turn became consolidated with ideas about Aryans because it was believed that the Aryans had migrated from the East to the West by following the sun. In Leighton's canvas, the hero is an Aryan, Apollonian, rationalist warrior above the irrational sexuality depicted below. Newall notes of this first treatment of the theme by Leighton: 'The symbolism is expressed in the rich and contrasting colours of the protagonists: the gold and white of the

heroic Perseus; and the green and black of the evil monster' (122). As Munich comments, 'the phallic-shaped promontory on which Andromeda and the monster stand projects into a canal-shaped inlet. . . . The promontory pushing into the inlet . . . signifies the forced encounter of woman and beast. . . . The elements in Leighton's picture convey bestial sexuality' (175). In this construction, Perseus maps male gender identity as rational, superior, Aryan, Apollonian, and dauntless. Leighton's 1896 canvas (Plate 2–16) heightens the heroism by omitting Andromeda and the creature altogether, showing only the hero silhouetted against the sky; again Leighton consolidates the Perseus and Bellerophon legends. Although the bloody Medusa head is held by his left hand, he reaches for an arrow with which to slay the creature; the emphasis here is as much on the conquest of sexual fears via the slaying of Medusa as it is on the rescue of Andromeda. As discussed in the catalogue *Victorian High Renaissance*, 'the rearing white horse, perhaps inspired by the Parthenon frieze, a cast of which decorated Leighton's studio, was a favorite romantic motif, appearing in such works as David's portrait of Napoleon on the St. Bernard Pass' (127). In addition, such associations link Perseus's ancient heroism with more contemporary historical embodiments of such ideologies. John Christian writes in *Victorian Dreamers* that the design adds to the ideological thrust of the canvas with the tension of its composition: 'The arched back and fluttering drapery of Perseus echo the shape of the frame, while balancing the movement of the figure and horse against the strong horizontals of the sky and landscape and the verticals of the foreground rocks' (116). The tondo form replicates the eye of the male gaze, catalysing the masculine agenda.

The greatest exploration of the Perseus legend was in the cycle by Edward Burne-Jones. Commissioned in 1875 by Arthur Balfour, at the artist's death only four of the eight selected episodes were completed: *The Baleful Head* (1887), *The Rock of Doom* and *The Doom Fulfilled* (1888), and *Perseus and the Graiae* (1892). *The Calling of Perseus, Perseus and the Sea Nymphs, The Finding of Medusa* and *The Death of Medusa* remained unfinished. Of the two central aspects of the legend, the slaying of Medusa and the rescue of Andromeda, only the Andromeda story was complete. The legend was an obsession with Burne-Jones. As early as 1865, he had drawn up a list of 28 episodes for possible wood engravings. Burne-Jones's failure to complete the Medusa canvases would be less striking were it not that Georgiana Burne-Jones specifies that 'the Medusa part of the legend, which attracted him most, he studied deeply: the Andromeda scenes, though they came later in the story, were finished first' (2.60). Ten gouache studies of episodes from the legend, some never begun in oils, survive, as well as the four completed oils and the four unfinished canvases. The biographical/attitudinal reasons for this situation are fully explored by Kestner (1984, 1989) but bear reinvestigation for the manner in which they illuminate Victorian culture and its concern for masculinity.

The fear of sexuality explains an element discussed by Kurt Löcher throughout the series, the fact that Perseus constantly either shades his eyes or only glances at other characters. It seems clear from this detail, and also from nude studies of Perseus and Chrysaor where the genitals are either eliminated or obscured, that castration anxiety was of enormous significance to Burne-Jones and his culture. It was particularly relevant to Burne-Jones, as he noted in one of his conversations:

> I was stabbed at school . . . the boy who did it was simply furious with me. It may have been my fault for anything I can remember – we hated each other I know. . . . It was in the groin, which was in a dangerous place. It didn't hurt much, but I felt something warm from my leg and putting my hand there, I found it was blood. (Lago 160)

The shading of the eyes in the *Perseus* may be taken as a protection of the testicles. Several nude studies of *The Doom Fulfilled* show the monster cutting through the groin of Perseus to rise like a phallus. Although the sea-monster in Burne-Jones's canvas is of indeterminate sex, the legend specified it was female (Robert Graves 1.240). The slaying of the monster is the killing of the threatening female, who would otherwise castrate the hero. Burne-Jones's delay in finishing *The Death of Medusa* is further associated with sexual circumstances. Although *The Death of Medusa* shows Perseus putting her head in his wallet, Burne-Jones did not depict the birth of Chrysaor and Pegasus from her corpse. Burne-Jones did not so much avoid *The Death of Medusa* as its consequence, *The Birth of Chrysaor*. The reason can only be that it was a double record of his origin, for his mother died six days after his birth. Burne-Jones avoided the death of Medusa because it represented his killing of his mother, but it also signifies her rejection of him, symbolically represented in the castrated Chrysaor. Löcher's point that the *Perseus* constitutes the artist's 'psychological reaction' (12) to the narrative is valid. As Zeitlin observes, the castration component 'can be deduced from the parallel between the mytho of Medusa and that of Uranos. Aphrodite is born from Uranos's severed phallos and Pegasus (and Chrysaor) from Medusa's severed head' ('Cultic Models' 154). The central point about these responses by Burne-Jones is that they reflect the reason that the culture at large was attracted to the Perseus legend: its modelling of heroism demonstrated the male overcoming the birth trauma and castration anxiety while obtaining a woman (who was Other by virtue of being culturally different) and making a commodity of her, verifying one's sexual and national superiority over the colonized and justifying an imperialist project.

In 1888 Burne-Jones completed a canvas, *Danaë and the Brazen Tower* which, while not part of the Perseus series, is the account of the hero's origin. In the image of a woman being incarcerated, however, Burne-Jones was expressing another element of his beliefs about women, for in 1897 he remarked: 'Women ought to be locked up. In some place where we could have access to them but that they couldn't get out from' (Lago 136). This

fear of being dominated by a female, widespread in Victorian culture, was expressed by Burne-Jones in other comments. In 1884, before painting *Danaë*, the artist said: 'Once [a woman] gets the upper hand and flaunts, she's the devil – there's no other word for it, she's the devil . . . as soon as you've taken pity on her she's no longer to be pitied. You're the one to be pitied then' (Lago 11). He felt artists should never marry:

> A painter ought not to be married; children and pictures are each too important to be both produced by one man. . . . No, the great painters were not married – Michael Angelo not married, Raphael not married . . . Del Sarto married! but we know what happened to *him*. (Lago 11)

Burne-Jones depicted Danaë contemplating the building of the tower in which she would be imprisoned. Zeus impregnated her in a shower of gold, already marking her status as a debased woman. The *Perseus* series enacts male rage at the female, incidents of which were numerous during the era. In addition, Burne-Jones's remark about Andrea del Sarto demonstrates that the threat of the woman had an aesthetic component, for the female might deflect or even destroy the male artist's talent and concentration. The Perseus depicted by Burne-Jones represents not only males in general; he is also the symbolic representative of the artist conquering the Other to pursue and maintain art. While *Danaë and the Brazen Tower* would appear to sympathize with the woman, in fact the artist identifies with the motives of King Acrisius in 'locking up' the woman. Heroism in Burne-Jones's construction of the legend consists of overcoming gynephobia and asserting male dominance.

The first episode of the series, *The Calling of Perseus*, depicts Athene summoning Perseus to his mission, giving him a sword and a mirror, by which to slay Medusa without having to see her. Burne-Jones's alterations from conception to execution of this episode are revealing. In a sketchbook in the Fitzwilliam Museum, Athene gives him a mirror, but the sword, extremely large, he already holds. In the gouache and in the oil, she endows him with phallicism in the shape of the sword and she looms much larger, whereas in the sketchbook he is nearly her height even though he is seated. In the unfinished oil, Perseus shades his eye, even though there is no reason to do so. In the second canvas, *Perseus and the Graiae*, Perseus finds the Gorgons' sisters and steals their one eye from them, illustrating male desire to deprive women of power. Now in armour, Perseus can begin his conquest of the feminine by stealing and appropriating female vision. The third canvas, *The Nymphs Arming Perseus*, depicts Perseus receiving the helmet of invisibility, the winged sandals, and the sack for Medusa's head from the nymphs.

The next two oils and the next three gouaches deal with the Medusa aspect of the legend. The two oils, *The Finding of Medusa* and *The Death of Medusa*, are unfinished; the three gouaches are *The Finding of Medusa*, *The Birth of Chrysaor* and *The Death of Medusa*. For *The Finding of Medusa*, several sketches of her head depict her as much more fierce than

in the oil or gouache, where she is beautiful and vulnerable. In the oil there are no snakes in her hair; Burne-Jones attempts to remove the terror of her phallicism. The gouache *The Birth of Chrysaor* shows Chrysaor with barely discernible genitals and the winged horse Pegasus rising out of the slain body of Medusa, as Perseus stands holding her head at his side. The decapitation of the head, coupled with the man born without genitals, suggests castration anxiety even as the death of Medusa paralleled the situation of his birth. In *The Death of Medusa* Perseus is depicted putting Medusa's head in the wallet. In the gouache she has snake hair; in the unfinished oil, no snakes appear. A gouache, *Atlas Turned to Stone*, not executed in oil, shows the paralysed Atlas holding up the world as Perseus flies past him. This is the first moment to suggest the undying power of the slain Medusa: she has the male power to harden, but in this episode it is directed against men. Her appropriation of this erectile power increases male gynephobia and misogyny, both of which galvanize the responses of the hero.

The final three canvases of the series, *The Rock of Doom*, *The Doom Fulfilled*, and *The Baleful Head*, were executed both as gouaches and as completed oils. In *The Rock of Doom*, Perseus removes his cap of Hades to reveal his face to Andromeda. In both the gouache and the oil, he glances hesitantly towards her. By its positioning, the hero's sword is a large phallus, but the hero appears anxious confronted with the naked female body. In sketchbook drawings, Andromeda is shown reaching her arms to her rescuer, but in the final depictions she is represented bound, revealing the artist's fear of having the woman show any assertive action. In *The Doom Fulfilled*, Perseus slays the monster as Andromeda observes. In the gouache, he has the sack with Medusa's head, showing the hair but no snakes, hanging by his side; in the oil, any reference to Medusa (as in Poynter's *Perseus and Andromeda*) has been eliminated. As with the previous panel, in the sketches Andromeda is much more active, yearning, and involved than in the final still attitude. The terror of castration is revealed by the action of the monster cutting through Perseus's groin. The 'rescue' accomplished, Perseus returns to claim Andromeda's hand from her father King Cepheus.

In *The Baleful Head*, the final canvas in the series, Perseus is showing Andromeda the head of Medusa reflected in a fountain pool. In drawings Perseus and Andromeda are standing side by side, with Andromeda grasping his waist or putting her arm around his neck. In the gouache and in the oil, however, the two stand clasping hands on opposite sides of the fountain. Andromeda gazes into the reflection as Perseus gazes at her. His pose indicates he wishes to have her glance at the reflection; her gaze, however, is intent. Looking into the well, Andromeda sees herself as Medusa. Perseus can now look directly at Andromeda's face since the 'rescue' is in fact the slaying of Andromeda's separate identity to accord with the narcissist's refusal to recognize the Other. Andromeda has been

commodified by her marriage. The sexual anxiety in the Medusa legend is the immediate cause of the sexual domination in the Andromeda section of the tale, which most critics agree was an accretion to the original story of Medusa. Both parts of the narrative have the same drive, however: the valorizing of the hero is the domination of the woman and her sexuality. It is in the *Perseus* cycle of Burne-Jones that the legend in the nineteenth century reflects most clearly its function of gender modelling in culture.

The fact that such conspicuous artists as Poynter, Burne-Jones and Leighton depicted the Perseus legend did not prevent its being attempted by many other painters and sculptors during the century. Images of the enchained Andromeda were completed by Arthur Hill (1875) and Frank Dicksee (1890). The slaying of Medusa before the enchained Andromeda remained the most prevalent episode in artistic representations as it most exemplified the hero in action. In the 1880s, Richmond finished a canvas of *Perseus and Andromeda* showing the hero sweeping down to slay the dragon. Henry Scott Tuke and Charles Kennedy both completed images of the slaying in 1890. In Tuke's *Perseus and Andromeda*, the naked hero attacks the creature with both sword and Medusa head; Andromeda glances over her shoulder from her enchained position. In Kennedy's *Perseus*, however, the hero in armour is in fact receiving a kiss from a reclining Andromeda, whose arms are free to embrace him although her ankles are shackled. He appears to conquer the beast by exposing the Medusa head in his right hand. In 1899 Arthur Nowell finished his *Perseus and Andromeda*, where Andromeda is surrounded by the coils of the dragon. As with Poynter, no suggestion of the Medusa head appears so that the heroic rescue may be emphasized.

Sculptors as well as painters were attracted to the theme of Perseus, following the example of the famous *Perseus* by Cellini of 1545–54. Figures of Andromeda alone were completed by Lawrence Macdonald (1842), John Bell (*c.* 1851), John Forsyth (1866), Edgar Papworth (1866) and Henry Leifchild (1869). Watts completed a marble head of Medusa in 1873. Sculptures of Perseus alone were also exhibited, one by George Simonds in 1878 entitled *Perseus the Liberator*, followed by a *Perseus* in 1883, showing the hero with the head of Medusa. Alfred Gilbert's 1882 *Perseus Arming* shows Perseus preparing for his heroic mission. Henry Fehr completed the plaster model *The Rescue of Andromeda* in 1893, depicting Andromeda prostrate beneath the monster as Perseus alights on its back. As in Cellini, Perseus holds the Medusa head extended before him; Fehr completed a bronze of the subject in 1894. Frederick Pomeroy's *Perseus* of 1898 shows the hero turning his face from the head extended before him. The mammoth sword reinforces his phallic supremacy. Charles John Allen's *Perseus Returning Victorious to the Gods* of 1894 shows the hero standing nude and undraped holding the Medusa head on a charger. The title indicates that the hero merits deification. In the sculptures by Allen, Simonds, Gilbert, Fehr and Pomeroy, the nude male body itself

becomes the phallus, the somatic signifier of the masculine. In all these pictorial and sculptural representations, the Perseus legend advances sexist, imperialist, masculinist, Aryan and solarist conceptions to construct the ideology of masculinity during the century. (See Kestner, 1987, for reproductions of these canvases concerning the Perseus legend.)

When represented in art, several of the deities in the Olympian pantheon modelled masculinity during the nineteenth century, including Apollo and Hermes. Artists such as Richmond (1886) and Tuke (1900) depicted Hermes nude, the latter with his phallic caduceus (both discussed in Chapter Six). The canvas depicting him in one of his classical functions is Leighton's *The Return of Persephone* of 1891 (Plate 2–17). In this composition, Hermes is shown in his role as Hermes Psychopompos or 'conductor of souls' bringing up Persephone from Hades to her mother Demeter, who awaits her with outstretched arms. Both mother and daughter have one hand in darkness, one in light; Persephone's robe indicates the yellow of young spring corn, the amber of Demeter's dress the fruition of autumn. The storm cloud behind Demeter suggests that her daughter can remain with her only temporarily. Jean-Joseph Goux discusses the meaning of Hermes and his association with the phallus in ancient philosophy, signalling its powerful modelling of the masculine through myth:

> The phallus is a masculine principle of generation, of production. . . . Plotinus hermeneutizes and deciphers a hidden wisdom in the figuration of Hermes. Through it we arrive at the very highest interpretation of the phallus. . . . This mention of Hermes's phallus stands out in Plotinus's discourse [imaging] The One [as] the generating principle. . . . The secret phallus of philosophy, the one that transpired in Plotinus's discourse as a metaphor of the One, the one that *logos* expresses, belongs . . . to Hermes . . . [a] god, of perfect ithyphallism, who will serve as metaphor of the *logos*. With Hermes . . . it is a positive phallus, . . . that phallus which joins the divine *logos*. . . . As the male organ of generation, the phallus is therefore essentially *logos* or source of the *logos*: rational power, or intelligible reason . . . the integration of rational power and the phallus. . . . It is by no means physical vigor but rather rational power (*logon energon*) that Hermes's erect phallus signifies. It is the emblem of guiding intelligence. . . . Hermes's phallus is not a simple penis but a spiritual power. . . . The masculine organ is spiritualized, idealized, to the point of becoming a sign of intelligence. (46–50)

Goux establishes that 'the virile organ is evoked' in Hermes's role 'as conductor of souls' (50). In addition, Hermes in Leighton's canvas fulfils the function of rescuer distinguished as male during the nineteenth century. Leighton's *The Return of Persephone* inscribes for its era rationality, rescue and guidance as gendered male, following the classical arguments of Plotinus and Plutarch.

A myth confirming the masculinity advanced in the Perseus legend is that of Apollo, whose alignment with solarism is crucial to the ideology of masculinity. Solarism intends a relational connection with the sun and its connotations, including illumination, rationalism, and vital cause.

Leighton's depiction of Perseus in a sunburst or Draper's enveloping of Jason with the golden fleece are inscriptions of solarism in the construction of masculinity. Several artists represented Apollo to serve this ideology of solarism. In 1874 Briton Riviere exhibited *Apollo with the Herds of Admetus*, accompanying the canvas with a quotation from Euripides's *Alcestis* noting that Apollo's becoming a shepherd was a punishment for slaying the Cyclops. Riviere depicts Apollo seated beneath a tree playing his lyre while tending the herds, composed of many species which would be warring with each other were it not for their taming by Apollo's music. Riviere deals with the god in a terrestrial context, thereby domesticating his heroism and demonstrating its application to mortals. Apollo appears in this canvas as both the inspirer of art and the rationalist who resolves factionalism by his functional enlightenment. The *Art Journal*, however, did not care for this construction of Apollo, preferring a representation more heroic:

> It is impossible to accept the figure here introduced as in any sense worthy to represent the beauty of the sun-god. . . . The suggestion of an antique theme awakens the recollection of a kind of beauty which is clearly beyond the reach of the artist. . . . [In *Apollo*] the god is ungodlike and lacks beauty. . . . (cited in Kestner, *Mythology* 165)

Riviere, a close friend of Leighton, remembered that he had praised the 'quality of [his] light' (Barrington 217) more than any other trait of his canvases, indicating Leighton's own predisposition to sun worship.

This emphasis on solarism becomes the basis of Riviere's 1895 *Phoebus Apollo* (Plate 2–18), in which Riviere sought to present Apollo in his Olympian, heroic persona, certainly a response to the criticism of the 1874 *Apollo*. In the 1895 canvas, Apollo is shown leading out his chariot, drawn by lions, at the break of day. His heroism is demonstrated by strong contrasts with the 1874 conception: in the 1895 he is not with placid beasts but with wild and active ones; he is standing in the chariot, not sitting on the earth; his body, golden-hued, is covered only by a flowing drapery; and his hands are not playing a lyre but actively exhorting his team. Most significantly, his golden hair flows behind him, signifying his Aryan status. This image of Apollo constructs him as the male hero. The strongly misogynist attitudes expressed by Apollo in Aeschylus's *Oresteia* lurk behind such a presentation, which shows the god above all sensual concerns. Richmond painted a series on the myth of Phaeton. In the canvas *The Rise of Phaeton* (Plate 2–19), for example, the male has seized the chariot of the sun and is hurtling through the cosmos. Despite the fact that the legend ends disastrously, Richmond's embodiment of the heroism, conveyed by the steep incline of the chariot as it scales the heavens, links the Apollonian idea with concepts of adventure and daring.

In 1876 Leighton exhibited *The Daphnephoria* (Plate 2–20), representing the procession held every nine years in May at Thebes to honour Apollo. A similar event was held in Tempe to commemorate Apollo's

slaying of the Python. The canvas contains eight groups in its processional frieze: a youth carrying a standard, the *kopo*, with representations of the sun, moon, and stars; the *daphnephoros* or laurel bearer, wearing an image of the sun around his head; boys carrying trophies; the *choragos* or chorus leader, holding a seven-stringed lyre and with hand raised to lead his singers; three groups of women singers; and finally a group of youths bearing vessels for the service, tripods sacred to Apollo. The sculptural sources range from the *Hermes* of Praxiteles for the boys at the rear to the *Doryphoros* and *Diadumenos* of Polykleitos for the *choragos*. The canvas is the quintessential celebration of sun worship and male supremacy, as the laurel bearer and chorus leader govern the procession. The procession in honour of Apollo celebrates the religion of art, praising the god of poetry and the cultivator of the Muses. This religion is unquestionably male. The *choragos*, who wears thin kid shoes associated with racing, holds the centre of the canvas by his physical splendour and artistic genius. Himself deeply engrossed in solarism, Richmond commented that *The Daphnephoria* 'could only have been painted in this century, the classic feeling it demonstrates is of to-day, when the severer forms of classic art appeal to the cultivated with more force than formerly' (Newall 89). The *daphnephoros* was male according to ancient ritual: women are excluded from the practice of art, although they may worship it. The idea that art is male – and heroic – is constructed by the solar context of *The Daphnephoria*.

The violence that could be associated with the constructions of Apollonian heroism, with its strong emphasis on the Otherness of women, is revealed in the canvases involving the legend of Apollo and Daphne, which depict the sexual aggressiveness of the god whose rape of Daphne was foiled when she was transformed into a laurel tree, which then became the symbol of male artistic triumph. In Waterhouse's *Apollo and Daphne* from 1908 (Plate 2–21), Daphne is being transformed into a laurel at the very moment Apollo, lyre in left hand, touches her. Harold Speed in 1910 showed the same moment in his *Apollo and Daphne*, but he divides the canvas by contrasting lights – Daphne thrown into shadow as she is transformed, a naked Apollo racing towards her illuminated from behind. The only canvas by a woman artist of this subject, Henrietta Rae's *Apollo and Daphne* of 1895, is also the only one to indicate the distress and defiance of Daphne. In Rae's painting, not only is Daphne turning in disgust from the god, Apollo himself is on one bended knee pleading with her as he stretches forth his arms. The canvases of the subject by male artists do not betray whether they recognize the violence of the scene or only its male-empowering agendas, but Rae's canvas does signal such a recognition. It is possible that the canvases by males are critiques of Apollonian sun worship in the canvases by Riviere or Leighton or Richmond. The fiercest construction of the violence of Apollo appears in Solomon J. Solomon's *Ajax and Cassandra* of 1886 (Plate 2–22), the most

famous rape/abduction canvas in Victorian painting. Throwing her hands to the sky, her breasts exposed in uplifted silhouette, Cassandra is carried down the steps of the temple of Athene by a brutal Ajax, who clenches his fist in sheer male defiance of the sanctuary and of the woman's wretchedness. (Athene, being born from Zeus's head, is male-identified, as she reveals at the conclusion of the *Oresteia*, so she would not offer asylum to Cassandra.) The brutality exemplified by Ajax, however, was begun by Apollo, who denied Cassandra the credibility of her prophecies when she refused his sexual advances. Ajax perpetuated the brutality; Agamemnon took her as his concubine to Mycenae; Clytemnestra slew her. The canvas exposes the misogynistic drive of the solar, Apollonian legend, which is perhaps the reason that it is the only canvas of this episode in British nineteenth-century art. Other constructors of masculinity suppressed this brutal link with Apollo to configure a masculinity supposedly devoid of such inclinations.

The classical heroes provided nineteenth-century British culture with prototypes and paradigms of masculinity via the mythological narratives of Greece and Rome. These in turn became the basis for the construction of masculinity, with empowering racist, Aryanist, solarist, imperialist and gendered agendas. In *The Politics*, Aristotle had declared: 'The male is by nature superior, and the female inferior; and the one rules, and the other is ruled; this principle, of necessity, extends to all mankind' (8). Briton Riviere's *An Old-World Wanderer* of 1887 (Plate 2–23) encapsulates all of these agendas: a resplendent male nude, dressed in a red tunic, has swum ashore to the coast of an undiscovered land from his galley, seen in the distance. The man, modelled after the *Doryphoros* by Polykleitos, like him carries a spear. The rising sun behind him illuminates his golden hair and irradiates his marmoreal body. Riviere's canvas constructs the racist component of male Caucasian exploratory and imperialist agendas not only of the ancient period but also of the nineteenth century. The solitary mariner, whose daring echoes that of Odysseus, is paradigmatic of the male self-sufficiency advocated in the classicizing canvases of the era. In such a canvas, the dominant ideology of heroic masculinity becomes reified. Riviere links the mariner with Apollo by his appearance on the coast at dawn or sunrise, anticipating the *Phoebus Apollo* he will paint eight years later. Simultaneously, the mariner echoes the explorations of Jason and the intrepid daring of Perseus in obtaining his kingdom. Painted during the post-1870 stage of British expansionism known as the New Imperialism, *An Old-World Wanderer* strategizes its classical model to promulgate an imperializing ideology. This nexus of significations demonstrates Hatt's claim that 'as the century progresses, the body becomes a central concern. Not only does masculinity come to be understood as coterminous with the physical, . . . but this physical prowess becomes conflated with the mental and the moral worth of a man. . . . Morality and masculinity become synonymous' (59).

In his essay 'Representative Men' from 1850, James Anthony Froude had expressed a desire for a 'modern ideal which shall be to him what the heroes were to the young Greek or Roman, or the martyrs to the Middle-Age Christian'. Froude continued that the age needed a new pantheon of great men in the form of biographies, such that a boy could be advised:

> Read that; there is a man – such a man as you ought to be; read it, meditate on it; see what he was, and how he made himself what he was, and try and be yourself like him. (Houghton 317–18)

During the nineteenth century, the construction of masculinity through pictorial representations of ideal models of maleness was to serve this function of imprinting heroic behaviours for young men. From the classical pantheon, depictions of Hercules, Jason, Apollo, Odysseus and Perseus configured masculinity in images widely circulated and discussed in the culture. Such was the function of the classical hero for the construction of masculinity by nineteenth-century British artists.

2–1. Herbert James Draper: *The Golden Fleece*, 1904; 61 × 106½; Bradford
Art Galleries and Museums.

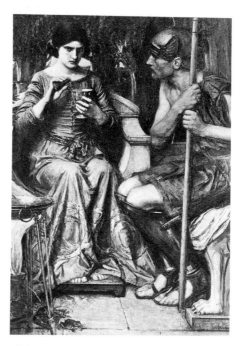

2–2. John William Waterhouse: *Jason and Medea*, 1907; photo: *Art Journal*
1909.

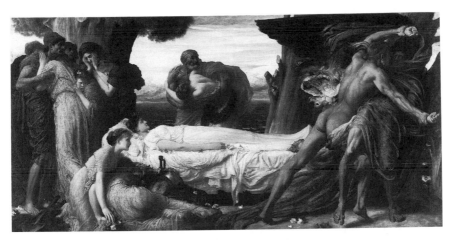

2–3. Frederic Leighton: *Hercules Wrestling with Death for the Body of Alcestis*, 1871; 51½ × 104½; Wadsworth Atheneum, Hartford. The Ella Gallup Sumner and Mary Catlin Sumner Collection Fund.

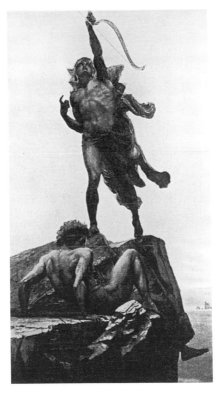

2–4. William Blake Richmond: *The Release of Prometheus by Hercules*, 1882; 141 × 72; photo: Stirling, *Richmond Papers* 1926.

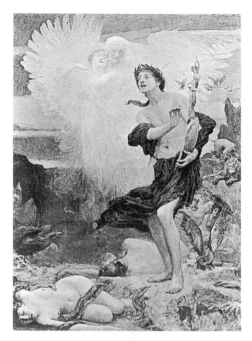

2–5. Solomon J. Solomon: *Orpheus*, 1892; 84 × 60; photo: *RAP* 1892.

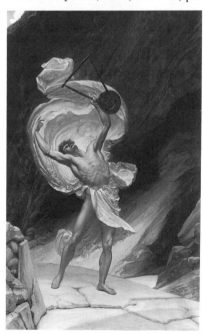

2–6. William Blake Richmond: *Orpheus Returning from the Shades*, 1900; 73 × 45½; Royal Academy of Arts, London.

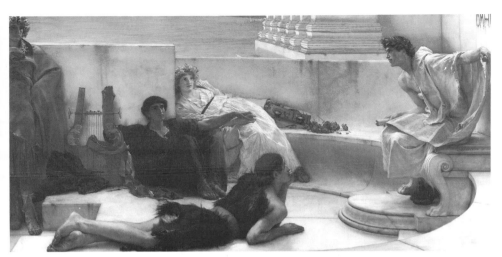

2–7. Lawrence Alma-Tadema: *A Reading from Homer*, 1885; 36 × 72⅜; Philadelphia Museum of Art: George W. Elkins Collections.

2–8. Herbert James Draper: *The Youth of Ulysses*, 1895; 78 × 34; photo: *RAP* 1895.

2–9. Thomas Spence: *The Temptation of Odysseus by Circe*, 1897; 76 × 44; photo: *RAP* 1897.

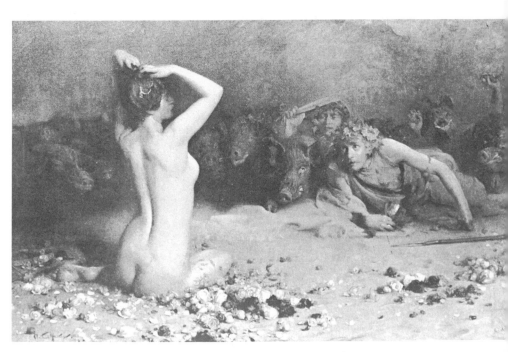

2–10. Arthur Hacker: *Circe*, 1893; 46 × 71; photo: *RAP* 1893.

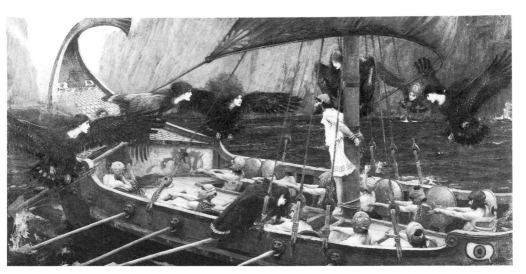

2–11. John William Waterhouse: *Ulysses and the Sirens*, 1891; 79 × 39;
National Gallery of Victoria, Melbourne, purchased 1891.

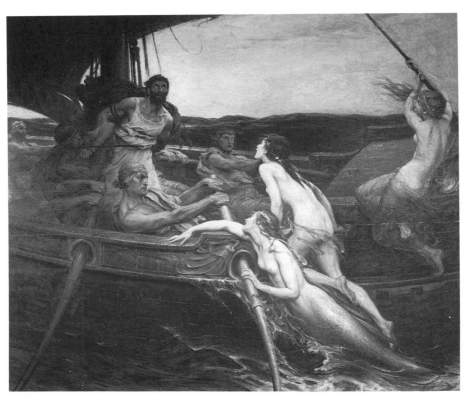

2–12. Herbert James Draper: *Ulysses and the Sirens*, 1901; 64 × 84; Ferens Art
Gallery: Hull City Museums and Art Galleries UK.

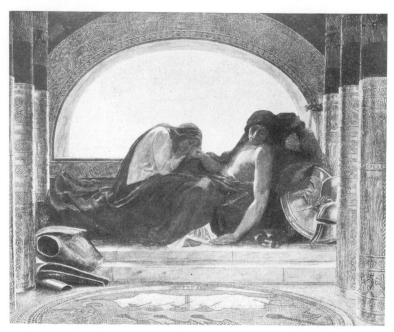

2–13. William Blake Richmond: *The Death of Ulysses*, 1888; photo: *Art Annual* 1902.

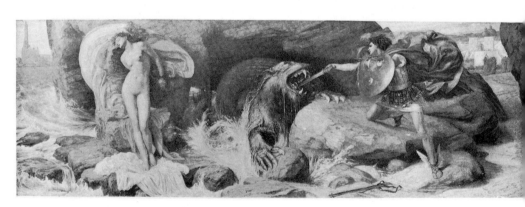

2–14. Edward J. Poynter: *Perseus and Andromeda*, 1872; 58 × 174; photo: *Art Annual* 1897.

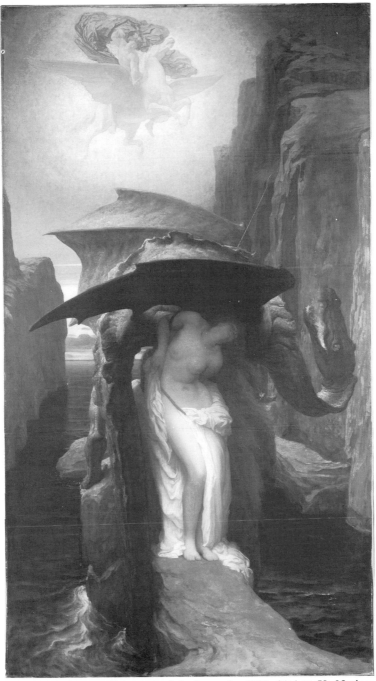

2–15. Frederic Leighton: *Perseus and Andromeda*, 1891; 91½ × 50; National Museums and Galleries on Merseyside (Walker Art Gallery, Liverpool).

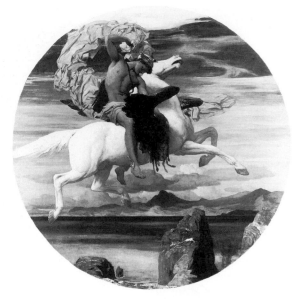

2–16. Frederic Leighton: *Perseus on Pegasus Hastening to the Rescue of Andromeda*, 1896; diameter 72½ inches; Leicestershire Museums, Arts and Records Service.

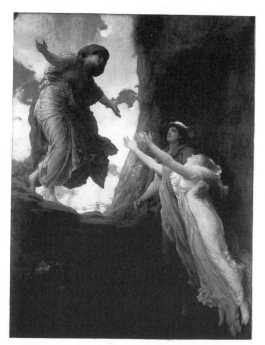

2–17. Frederic Leighton: *The Return of Persephone*, 1891; 79 × 59½; Leeds City Art Galleries.

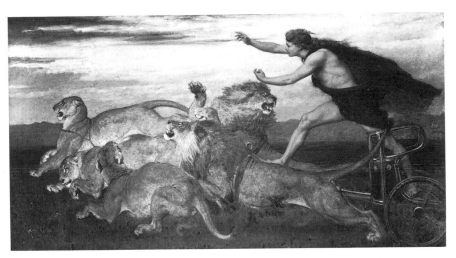

2–18. Briton Riviere: *Phoebus Apollo*, 1895; 53¼ × 96; Birmingham Museum and Art Gallery.

2–19. William Blake Richmond: *The Rise of Phaeton*, n.d.; photo: *Art Annual* 1902.

2–20. Frederic Leighton: *The Daphnephoria*, 1876; 89 × 204; National Museums and Galleries on Merseyside (Lady Lever Art Gallery, Port Sunlight).

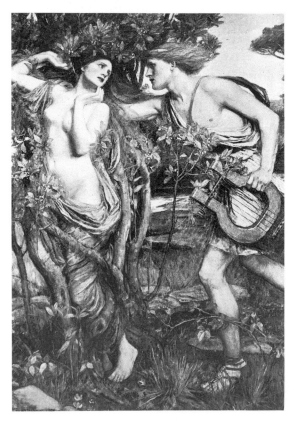

2–21. John William Waterhouse: *Apollo and Daphne*, 1908; 56½ × 43¼; photo: *Art Journal* 1909.

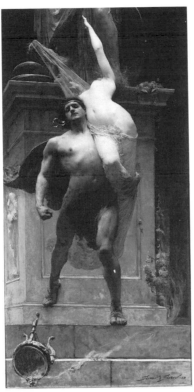

2–22. Solomon J. Solomon: *Ajax and Cassandra*, 1886; 132 × 60; Collection:
Ballarat Fine Art Gallery.

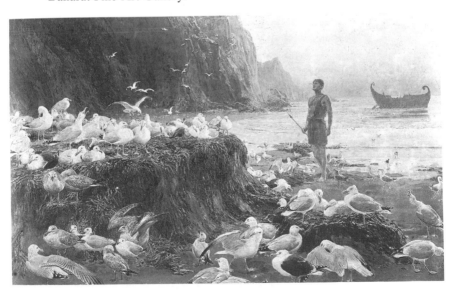

2–23. Briton Riviere: *An Old-World Wanderer*, 1887; 46 × 72; City of
Nottingham Museums; Castle Museum and Art Gallery.

3
The Gallant Knight

In *The Great War and Modern Memory*, Paul Fussell discusses the major tropes that governed the perception of British culture about the forthcoming war in 1914 and during its early years. 'Everyone knew what Glory was, and what Honor meant' (21) he notes, and he observes:

> The tutors in this special diction had been the boys' books of George Alfred Henty; the male-romances of Rider Haggard; the poems of Robert Bridges; and especially the Arthurian poems of Tennyson and the pseudo-medieval romances of William Morris. (21)

Fussell proceeds to evolve a table of the 'essentially feudal language' that established a set of equivalents embodying the tropes of knighthood, pseudo-medievalism, and heroic quest:

A friend is a	comrade
Friendship is	comradeship, or fellowship
A horse is a	steed, or charger
The enemy is	the foe, or the host
Danger is	peril
To conquer is to	vanquish
To attack is to	assail
To be earnestly brave is to be	gallant
To be cheerfully brave is to be	plucky
To be stolidly brave is to be	staunch
Bravery considered after the fact is	valour
The dead on the battlefield are	the fallen
To be nobly enthusiastic is to be	ardent
To be unpretentiously enthusiastic is to be	keen
The front is	the field
Obedient soldiers are	the brave
Warfare is	strife
Actions are	deeds

To die is to	perish
To show cowardice is to	swerve
The draft-notice is	the summons
To enlist is to	join the colours
Cowardice results in	dishonour
Not to complain is to be	manly
To move quickly is to be	swift
Nothing is	naught
Nothing but is	naught, save
To win is to	conquer
One's chest is one's	breast
Sleep is	slumber
The objective of an attack is	the goal
A soldier is a	warrior
One's death is one's	fate
The sky is	the heavens
Things that glow or shine are	radiant
The army as a whole is	the legion
What is contemptible is	base
The legs and arms of young men are	limbs
Dead bodies constitute	ashes, or dust
The blood of young men is	'the red/Sweet wine of youth' – R. Brooke.

As Fussell notes, 'this system of "high" diction was not the least of the ultimate casualties of the war. But its staying power was astonishing' (22).

The tropes embodied in Fussell's table of equivalents, however, originated during the preceding century, encouraged by the host of books, events, activities and theories which constituted the medieval revival during the Victorian period. These tropes were to form the basis of a powerful tradition of 'medievalizing' art during the nineteenth century, a major function of which was to construct a paradigm of masculinity based on conceptions of knighthood and chivalry which was to endure well beyond the First World War.

Recently, many scholars, including Mark Girouard, Muriel Whitaker, Debra Mancoff and Joanna Banham, have traced the major components of this Victorian medievalism, which can be summarized before one considers specific types of medieval iconography and their formation of masculine ideologies. Among the major literary components were the works of writers during the Romantic period, especially the poems of John Keats, specifically *La Belle Dame sans Merci* (1819), and the novels of Walter Scott, particularly *Quentin Durward* (1823) and *Ivanhoe* (1820), as well as Scott's compilation of balladry, *Minstrelsy of the Scottish Border* (1802). As Fussell notes, Tennyson was central to the formulation of medievalizing ideologies during the era, beginning with *The Lady of Shalott* (1832–42)

and leading to *Idylls of the King* (1859–88). Throughout the latter, a series of dichotomies constructed the medieval world for the Victorians, some of the most significant being: masculine/feminine, order/disorder, spirit/flesh, trust/disbelief, progress/decay, civilization/bestiality, heroism/anti-heroism, and respectability/prurience. Conventional allegorical readings of some of the characters in the *Idylls* embodied gendered paradigms, such as: Arthur = soul, Vivien = sensuality, Camelot = ideal society, Geraint = strong masculinity, Elaine = self-denial, Guinevere = beauty, Galahad = purity, and the Grail = the Ideal. Such constructions, whether in Keats or Tennyson, were to become envisioned in Victorian medieval iconography which deployed such concepts to advance ideologies of masculinity and femininity. The Pre-Raphaelite involvement with the Moxon illustrated *Tennyson* in 1857, or the decoration of the Oxford Union in the same year, reflects the intense engagement of the culture with literary medievalism, above all with Malory's *Morte d'Arthur*, which had appeared in an edition by Robert Southey in 1817. Dante Gabriel Rossetti declared that 'these chivalric, Froissartian themes are quite a passion of mine' as William Michael Rossetti recorded (198), and John Dixon Hunt notes that among the alternative titles for the Pre-Raphaelite journal *The Germ* were *The Chalice*, *The Spur* and *The Casket* (37). As Girouard observes: 'Scott's novels suggested desirable standards, not just for young gentlemen but for gentlemen of all ages' (37), a statement equally applicable to Malory's or Tennyson's writings.

Chivalry and the Middle Ages also became the focus of intense historical interest during the century, as evidenced by such works as John Lingard's *History of the Middle Ages* (1819), Kenelm Digby's *The Broad Stone of Honour* (1822), Charles Mills's *History of the Crusades* (1820) and his *History of Chivalry* (1825). Digby's book, 'an encomium on the Middle Ages . . . offered a code of behaviour which modern man could aspire to' (Banham 8). The appearance of Thomas Carlyle's *Past and Present* in 1843, with its juxtaposition of the medieval monastery of Abbot Samson with the industrial world of the Captain of Industry, espoused a medieval, hierarchal ideal for the construction of modern society. This series of juxtapositions was also the foundation for Augustus Pugin's *Contrasts* of 1836, which compared the architecture of the Middle Ages with the debased buildings of the present, a view pursued in Pugin's subsequent *True Principles of Christian Architecture* in 1841. Of course Ruskin's praise of Gothic in *The Stones of Venice* in 1853 solidified the preference for the Gothic, which had already been manifest in the architectural style selected for the new Palace of Westminster after the fire of 1837. A medieval idea was also the basis of the ideology advanced by Benjamin Disraeli in *Sybil* in 1845 with its political programme of young England, which called on the aristocracy of Britain to accept its leadership responsibilities in guiding and governing society.

The central event which represented the medieval world for the Victorians was the tournament staged by the Earl of Eglinton in 1839,

which brought tournaments, beautiful women and banquets to life. As Banham argues, 'The Eglinton Tournament was both an expression of and outlet for the medieval fever and the sway of chivalric ideas that gripped sections of society at this time' (74). The importance of chivalry, as Girouard observes, rests on the fact that 'it *was* a code, and moreover one devised for an upper-class elite and designed to make those who adopted it think of more than their self-interest' (261). In addition, 'it was made glamorous and therefore attractive by its romantic associations, which clothed gentlemen in metaphorical armour and mounted them on meta-phorical chargers' (261). Such an ideal would apply not only to domestic policy but to the conduct of empire; gentlemen would constitute 'a knight-errantry fit to keep the marches of an empire, and to purge the land nearer home of wrong, violence, lust' (Girouard 222). Whether conceived as duty, the White Man's Burden, expansionism, or idealism, the challenge of empire was faced with the paradigm of knighthood and chivalry as a foundational myth: 'chivalry rubbed shoulders with religion, pride of race, and self-interest' (227). Mancoff (1990) summarizes the importance of such chivalric constructs for the formation of masculinity during the era:

> Through the literary tradition chivalry was defined as the culmination of manly virtue, incorporating a high sense of honor, a disdain for danger and death, a taste for adventure, vast compassion for those inferior in prowess or social standing, self-sacrifice, and altruism. . . . Ellis' anthology [*Specimens of Early English Metrical Romances*, 1805] of chivalric literature popularized the association of knighthood with perfected manhood. The new hero in chain mail or plate armor had little to do with historical reality. He was a reflection of contemporary virtues and values, cloaked in chivalric raiment. . . . Not only intelligible, the new chivalric ideal was applicable to the contemporary Briton, because it was built on virtues thought to be inherent in the British character, irrespective of historical context. Bravery, loyalty, faith, and courtesy knew no chronological barriers. . . . The hero of revivalist chivalry was not an accurate reconstruction of a past ideal but an icon of modern aspiration. (35, 41)

Everything from the assemblage of great armour collections to the assimilation of the Prince Consort to chivalric models contributed to the decisive role knighthood and chivalry played in the construction of nineteenth-century masculinity. As Richards observes, the chivalric ideal secured the concept of the gentleman:

> The chivalric code was reformulated to provide a living and meaningful code of behaviour for the nineteenth century gentleman, who was seen as the embodiment of bravery, loyalty, courtesy, modesty, purity and honour and endowed with a sense of *noblesse oblige* towards women, children and social inferiors. (113)

In this construction, pictorial representations of medieval elements, characters and ideals provided the iconography which, through mass reproduction, secured the equation of maleness with knighthood until well after the First World War.

One of the most striking dimensions of the study of pictorial art in

nineteenth-century Britain is the examination of the dynamics of cultural production through painting. In Britain, pictorial representations of chivalry acted as models for the culture and particularly gendered difference in the culture, especially the construction of masculinity. The chivalric model existed in many manifestations in Victorian England, the literary manifestations of which paralleled the pictorial emphasis. For example, one might recall Heathcliff's outburst about Isabella Linton's infatuation with him:

> She pictur[ed] in me a hero of romance, and expecting unlimited indulgences from my chivalrous devotion, I can hardly regard her in the light of a rational creature, so obstinately has she persisted in forming a fabulous notion of my character, and acting on the false impressions she cherished. (I.14)

Emily Brontë clearly preceives the degree to which the chivalric ideal deluded both men and women, but particularly women, coerced as they were by patriarchy to identify the male with knighthood. Later in the century, in *Jude the Obscure*, Hardy has Phillotson recount to a friend his shock at a woman asking to be released from marriage to him:

> Have you ever stood before a woman whom you know to be intrinsically a good woman, while she has pleaded for release – been the man she has knelt to and implored indulgence of? . . . I have been that man, and it makes all the difference in the world, if one has any manliness or chivalry in him. (IV.4)

Hardy's linking of manliness with chivalry, to the extent that they become synonymous, summarizes the process of constructing masculinity in Victorian society. In twentieth-century men's studies the chivalric male has become recognized as one of the most important constructions of maleness in culture, as Doyle writes:

> The rise of the soldier, or knightly, class provided a new ideal for the male gender, one that transformed the asexual spiritual male [of early Christianity] into a sensual chivalric, or knightly, male. . . . The male gender during the feudal period focused on the model of a fighter, a soldier, although not just a common soldier but a very special soldier – the knight-errant. No longer did the male ideal include the spiritual male's sense of asexual self-renunciation and nonviolence; rather, the chivalric male ideal emphasized physical strength, prowess in combat, loyalty to the king or liege lord, and devotion to a lady. (31–32)

The construction of gendered difference was central to this chivalric model:

> The view of womanhood in the guise of the lady is a significant feature of the feudal period. . . . Under feudalism a new view of womanhood developed, one that included a dualistic version of woman's nature. Women were seen as either pedestaled virgins or lusty temptresses and prostitutes. . . . Feudalism's dualistic view of womanhood has come down through the ages and contributed to the present-day conception of woman's nature. (32–33)

In the nineteenth century, this chivalric model pervaded society, from the compulsion to rescue prostitutes to Baden-Powell's Boy Scouts. Males were constructed as heroic knights, females as femmes fatales or Angels in the House. As Stearns observes, it is important to remember that the

'nineteenth century, effectively launched and ended by major wars, was a militant, indeed military century' (68).

Contemporary social historians were aware of this modelling by chivalric paradigms. Carlyle constructed a male-empowering model, and in the monastery an exclusively male medievalism in *Past and Present* (1843), which was challenged by John Stuart Mill in *The Subjection of Women* when he wrote in 1869:

> We have had the morality of submission, and the morality of chivalry and generosity; the time is now come for the morality of justice. . . . The chivalrous ideal is the acme of the influence of women's sentiments on the moral cultivation of mankind; and if women are to remain in their subordinate situation, it were greatly to be lamented that the chivalrous standard should have passed away. . . . But the changes in the general state of the species rendered inevitable the substitution of a totally different ideal of morality for the chivalrous one. . . . Chivalry left without legal check all forms of wrong which reigned unpunished through society. (183, 224)

More recently, Lacan has recognized that the chivalric idea of courtly love actually inscribed male dominance rather than male service:

> [Courtly love] is an altogether refined way of making up for the absence of sexual relation by pretending that it is we who put an obstacle to it. It is truly the most staggering thing that has ever been tried. . . . It is rooted in the discourse of fealty, of fidelity to the person. In the last resort, the person is always the discourse of the master. For the man . . . [the] lady was entirely, in the most servile sense of the term, his female subject. (*Feminine* 141)

In Victorian Britain, the discourse of chivalry, and its construction of gendered difference, became 'the discourse of the master' in Lacan's terms. Chivalric discourse was part of the 'self-conscious assertiveness about nineteenth-century masculinity' recognized by Stearns (78).

In the iconography of chivalry in the nineteenth century, this inscription of maleness and dominance is marked by armour, which transforms the male body into the supreme signifier of masculinity, the permanent erection. It is striking that in Greek art it was the naked male who represented *aretē*, that is male nobility, manliness, and virtue, with the naked phallus symbolizing *aretē*, as Walters has demonstrated (43–45). For the Greeks, it was the naked male that constructed masculinity; for the Victorians, it was the armoured male. As Foucault observes, armour and its representation marks a transformation in the construction of sexuality: 'The arrangement that has sustained [sexuality] has been linked from the outset with an intensification of the body – with its exploitation as an object of knowledge and an element in relations of power' (107). Armour intensifies the power and presence of the male body by magnifying it. If, as Bann contends, 'the suit of armour serves as a metonymy for the human body' (113), it is in fact metonymic for the male body, maleness as phallus. This arming is inherently defensive and because of its association with war inherently not only masculine but hypermasculine, that is, involved in a

situation – war – not 'ordinary' even for males. This hypermasculinity, construction by armour, is signified in at least four ways:

1. The armour is an exaggeration of the phallus, making permanent its erectile state;
2. The armour is bellicose, aggressive, combative, martial, all qualities distinguishing masculinity;
3. The armour explicitly links the masculine with the moral, since it conceals the fallen flesh abhorrent to Christianity;
4. The armour protects the genitals against castration and castration anxiety.

In nineteenth-century iconography, armour illustrates Klaus Theweleit's ideas in the two volumes of *Male Fantasies* that armour empowered by making men feel ' "separate" from the rest of the world and prevented them from finding convincing arguments to show that what penetrated that armour was not just an illusion' (1.328). The purpose was the maintenance of 'the appearance of invulnerability' through the 'technicization of the body' even as the subordinate wife might become 'part of [the knight's] body armour', with 'weapons in general function[ing] to a large extent as part of the body-armour' (2.202, 222, 283). Theweleit's observation about Germany is equally applicable to the iconography of armour in nineteenth-century painting: 'The army, high culture, race, nation – all of these appear to function as a second, tightly armoured body . . . extensions of himself' (2.84). Clothing, Roland Barthes notes, 'because touching the body and functioning simultaneously as its substitute and its mask . . . is certainly the object of a very important investment' (236), very much the function of the knight's armour. The importance of this function of armour as signifier of the masculine is epitomized in Tennyson's *Idylls*, when Guinevere first sees Arthur: he is not in armour and consequently she does not love him.

The representation of armour in Victorian art exists in several historical contexts – classical, medieval, Renaissance – indicating its unchanging function in the construction of masculinity. It is of particular interest, as Baker demonstrates, that Victorian artists were often avid collectors of armour. This collecting habit was both masculinizing and aesthetic: such a collection would identify the owner with a strongly masculine paradigm, dispelling any question that being an artist was not masculine. Often the armour was kept in the studio, but its function was not only one of providing evocative props. In addition, the representation of armour supplied splendid occasions for experiments with effects of light. In painting armour, artists were therefore constructing a masculinity applicable in general to males but specifically to themselves as artists as well.

Classical-subject canvases deployed armour to construct masculinity, as in Edward Poynter's *Faithful Unto Death* of 1865 (Plate 3–1). When exhibited, the canvas was accompanied by the following notice:

In carrying out the excavations near the Herculanean gate of Pompeii, the skeleton of a soldier in full armour was discovered. Forgotten in the terror and confusion that reigned during the destruction of the city [79 AD], the sentinel had received no order to quit his post, and while all sought their safety in flight, he remained faithful to his duty, notwithstanding the certain doom which awaited him. (Graves VI. 197)

Poynter constructs the masculinity by the deployment of light on the armour (note the diagonal of shoulder, helmet, lance), by the insistent verticality (lintel, soldier, spear, shadow, passage), and by a particularly intriguing detail, the small graffito of a sentry incised on the block at the left of the canvas, indicating the permanent record of this masculine ideal. The modelling of gender was recognized by the *Art Journal* in an article by James Dafforne:

The man, a true hero, swerves not from his fidelity to his trust, though the burning red liquid streams along the corridor, carrying terror and destruction with it, as evidenced by dead bodies already lying around him. There is unflinching firmness manifest in the expression of the man's face, and in the attitude of every limb . . . a living death. (18)

Rosenthal cites the account of a cadet at Reigate Grammar School:

When posted as sentry, [he] was accidentally left on his post when the field day was over. But though night came on, and it was very cold – in November last – the lad stuck to his post till he was found in the middle of the night, half perished with cold, but alive and alert. (45)

How permanent is this modelling is verified by Baden-Powell's use of the ancient anecdote in *Scouting for Boys*, first published in 1908, where for him it exemplifies the Scouts' ideal of loyalty (234). Although the male nude in Greek art represented manliness, Victorian re-creations of myth often employed the armoured male in a classical context, especially in reconstructing a myth, as Poynter's *Perseus and Andromeda* (1872), previously discussed, indicates. In Poynter's representation, the weaponry, particularly the shield and falchion, are extensions (in Theweleit's terms) of Perseus's body, while the armed male is clearly constructed in opposition to and in contrast with the naked, vulnerable Andromeda: the naked female body represents defenselessness, the armoured male body power and resourcefulness, as also in Burne-Jones's *The Rock of Doom* and *The Doom Fulfilled* from the Perseus series. This strategy of naked female/ armoured male was a *topos* of representations of armour in Victorian painting.

As Lehman observes, 'traditional patriarchal constructions of masculinity benefit enormously by keeping the male body in the dark' (*Realm* 105). Following his 1872 *Perseus and Andromeda*, in 1873 Poynter painted *The Fight between More of More Hall and the Dragon of Wantley* (Plate 3–2) for another panel of the Earl of Wharncliffe's billiard room. As with the previous panel, this depiction, derived from an English ballad pre-

served in Percy's *Reliques*, deploys an armoured male and an imperilled female, in this instance clothed. This tale of rescue had a familial resonance for the Wharncliffe family. Monkhouse notes, however, an important resemblance between this 1873 canvas and its classical predecessor: 'Another moment and that English Andromeda, who has apparently been tied to a tree as a tribute to the monster, will be free to her hapless family' (16). The association with the classical rescue of Andromeda is thus intentional. Also, as Monkhouse elaborates, the canvas is explicitly heroizing in its agenda:

> The terrible nature of the previous struggle is well suggested by the broken lance and shattered branches which the dragon has snapped in his fury. And the wild, contorted stems of the 'wych-elms' or other fantastic trees aid greatly in the weird impression of the whole composition. (16)

In this depiction, More of More Hall distills the essential masculinity of both Perseus and of St George. As Inglis notes, however, the version of the legend favoured by the Wortley family involved rescue and subsequent marriage:

> A Miss Wortley had been carried off by a dragon at some unspecified and early date, but had been rescued by a young man, who afterwards married her. (251)

In both the *Perseus and Andromeda* and *The Fight between More of More Hall and the Dragon of Wantley* 'there was a hero delivering the death-blow, and a maiden shrinking in fear' (251). Therefore, in Poynter's canvas the armoured male embodies the ideology of chivalry in the domestic, and predominantly male, environs of a billiard room for a nineteenth-century gentleman.

A function of armour was also to signify the heroic and, for the viewer, to inculcate hero-worship, often in civic contexts as in *Faithful Unto Death* but with strong political ramifications. An especially striking example of this practice is Ford Madox Brown's *Cromwell and the Vaudois* of 1878 (Plate 3–3). It was Carlyle in *On Heroes, Hero-Worship* (1841) and in *Letters and Speeches of Oliver Cromwell* (1845) who 'formulated the Victorian idea of the Lord Protector' (Strong 148). Cromwell had earlier figured in Brown's *Cromwell on His Farm* in 1874, and Brown named his son Oliver in homage to Cromwell. In *Cromwell and the Vaudois*, Brown depicts Cromwell at Milton's home in Petty France, dictating to his secretary in English the despatch of 26 May 1658 protesting the persecution of Protestants in France; Milton translates the orders into Latin to his amanuensis Andrew Marvell. At the right is a declaration of a public fast to commemorate the massacre of Protestants in Switzerland, while the English rose – on the screen to the right and on the floor left – signifies Britain. Note that Cromwell's head is turned from the French fleur-de-lys on the mantel. Brown constructs the painting to contrast the aesthetic hand of Milton with the armoured physique of Cromwell, the juxtaposition of *via contempliva* and *via activa*. Cromwell faces the source of light and it

reflects on his armour, while a halo of light forms behind his head; the laurel wreath on the organ behind Milton similarly ennobles him. This all-male world of war and diplomacy emphasizes action as a component of the cult of masculinity.

This potential for action is also the subject of Leighton's *A Condottiere* of 1872 (Plate 3–4), where the chain armour and steel cuirass inscribe the Victorian emphasis on masculine energy. The warlike and threatening nature of this figure's masculinity is indicated not only by his function (as a professional soldier or soldier of fortune) but by his name, as the *condottiere* was 'literally a contractor for warfare (*condotta* = contract)' (Nickel 9). As with Brown's *Cromwell*, the light falls on the armour to emphasize the male's power highlighted by contrast with the man's dark, battle-tested complexion. The antecedents of this canvas, however, are as much sculptural as pictorial, particularly the Renaissance bronze sculpture of *condottieri* such as Donatello's *Gattamelata* (*c.* 1447–53) in Padua or Verrocchio's *Colleoni* (1487–96) in Venice. A specific prototype is Paolo Uccello's monument to the English *condottiere* John Hawkwood ('Giovanni Acuto') of 1436 in the Cathedral in Florence. (This man was well known through Conan Doyle's novel *The White Company*, 1891.) In addition, the canvas illustrates the Victorian predilection for the armoured male, as the face of Leighton's figure, and his stance, particularly the right hand, evoke Michelangelo's nude *David*. The scarlet tunic underneath the cuirass and chain mail leave nothing in doubt about the bellicose warrior who contracted services on a strictly entrepreneurial basis, a telescoping of the economic and the powerful male of the nineteenth century. Leighton's *Condottiere* exemplifies Foucault's thesis about war and politics: 'It is one of the essential traits of Western societies that the force relationships which for a long time had found expression in war, in every form of warfare, gradually became invested in the order of political power' (102).

In the construction of Victorian masculinity, armour was frequently associated with chivalric ritual, no more so than in John Pettie's *The Vigil*, exhibited in 1884 (Plate 3–5). The fact that the canvas was purchased by the Chantrey Bequest indicates that its subject accorded with cultural prerogatives. The night vigil in the ceremony of initiation was crucial in emphasizing the religious component of the essentially secularized institution of knighthood, and its construction of gender was paramount, as it was an all-male procedure:

> The Vigil of Arms was one of the religious exercises, which in the Middle Ages preceded the conferment of knighthood. The process of inauguration was commenced in the evening by the placing of the candidate under the care of two 'esquires of honour' . . . who were to be 'governors in all things relating to him.' [After the ritual bath] they poured some of the water of the bath over his shoulders, signing the left shoulder with the cross. . . . Then the two ancient and grave knights returned and led him to a chapel . . . [where they] kept the vigil of arms until sunrise, the candidate passing the night 'bestowing himself in visions and prayer.' (Martin Hardie 122–123)

In Pettie's canvas the dawn light breaks into the Norman nave, contrasting with the spiritual light emanating from the altar, at the foot of which are the knight's shield, helmet and armour. The knight holds the cross hilt of the sword, linking earthly militarism with transcendental spirituality. Two particularly relevant components of Pettie's construction of masculinity are noteworthy. First, the canvas perfectly illustrates Theweleit's argument that the armour becomes an extension of the body, as the stripping, bathing, anointing, clothing ritual of the vigil indicates. Second, its all-male character marks the vigil experience as a rite de passage of major consequence in solidifying allegiance to a masculine ideal. H.R. Hays notes of the Knights Templars, founded in 1118, that the organization was 'the best example of the men's house surviving in the Middle Ages. . . . They combined the rejection of women with the sadism of warfare . . . [swearing] to live in poverty and chastity' (134–135), and the male world of Pettie's initiation ceremony evokes such a paradigm. The relevance of the canvas to British military interests is especially indicated by the fact that it was exhibited at the Royal Academy in May, two months after the Battle of Tamai on 13 March 1884. The decision of the Chantrey Bequest to purchase the canvas was unquestionably a political as well as aesthetic decision.

There can be little doubt that it was Pettie's *The Vigil* which inspired Henry Newbolt's poem of the same title published in 1898, the first stanza of which appears to be a verbal transcription of Pettie's canvas:

> England! where the sacred flame
> Burns before the inmost shrine,
> Where the lips that love thy name
> Consecrate their hopes and thine,
> Where the banners of thy dead
> Weave their shadows overhead,
> Watch beside thine arms to-night,
> Pray that God defend the Right.

The poem continues that this knighthood has a civic, not self-centred, objective: 'Glory sought is Honour lost,/How should this be knighthood's end?' To reinforce the contemporary context, Newbolt then links such knighthood to the exploits of Gordon at Khartoum or Outram during the siege of Lucknow during the Indian Mutiny:

> Single-hearted, unafraid,
> Hither all thy heroes came,
> On this altar's steps were laid
> Gordon's life and Outram's fame. (Newbolt 47)

Newbolt in a letter of 8 August 1914, during the commencement of the First World War, noted:

> *The Vigil* is being quoted, sung, recited and reprinted from one end of the country to the other . . . but so far no-one – even among my friends – has observed that it was published in 1898 and has appeared in all three of my published volumes since then. (148)

Reproductions of *The Vigil* by Pettie are the perfect text to illustrate Newbolt's hortatory verses. As late as 1926, at a national gathering of Rover Knights, there was 'a large tableau vivant entitled "The Vigil" in which Rovers acted out an imaginary investiture and dedication ceremony as a kind of living icon before the young Rover knights' (Mangan and Walvin 207). The Rovers became *homines newboltienses*.

Briton Riviere's *Requiescat* of 1889 (Plate 3–6) is a smaller version of a canvas exhibited in 1888. Famous as an animal painter, Riviere had already employed chivalric conceptions in such canvases as the 1879 *In Manus Tuas, Domine* of a knight holding his sword as a cross as he prepares to enter a threatening chasm. *Requiescat* represents the conclusion of a knight's life even as *The Vigil* had signified its commencement. Riviere's knight rests on an embroidered coverlet dressed in his armour, a crown of oak leaves resting on his cuirass. The inspiration for the painting would appear to be the tomb effigy of the Black Prince in Canterbury Cathedral, with the implication that 'the effigy's own eyes are fixed in death on the image of the Trinity painted on the ceiling, or tester, above him' (Vale 12). The work evokes as well the Black Prince's father, Edward III, and his founding of the Order of the Garter in 1348, particularly in the blue tonality of the coverlet (evoking the badge of the order). Riviere's *Requiescat* is a summation of chivalric masculinity of the 1880s, which had been marked by imperial battles such as Tel-el-Kebir in 1882, Tamai 1884 and Abu Klea 1885, and by the death of Charles Gordon at Khartoum in 1885, commemorated in 1888 by the erection of Hamo Thornycroft's statue of Gordon in Trafalgar Square. Exhibited in its first version also in 1888, Riviere's *Requiescat* is not only the pictorial memorial to Gordon (George Joy's *The Last Stand of General Gordon* appeared only in 1893) but also the representation of the sculpture's underlying chivalric ideology, suggested by the shield on the statue's pedestal.

The patron saint of England as well as the Order of the Garter is St George, whose representations during the nineteenth century attest to his pre-eminence, codified by Baden-Powell when he declared in *Scouting for Boys* that the saint was 'the patron saint of cavalry and scouts all over Europe' (225). Hitchkock (1897), Fehr (1898), Frampton (1899, 1904), Riviere (1900), Ford (1902) and West (1915) constructed this masculine ideal in representations of St George. Again, the Order of the Garter figures in the iconography of St George, inasmuch as St George's Chapel, Windsor, was the scene of solemn mass on the Saint's day, 23 April, on which in the early twentieth century Baden-Powell advised Scouts to 'wear a rose' (225). As Rosenthal observes, Scouting was reliant on much medieval ideology, including that of King Arthur and the legend of St George: 'the scout's uniform is like the knight's armor' (40). The power of this image is particularly represented in Solomon J. Solomon's *St George* of 1906 (Frontispiece), of interest for two reasons. Although a Jewish artist, Solomon selected this canvas for his Diploma Picture to the Royal

Academy, his youngest brother Albert having posed for the saint. While active in Jewish causes, Solomon emphasizes his Englishness with his deposit of a Christian subject. He underscores the cultural masculinity of this supremely chivalric icon, moreover, by depicting not only the slaying of the dragon but the 'rescue' of the maiden, thus juxtaposing the gendered with the political subject: the gendering of politics with the politics of gender. The light falls on the pauldron and gauntlet, emphasizing the masculinity of the act of slaying as well as the superior ability of the knight, who conquers the beast *and* carries the maiden despite not being on horseback. In his only other explicitly chivalric canvas, *Equipped* of 1900, Solomon had depicted a squire affixing a poleyns to the knee of his knight, so the sequence from *Equipped* to *St George* encapsulates the rite of passage of knightly initiation and its fulfillment in conquest.

While conquest of external enemies was one component of the chivalric code, another was the conquest of self, suggested by Pettie's *The Vigil* but particularly constructed for the nineteenth century in Arthur Hacker's *The Temptation of Sir Percival* of 1894 (Plate 3–7). Derived from Malory's *Morte d'Arthur* (Book XIV, chapters 8 through 10), the canvas represents Percival's temptation to lose his virginity to a beautiful lady, in reality Satan in disguise. The episode suggested to Hacker reads:

> And anon she was unclothed and laid therein. And then Sir Percivale laid him down by her naked; and by adventure and grace he saw his sword lie on the ground naked, in whose pommel was a red cross and the sign of the crucifix therein, and bethought him of his knighthood and his promise made toforehand unto the good man; then he made a sign of the cross in his forehead, and therewith the pavilion turned up so down, and then it changed unto a smoke, and black cloud, and then he was adread. (2.203–04)

Hacker's canvas is of particular interest in illustrating the resistance of this iconography to representing the naked male body, even when the source, as here, would so mandate. In the canvas, Percival has removed his helmet and rested his lance but otherwise is armoured. The potential for demasculinization/castration is circumvented by this strategy. He is shown about to drink the damsel's wine, although in Malory he had already done so before seeing the pommel. Hacker uses this device to depict the red glow from the wine falling on Percival's hands through the transparent goblet. The autumnal setting emphasizes the threat of the world, decay, death, and woman. Hacker's construction of woman as Satan embodies the extremity of female venality within chivalric iconography. Hacker's refusal to depict the naked male body is especially interesting because the naked female body was often his subject. Protecting the mortal flesh, the armour becomes a hypermasculine signifier of gendered difference.

A subject which depicted accomplished female venality was *La Belle Dame sans Merci* derived from Keats's poem, but even in these representations the initial phase of the seduction rather than its conclusion is depicted, pictorial equivalents to the admonitory drive of Keats's quatrains.

The most powerful of the depictions is that by Frank Dicksee in 1902 (Plate 3–8), with the quatrain 'I set her on my pacing steed . . .' on its frame. The lady, with unbound red hair, is seated on the knight's black charger; he has removed his helmet and walks beside her in a twilight landscape. Dicksee's precision with details conveys both the enchantment and the threat: the reflection of the red scarf on the helmet; the leaf over the knight's left arm partially eaten by beetles; the rapt gaze of the knight; the downhill sloping of the path; the cruciform posture of the knight, whose left arm is in light, the right being in shade. The association of red hair with female venality is strongly suggested. Like Hacker, Dicksee is reluctant to show the knight without armour or unarmed, as occurs in the seduction recorded in succeeding stanzas. This construction in *La Belle Dame sans Merci*, however, is central to contesting masculinity as a 'monolithic position', as Lehman observes:

> Masculinity is not simply a position of power that puts men in comfortable positions of control. If we ignore studying images of the male body, we are likely to think of masculinity as an ahistoric, powerfully secure, monolithic position rather than one riddled with cracks. If we understand masculinity as a constant contradictory struggle rather than just the privileged position within a power disequilibrium, we come closer to a full definition of gender studies that explores the variety of ways in which patriarchal ideology structures, defines, and limits sexuality and the body for men as well as women. (*Realm* 108)

The canvas demonstrates Stearns's proposition that 'chivalry did not really resolve the conflicts of manhood' (37). Dicksee's canvas constructs a masculinity contested and threatened but not yet conquered.

The actual missions of knighthood, particularly those involving rescue, which figure so largely in Victorian reclamation schemes involving prostitutes, for example, are the focus of several memorable canvases, none more so than John Everett Millais's *The Knight-Errant* of 1870 (Plate 3–9). As Girouard notes, the canvas derives inspiration from Millais's 'rescuing of a damsel in distress. For John Ruskin's wife Effie . . . was certainly in distress; and Millais came to her rescue by falling in love with her' (158). As early as 1844, Millais had compiled a manuscript book entitled *Sketches of Armour*, composed of drawings 'made in the Tower of London armoury' (158). When originally exhibited, the woman in *The Knight-Errant* had her face turned towards the spectator, but Millais was compelled to repaint it in order to sell the canvas. As with Poynter's *Perseus and Andromeda* or Burne-Jones's *The Rock of Doom*, the contrast between the armoured knight and naked woman emphasizes her need of rescue. In contrast to the accomplished robbery and rape represented in *The Knight-Errant*, Frank Dicksee's *Chivalry* of 1885 (Plate 3–10) shows the knight arriving in time to prevent or slay the potential ravisher. As Richard Jenkyns observes about *The Knight-Errant* and *Chivalry* they represent 'the Andromeda theme in medieval costume': 'The rescuers are clad from head to foot in armour; the women are in a state of undress, partial or complete. They seem victims;

but the titles of these two pictures allude to a tradition of medieval romance in which the man is his lady's servant' (*Dignity* 119). In fact, the armour and the structure of the painting establish male superiority. The victorious knight in Dicksee is silhouetted against the sunset sky, left foot planted on the villain, as the lady gazes at the conquest from the foreground. Banham and Harris observe: 'His stance is vigorous and confident, his muscular neck and powerful physique betoken strength and energy. His cropped hair, clean-shaven face and stern expression suggest discipline and abstinence, while his tanned complexion implies the hardy, outdoor life of a military man. He . . . combines spiritual and mental virtues with the physical prowess of chivalry . . . reaffirming contemporary definitions of masculine and feminine roles and responsibilites' (177–178). The knight in *Chivalry* is the embodiment of the Muscular Christianity advocated in mid-century by Thomas Hughes and F.D. Maurice, with the glistening armour aggrandizing the male body. The knight 'resembles the elegant, well-bred youths he is meant to inspire' (Mancoff, 1990, 226).

In the years preceding the accession of Queen Victoria, and during the early years of her reign, a number of events acted as a catalyst for the chivalric revival that was to be so influential during the later years of her reign. Among these were the publication in 1822 of Kenelm Digby's *The Broad Stone of Honour*, the burning of the Palace of Westminster in 1837 and the competition for its replacement, the publication of Pugin's *Contrasts* in 1836, and the Eglinton Tournament in August 1839. Digby's book was published with the subtitle 'Rules for the Gentlemen of England', and as Girouard observes, 'Digby was not writing a history of chivalry; he was encouraging his readers to be chivalrous. . . . Digby used "knight" and "gentleman" as virtually interchangeable terms' (60), and the code advocated by Digby was to endure in Baden-Powell's formulations of behaviour in the Boy Scouts, to whom he recommended Digby's book (232). Pugin's *Contrasts* advanced the cause of Gothic over classical architecture, a decision which influenced the design of the new Houses of Parliament (1847–63). Just how pervasive was the sway of 'medievalizing' can be seen in several images of royalty. In 1846 Edwin Landseer completed his canvas *Queen Victoria and Prince Albert at the Bal Costumé of 12 May 1842* around which the influences of Pugin, Digby and Eglinton coalesce. The Queen is depicted as Queen Philippa and the Consort as Edward III, undoubtedly because Edward III had founded the Order of the Garter. Albert's 'surcoat and red velvet mantle were . . . copied from funeral sculpture in the Abbey, an effigy of Edward III. . . . Victoria and Albert stand in front of two elaborate Gothic chairs beneath a canopy which bears the Plantagenet arms' (Banham and Harris 76). An additional reason for the appearance of the royal couple as these two specific characters may also be the fact that 'Edward III took his wife Philippa and the many ladies of her court on shipboard into the dangerous naval battle of Sluys' in 1340 to protect them, a 'solicitious provision for queens' not

found in Arthurian romances (Stone 37). In Landseer's construction, while Albert is the taller, it is notable that one of his feet is below the Queen's and that his gaze is respectfully turned towards her.

The Queen may have been so impressed by Albert's costume that she suggested a portrait of him in armour would be most welcome. The Prince did, in fact, give her a miniature of himself in armour by Robert Thorburn (Plate 3–11) for her birthday in 1844. The Queen noted in her journal: 'My beloved Albert is painted in armour, which I so much wished . . . I cannot say how beautiful it is, nor how it exactly portrays the dear original.' The Lady of the Bedchamber observed it was 'most beautiful indeed. Quite his gravest manliest look, and done when he was rather tanned . . . *in armour*' (Girouard 115). As Girouard remarks:

> The picture was something of a breakthrough in English iconography . . . Prince Albert had taken part in no event; he was not assuming a historical character; he had never been near a battlefield. His armour symbolised his chivalrous qualities in civilian life. The application of the code of chivalry to modern gentlemen, as expounded by Kenelm Digby, had been given royal ratification. (115)

It is probably not accidental that Albert's pose anticipates that of Leighton's *Condottiere*, which integrates Digby's prescription with Italian martial behaviour under the aegis of royal sanction. This assimilation of royalty with chivalric ideals was even carried to those in the royal household. Victoria's daughter Princess Louise, for example, painted her *Portrait of Colonel the Hon. Charles Lindsay*, exhibited in 1889, evoking this tradition. Lindsay, equerry to the Queen, is shown in antique armour as a knight.

This royal sanction so early in the Queen's reign was a catalyst for a similar ideology among her subjects. Just as Pettie's *The Vigil* records an actual chivalric rite of passage, art could provide a surrogate of that experience to young acolytes in training to be knights of the empire. In particular, the figure of Sir Galahad proved to be an indelible paradigm of behaviour for adolescents. Painted by several artists (Rossetti 1859; Hughes 1870; Paton 1880 and 1884; Schmalz 1881), no representation achieved more currency than that of G.F. Watts from 1862 (Plate 3–12). During 1882, when the work was exhibited at the Grosvenor Gallery, H.E. Luxmore wrote to Watts to ask if the *Sir Galahad* were available for Eton College. Eventually a study was worked up in June 1897 and the replica was presented to Eton. The inculcation of the ideal of manly purity was the intention for its display and purchase, as Watts desired:

> I recognize that from several points of view, art would be a most valuable auxiliary in teaching, and no where can lessons that may help form the character of youth of England be more important than in the great schools where statesmen, and soldiers, and leaders of thought receive their first impressions. (*The Pre-Raphaelites* 1946, 104)

In Watts' conception Galahad stands, helmet removed in reverence, in contemplation, the ethereal light illuminating his armour and giving a

spiritual quality to his masculinity. Whitaker notes that Watts's *Sir Galahad* 'was reproduced as a stained glass window (1819) for St. Paul's, Fairlie, Ayrshire, for Grahamstown in South Africa and for at least six other places. It appeared on the cover of an early twentieth-century periodical, *Honour*, because Galahad was the "type of perfect manly courage and purity" ' (216). Mancoff (1990) notes that in Watts's conception 'the gleam of his costume spoke of his untarnished soul' (208). The fact that the canvas in reproduction was presented to boys upon leaving Eton established the connection between the encoding of masculinity and political objectives. As Schindler observes, Galahad 'served as a medieval *exemplum virtutis*' (122).

The example of Watts's *Sir Galahad* demonstrates the semiotics of masculinity and the empowerment of males through the male gaze. As Laura Mulvey has argued, the male gaze serves two ends: first, scopophilic, that is, 'pleasure in looking at another person as an erotic object'; second, narcissistic, serving 'ego-libido . . . identification processes'. Through the male gaze, art becomes 'coded into the language of the dominant patriarchal order', with the 'determining male gaze' establishing that 'pleasure in looking has been split between active/male and passive/female' (815, 805, 808). In Victorian culture, representations of armour served both these functions. In such canvases as *Perseus and Andromeda*, *The Knight-Errant*, *St George* or *Chivalry*, the juxtaposition of the armoured male body and the naked or undressed female body satisfied both scopophilic and narcissistic ends for the male observer. In images of armoured males alone, such as *The Vigil*, *Requiescat*, *Sir Galahad*, *Faithful Unto Death*, or *A Condottiere*, the narcissistic function was paramount, as males beheld ideal masculinity constructed in such iconography. When it is remembered that pictures exhibited at the Royal Academy had to pass the review/gaze of the all-male Hanging Committee, it is not surprising that such iconography received approval or that the Chantrey Bequest would purchase a work like Pettie's *The Vigil* as much for ethical as aesthetic reasons. The fact that *Sir Galahad* was distributed in a print version to graduates of Eton, furthermore, reflects the power of rapid, accurate, cheap reproductions in circulating not merely images but encoded paradigms of masculinity. Framed and displayed, such reproductions exerted a powerful influence long after the annual exhibition was removed from the Academy's walls. If one surveys the volumes of *Royal Academy Pictures*, in which selected exhibits were reproduced, nearly 120 works involving chivalric subjects or motifs were exhibited between 1888 and 1915. (This is by no means the total, simply those chosen for reproduction.) The circulation of these volumes, as well as many descriptions and/or reproductions in such guidebook series as *Academy Notes* (1875–94), *Grosvenor Notes* (1880–89) and *Pall Mall Pictures* (1885–92) meant that the empowering gaze could function in reference sources, domestic interiors, foreign libraries, schools and newspapers. 'For the man, looking is an activity in its

own right: a way of taking possession and control, a symbolic equivalent to the sex act' (Walters 304).

Even into the twentieth century, not only did the armoured male survive as an ethical ideal; it also was configured as a paradigm of the artist himself. In his 1925 Address to the students of the Royal Academy, the President, Frank Dicksee, used such a discourse to describe the artist and his mission:

> It is for you so to *equip* yourselves that when the history of your times is written it may be seen that your heritage has not been wasted, and that your labour has been faithful and sincere. . . . Old traditions and former standards are ignored and have again to go through the *ordeal by battle*. Little wonder is there that the young Student, who has started on this *quest* full of hope and enthusiasm, is bewildered and at times appalled. . . . How is he to *arm himself* that he may pass through these dangers and protect himself withal? . . . I must assume that you all possess that *indwelling spiritual quality* . . . for this is the force that will urge you on to the *great adventure*. . . . If you have it not, then put off *your armour*, for the *battle* is not for you. [italics added] (8–9)

Two years later Dicksee employed this same discourse:

> Your *equipment* must be as that of the *Happy Warrior who seeks the Holy Grail* whose *armour* is so well worn that it troubles him not at all, who is so complete a *horseman* that his horse is at one with himself, and in this wise with *weapons* that will not fail him, he can concentrate all his efforts on the *quest* that it is his ardent hope to attain. [italics added] (10, 13)

This language and this paradigm perforce exclude the participation of women in politics, imperialism and art, where the ideal image of the art student is that of the knight in *The Vigil*, an aspirant to an all-male community. Dicksee's *The Two Crowns* of 1900 (Plate 3–13), of a victorious knight being lauded in a triumphal procession, inscribes the armoured code of masculinity: seated on a white charger; the focus of the female gaze; the knight gazing only at Christ, whose surrogate he is on earth; armoured in political conquest and adulation. Its imperial force is accentuated by its being exhibited during the height of the Boer War. As the quotations from Dicksee's Academy addresses demonstrate, however, the chivalric code was a guide not only for Victorian gentlemen in general but for the aspiring artist in particular. *The Two Crowns* advances an aesthetic as well as ethical ideal. The suit of armour Dicksee used as a model in *The Two Crowns* and in *Chivalry* stands in his studio as photographed for Dibdin's *Art Annual* monograph of 1905 (p. 31).

The significance of armour and its function endured far into the twentieth century. Its encoding of gendered difference may be indicated by its use in Baden-Powell's *Rovering to Success: A Book of Life-Sport for Young Men* of 1922. Constructing his book around four rocks which pose temptation for males (horses, wine, women, extremists), Baden-Powell lists, as an 'antidote' to women, '*Chivalry* and health of mind and body' (201). Earlier in the book the entry for 'Manliness' is led by 'Chivalry',

where the two are synonymous (109). Only with the advent of women's studies and men's studies has the armoured ideal been critiqued.

This survey of the functioning of armour in Victorian art indicates the range of narratives and subjects this common denominator could include in its construction of masculinist ideologies. St George, *La Belle Dame sans Merci*, Arthurian subjects, and generalized knighthood, however, anchored an entire range of iconography during the nineteenth century. Several of these topics merit specific consideration, for they demonstrate not only the repetition of such motifs but also the subtle variations artists effected in their diverse constructions of similar themes.

One of the most significant of the literary works constructing chivalry was that of Keats's *La Belle Dame sans Merci* as seen in Dicksee's canvas. Dicksee's representation, however, is a culmination of a tradition extending back to the nineteenth century and beginning with artists of the Pre-Raphaelite circle. Among the most important was the representation by Arthur Hughes, completed in 1863. In this image, the knight is waylaid by the Lady but, more significantly, the ghosts of her previous victims hover behind her. Although the knight is mesmerized by the Lady, the observer obtains and retains a different idea – that of female venality and the hazards of maleness, even chivalric masculinity, confronting such a devious and deluding female: the knight already has no helmet, and he is represented divesting himself of his shield. It is the observer who is treated to the vision of the doomed victims, which is reserved to the knight in Keats's text. The dark charger emphasizes the hazard confronting the knight who is yielding his arms. In Walter Crane's image from 1865, an armoured youth leads the Lady on a white charger along a symbolically downward path. Like the Lady in Hughes's image, her hair is unbound, indicating her fallen state, and the twilight world of Crane's canvas, as in Hughes's, stresses hazard and danger. The Lady would appear to be luring the youth along the path, or perhaps even guiding him. In *An Artist's Reminiscences*, Crane recorded how he 'obtained permission to make studies in the Armoury of the Tower of London. . . . I was much interested in armour and costume' (81–82). A lost canvas, and the only representation of the subject by a woman, is the *La Belle Dame* of Anna Lea Merritt, exhibited in 1884. Unlike the male artists, Merritt shows the knight asleep, with the Lady towering above him. Only in this canvas by a woman is the male shown asleep, although it is a major motif of the Keatsian source. Thus did males edit and expurgate their sources to present danger but not defeat.

John William Waterhouse's famous representation from 1893 (Plate 3–14) is particularly disturbing. Waterhouse shows the Lady as his trademark *jeune fille fatale*, with the fatal red/auburn hair. She is depicted seducing the knight by using her hair as a slip-knot to strangle him; he is already resting his lance on the ground. The canvas is particularly unusual because the knight is a self-portrait of Waterhouse: here the artist implicates

himself in the text in an extraordinary fashion. The red banner of the lance tellingly indicates the fatal nature of the encounter, while the innocence of the Lady's visage conveys all the danger of her sexuality by camouflaging it. Hobson summarizes the brilliant detail which conveys Waterhouse's idea so forcefully:

> The girl crouches like a fawn, literally wearing her heart upon her sleeve, and lifting her perfect face in silent invitation to the kneeling knight she draws him down inexorably with the luxuriant noose of her hair. His full armour is emblematic of the artist's own Victorian propriety, yet here the darkened trees form a backcloth both to passion and to fear, and the shadowed countenance of the knight forebodes his inevitable doom as he grasps the lance whose rigidity betrays his desire. (1989, 52).

The degree to which the idea of *La Belle Dame* endured is indicated by Frank Cadogan Cowper's image from 1926, which shows the Lady binding her hair after seducing the knight, who now lies in so deep a sleep that a spider's web has grown around his face. The poppies in the foreground and surrounding the Lady assimilate her to the Diana/Endymion legend, as the knight would appear to be cast into an eternal sleep. Armoured but impotent, the image presents the paradox of masculinity so concentrated in Keats's text.

One of the most frequently used sources for medieval imagery in the century was Tennyson's *The Lady of Shalott*, published in versions of 1832 and 1842. Artists such as Crane and Waterhouse were attracted to both Keats's *La Belle Dame* and to Tennyson's text, the latter showing the male victorious, secure in his armour, as the former had represented the threat to chivalry. In William Egley's 1858 canvas, the Lady is shown just prior to the catastrophe, as 'She Left the web, she left the loom'. As she prepares to gaze at Lancelot, who is reflected in the mirror armoured with a plumed helmet, the Lady appears pensive. Details such as the mullioned leaded window, and particularly the contrast between the sunny exterior land-scape and the ornate and heavy interior of the Lady's *hortus conclusus*, emphasize the gendered nature of the paradigm: Lancelot is in the sunlit outside world, the Lady is restrained within the imprisonment of patriarchy. As Banham notes, 'the pale and pensive Lady of Shalott is set against the robust and active figure of Sir Lancelot reflected in the mirror' (168). Walter Crane in 1861 shows his Lady of Shalott floating dead to Camelot, the image of the corrupted soul destroyed by sensuality and by repudiation of the patriarchal restrictions which confined her. John Byam Shaw's canvas of 1898 depicts the Lady inscribing her name on the prow of her boat, prior to her fatal embarkation. Dressed like a nun, another powerful patriarchal construction of women, the Lady may or may not be victorious in writing her name – either her signature or her epitaph. The dead leaves fallen around her suggest the latter. Sidney Meteyard painted the Lady swooning at an image of lovers in his canvas of 1913. She has already accepted an image of the masculine as armoured, as the tapestry

depiction of Lancelot indicates. As Nelson notes, the artist 'emphasizes the sensual mood of the Lady's newly awakened sexual desire' while the mirror image of the lovers serves as an 'imaginary bridge between the picture of Lancelot and herself' (*Ladies of Shalott* 9). William Holman Hunt's *The Lady of Shalott*, painted from 1886 to 1905, remains one of the most powerful representations. As with Egley's canvas, an armoured Lancelot is seen in the mirror as the curse comes upon the Lady, whose hair flies loose (indicating her fallen state) as she becomes entrapped in the web. Hunt includes a range of symbolic details (analysed by Neuringer, *Ladies of Shalott*): the shoes indicating the sanctity of the bower; threatening Medusa heads assimilating the Lady to a femme fatale; a medallion of the Virgin, whose devotion to duty the Lady has shunned; the extinguished lamp, at which the Lady gazes; and the tapestry itself, containing such details as Lancelot kissing someone's fingertips. The difference in scale between the Lady and Lancelot only demonstrates the force of the armoured male who, while seen diminished, nevertheless survives by his gender alone.

The artist most attracted to the theme of the Lady of Shalott during the century was Waterhouse, who painted the Lady three times, in 1888, 1894 and 1916. The most famous of these representations shows the Lady releasing the boat as she begins her journey to Camelot; on the prow of the boat, a crucifix rests before her, but maleness is inscribed on the embroidered coverlet on which she sits, particularly one medallion which shows knights at a joust or marching. The autumnal landscape and the unbound red hair are part of the iconography of this motif, but Water-house's innovation is to show the Lady's lips parted in a song, perhaps an expressive gesture testifying to her acceptance of her new identity. The rendition of 1894 shows the Lady at the moment the curse becomes operative, as she glances at Lancelot, reflected in the mirror behind her, armoured, with his phallic lance held erect before him, the same marker of masculinity Waterhouse had deployed in his *La Belle Dame sans Merci* the previous year. While Waterhouse's rendition echoes Hunt's from the 1857 Moxon *Tennyson*, as Hobson points out he achieves an original conception:

> The figure of the girl is the centre of our attention. The passing knight is visible in the mirror; we take his place in the window and she looks into our eyes. We could not be more directly involved in the action. (1989, 53)

The incorporation of the viewer into the canvas as Lancelot is a complex strategy by which the male superiority of the viewer becomes inscribed in the act of viewing itself, reinforcing the gendered conflict in the canvas and text. This conflict is then accentuated by the circular motifs pervading the canvas, as Hobson observes: 'the roundels of the tapestry and the tiled floor, the semi-circle of the chair, the mirror itself' (53). In the 1916 rendition, Waterhouse moves to an even earlier moment in the poem, as

the Lady gazes wistfully at the reflection in the mirror of two lovers sailing down the river, with the bridge to Camelot visible through the window arches. As Hobson observes, 'the window arches, the small glass panes, the roundels on the weaving' (1980, 137) derive from the circular motifs of the 1894 rendition, again suggesting the sequestration and claustrophobia of Victorian gendered conceptions of women. The canvases are united by the presence in all three of the tapestry with the narrative medallions, which inscribe the masculine chivalric tale that entraps the Lady and reinforces chivalric masculinity.

Chivalric masculinity of a sort different from Lancelot's was represented in the image of the chaste and pure Sir Galahad, who contrasts with the sensual Lancelot and achieves the Quest of the Holy Grail. Although Watts's image is unquestionably the one most revered by everyone from schoolmasters to prize-winning pupils to soldiers in the trenches of the First World War, other artists were perforce attracted to this construction of male purity. Among the most important were Rossetti and Joseph Noel Paton. In 1859, Rossetti finished *Sir Galahad at the Ruined Chapel*, derived from his illustration to Tennyson's 1842 *Sir Galahad* included in the Moxon *Tennyson*, the third stanza. Galahad is shown kneeling before 'the altar of a shrine in the woods. Unseen by him, several young women pray and toll the bell hanging at the entrance to the shrine' (Banham 164). As Banham notes, the reworking of Arthurian material was intensely engaged with issues of gender:

> In the 1840s and 1850s the examples in the *Morte d'Arthur* of 'the noble acts, feats of arms of chivalry, prowess, hardiness, humanity, love, courtesy, and very gentleness' (Caxton's original preface) were reworked and reinterpreted in cultural products around Victorian ideals of masculinity and femininity, and given new meanings in terms of contemporary debates about the different roles of men and women. . . . Galahad became an ideal of masculinity – celibate, pure, spiritual and pious. . . . This ideal of masculinity was understood against a more prevalent definition of man as driven by sexual urges and animal passions. . . . Galahad's purity, love of Christ and abstinence from relations with women are set against Launcelot's physical and sensuous relations with Guinevere. (164–165)

Galahad's attainment of the Quest was the subject of Rossetti's *How Sir Galahad, Sir Bors and Sir Percival were Fed with the Sanc Grael* of 1864, which shows the three men before the Damsel of the Grail. Such images contrast with Rossetti's representations of Lancelot in, for example, his pen and ink drawing of 1857 of *Sir Launcelot in the Queen's Chamber* or the 1855 watercolour *Arthur's Tomb*, which shows the lovers at the King's tomb, on which is depicted the Grail Quest itself, contrasting quite overtly the two types of masculinity embodied in the Arthurian chivalric ethos. In the latter, Lancelot still has a shield (slung behind his back) and the effigy of Arthur shows him in armour; much changed is Guinevere, now in a nun's habit. In the 1857 study for *Sir Launcelot's Vision of the Sanc Grael*, Rossetti's subject for the Oxford Union Debating Hall murals, Lancelot is

asleep before the Damsel of the Grail (modelled by Elizabeth Siddal) as Guinevere (modelled by Jane Morris) intervenes between the knight and the vision.

Joseph Noel Paton painted several representations of Galahad. In *Sir Galahad's Vision of the Sangreal*, *c*. 1880, the knight has removed his helmet in reverence before the vision, as three angels hover above him; even his steed seems imbued with the same awe. In the 1884 *Sir Galahad and His Angel*, the knight is almost an adolescent, mounted on a symbolic white steed, looking upwards as directed by his guardian angel, who rests a lily on his shoulder. From 1889–90 came *How An Angel Rowed Sir Galahad across the Dern Mere*, which 'can be understood as an allegory of the voyage of the soul through life. Like Sir Galahad protected by the angel, the soul is guided and sustained against sin by faith. . . . Arthurian legends become adjuncts to a Bible class description of the Christian life' (Banham 173). The motto *Beate mundo corde* ('Blessed are the pure in heart') is inscribed on Galahad's shield, marking him as the paradigm of militant purity. Paton was to demonstrate the intensely sexual nature of this purity programme in his 1883–86 *The Choice*, which shows a knight torn between a protecting angel and a Siren-like lady of the world who lures him with wine and sexuality; the serpent at her feet marks her as Satanic, similar to the temptress in Hacker's *The Temptation of Sir Percival*. Here even armour is almost not sufficient proof against women unless the male is given auxiliary aid by a protecting angel.

Paton's images of knights are especially intriguing when contrasted with those by Arthur Hughes, particularly with his *Sir Galahad* of 1870 (Plate 3–15). Hughes's knight, as in one of Paton's, is shown with three angels hovering before him; like other images, he is mounted on a white charger, lance held erect. In contrast to Paton's images, however, masculinity and purity are being challenged: brambles mark the horse's path, the 'road stretching before him is a rugged terrain, all boulders and treacherous cliffs, seemingly impassable' (Mancoff, 1990, 208). The knight's shoulders are hunched, but the face expresses resolution and caution. The landscape evokes that of Browning's *Childe Roland* to suggest this world as a place of spiritual testing. Hughes's basic commitment to the chivalric code is attested to by his *Knight of the Sun*, *c*. 1860 (also existing in a watercolour version and in a worked-up study *c*. 1893). In this canvas, an aged knight is being carried by faithful followers to his final resting place; F.G. Stephens stated in 1873 that the source was an ancient legend (unidentified) of a knight 'borne out of his castle to see, for the last time, the setting of the luminary he loved' (*The Pre-Raphaelites* 1984, 187). The knight devoutly clasps his hands before the vision of the sunset, linking masculinity to nineteenth-century solarism. The attendants carry his arms behind him. Mancoff regards this canvas as a summary of the motif of the Fallen Hero: 'His service under the ensign of light is over and he meets his fate in impending darkness. . . . Here was the creed of the last generation

of revivalist chivalry; action, not station, was the true hallmark of valor. An honorable life was its own reward' (195).

As Mancoff asserts, the 'most popular incarnation of the Fallen Hero was the passing of Arthur' (195), a subject painted by several artists to construct the paradigm of the ideal masculine ruler, taking as its inspiration not only the *Morte d'Arthur* but also Tennyson's poem *Morte d'Arthur* of 1842. Painted at nearly the same time as Hughes's generalized Knight of the Sun, James Archer's *La Mort D'Arthur* of 1861 shows the dying King recumbent on land, surrounded by the three queens Morgan Le Fay, the Queen of Northgali [North Wales], and the Queen of the Wastelands, with a fourth possibly representing Nimuë, the Lady of the Lake. A figure carrying the Holy Grail approaches at the right of the canvas, while at the left a man reminiscent of Merlin converses by the shore with another figure. The King's bandaged head signifies his life of strife, the Grail his redemption and salvation at Avalon, as Banham indicates 'a ritual reminiscent of the last rites over the body of the dying' ruler (175). Frank Dicksee painted *The Passing of Arthur* in 1889 (Plate 3–16), illustrating the moonlit barque bearing the dying Arthur with the three queens as it leaves the shore. Dicksee constructs the canvas specifically so that the moonlight will fall on the King's armour, connoting his heroic masculinity but also his mysterious passage to Avalon and the ambiguity about his return. The *Academy Notes* of 1889 described it as 'a Tennysonian rendering of the legend' (vii). The calm waters suggest Arthur's rest as the bright stars signify his masculine triumph. Burne-Jones left incomplete at his death the mural-sized *The Sleep of Arthur in Avalon* (1881–98). For Burne-Jones, the canvas was not only a cultural manifesto but a personal credo. Signalling his identification with the King, he is recorded in the *Memorials* as stating in 1882: 'The Sleep of Arthur in Avalon is my chief dream now, and I think I can put into it all I most care for,' adding 'I shall let most things pass me by. I must, if I ever want to reach Avalon' (2:125, 340). In the canvas, Arthur, modelled by William Morris, is asleep under a bronze canopy detailing episodes from the quest of the Grail, his body watched over by the three queens, his armour being held by female attendants. Other women play musical instruments about the King's bed. In the midst of working on this canvas, Burne-Jones designed the costumes for Joseph Comyns Carr's *King Arthur* in 1894, so the legend appeared to take life on the stage.

The knights of Arthur's court, however, did not always share the purity or idealism of the King. Representations of these individuals were in conflict with the chivalric masculinity encoded in figures such as Arthur, Galahad and Percival. One of the more ambiguous members of the Round Table was Tristram, the protagonist of 'The Last Tournament' in the *Idylls* and the embodiment of cynicism, and also the protagonist of Wagner's *Tristan und Isolde* of 1865. In the Tennyson, the cynical Tristram, who recognizes the self-projective narcissism that is the chivalric code, is slain

by an enraged husband. In Sidney Meteyard's *Tristram and Iseult*, *c.* 1890s, the knight in armour, but with helmet laid aside, kneels before Iseult, who prepares to rise from her throne to greet him. Presumably now married to Mark, the canvas charts the adultery of the lovers. Meteyard endows their love, however, with a celestial blessing via the light pouring into the room through the roundels of the window. Herbert Draper's lost canvas *Tristram and Yseult* of 1901 (Plate 3–17) shows the lovers just as they have drunk the potion compelling them to their disastrous love. Unlike Meteyard, who shows the knight in armour, Draper imagines a more primitive clothing of animal skins and chain mail for his knight, who gazes in a trance at Yseult as the crew rows towards Britain from Ireland, probably strongly influenced by the conclusion of Act I of Wagner's opera. In Blair Leighton's 1907 *Tristram and Isolde*, Tristram sits aboard ship singing to his harp before Isolde. Blair Leighton has derived the ship motif from Wagner and Draper, but he is compelled to find a new element, Tristram's singing, to differentiate his own composition. Here the concept of courtly love is especially accentuated through the focus on the knight's singing. The more violent cast of courtly love is the disastrous aftermath to the love affair presented in Ford Madox Brown's *The Death of Sir Tristram* of 1864 which shows the distraught Isolde raising the body of the dead Tristram as King Mark gloats over the couple. Originally conceived as a stained glass subject, the model was installed at Harden Grange in 1862 as part of its decoration by Morris, Marshall, Faulkner & Co. Waterhouse, confronted with these predecessors, selects the moment of the drinking of the potion for his 1916 *Tristram and Isolde*. As in Meteyard, Tristram's helmet rests beside the knight's foot, but otherwise Tristram is shown in full armour. Waterhouse sets the ship on a greenish sea, with the Cornish coast in the background, doubly isolating his lovers. As Hobson observes, Waterhouse 'characteristically choos[es] not a tournament or passage of arms but the meeting of lovers. . . . Once more, he selected a moment both of stillness and of powerful emotions' (1989, 116). A detail such as the floating of Isolde's veil in the wind conveys the isolation and the imperilling of the episode.

Another variant of the besieged and conflicted and tested chivalric paradigm is the tale of Tannhäuser, which received impetus from Wagner's *Tannhäuser*, first performed in 1845 and later in a revised version in Paris in 1860. *Tannhäuser* explores the testing of masculine purity by the opposition of the sensuous pagan Venus and the chaste Christian Elizabeth. In Frank Dicksee's *The Redemption of Tannhäuser* of 1890 (Plate 3–18), the conclusion of Act III of Wagner's opera is depicted to show the final allegiance of the poet to his masculine ideals. Tannhäuser falls on the bier of the dead Elizabeth as the vision of Venus departs, while a monk enters with the blooming staff announcing the poet's absolution. The shrine of the Virgin attests to the lofty allegiance of the knight. As in Dicksee's *Chivalry*, the light is that of sunset: the *Magazine of Art* noted that the

'contrasts of light as of passion are the themes of this picture' (222). No women attend the bier, only monks and other males, demonstrating that women have no contribution to make in the dichotomous construction of the feminine. The all-male fraternity of monks, and the presence of the bishop, inscribe patriarchal structures. The concept of pilgrimage (with its associations of Teutonic/Aryan *Bildungsreise*, temptation, struggle, quest and conquest) is aligned with Dicksee's conception of the artist *qua* artist and the teleology of the knight's chivalric code. *The Redemption of Tannhäuser*, however, is also meta-artistic in its gendering. The canvas in its composition clearly echoes the frieze-like arrangement of the figures in Leighton's *The Daphnephoria* of 1876, which also constructed art as masculine. Even the acolytes with their censers echo the attendants in Leighton's canvas. Just as *The Daphnephoria* constructed art as masculine by its association with a festival of Apollo, in *The Redemption of Tannhäuser* the poet, in monkish pilgrim's garb, encodes the idea of art as the new, all-male religion. The *Art Journal* (1890) emphasized this point by noting: 'Venus, the baleful demon-goddess, vanishes baffled in a lurid radiance' (167). Both the Leighton and the Dicksee, the one in classical contexts, the other in medieval/chivalric contexts, construct art as a function of male subjectivity. The artist in both canvases is not marginal but rather central to the enterprise of masculinity: the bishop, the acolytes, the other pilgrims, and the poet Wolfram all direct their gazes at the poet Tannhäuser, who becomes paradigmatic of masculinity.

Burne-Jones completed his *Laus Veneris* between 1873 and 1875, showing the goddess Venus and her attendants preparing to waylay the armoured knights passing before their bower. Inside the walls of the chamber, Burne-Jones shows the fearsome nature of the threat of women by wall paintings of the passing of Venus and the seduction of a victim by a Siren. Inspired by Morris's 'The Hill of Venus' in *The Earthly Paradise*, as well as by Wagner and by Swinburne's poem published in 1866, Burne-Jones invests Venus with a stunning orange drapery and a seductive languor guaranteed to challenge the armoured knights. Laurence Koe's 1896 *Venus and Tannhäuser* shows the naked goddess reaching for Tannhäuser, who kneels on the ground casting his eyes to heaven as he clings to his sword. Here the chivalric image encodes not so much masculine victory as female venality, showing the testing of the knightly ideal rather than its supremacy. John Collier's *In the Venusberg* [*Tannhäuser*] of 1901 depicts the knight kneeling in awe before Aphrodite, who raises her arms to expose her breasts to the knight before crowning him with flowers. A naked attendant draws the goddess's doves to her. The challenging of the chivalric code in Collier's canvas, recalling the images of Koe and Burne-Jones, reveals that this dimension of the Tannhäuser legend attracted artists because of its contestation of knighthood. Only Dicksee, among major artists, so embraced the code that he could securely depict its triumph. As with the representations of *La Belle Dame sans*

Merci, the Tannhäuser legend exposed a fragility about the masculinizing code of chivalry that other legends, such as that of Galahad, constructed with more surety.

In addition to the legend of King Arthur, the other medieval icon most constructive of nineteenth-century British masculinity was of course the myth of St George, patron saint of England. Artists from the Pre-Raphaelite period through the end of the century and even during the First World War painted this image. Rossetti's *The Wedding of St George and the Princess Sabra* of 1857, possibly derived from Percy's *Reliques*, shows the knight having slain the dragon (dead at right) and embracing his bride, the eroticism of the event being conveyed by the bed in the background. Rossetti's knight, still in armour, sits as the Princess Sabra ties a lock of her hair around his neck, recalling a drawing by Rossetti on the *La Belle Dame* theme in which the same motif appears. While the connotation of the gesture here is amatory, there is nevertheless suggested an element of conflict and threat from female sexuality. Rossetti's love of heraldry is confirmed by the cramped construction of the design.

It is particularly during the 1890s and after that the image of St George enhanced the Royal Academy exhibitions. Whether this was the result of strengthening the masculinity of troopers in the colonial wars, nostalgia for victories at the Crimea, or encouragement for the Boer War and the First World War may be debated. It is evident, however, that the circulation of the image of St George was crucial to the construction of masculinity at the end of the century. George Hitchcock's *St George* appeared in 1897, showing the knight, in celestial light, approaching a grove where a violated woman sits awaiting her rescuer; the contrast of light, with the male graced by the sun, the violated woman in shadow, makes clear the ideological direction of the canvas. In 1898 Henry Fehr exhibited his statue of *St George and the Rescued Maiden*, a work conveying its idea by scale, being 9 feet high. Fehr's knight holds the maiden in his left arm, while his sword slices the neck of the dragon at his feet. The juxtaposition of the woman's naked body against the male's armoured body perfectly illustrates Theweleit's thesis about the armoured male warding off castration anxiety by encasing his limbs in a symbolic permanent erection. In 1899, George Frampton exhibited his statue of *St George*, 18 inches high, without the maiden. Here the symbolic function of the knight is emphasized, as the narrative of his adventures is effaced to transform him into a national icon; he holds a banner and rests his shield on a globe undoubtedly symbolizing in abstraction the concept of empire. Briton Riviere's *St George* of 1900, which shows a terrifying dragon along the right diagonal of the canvas (even to the dead mount of the knight), reveals that the rescue of the maiden, who bends over the recumbent knight, was exacted at a cost. While the knight does not appear wounded, his exhaustion is marked. Frampton's completed statue of St George, the model of which had been exhibited in 1899, was exhibited in 1904, a work 4 feet high. Frampton

includes the dragon in his image, which certainly would have gained in resonance in the aftermath of the Boer conflict.

Frank Salisbury's *The Quest of St George* of 1909 shows the knight leaving on a civic mission, accompanied by a lady imploring heaven for protection. Here a bishop blesses the departing knight, and the civic emphasis accords with the cultural construction of St George in Victorian and Edwardian culture. At 6 × 10 feet, the canvas deploys scale to convey its ideology. As late as 1915, J. Walter West exhibited his *St George of England*, showing the knight slaying a dragon. An ominous element is the skull West places in the foreground of the painting, premonitory of the thousands about to die in the world war undertaken months before this exhibition. The paradigm of St George was invoked in poetry by Newbolt in his *St George's Day: Ypres, 1915*, written in 1918, specifically linking the soldiers of the First World War with this masculine topos:

> To fill the gap, to bear the brunt
> With bayonet and with spade,
> Four hundred to a four-mile front
> Unbacked and undismayed —
> What men are these, of what great race . . . ?

The refrains respond:

> *Let be! they bind a broken line.*
> *As men die, so die they.*
> *Land of the free! their life was thine,*
> *It is St George's Day. . . .*
> *Let be, let be! in yonder line*
> *All names are burned away.*
> *Land of his love! the fame be thine,*
> *It is St George's Day.* (129–130)

The First World War verified the proleptic nature of the statues by Fehr and Frampton and the canvases by Hitchcock, Riviere, Salisbury and West, which constructed late-Victorian and Edwardian masculinity via this icon. For a war memorial at Clifton College, Bristol, his alma mater, Newbolt commemorated those fallen in the First War as 'Thy flower of chivalry, thy fallen fruit/And thine immortal seed' (142).

That St George both inspired and commemorated British military heroism is demonstrated by Alfred Drury's Boer War memorial at Clifton College, Bristol. There had been considerable rivalry about whether the statue should represent an officer in khaki or a knight in armour, the latter finally selected. 'The choice was surely the right one,' Girouard observes, 'for the resulting young man (ostensibly St George) standing high on his pedestal and looking towards South Africa over the cricket fields epitomizes everything that Clifton of those years stood for' (174). St George was also the subject of hunt steeple chase trophies during this period, and of course Ruskin's Guild of St George, established in 1870, had embodied chivalric ideas in its very conception. As Girouard notes:

'He hoped that the Guild would develop into an ideal society, working its own lands away from the corruption of the cities. . . . Landlords would have to be able to work "as much better than their labourers at all rural labour as a good knight was wont to be a better workman than his soldiers in war" ' (250). Abroad, St George was also the patron of the empire, as Girouard observes: 'The chivalry of the Empire was presided over by the figure of St George slaying his dragon. . . . The fact that he was England's traditional patron saint, that he was also accepted as the patron saint of chivalry and that slaying dragons, and rescuing those in distress by doing so, beautifully symbolised what imperialists believed the Empire was all about, ensured his popularity' (229). In the circulation of an iconography of the saint, artists played a crucial role in constructing the image of the heroic knight as well as constructing the essence of British masculinity for the era.

Ideas about chivalry, including such elements as the rescue of those in distress or the performing of other deeds of generosity, could appear in more generalized contexts than Arthurian narrative or the legend of St George. For example, John Rogers Herbert's *The Monastery in the Fourteenth Century: Boarhunters Refreshed at St Augustine's Monastery, Canterbury*, of 1840, demonstrates the link between religious and chivalric codes in the generosity shown by the monks to the hunting party. Banham notes:

> Herbert represents the secular and religious spheres as closely allied with one another in relations of co-operation and mutual respect. Herbert's monks are civil and solicitous in their ministrations to the hunting party, whilst in details like the cross embroidered on the saddle-cloth and the intermingling of objects in the bottom right of the painting the medieval state is shown as firmly interwoven with the Church. (23)

Herbert's canvas prefigures the adulation of the monastery which became confirmed in Carlyle's *Past and Present* of 1843. Herbert's canvas is certainly inspired by Pugin's *Contrasts* four years earlier, which, as Forbes notes, 'in plate after plate [contrasted] the ugliness and the soullessness of nineteenth-century England to the good life of the Middle Ages' (*Royal Academy Re-visited* 64). Herbert was converted to Roman Catholicism in the year in which the canvas was painted, giving it a personal as well as cultural significance.

If the monastery provided one kind of assistance, the element of rescue of those in distress continued to be a key element of chivalric iconography, as in Walter Crane's *The Laidley Worm of Spindleton Heugh* of 1881. Crane's canvas is a perfect exemplification of the triumph of masculine chivalry over female venality, as revealed by the description of the canvas in *Grosvenor Notes*:

> The Laidley Worm of Spindleton Heugh is a Northumbrian ballad. . . . The Lady Margaret is transformed into the Laidley Worm by the malice of a wicked step-mother and the arts of certain witch wives. The Worm devastates the

country, and word of its ravages goes over the sea, whence a knight (the Childy Wynd) voyages, and landing at Budle Sands, reaches Spindleton and goes to meet the worm. . . . In the end the lady regains her natural shape, and they ride off together to Bamboro' Castle, to oust the step-mother, who is finally transformed herself into a toad. This episode (of the riding away) is shown in the picture, as also another, the witch wives trying by spells to destroy the good knight's ship. (41)

Crane's canvas is a narrative triptych, with the arriving ship on the left, the transformation of the Lady in the centre, and the ride to the castle on the right. The erotic nature of the conquest is conveyed by the knight kissing the emerging nude female, again deploying the juxtaposition of naked female flesh against male armour. Female venality is signified by the serpent nature of the Lady prior to her rescue.

Another rescue scenario with chivalric connotations is Holman Hunt's 1851 *Valentine Rescuing Sylvia from Proteus*, taken from Shakespeare's *Two Gentlemen of Verona*, which shows the armoured Valentine rescuing Sylvia from his friend Proteus, who had attempted to violate her. The violence of Proteus's assault is marked by his cap on the ground. The defeat of his aggressive sexuality is marked by his sword resting on the earth. Valentine, in contrast, is standing, his moral uprightness signified by his armour and chain mail. The contrast of masculinities in this picture is paralleled in a different manner several years later in William Shakespeare Burton's *A Wounded Cavalier* of 1856 (Plate 3–19). Set during the Civil War, a wounded Cavalier (or royalist), whose dispatches have been stolen and whose sword is broken, lies on the ground tended by a Puritan woman, as her censorious brother or husband, holding a mammoth Bible, observes his political opponent. A spider has woven a web between the sword and surrounding brambles, suggesting that the Cavalier has been here for some time. Burton intends the viewer to sympathize with his armoured Cavalier rather than with the Puritan, as the woman's gaze and the fallen Cavalier's light hair attest. In such Pre-Raphaelite subjects as *Valentine Rescuing Sylvia from Proteus* and *A Wounded Cavalier*, the armoured male embodies, whether in victory or defeat, the lofty ideals of chivalry. In both paintings, the contrasting masculinities, the latter in historical circumstances, juxtapose the preferred to the denigrated variant, with the chivalric paradigm superior.

Various elements associated with knighthood were emphasized during the century to indicate the *rite de passage/Bildungsreise* components of the chivalric life. A. Chevallier Tayler's 1903 *Benedictio Novi Militis* [Blessing of the New Soldier] shows the investiture of a new knight by a bishop. Tayler emphasizes the tradition of knighthood by the tomb and effigy of an earlier warrior in the background. The notes prefacing the *Royal Academy Pictures* volume of this year claim:

> This is a service (the blessing of the young soldier) much in vogue in mediaeval times, and is still used in the Catholic Church. The subject is taken from the *Pontificale Romanum*. (iv)

As with much of this painting, scale aggrandizes the subject, in this instance a canvas, without frame, measuring 72 × 44 inches. Campbell Taylor's *The Young Knight* of 1907 depicts a youthful warrior after his investiture by the bishop seen against the stained glass window of the chapel in the distance. As he passes the monks and nuns in the choir, he glances at a tomb effigy, which permits Taylor to encompass the past history of knighthood as well as its present and future in the new member of the order. Edmund Blair Leighton's *The Dedication* of 1908 (Plate 3–20) shows a knight presenting himself before the altar, accompanied by his lady, prior to departing on a quest or war; his squire stands beside his dark mount outside the chapel door. Devotion, chaste love, commitment and courage are linked in a single image, as light filters through the stained glass windows. Canvases such as *The Dedication* or *The Young Knight* modelled paradigms of masculinity for the youth of England, with their inclusion in *Royal Academy Pictures* volumes marking the participation of the art establishment in the construction of masculinity during the era.

A later stage of the knight's life is embodied in John Gilbert's *Onward!* of 1890, showing an armoured knight on a rearing mount raising his standard to lead his comrades into battle. Gilbert assimilates his knight to Renaissance equestrian heroizing sculpture as well as injects dynamism into the construction of masculinity by the rearing steed. Solomon's *Laus Deo!* of 1899 shows a knight, under the guidance of a guardian angel, fording a stream as a lady sits on the opposite bank. In 1900 Solomon exhibited *Equipped*, showing a squire arming his knight in a stable. Stressed in this canvas is not only the transformation of the male body into a permanently defensive weapon but also the transmission of knightly codes from one generation to another, as the youthful squire learns the practices of knighthood by his service to his lord. It is possible that the scene represents an armourer's workplace, which reinforces this conception. Sheridan Knowles's *The Wounded Knight* of 1895 shows two monks rowing a wounded warrior as a maiden clasps her hands in prayer for him. Drawing on the iconography of the death of Arthur, Knowles generalizes the Arthurian model to include all chivalric males. Female devotion was marked that year with the simultaneous exhibition of W.E. Lockhart's *A Mirror of Chivalry*, depicting a lady seeing her reflection in her knight's cuirass. Nothing could make more evident the total dependence of women on the chivalric male, as the lady here can assume an identity only as part of the knight's equippage. Male dominance through the chivalric enterprise is epitomized in such a construction.

The degree to which the chivalric code modelled masculinity during the era can be precisely demonstrated from the example of Robert Baden-Powell and the Boy Scout movement. From its inception in 1908 Scouting aligned itself with chivalric codes to impress on its members an ideal of masculine behaviour inextricable from knighthood. In Chapter VII of *Scouting for Boys*, entitled 'Chivalry of the Knights', Baden-Powell

develops an ideology of knighthood in his Camp Fire Yarn No. 20: 'Knights Errant – Helpfulness to Others – Courtesy to Women'. It is valuable to cite extracts from this discourse, as the formative influence of the Scouting movement is beyond doubt. It summarizes the influence of the chivalric code as promulgated in the Victorian age and exemplifies its extension into the Edwardian era and beyond. Baden-Powell begins by evoking a romanticized distant past:

> 'In days of old, when knights were bold', it must have been a fine sight to see one of these steel-clad horsemen come riding through the dark green woods in his shining armour, with shield and lance and waving plumes, bestriding his gallant war-horse, strong to bear its load and full of fire to charge an enemy. And near him rode his squire, a young man, his assistant and companion, who would some day become a knight. . . . In peace time, when there was no fighting to be done, the knight would daily ride about looking for a chance of doing a good turn to any wanting help, especially a woman or child who might be in distress. When engaged in thus doing good turns, he was called a 'Knight Errant'. . . . The knights of old were the patrol leaders of the nation, and the men-at-arms were the scouts. . . . You patrol leaders and scouts are therefore very like the knights and their retainers, especially if you keep your honour ever before you. . . . (223–224)

'Chivalry,' Baden-Powell announces, ' – that is, the order of the knights – was started in England some 1500 years ago by King Arthur' (224). As Girouard notes, 'The origins of the code of chivalry are pushed back, with cheerful disregard of history, to the days of King Arthur, who is assumed to have been a real person living in A.D. 500. "The Knight's Code" . . . [is] ostensibly as laid down by King Arthur but in fact apparently distilled by Baden-Powell from Malory and Digby' (255). Baden-Powell announces that the knights 'had as their patron saint St George, because he was the only one of all the saints who was a horseman. He is the patron saint of cavalry and scouts all over Europe' (225). Baden-Powell establishes nine rules of chivalry, noting: 'These are the first rules with which the old knights started, and from which the scout laws of to-day come. . . . A knight (or scout) is at all times a gentleman' (225). These rules are epitomized by the first: 'Be Always Ready, with your armour on' (225). Chivalry to women is embodied in the person of King Arthur: 'King Arthur, who made the rules of chivalry, was himself chivalrous to women of whatever class' (230). At the conclusion of Camp Fire Yarn No. 20, Baden-Powell recommends as additional reading Scott's *Ivanhoe* and Digby's *The Broad Stone of Honour* (232).

In the next Camp Fire Yarn, no. 21, devoted to 'Self-Discipline', ideals such as honour, fair play and honesty are advanced around the chivalric standard. Loyalty is declared to be 'one of the distinguishing points about the knights. If [a man] does not intend to be loyal, he will, if he has any honour and manliness in him, resign his place' (234). Baden-Powell notes subsequently, 'The old knights, who were the scouts of the nation, were very religious' (242), surely evoking the images of knights in chapels

constructed by Pettie, Taylor, and many others. General Charles Gordon at Khartoum becomes the model of knightly observance of duty. The element of rescue noted so frequently in knightly iconography is incorporated into Baden-Powell's discussion of the Knights of St John; 'as a scout it is your business to be the first man to go to the rescue' (253). 'Scoutcraft includes the qualities of our frontier colonists, such as resourcefulness, endurance, pluck, trustworthiness, etc., plus the chivalry of the knights' (307) he declares, assimilating imperialists within orders of chivalry. An image of St George slaying the dragon is appended to Chapter IX on 'Patriotism' devoted to the empire (283). Marlon Ross observes, 'the age of chivalry may be gone, but the principles that made chivalry possible are the ones on which the modern nation-state must ground itself' (57). In the introduction to *Scouting for Boys*, Baden-Powell had asserted: 'In the old days the Knights were the scouts of Britain. . . . We are their descendants' (25).

It is important to recognize that not only were chivalric ideas promulgated in *Scouting for Boys*: they also constituted a primary component of a scoutmaster's training, as expressed in Baden-Powell's *Aids to Scoutmastership*, first published in 1920. A drawing of a knight guiding scouts appears on page 19 of this work, with the legend: 'The Scoutmaster guides the boy in the spirit of an older brother'. In the section devoted to character, a young knight is shown kneeling, gaze upwards, offering his sword to God as his helmet rests at his knees; the legend accompanying the sketch reads: 'The code of the knight is still the code of the gentleman today' (47). In this section of the *Aids to Scoutmastership*, Baden-Powell reiterates the ideas about chivalry expressed in *Scouting for Boys*. The rules are declared as originating at the time of King Arthur and 're-published in the time of Henry VII' (49). 'The romance of the Knights has its attraction for all boys and has its appeal to their moral sense. Their Code of Chivalry included Honour, Self-Discipline, Courtesy, Courage, Selfless Sense of Duty and Service, and the guidance of Religion. . . . The ideals of the Knights and the idea of fair play is above all the one which can be best instilled into boys' (49). In the summing up at the end of *Aids to Scoutmastership*, a youth in khaki shorts, obviously the successor to St George, is shown slaying a dragon, with the caption: 'With character and a smile the boy will overcome evils on his way' (94).

The intersection of chivalric coding as it applies to the construction of masculinity vis-à-vis the feminine is a central project of Baden-Powell's *Rovering to Success: A Book of Life-Sport for Young Men* of 1922, the handbook for the Rover movement, begun during the First World War in 1917, that became in the United States the Explorers. Baden-Powell isolates four temptations or rocks on which a young man may founder, one of which is Women, to which a long section of *Rovering to Success* is devoted. After discussing the nature of semen and the occurrence of nocturnal emissions ('The germ is a sacred trust for carrying on the race'),

Baden-Powell indicts masturbation and describes venereal diseases. In this chapter, the section devoted to manliness is led by a discussion of chivalry: 'You will, I hope, have gathered from what I have said about this Rock "Woman", that it has its dangers for the woman as well as for the man. But it has also its very bright side if you only manoeuvre your canoe aright. . . . The paddle to use for this job is CHIVALRY' (109–110):

> A man without chivalry is no man. A man who has this chivalry and respect for women could never lower himself to behave like a beast, nor would he allow a woman to ruin herself with him by losing her own self-respect and the respect of others. It is up to him to give the lead – and that a right one; and not to be led astray. . . . I have known such chivalry on the part of a man to give further than this, even to the point of raising a woman who had fallen. . . . Chivalry, like other points of character, must be developed by thought and practice, but when gained it puts a man on a new footing and a higher one with himself and with the world. . . . To be chivalrous he must put a woman on a pedestal, and see all that is best in her; he must also have sympathy for the weaker folk, the aged and the crippled; and he must give protection to the little ones. . . . For this he must use his self-control to switch off all that is impure from his mind and ensure that his own ideas are clean and honourable. (110)

Baden-Powell advises that Rovers will not masturbate and that they need not fear being impotent upon marriage if they so refrain; 'Save Yourself and Help to Preserve the Race' runs one subhead (113). Upon being married, 'You've got to show your manliness and chivalry as [your wife's] comforter and protector' (127).

In his summary of the rocks or temptations (Horses, Wine, Women, Extremists), the antidote to the rock designated Women is '*Chivalry* and health of mind and body' (201). The purpose of the Rover Brotherhood is also to preserve white maleness. The penis is designated 'the racial organ' (111) and one of Baden-Powell's drawings illustrating 'A White Man and a Man' juxtaposes a Caucasian male in shorts with a top-hatted simian-appearing individual (120). The Rover Brotherhood expands the chivalric ethos of *Scouting for Boys* to a specifically sex- and race-inflected valence. The mass circulation of iconography dealing with chivalry unquestionably contributed to the elaboration and dissemination of chivalric codes which eventually found expression in *Scouting for Boys*, *Aids to Scoutmastership* and *Rovering to Success*, particularly as Baden-Powell recognizes the value of illustration and iconography in all these handbooks. At least 120 reproductions of chivalric iconography had appeared in the series *Royal Academy Pictures*, volumes easily accessible, and that number of course only a part of the chivalric iconography exhibited during the period at the Academy or at other institutions such as the Grosvenor Gallery and the New Gallery.

As Girouard and others have demonstrated, the chivalric ideology survived the First World War, where it was deployed in recruiting posters, commemorative medallions, memorial statuary and stained glass windows. The lasting influence of this imagery in the post-war period is indicated by

several important canvases. In 1929, Robert Gibb exhibited *Backs to the Wall, 1918*, the title of which derives from General Sir Douglas Haig's famous Order of the Day, 12 April 1918:

> Every position must be held to the last man. There must be no retirement. With our backs to the wall and believing in the justice of our cause, each one must fight on to the end. (Fussell 17)

In Gibb's canvas, khaki-clad Scottish troops stand 'defiantly with their bayonets at the ready' (Harrington 595). Of particular interest, however, is the assembly of ghost knights in the sky behind the young infantrymen: Gibb assimilates the chivalric heroism of the infantry with that of their paradigms and predecessors of the past. As Whitaker comments: 'Despite the tragedy of war, chivalry as an ideal was not discredited in the post-war period' (313). Not far is the Icelandic Valhalla awaiting the men. As Fussell notes, however, the Order of the Day had an element of Hardyesque irony about it, as one corporal noted: 'We never received it. We to whom it was addressed, the infantry of the front line, were too scattered, too busy trying to survive, to be called into any formation to listen to orders of the day' (17). Gibb's *Backs to the Wall* therefore is a superb example of the construction of masculinity by reference to a chivalric paradigm in a contemporary battle context which in fact never occurred.

Frank Dicksee's 1921 *The End of the Quest* (Plate 3–21) is a summation of the themes of pilgrimage, adventure, conquest and chivalry that mark the chivalric sequence of 'medievalizing', masculinizing iconography. A returned knight, dressed as a pilgrim, kneels before an enraptured woman on a throne, an embodiment of Ruskin's queen from *Of Queens' Gardens*. Unlike Elizabeth, whom Tannhäuser finds dead, the woman in *The End of the Quest* prepares to rise and greet her beloved. The picture commemorates the First World War in that the pilgrim's hat resembles a soldier's helmet; it also acknowledges the legislators/warriors of the War. Added to this constellation of significances is the element of courtly love, 'the conception of the lover as pilgrim' (*Last Romantics* 121). Yet the man's brow is furrowed, perhaps with anxiety about this love or about the enterprise in battle which has engaged him. Nevertheless, the element of quest marked in the title links ideas of adventure and *Bildungsreise* in a manner recalling much Victorian iconography about the goals of knighthood.

A final image demonstrates the intention of imprinting on young males the ideology of chivalry – Frank Calderon's *A Son of the Empire* of 1899 (Plate 3–22), which gains particular point in the context of the Boer War and of the subsequent construction of chivalry by Baden-Powell in the Boy Scout movement. A rural lad hoists a twig to his shoulder in imitation of the lances held by the cavalrymen galloping down the road of his rural village. In the distance are four little girls, obviously isolated from and

excluded from the ideology exhibited before them. Behind them, even farther down the road, are more lancers. The four girls, diminished and recessed into the distance, are a stark contrast to the four lancers featured so prominently. As in Dicksee's *The Two Crowns*, the women cast the idolizing gaze on the males, thereby demonstrating Victorian hero worship. The village setting, furthermore, emphasizes the universality of the chivalric paradigm: marching infantry would not convey with this incisive force the construction of masculinity as well as could mounted lancers. The canvas is given particular point because the charge of the 21st Lancers at Omdurman in 1898 had made these men immortal. On their steeds, however, they become not merely contemporary knights but inheritors of the knights on chargers of the past. The scarlet 'frock' of the men's costumes vividly contrasts with the drab landscape. Calderon's *A Son of the Empire* anticipates the formulation by Baden-Powell of scouts as 'sons of the empire'.

An early text of the Men's Movement, Fasteau's *The Male Machine* of 1974, echoes Mill's *Subjection of Women* a century earlier:

> The male machine is a special kind of being, different from women, children, and men who don't measure up. He is functional, designed mainly for work. . . . His most important positive reinforcement is victory. He has armor plating which is virtually impregnable. . . . The male sterotype makes masculinity not just a fact of biology but something that must be proved and re-proved, a continual quest for an ever-receding Holy Grail. . . . In more urbane circles, men use subtler protective devices. Unwilling and, because they are human, often unable to avoid showing that they care about certain women as more than sex objects or ornaments, men have ritualized the gestures of deference and involvement. We call the system, what remains of it, Chivalry. . . . But, like all such solutions, chivalry doesn't really work. Ritualizing acts of courtesy depersonalizes them, destroys their ability to convey feeling for the particular person at whom they are directed. . . . Chivalry serves men better as a weapon. In situations with an undercurrent of hostility or bargaining, courtesies which force a woman into a position of having received consideration and personal favors put her at a disadvantage. Men can make chivalrous gestures without personal exposure, while women are expected to receive them as though they were personal and thus feel personally obligated. The woman 'owes' a response . . . the feeling of obligation is itself a burden. (1 2, 62–63)

If this transformation of chivalry and its semiotics of masculinity is being undertaken, it is the first genuine re-formulation of masculinity since the end of the eighteenth century. Laqueur details 'the . . . dramatic re-interpretation of the female body in relation to that of the male' which occurred in the later eighteenth century: 'a new model of incommensurability triumphed over the old hierarchical model in the wake of new political agendas . . . [a] grounding [of] the social and cultural differentiation of the sexes in a biology of incommensurability' (*Orgasm* 17–19). As an extension of the male body, as a signifier of masculinity, armour was the supreme device for constructing the male body as completely incommensurable with that of the female, especially if juxtaposed with the naked

female body. The iconography of chivalry and its construction of masculinity in nineteenth-century British painting is a legacy of this politicized biology that has endured for almost two centuries, attesting to the power of and empowerment by the discourse of pictorial representation.

Despite the fact that eight and a half million people had been killed in the First World War, Henry Newbolt, the architect of gamemanship for Victorian Britain in his poem *Vitaï Lampada* (1898), recorded on the signing of the Armistice: 'Think of the Fleet going up the Dardanelles – Think of the centuries – Think of chivalry victorious' (Girouard 293). Editions of *Scouting for Boys*, which quoted Newbolt's poem (290–291), long after the War continued to carry Baden-Powell's exhortation: 'You scouts cannot do better than follow the example of your forefathers, the Knights, who made the tiny British nation into one of the best and greatest that the world has ever known' (26). This ideal, as Baden-Powell noted, was accessible to all: 'A knight (or scout) is at all times a gentleman. So many people seem to think that a gentleman must have lots of money. That does not make a gentleman. A gentleman is anyone who carries out the rules of chivalry of the knights' (225).

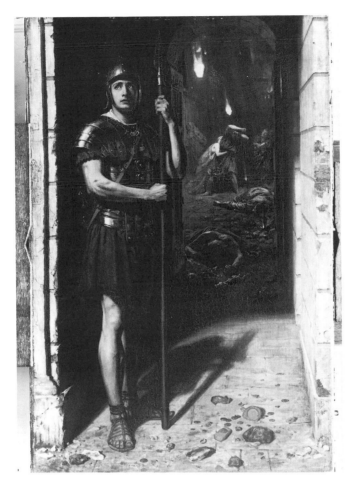

3–1. Edward J. Poynter: *Faithful Unto Death*, 1865; 45¼ × 29¾; National Museums and Galleries on Merscyside (Walker Art Gallery, Liverpool).

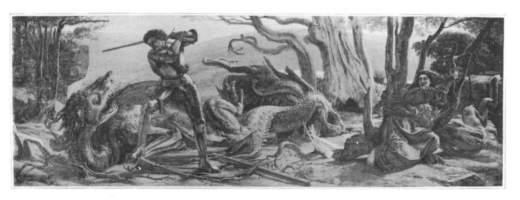

3–2. Edward J. Poynter: *The Fight between More of More Hall and the Dragon of Wantley*, 1873; 58 × 174; photo: *Art Annual* 1897.

3–3. Ford Madox Brown: *Cromwell and the Vaudois*, 1878; 31 × 37; City of Nottingham Museums; Castle Museum and Art Gallery.

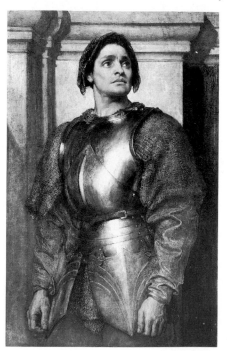

3–4. Frederic Leighton: *A Condottiere*, 1872; 47 × 28½; Birmingham Museum and Art Gallery.

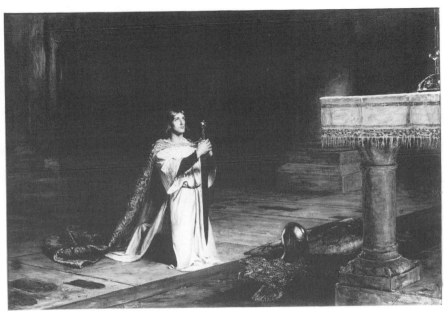

3–5. John Pettie: *The Vigil*, 1884; 46 × 66; Tate Gallery, London.

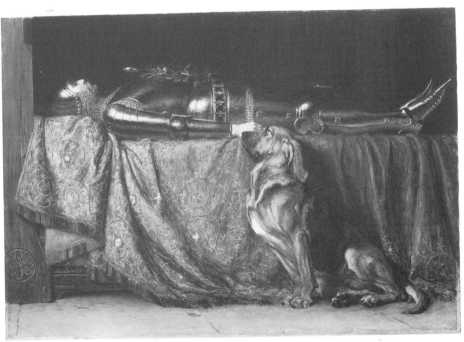

3–6. Briton Riviere: *Requiescat*, 1889; 25 × 35¾; The FORBES Magazine Collection, New York.

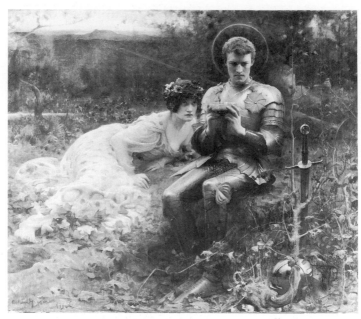

3–7. Arthur Hacker: *The Temptation of Sir Percival*, 1894; 52 × 62; Leeds City Art Galleries.

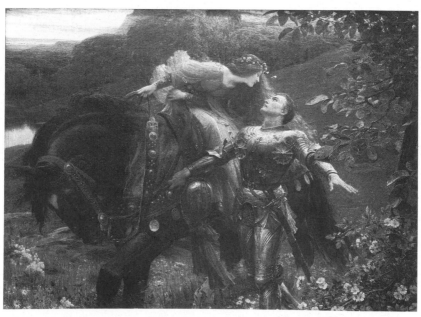

3–8. Frank Dicksee: *La Belle Dame sans Merci*, 1902; 54 × 74; Bristol Museum and Art Gallery.

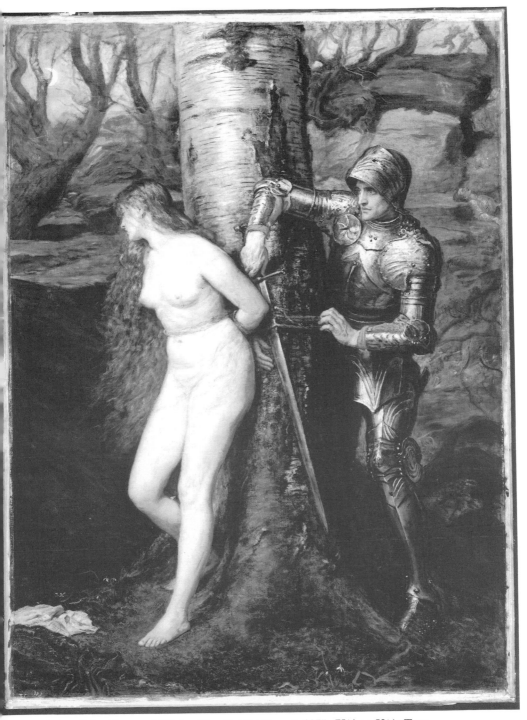

3–9. John Everett Millais: *The Knight-Errant*, 1870; 72½ × 53¼; Tate Gallery, London.

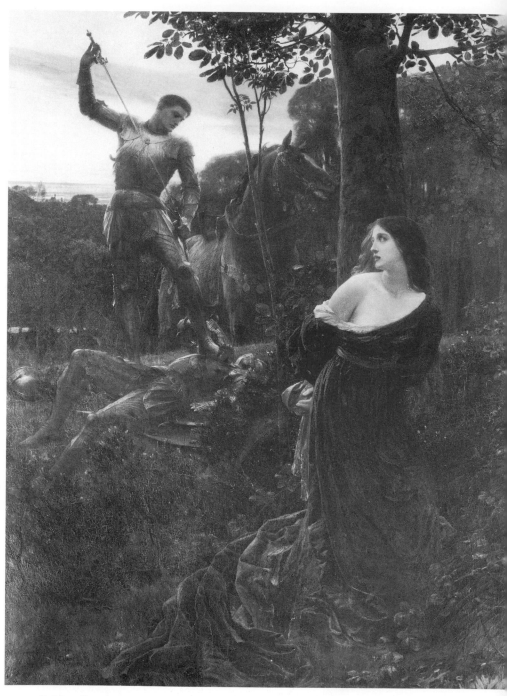

3–10. Frank Dicksee: *Chivalry*, 1885; 72 × 53; The FORBES Magazine Collection, New York.

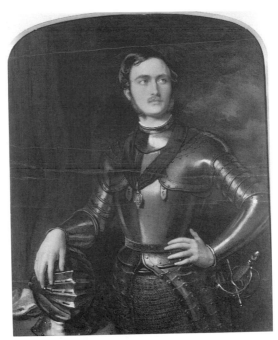

3–11. Robert Thorburn: *Prince Albert*, 1844; miniature; The Royal Collection © 1994 Her Majesty Queen Elizabeth II.

3–12. George Frederic Watts: *Sir Galahad*, 1862. 76 × 42; Fogg Art Museum, Harvard University Art Museums, Bequest of Grenville L. Winthrop.

3–13. Frank Dicksee: *The Two Crowns*, 1900; 91 × 72; Tate Gallery, London.

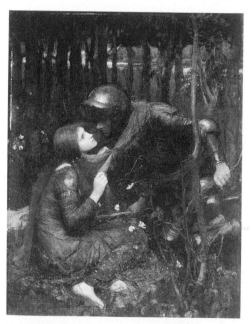

3–14. John William Waterhouse: *La Belle Dame sans Merci*, 1893; 44 × 32; photo: *Art Annual* 1909.

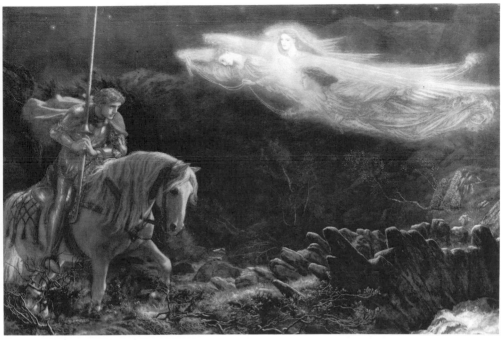

3–15. Arthur Hughes: *Sir Galahad*, 1870; 43½ × 65; National Museums and Galleries on Merseyside (Walker Art Gallery, Liverpool).

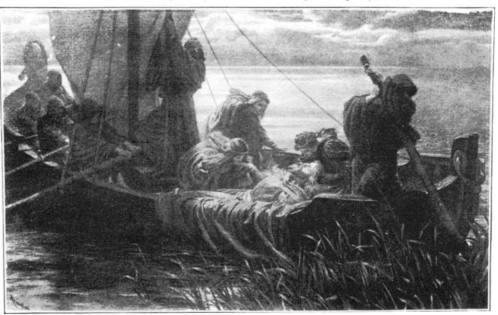

3–16. Frank Dicksee: *The Passing of Arthur*, 1889; 59 × 98; photo: *RAP* 1889.

3–17. Herbert James Draper: *Tristram and Yseult*, 1901; 54 × 84; photo: *RAP* 1901.

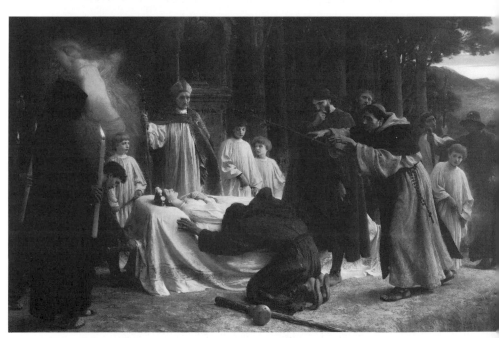

3–18. Frank Dicksee: *The Redemption of Tannhäuser*, 1890; 56 × 108; Christopher Wood Gallery, London.

3–19. William Shakespeare Burton: *A Wounded Cavalier*, 1856; 35 × 41;
Guildhall Art Gallery, Corporation of London.

3–20. Edmund Blair Leighton: *The Dedication*, 1908; 55 × 43; photo: *RAP*
1908.

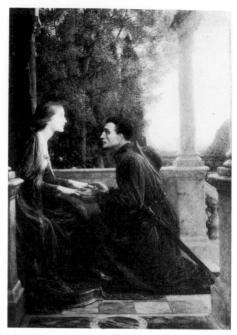

3–21. Frank Dicksee: *The End of the Quest*, 1921; 57 × 42; Leighton House Museum, London.

3–22. Philip Hermogenes Calderon: *A Son of the Empire*, 1899; 24 × 40; photo: *RAP* 1899.

4

The Challenged Paterfamilias

One of the most powerful constructions of masculinity in nineteenth-century Britain was the model of the paterfamilias, the man in the family unit required to be provider, lover, husband, supporter, moral guide, infallible authoritarian and unquestioned arbiter. The classic paradigm of the successful paterfamilias in the nineteenth century is:

> largely a portrait of worldly and practical fathers, of worldly and practical sons, sons who mixed well in school, won friends in clubs, gained promotion in army, navy and church, rose to power in parliament and ended ruling others both as statesmen and as fathers. . . . These rulers in turn imposed their paternal outlook and their independent temperament on every sphere of English society and on the farthest reaches of the British Empire. (Roberts 78)

This paradigm was most ideally realized in the strata of the upper middle class and the landed aristocracy, but, as Roberts suggests, some of its standards, particularly its paternalism and patriarchal attitudes, by which the paterfamilias was the dominant male in the family, became universalized. Roberts isolates three qualities – remoteness, sovereignty, and benevolence – which he states characterized the patriarch. Remoteness might depend not only on the father's own career and its arena but also on whether or not the male children were sent to school. More broadly defined, however, 'remoteness, physical and psychological, formed a prominent feature of many a nineteenth-century father' (62).

The element of sovereignty was secured by a man's 'personal charisma, patriarchal tradition, and bureaucratic authority' and such a paterfamilias 'expected deference' (63). Roberts notes that it was 'the father's prerogative to choose the son's profession and very few rebelled' (63). The consequences for wives and daughters meant that they:

> were even less inclined to question the sovereignty of the paterfamilias. They subordinated themselves totally to the wishes of the master of the household and by doing so won universal praise. (63)

Benevolence of course varied according to the man's resources and disposition. Under the press of Evangelicalism, as the century progressed,

many men added to the traits of the paterfamilias the 'admonitory' role (68), urging 'resolution, struggle, and manliness' through 'moral strictures' (69), which often meant 'the imposition on the child of a strong super ego' (70). If the father were not physically present, then the task of inculcating masculinity fell to surrogate fathers, above all schoolmasters and older boys: 'the boarding schools . . . carried on the father's value of manliness' (74). In such a manner, the Victorian father 'bequeathed to [his sons his] dominant social outlook, that of paternalism' (75). The consequence for society was decisive:

> The paternal authority of such fathers extended beyond the living-room of a nuclear family. It made paternal authority generalized, impersonal, and hierarchical; not intimate, confining, or enveloping. It formed a pattern of authority that was repeated in the public schools and universities, in the army and navy, and in the Church and local government. . . . Such a model provided the mid-Victorian governing classes with a paternalist social outlook. (76)

Males in Victorian society, even if they lacked the resources to take on all the elements of the paradigmatic paterfamilias, could nevertheless realize some of these qualities, such as the sovereign and the admonitory components of this model. Michael Gordon's examination of nineteenth-century marriage manuals and their depiction of the ideal husband, read by large numbers of middle- and perhaps even some lower-class individuals, found that there were 'two conditions more frequently encountered than any others: 1. the husband as the dominant partner; and 2. the husband as provider' (230). For most males, regardless of class, these dimensions of the ideology about the paterfamilias constituted desirable objectives in the realization of their masculinity.

It is in the situation of the paterfamilias, however, that the conflicting nature of paradigms for masculinity becomes manifest and exposed. Unlike men in mythical heroism, chivalric knighthood or committed militarism, the male in the family construction was required to interact intensely not only with other males but with women and children. Unlike the domains of the classical hero or the chivalric knight, which were often exclusively male, the space of the paterfamilias was heterosocial rather than homosocial. This interaction beyond all-male groupings exposed the conflictual masculine model by gendered, ageist, classist, economic and political oppositional encounters, over only some of which did a male have control or decisive regulation. The dominant fiction and the patriarchal paradigm were frequently exposed as fallible, untenable, dependent and ambiguous under the pressure of economic, sexual, political and class constraints that revealed the male's vulnerable rather than empowered condition, that signified his reliant rather than independent status, and that often showed his tenuous rather than certain control of social forces.

This gender conflict is particularly intriguing because representations of the role of the paterfamilias and his functions were predominantly painted by male artists, particularly the group of artists now denominated the

'social realist' painters of the period, most importantly Hubert von Herkomer, Luke Fildes, Frank Holl and Thomas Kennington. Social realist artists were simultaneously constrained by the gender expectations of Victorian patriarchy and defiant of its codifications of male and female behaviours. In their work, hegemonic masculinity was subjected to a scrutiny not acknowledged by artists concentrating on mythical, military or chivalric motifs. While the iconography of women in these canvases conforms to gendered notions of female helplessness, passivity or abandonment, males often appear feminized according to patriarchal conceptions because they were impoverished, destitute, unemployed, improvident or resourceless. Gendered conceptions affect both the content and the execution of such paintings. For example, artists depict a reversal of gendered roles in representations of men who were compelled, by the absence or death of a spouse, to become mothers to their offspring (Thomas Faed's *Worn Out* or Luke Fildes's *The Widower*). As women were granted greater protection through legislation, the balance of power in the family was disturbed (as in Orchardson's *The First Cloud* or Collier's *A Fallen Idol*). On the other hand, the grieving couple in Fildes's *The Doctor* conforms to patriarchal ideas of the stalwart husband and resourceless wife; in Herkomer's *Hard Times*, the male is standing, the woman prostrate from exhaustion. For many middle-class artists, nevertheless, lower-class males assume traits generally associated with the feminine: marginality, dependence and passivity. Class and gender confront one another in ways that expose the dominant fiction and the castration/exclusion of many men from patriarchal constructions of masculinity.

This conflictive representation of males in familial/domestic contexts resulted from the inability of men to control extra-familial forces which might have a direct impact on their domestic situation; for example the hazards of unemployment or the pressure to emigrate or the unrest in the colonies which might necessitate foreign service. In addition, however, another source of conflict was that the domestic sphere was perceived as peculiarly the domain of women, particularly as constructed by the ideologies of female domesticity and the Angel in the House. The formulation of this belief is most famously expressed in Ruskin's *Of Queens' Gardens* in 1864, the best known of the statements of the doctrine of 'separate spheres' for men and women:

> The man's power is active, progressive, defensive. He is eminently the doer, the creator, the discoverer, the defender. . . . But the woman's power is for rule, not for battle, – her intellect is not for invention or creation, but for sweet ordering, arrangement, and decision. . . . Her great function is Praise; she enters into no contest, but infallibly adjudges the crown of contest. . . . [The home is] the woman's true place and power . . . infallibly wise – wise, not for self-development, but for self-renunciation: wise, not that she may set herself above her husband, but that she may never fail from his side . . . with the passionate gentleness of an infinitely variable, because infinitely applicable, modesty of service. (18.121–123)

At the same time, Ruskin observed: 'We hear of the "mission" and of the rights of Woman, as if these could ever be separate from the mission and rights of Man' (119). Thus, while the woman was constructed as domestic, the male as public, the male was nevertheless to reign in the home. This conflicted situation is reflected, for example, in George Elgar Hicks' *Woman's Mission: Companion of Manhood* of 1863 (Plate 4–1), the second in a triptych treating woman's role, the others being *Guide of Childhood* and *Comfort of Old Age*. In this painting, a wife leans against her husband as a buttress does against a cathedral. Covering his face with his hands to hide his grief at the news learned of the death of a relative (note the black-bordered letter), he lapses from the traditional stalwart male behaviour. At the same time, however, his position as the dominant person in the home is conveyed by myriad details: the slippers provided by the wife, the domesticity of teapot and cup, the flowers on the mantel, and the wife's clinging albeit supportive stance. *The Times* (27 May 1863) noted that the triptych concerned 'woman in three phases of her duties as ministering angel' (6). The artist himself endorsed this ideology, declaring 'I presume no woman will make up her mind to remain single, it is contrary to nature' (Allwood 33). In *Myths of Sexuality*, Lynda Nead argues about this canvas:

> The woman's posture signifies a mixture of support and dependency. She looks up at her husband with concern in a pose which emphasizes the white curve of her neck. . . . Although the man is weakened, there is no hint of a shift of dependency; he checks and controls his feelings, she offers her support but at the same time confirms her subordination to him. . . . Norms of masculinity and femininity are constructed in this image. . . . The wife is smaller than her husband and her action is *responsive*; she is economically, legally, socially and ideologically dependent. (13–14)

Hicks deploys the Victorian convention of the narrative painting to construct an ideology about the male in domestic circumstances which conveys male supremacy even as it demonstrates that for the paterfamilias his function entailed a conflicting element: the title *Companion of Manhood* suggests that in this role the male could not act alone.

The failure to fulfil the male 'mission' in the domestic sphere could bring disaster on wife and children. In Robert Martineau's *The Last Day in the Old Home* of 1861 (Plate 4–2), an aristocrat addicted to horse-racing and improvident living has brought down his house, as Wood (1981) observes:

> This moral tale shows a feckless young aristocrat, who has gambled away everything on the horses, now drinking his last glass of champagne in the ancestral home. . . . Every object in the room has significance – the picture of horses, the auctioneer's lot numbers, the sale catalogue on the floor, the newspaper open at the word 'Apartments', the old mother paying the family retainer, who in turn gives her the keys. (72)

The canvas is startling in the manner in which it demonstrates the collapse of enduring ideologies, particularly those of chivalry: the tapestry adjacent to the mantlepiece, the suit of armour, the breastplates and helmet above the mantel, and the shrine at the left all represent the consequences of

abandoning the dominant ideology of chivalric behaviour. The portraits of ancestors glance in an admonitory attitude at the wastrel scion of the family. *The Last Day in the Old Home* clearly demarcates the male as leader, in this instance a failed one, and further underscores the precarious nature of woman's ostensible 'rule' in the home, which in the end amounts to a fiction. The canvas brilliantly aligns the traditional masculinity of chivalric standards and the consequences of a lapse from those constructions. As Stearns argues:

> Chivalry described only a small part of behavior in practice. It did not really cover the vital role of man as father. . . . Chivalric honor could easily degenerate into the petty and brutal defense of the family name, the protection of female purity into quick reactions to real or imagined abuse of sister or daughter. Chivalry did not really resolve the conflicts of manhood. (37)

Martineau's canvas illustrates the dilemma of the paterfamilias as the century advanced: 'But there was little thorough or explicit rethinking of what it meant to be a man, for the whole point of manhood was to provide an anchor amid change. Yet it was unquestionably more difficult for men to fit anything like the traditional image' (Stearns 78). In both *Companion of Manhood* and *Last Day in the Old Home*, the conflicted nature of the function of the paterfamilias becomes evident.

The representation of the paterfamilias in his range of behaviours was greatly influenced by historical events, many of which compelled males to confront the issues of economic and gender disruption heretofore conceived as incontrovertible. Renée Free has elaborated some of the more prominent components of the economic challenges facing males from the 1860s onwards:

> The 1860s saw the last cholera epidemic [albeit] life expectancy was only 46. . . . In 1867 the ship-building industry collapsed, leaving masses unemployed. Railway demolitions in the inner city led to the overcrowded poor becoming even more overcrowded. . . . The great gulf between rich and poor produced no true understanding of the social conditions, and the extent of social reform needed. . . . More demolitions in 1875 and 1879 for the railway increased the housing crisis. . . . The 1880s saw cyclical depressions every six or seven years, 1884, 1890. The winter of 1885-6 was especially severe. The West End was threatened in a riot of 1886. . . . The climax came in 1887, Bloody Sunday, November 13th. . . . With the 1889 Great Dock Strike, discipline won the support of propertied London. (4–5)

In addition, as Rodee notes, 'the depression which began in 1873 had grown severe by the end of the decade and did not finally end until 1896. Many cotton mills and iron foundaries shut down and even coal mining declined sharply. . . . Many prophesied that revolution was imminent' (167). Agricultural districts were assailed by the consequences of the Enclosure system, the absentee landlords, and the famines which hit Ireland in 1845 and 1846. The rapid increase in population throughout the century contributed to demands for government intervention even as others argued a laissez-faire position.

In addition to these economic pressures and constraints, the gradual granting of rights to women as the century progressed redefined the male as husband and lover: the dominance and superiority presumed to be constituted by possession of the penis and its symbolic presence as the phallus was interrogated or even relegated by scientific and legislative transformations in the culture. In 1843, for example, the vulcanization of rubber made the cervical cap popular; the condom became more durable and less expensive. In 1851, Harriet Taylor published her famous article on enfranchisement in the *Westminster Review*, and in 1854 books by Barbara Lee Smith Bodichon (*A Brief Summary in Plain Language of the Most Important Laws Concerning Women*) and Caroline Norton (*English Laws for Women in the Nineteenth Century*) informed a wide public about the legal construction of the woman. A series of acts began to transform marital relations. By the Matrimonial Causes Act of 1857, for instance, divorce became more accessible to the middle class, even though the grounds for divorce for men and women differed. However, a woman was no longer required to give income to her former husband. With the Married Women's Property Act of 1870, a woman became entitled to all the wages she earned and could retain her earnings after marriage; and by the Comprehensive Property Act of 1882, women became entitled to independent ownership of property, retaining the same property rights as unmarried women; the Matrimonial Causes Act of 1878 had provided for separate maintenance for the wife of a husband convicted of aggravated assault, and the Matrimonial Causes Act of 1886 gave a woman the right to sue her husband for maintenance. Information about birth control became more accessible after the 1877 Bradlaugh/Besant trial, with Annie Besant's *Law of Population* altering contraceptive practices for the middle class. The repeal of the Contagious Diseases Acts (1864, 1866, 1869) in 1886 represented the success of a concerted campaign by women to invalidate legislative institutionalization of the double standard. Of course, much of the legislation affecting women had wide repercussions on males, no more so than on the paterfamilias and his relations – sexual, authoritarian, admonitory – within the family. Paintings of the paterfamilias in his various functions, therefore, while completed almost exclusively by male artists, recognized the man in the family as a focus for contesting constructions of the masculine as much as a locus for the reinforcement of patriarchal ideologies. In particular, three dimensions of the paterfamilias paradigm drew the attention of artists in their representations: the worker/provider; the authority figure; and the husband/lover.

While the professional man drew the attention of artists, it was particularly the nature of lower class male labour that concerned artists. In canvases glorifying the male labourer, male artists often assimilated the working-class man to the ranks of patriarchal paradigms by representing his diligence, trustworthiness and integrity. Carlyle's exhortations about

the dignity of labour in 'Signs of the Times', 'Characteristics' and *Past and Present*, as well as Samuel Smiles's *Self-Help* of 1859, conferred a dignity on work which was often seen as crucial to the male as provider and citizen. A particularly vivid example of this construction appears in George Elgar Hicks's *The Sinews of Old England* of 1857, where the construction worker or navvy is shown departing from his wife as his little son imitates his father by digging with a toy spade. The navvy, in corduroy trousers 'secured below the knee with "yarks" '(Allwood 22) casts his gaze upwards, signifying his rigour, vitality and optimism. His wife is a working-class version of the Angel in the House as she leans against him. The wife clings to this paterfamilias like the ivy, symbol of constancy, clings around the wall of the entrance to the cottage. Wifely allegiance to the husband is also the subject of Joseph Clark's *The Labourer's Welcome* (date unknown). Reflected in the mirror, the young husband returns to the cottage, one well-ordered by the wife, who sits engaged in that quintessential female occupation, knitting. The tea items are set on the table in preparation for his evening repast. Lynda Nead notes the gendered modelling in the canvas:

> *The Labourer's Welcome* . . . presents a bourgeois view of the class below it but, as high art, it is intended for bourgeois consumption. . . . The theme of the return of the paterfamilias from work and the activities of the woman for his return was a common one in nineteenth-century representations of the home. . . . The picture places the audience in the same position as the man. Our view of the domestic interior is in fact his view also and it is from this position that the scene is made intelligible; we share the experience of beholding the preparation performed by his wife for his return. (38–39)

Of particular interest in the canvas is the print on the wall to the right of the mirror, which looks like it is of the canvas by Sir Francis Grant of Prince Albert painted 1843–45. If that is the case, then the ideology of the paterfamilias, set in the working class, painted for the middle class, evokes that of the Prince Consort himself. Here the standard of the paterfamilias transcends any class distinction to become universal gender marker.

An even more heroizing construction of the worker is Ford Madox Brown's famous and definitive *Work* (1852–65), a canvas much influenced by Carlyle's *Past and Present*. Brown's own description serves to emphasize the gendered nature of its construction:

> At that time extensive excavations, connected with the supply of water, were going on in the neighbourhood, and seeing and studying daily as I did the British excavator, or *navvy*, as he designated himself, in the full swing of his activity (with his manly and picturesque costume, and with the rich glow of colour . . .), it appeared to me that he was at least as worthy of the powers of an English painter [as other subjects]. . . . Here are presented the young navvy in the pride of manly health and beauty; the strong fully developed navvy who does his work and loves his beer; the selfish old bachelor navvy, stout of limb . . . the navvy of strong animal nature. . . . (*Ford Madox Brown* 19).

The central navvy, standing like a classical statue, evokes the worker as

hero model, but Brown's concern in the canvas is to depict a range of masculine types of navvies. To counterbalance this physical masculinity, he has placed studies of Carlyle and of F.D. Maurice, representatives of intellectual masculinity, to the right of the workmen. Brown's repeated use of the word 'manly' in his description of the canvas signifies its intention to incorporate the labourer and the intellectual into one rubric. As Vance notes, '*Work* . . . is the supreme manly Christian painting' (*Sinews* 6). This heroizing of the navvy could also involve a human dimension, such as is exhibited in Briton Riviere's *Giants at Play* of 1883; here 'three navvies in hobnailed boots lying on the ground during noon rest . . . [play] with a puppy' (Rodee *Scenes* 83). In this instance, the navvy is both god and man, as the title indicates.

Ford Madox Brown's *Work* elevates male labour as a component of masculine ideology. In William Bell Scott's *Iron and Coal: The Nineteenth Century* (1861) the gendered nature of labour is strongly codified. In a scene representing the iron industry of Newcastle, Scott includes many details marking industrial progress during the era: the air pump for the ship's engine, the anchor, a drawing of a locomotive, ironworkers making an anchor, the Armstrong gun on the left, the pit boy with his Davy lamp, telegraph wires, and Robert Stephenson's High Level Bridge completed in 1849. Such details emphasize the alignment of the canvas with the ideology of work in Carlyle's writings, particularly the glorification of the Captain of Industry in *Past and Present*. Paul Usherwood has demonstrated that the canvas is not a realistic depiction of an actual scene but an ideologically strong composite accumulation of details and buildings, conveying the idea that 'the North is an Other' (40). In particular, Usherwood notes the gendered ideology of the canvas:

> Newcastle is construed as emphatically masculine. This is a Newcastle which seemingly only values men's work. Women's work does appear, but it is hard to find: the activities of the fishwives and milkmaid on the Quayside are rendered so small as to be almost invisible and the work of the little girl in the foreground, in the shape of the midday meal on her lap which she has prepared for her father, one of the workmen, is wrapped up in a bundle and therefore hidden from view. The implication is that women's work is performed elsewhere, in a separate sphere. The little girl may be bodily present in the man's world . . . but clearly this is not where she properly belongs . . . she alone is idle . . . [Her presence] is to affirm the essential masculinity of modern industrial work and at the same time, by implication, the essential masculinity of modern Newcastle. (50–51)

In the canvas, the ironworkers with their hammers recall the classical prototype of Hephaestus/Vulcan at the forge, even as Riviere's navvies are 'giants at play'. In preparing the canvas, in fact, Scott visited Stephenson's railway engine factory, noting that 'wheels of welded iron were lifted out of the furnace red hot and four giants, "strikers" with mighty sledge hammers

strode round them striking in succession' (*Pre-Raphaelites: Painters and Patrons* 109).

In contrast to Scott's *Iron and Coal*, the celebration of rural labour is exemplified in Redgrave's *The Valleys also Stand Thick with Corn* of 1864 (Plate 4–3), the title of which echoes the 65th Psalm. Redgrave constructs the paterfamilias as a priest hailing the harvest, evoking the myth of the countryside as pastoral/idyllic discussed by Payne, the wheatfields replete with biblical associations, especially during the harvest (39). The stooks moving diagonally into the distance construct the landscape like the nave of a cathedral. The religious associations are confirmed by the man in the distance raising both his arms, as well as by the flocks of birds, which represent the souls of men following John Linnell's conception of the harvest as 'that glorious type of the everlasting Harvest of spirits' (cited in Payne 39). Redgrave constructs a rural priesthood, the father's back being turned on his wife, small children and son, all of whom are outside the sacred precinct. The curls of smoke rising in the distance signify again this sacerdotal role of the paterfamilias. If one follows Barker-Benfield's contention that 'impregnation could be as much a way of controlling woman as castration' (357), then an additional element of gendered power exists in the canvas. It becomes a representation of the 'accumulation of power, representing the three conquests of self, woman and nature . . . the fantasy of self-reproduction, the climax of male claims to self-marking' (358). Redgrave's canvas not only exemplifies the 'linking [of] manhood and work' (Stearns 52) but also constructs the working-class male's labour as part of the dominant fiction. Distinctions of class are surmounted by the dynamics of gender empowerment.

In 1858, by one of those strange coincidences in the history of art, two canvases, both of the same subject, were exhibited at the Royal Academy, John Brett's *The Stonebreaker* and Henry Wallis's untitled canvas of the same subject. As Lionel Lambourne notes, both canvases may owe their inspiration to a work by Edwin Landseer, *The Stonebreaker and His Daughter* of 1830:

> The theme was a topical one for since the late eighteenth century the road system of the country had been dramatically improved by the work of Telford and Macadam, improvements accomplished not with sophisticated modern earthmoving techniques but by the physical labour of stonebreakers and navvies. (2)

In Brett's canvas (Plate 4–4), a youthful boy is 'kapping flints on Box Hill, Surrey, while his dog plays nearby' (Lambourne 3). A milestone reads that it is 23 miles to London. While the canvas is often construed as happy, a minute investigation of the boy's face reveals it is frowning, not only from the glaring sun but from the backbreaking labour. To this end, the box tree is a major signifier: it is dead and clearly foretells the fate of the boy himself. David Cordingly notes that a recently discovered sketch for the painting has written 'to one side of the drawing . . . "The wilderness of this

world" and "Outside Eden" ' (145). In addition, Brett compared life and its human victims to crushed stone in several diary entries:

> I wonder what may be the history of every beggar, every poor old woman of 70 whom I see selling matches or tracts and think how the tempests have beat vehemently upon many a desolate soul whose whole self seems to consist of a mere shell of hard, earthy stones – how the pitiless arm of destiny seems to pick away with his pick-axe at the feeble structure of humanity. . . . [If a human being were] even to be known, appreciated, loved only by one pure spirit . . . there would be some hope of success here – the hearts [sic] blood would not flow away into an ocean or over a heap of flint stones' (Cordingly 145).

What is striking in Brett's diary entries is the merging of male and female worker and his clear recognition of the force of economics on gendered conceptions. In Wallis's canvas (Plate 4–5), which was exhibited with a quotation from Carlyle's *Sartor Resartus*, the stonebreaker has in fact died: a stoat on his right boot recognizes this death. The dead worker is clothed in the signs of his serfdom: smock, corduroys, highlows (a kind of boots). Unlike the sunlit landscape in Brett's canvas, Wallis exploits the pathetic fallacy with his autumnal background and sunset; in fact, the worker fades into the landscape, disintegrating before the observer's eyes. Even in a work such as Frederick Walker's *The Plough* (1870), which so influenced and stunned Gerard Manley Hopkins, the energetic drive of the plough-man is mitigated by his location in a landscape which dwarfs him; the stone escarpment emphasizes human transitoriness much as do the canvases by Brett and Wallis.

The male as provider becomes intensely problematized in the canvases about the unemployed, which began to appear during the 1870s onwards as a result of the depression, although such had been anticipated earlier. One of the few representations of the consequences – economic and gendered – of the Irish Famine is G.F. Watts's *The Irish Famine* of 1849–50 (Plate 4–6), painted during the great period of distress 1846–49. As Treuherz notes, 'Watts was depicting not just a starving but an evicted family' (*Hard Times* 28), and while its imagery links it with a *Holy Family* or a *Flight into Egypt*, its subject also is a brutally disabused male: with fists clenched, jaw set, eyes despairing, he is deaf to the importunities of his wife or the lamentations of his aged mother. His alienation is embodied in this very recognition that he is now no longer male at all: Watts records his resistance to assimilation to the feminine paradigm of passivity and resourcelessness. As in the Wallis and Brett, the stones signify not only his transitoriness but also the uncaring, bleak world he must confront. The tramping bundle at the man's feet become existentially signifying. Following this interrogation of masculinity in Watts, Luke Fildes's *Applicants for Admission to a Casual Ward* (1874) depicts a line of ruined, outcast men and women awaiting admission to a casual ward, where, for a bit of subsistence, they had to spend two nights and one day working in the ward, the last stop before the dreaded workhouse. Myers has analysed the

various accounts by Fildes of the origin of the canvas, which appears to have been derived from actual observation of such an event. The presence of the destitute woman in the foreground, while drawing the observer's eye initially, cannot obscure the range of destitute males against the wall: a man in a top hat in the doorway, a drunkard, a redundant mechanic holding his little child, a 'gutter' male child, a man in a Scottish cap, a thin stowaway, and a veteran leaning on a crutch; an unemployed clerk on the left registers his shock at this assemblage. The fact that the canvas contains more males than females indicates that in addition to chronicling this depressing situation, Fildes recognizes the shocking gender reversal of these men, now in a single file with women and thus as much marginalized as their female counterparts: the canvas does much more than reveal the inadequacies of the Houseless Poor Act.

Inspired probably by Watts' *Irish Famine* (exhibited for the first time only in 1881), Herkomer painted his famous *Hard Times* (1885) (Plate 4–7), showing the plight of the unemployed navvy, desolate along a roadway as his exhausted wife nurses their small child. As Edwards notes: 'The economic depression which began in 1873 worsened during the 1880s, and hundreds of workers "on-the-tramp" for the too few jobs available were a common sight' (1987, 96); Rodee (1975) notes that 'the bound tools and bundles of belongings make the meaning of the title clear' (97). The dreary landscape, 'leafless trees outlined against the chilly sky' (311) reinforces the destitution and isolation of this group. The use of a 'triangular composition and . . . of a rushing perspective in the foreground' (311) is not only striking but serves to engage the viewer by the road's diagonal as well as emphasize the marginal status of the family. Some components of patriarchal gendering, however, remain: the woman's face is downcast, the man's uplifted; she is seated on the earth, he is standing silhouetted against the sky. The labourer's pose, like that of the central navvy in Madox Brown's *Work*, evokes classical sculpture to heroize the labourer. Thus, even though he is not the 'provider' at the moment, the labourer in the canvas still remains the 'dominant partner', in terms of both the subject and its composition. This mode of constructing gender is eschewed in Frederick Brown's *Hard Times* of 1886, which evokes both Dickens's novel and Herkomer's canvas. A labourer 'on the tramp', as his stick and bundle indicate, sits in a tavern staring into nothingness, while a girl warms herself at the fireplace. Rodee notes: 'The scene may simply show a moment of rest in the wanderings of another out-of-work navvy. Possibly, though, it was intended to show Stephen Blackpool, the doomed hero of Dickens' *Hard Times*, after his melancholy departure from Coketown to seek work' (1975, 103). Unlike Herkomer, who introduces an element of classicizing heroism into his worker, Brown avoids all suggestion of aggrandizement: his male is genuinely marginalized. Both Herkomer's *Hard Times* and Brown's *Hard Times* demonstrate the validity of Stearns' observation that 'manliness at work involved not only adaptation to rapid economic change

but responsibility for economic security that too often was beyond any mortal power' (63).

In Herkomer's *On Strike* (1891) (Plate 4–8), the gendered question is again confronted. Probably inspired by the Dock Strike of 1889, the canvas depicts a labourer standing outside the doorway of his flat, as his exhausted wife leans on him, holding a disgruntled child as a daughter stands in the background. The woman's face is tear-stained, the man's more confused than defiant, with his empty pipe signalling not only his destitute financial plight but possibly his impotence and castration at the collapse of the dominant fiction. Details such as the splintered doorstep suggest the marginal status of the labourer and his family. Still, as with Herkomer's *Hard Times*, the gendered paradigms retain some hold: the woman sheds a tear, not the male; the woman is linked with the child; and the man stands outside the domestic sphere which frames the remainder of the family. The yarks which bind the man's trousers recall those in Hicks's *The Sinews of Old England*, but a generation later the dominant fiction has become untenable. Dudley Hardy's *The Dock Strike 1889*, exhibited in 1890, shows the manner in which the fiction might be rewritten: not dominated by middle-class or upper-class notions, but rather constructed among the solidarity of men in labour protest. Hardy represents an actual event of the strike, the leader John Burns 'inciting his fellow workers to rally to the cause' (*Hard Times* 101), an action which did achieve results. In *On Strike*, Herkomer was to generalize the issue to suggest that older patriarchal forms of masculinity were being obviated. In this redefinition of masculinity, however, women were excluded: in Hardy's painting, a little girl is begging at the extreme left of the canvas, and in Herkomer, the wife must depend on the husband's actions for any clarification of her circumstances.

How sharp the contrast is between the dominant fiction of the workman and its collapse is demonstrated by a comparison of Frederick Walker's *The Old Gate* of 1869 with two paintings by Thomas Kennington, *The Battle of Life* (1887) and *The Curse of the Family* (c. 1892). In Walker's canvas (Plate 4–9), the navvy returning home passes the gate of a widow, who is seen exiting with her female servant. The widow's gaze is cast down before the sharp scrutiny of the navvy, whose posture deliberately echoes that of Polykleitos's famous *Doryphoros* from antiquity. With his spade substituting for the ancient spear, the man struts in masculine confidence, holding his filled pipe. Here, the male gaze empowers, the physical strength of the navvy constructs patriarchal gender notions. In the 1887 *Battle of Life*, however, all is altered: the carpenter father has been unable to find work and the entire family is ruined by poverty. A wife, older daughter and infant register his despair. Slumped in his chair, unable to stand, the male confronts the abyss between himself and economic independence. Even more harrowing is Kennington's *The Curse of the Family* (c. 1892) (Plate 4–10). A drunken man, after a brawl, lies on the floor next to an overturned chair, as his wretched spouse, forced to take in laundry, caresses her arms,

possibly beaten by the man, while the daughter huddles with a visitor. Not only is the male devoid of economic security; his inability to realize the dominant fiction, to be incorporated into the masculine paradigm, has bestialized him. Significantly, it is the wife who now stands – and must. Considering that her chances for divorce were unrealistic even if available, the dehumanization attendant on her husband's disintegration is evident. Kennington's is one of the few canvases in nineteenth-century British art which shows a drunken man in domestic surroundings, so cautious were male artists of depicting the depth of degradation this involved in so convincing a wreck of the masculine paradigm.

One consequence of this unemployment was vagrancy, which led to the exclusion of many males from all masculine encoding. The harsh consequences of the Irish Famine and later of agricultural and industrial depressions meant that many citizens were forced to confront men and women who had no fixed abode and no certain occupation. Vagrants were often represented in family groups, which increased the observer's awareness of the male's inability to conform to the gendered paradigm of provider. In Walter Deverell's *The Irish Vagrants* (1853–54), Deverell confronts not only the problem of unemployment but also that of immigrants who had come to Britain. Holman Hunt recorded that Deverell was deeply moved by the plight of the poor as a result of reading Carlyle and Kingsley. In the canvas, an Irish family slouches by a road, the father resigned and dejected, the mother angry as she watches her offspring, who beg off a lady who ignores them. Although the field beyond reveals harvesting in progress, these labourers are unemployed. Deverell leaves open the question of whether ethnic prejudice has further displaced these individuals. Here an entire family has been marginalized, with the father incapable of approximating the role of provider. In Frederick Walker's *The Vagrants* (1867), a group of women and children surrounds a sputtering fire; there is no family patriarch visible. With this absence of adult males, Walker conveys not only the destitution of his gypsy wanderers but also the ability of some men to avoid such outcast status. Walker nevertheless endows his figures with ennobling attitudes: the mother in the middle is a variant of the Madonna and Child, while the woman on the right echoes the caryatids of classical Greece. The youth on the left, the only resourceful male in the canvas, reflects in his bearing both endurance and resignation. Walker had depicted two males, an old blind man and a youth, in the 1866 *Wayfarers*, so perhaps their exclusion in *The Vagrants* was intentional. Certainly Walker was aware of the disruption to conventional notions of masculinity experienced by such outcast males, and in neither picture does he offer any solution to their plight.

No image of the destitute so encapsulates this transitional nature of masculinity more than Dudley Hardy's *Sans Asile* of 1888 (Plate 4–11), unquestionably the most intense construction of destitution in Victorian art. The canvas records a period in 1887 when, according to *The Times* (10

November 1887, 7) the homeless 'turned Trafalgar Square into a public dormitory'. In the dawn light, men and women, some of whom are so cadaverous as to resemble corpses, gradually awaken to another day of living hell. A.E. Johnson notes:

> Sombre and gloomy, it is in strong contrast to the opulent colour which is so characteristic a feature of many of Dudley Hardy's paintings; but though it does not reveal the wealth of his resources as a colourist, it exhibits very finely his power of composition, the restraint imposed by his nicely balanced sense of drama, and his deeper qualities of sympathy and humanity. . . . *Sans Asile* was quickly famous. Admiration was compelled by the subtle strength with which the grim tragedy of its subject, so easily reft of poignancy by a false touch, was handled, and admiration was not withheld. (20, 22).

In contrast to the individuals in *The Irish Famine*, *The Vagrants* or *Wayfarers*, the outcast in *Sans Asile* are located not in the country but in the heart of the city, beneath one of Landseer's lions commemorating the triumph of Britain over Napoleon. Hardy politicizes the plight of these outcasts in a manner neither Deverell nor Walker pursues. Distinctions of gender are rendered nugatory here; neither men nor women have any destination, and economics has made these males as marginalized as women. Unlike his canvas *The Dock Strike*, Hardy cannot show these men in a group exerting political force. In *Sans Asile*, politics itself has no meaning when such abject starvation becomes the only consideration. Claude Phillips, writing of *Sans Asile*, grasped this intention by Hardy: 'The miseries of today, on the other hand, are the results of the grinding action of mere things, mere conditions, the chance medley of a world of hard, involuntary and irresponsible forces. Victims of such pressures and such massive movements are the unfortunate who . . . were suffered to rest in the various English weather, under the paws of Landseer's lions. Their graceless limbs in accidental pose resemble death as much as sleep' (Rodee *Scenes* 228–229).

The challenge of assuming the role of paterfamilias is the subject of Frank Holl's 1869 *The Lord Gave and the Lord Taketh Away* (Plate 4–12), showing a young curate leading prayers as the family gathers around the modest dining table. Succeeding to the place once occupied by his father, the curate's face reveals the anxiety attendant upon becoming the head male of the household, as the frown on his face indicates. The title of the canvas derives from Job 1.21, but the actual inspiration was Dinah Mulock Craik's *The Head of the Family* of 1851:

> They gathered round the table – Lindsay sitting where she had presided for some years as mistress of her father's household. Opposite to her was that father's empty chair. Each glanced that way, and then all eyes were lowered. None looked up, and all kept silence as Ninian came in and took the vacant place. There was a pause – as if each waited for the ever-silenced voice; and then Ninian, in his low, quiet tones, said the grace: 'Lord, we thank thee for these and all thy mercies; and forgive us our sins, for Christ's sake. Amen.' And all felt this to be the token whereby their brother took upon himself the duties,

responsibilities and rights of eldership, and became henceforth the Head of the Family. (*Hard Times* 75)

The aged mother at the left edge of the canvas must endure the reconstitution of the family so soon after the father's burial. The sailor brother and the curate's three sisters bow their heads to the inevitable. *The Times* (18 June 1869) noted an additional obstacle in the family's history: 'Everything indicates a long struggle of education and refinement with the most pinching poverty' (4). Holl was to limn the difficulty of the role of the paterfamilias again in the 1872 *I am the Resurrection and the Life*, depicting a man leading a funeral procession to the cemetery to bury his wife: his stupefied gaze records his grief, as does the black scarf around his hat. The loss of the mother is signalled by another mother and two children observing the funeral in the background.

In situations as untenable as those depicted by Herkomer, Kennington or Hardy, one possible resource would be emigration to the colonies or to America. A number of emigration societies, such as the National Benevolent Emigration Society of 1849, had advocated this procedure to relieve the poverty in Britain. By 1863, it was estimated that five and a half million people had emigrated between 1815 and that date (Edelstein 1979, 240), and it had figured in novels from *Mary Barton* to *David Copperfield*. A number of conventions govern such depictions of emigration, as Edelstein notes, such as the stormy sky and the inclusion of families as emigrants rather than the more normative single man or woman (242). By 1850, important canvases engaging the issue of emigration were appearing. James Collinson's *Answering the Emigrant's Letter* (1850) shows the family unit in a rural setting. The emigration motif is introduced by the map in the father's hand, which reads 'South Australia'. Presumably because the son can write, he is doing so as the family dictates the news. Key to the painting is the exchange of glances between husband and wife, who may be contemplating emigration. Details in the canvas indicate this is not a destitute family, although the man's furrowed brow indicates anxiety at the forthcoming decision: the blue and white china on the mantel and window sill; the silver on the mantel; baby's argyle socks, not the cheapest possible; and the Staffordshire objects clearly indicate the family is not impoverished. The gendered idea is contained in the medallion of the Madonna and Child over the mother's head, while the father's tools rest beside him. The caged bird may evoke the economic imprisonment of the family, nevertheless, as it was a commonplace for emigrants to write from the colonies that they felt like escaped birds in their new freedom. In Collinson's *The Emigration Scheme* of 1852, the conviction to emigrate is overt: the boy is reading the *Australian News* to the assembled family group. While the surroundings indicate the family is not destitute, the figure of older woman/mother on the left holding the head of a feverish or troubled girl indicates distress, while the perplexed look of the father in the centre appears to be embracing the idea of leaving Britain. Collinson's two

paintings reflect the dawning consciousness on the part of the paterfamilias that a decision must be made.

Often men would appear to have had no choice about emigrating. In Ford Madox Brown's *The Last of England* (1855), a middle-class male, his wife and infant child are seen on the deck of the *Eldorado* after their departure, with the white cliffs of Dover receding in the wake of the ship. Inspired by the departure of his friend Thomas Woolner for Australia in 1852, Brown included his own face as the husband, since he himself had contemplated such a move; the man's face registers the anger he feels at his status, while the wife appears more optimistic. The circular shapes – of the canvas, of the umbrella, of the couple's arms – construct another Holy Family, but Brown includes all classes of men: the cabin boy and the angry man shaking his fist. Edelstein notes the gender reversal in the design of the canvas: 'Ignoring the usual contrast of emotion between the partners, and the active role of the husband as comforter, Brown creates this moving symbol of family ties by this rhythm of interlocking hands' of the couple (1979, 253). Again, such a reconfiguring of gender is to be contrasted with a work such as Richard Redgrave's *The Emigrants' Last Sight of Home* of 1858 (Plate 4–13), representing a father raising his arms in farewell to his former friends in the village, scattered on a wide landscape. Here, however, the man and woman do not form so unusual a couple as in Madox Brown's canvas for, as Edelstein notes, 'his wife [is] seated beside him, not quite sharing his enthusiasm' (255). The male is constructed as still the commanding force in the family unit. Just as the male stands and the wife is earthbound in Herkomer's *Hard Times*, so too is the gendered distinction maintained in Redgrave's *The Emigrants' Last Sight of Home*. As Casteras and Parkinson suggest, the father may be a 'modern Joseph' with 'a carpenter's bag with a small saw in it' (138), thereby evoking the Holy Family. A striking peculiarity of the canvas, however, as these scholars note, is that the father 'does . . . turn his back upon' the family, marking his authority but also delineating his difference from the group. The father as paterfamilias guides the group but he is, by intention or inevitability, isolated. The poignancy of the landscape is that it strongly suggests its opposite, the sea which the family must cross to its new homeland, an often perilous, dangerous, and disease-filled excursion. It was also known that sexual profligacy aboard ship often led to the seduction of girls and women, something that was perhaps on the mind of the man's spouse in Redgrave's canvas.

The press of external circumstances on masculine paradigms is not more vividly illustrated than in the case of Scottish emigrants, where being male was no protection against the harshness of the 'clearances'. As Edelstein argues (1979):

There were major clearances of Highland land from 1782–1820 and 1840–52. . . . The clearances were particularly brutal. At their most extreme, cotters and other tenants were slaughtered because of their resistance or, in a less fatal

fashion, families were forcibly evicted, their household goods and the rare timbers for their houses, burnt before their eyes. (276–366)

In Thomas Faed's *The Last of the Clan*, 1865, 'the spectator is present on the boat drawing away from the harbour and gazing at the women, children and aged left behind' (Treuherz, *Hard Times* 43). An old man sits astride a pony while his granddaughter buries her face in her hands at his side; other villagers mourn and watch the departure of the young men and the able to the new world. The ruthlessness of Faed's dissection of the masculine paradigm is intensified by his principal focus being a clan leader, reduced to destitution from former masculine control, guidance, and authority. The same situation persists in John Nicol's *Lochaber No More* of 1883, where an old man gazes at the receding Scottish coast as his daughter weeps, bent over their luggage. As Edelstein notes, 'following the common representation, the woman is more visibly upset than the man' (281), although his stoicism may represent a repression of anger and despair, also gendered to be male. Dorothy Tennant's *The Emigrants* of 1886 maintains this same gendered demarcation. Frank Holl's *Gone* of 1877 shows a group of women standing amidst the steam of a train which has taken away their husbands, lovers and fathers. In Holl's canvas, the women are left resourceless and abandoned, the males, by virtue of their gender, permitted to 'explore' and migrate to new territories. The women must depend on the men's sending for them, an uncertain prospect, as Holl indicates by their alienation and concern.

In *Pressing to the West: A Scene in Castle Garden, New York* of 1884, Herkomer shows a group of immigrants newly arrived in New York waiting in the reception hall for dispositions of their cases. Italians, Jews, Swiss and Germans are scattered around the hall and on the floor. The central group displays a nursing mother (anticipating the woman in *Hard Times*) refusing nourishment from her husband, who implores her to eat lest she be refused entry to the United States. The mother's eyes are red with exhaustion and anxiety. Even as she prepares to nurse her infant, the mother refuses food herself, perhaps exercising the feeble control of her body that grants her a moment's respite from her husband's entreaties. The canvas, however, raises two other ideas. Most importantly, males were able, by leaving England, to reassert their masculine prerogatives in another territory. The fact of empowerment through gender was transported to the new country, so the dissent of the women in Redgrave or Herkomer may well register this awareness that even if such emigration is good for males, for women it will be merely a replication of their subordinate status. The canvas also intimates that in the colonies at least (if not in the United States), the imperial aura will permit white males to re-establish their hegemony over the natives if not over other whites. Thus, pictures of emigration are sites for contesting and interrogating gender but also for reasserting gendered privileges in a new mode of empowerment, colonization.

If individuals were not moved to emigrate and still confronted poverty,

another alternative masculinity might become operative, that of the criminal who from inclination or circumstance may engage in such behaviour, even from the motive of feeding his family. The convict or criminal was not generally a popular subject for fine art in the nineteenth century, but the potential for criminality figured extensively in fiction, particularly in sensational fiction and in the novels of Dickens. A few striking examples of this construction of male criminality serve to reflect its interrogation of that potential within the range of masculine proclivities. In the 1869 *Prisoners* by Briton Riviere, a peasant has been apprehended for poaching, having been wounded in the process. The man is confined in a bare prison, with only his dog for company. On the wall behind is a graffito of a man hanging from a gallows. As Rodee notes:

> Under an 1816 law convicted poachers could be transported to a penal colony for seven years and, until 1827, illegal hunters could be maimed with traps and spring guns. It was well into the century before poachers were regarded with much sympathy by the public, so that the subject was never common in English painting. (*Scenes* 52)

In Riviere's work, however, the observer of the canvas has been placed in the position of the judge or jailer, compelling one to examine the plight of men reduced to this stratagem to subsist. The graffito on the wall of a man being hanged underscores this interrogation. Considering that a depression was four years away, it is not surprising that in rural districts hunger was the implicit subject of the painting. The presence of the dog in the canvas forces the observer to wonder whether or not he or she would be more compassionate. *Prisoners* is disarming because it presents so starkly a construction of masculinity totally at variance with patriarchal ideal constructions; here the man is lower class, wounded, criminal, marginalized and outcast.

In *Newgate – Committed for Trial* of 1878, Frank Holl painted another harrowing construction of criminal masculinity. Holl described the setting in a letter:

> [It was] the part of Newgate prison, called the cage – in which prisoners whilst on trial are permitted at certain hours, & on certain days, to see their friends – on the inner side the prisoners are placed, & in the passage – their friends are conducted to them when their relations or friends are at once brought out – A Warden walks between the 2 gratings, who can hear and see everything that takes place between the friend & prisoner – It is particularly impressive for scenes of such pathos & agony of mind on both sides take place. . . . I shall never forget the impression it made upon me. . . . Prisoners of all sorts of crime were there – the lowest brutal criminal – swindlers, forgers, & boy thieves – all caged together, awaiting the results of their separate trials, & in one or two cases, the misery of their friends in seeing them in this hopeless condition, fell but lightly on their brains dulled by incessant crime. . . . (*Victorian Taste* 96)

The design of the work, with its sharp diagonal, draws the observer's gaze

into the canvas; the viewer becomes one of the visitors. The prisoner on the extreme left derives from an incident witnessed by Holl himself:

> A young wife was seeing for the first time her husband, a young man of good family, and who had filled a trusted position in one of the largest and most important banking houses. Falling amongst evil companions, he had been tempted to misappropriate a very large sum of money. . . . He was arrested, tried, and sentenced to five years' penal servitude. (Reynolds 144–145)

The man lunging at his wife and child, next to the embezzeler, is a wife-beater; the woman draws her child protectively away from him. In canvases such as *Newgate – Committed for Trial*, a threatening alternative masculinity – brutalized, disempowered, resourceless – was constructed, revealing a disturbing dimension of the influence of economics on the construction of masculinity.

The male in the family, if not disempowered by unemployment or poverty, was construed as a figure of authority in the family context. As Rose Tremain notes, this was true even if the family were working class: 'That the conditions in which the average working man was forced to sweat out his lifetime were little better, his pay marginally more realistic, and the hours he had to work often even worse, in no way mitigates the conditions imposed on the woman. At least in his own home the working man was absolute master' (10). The most important function assumed by the father, in addition to that of provider, was arbiter of moral justice and dispenser of sexual regulation in the domestic sphere. The representation of males in canvases constructing such regulation is problematical, for any depiction of the erring girl, fallen or falling woman, or straying wife inevitably entailed the participation of other men in her seduction and betrayal. Artists representing the plight of such women, and their surveillance and control by males enforcing moral prerogatives, had to confront male complicity in the moral dilemma represented, often making the picture one of conflict and ambiguity about masculinity rather than surety.

One of the earliest of such representations is Richard Redgrave's *The Outcast* of 1851 (Plate 4–14), depicting a Victorian patriarch sending his errant daughter and her bastard infant out into the snow beyond the domestic threshold. What at first appears an almost parodic instance of abusive male authority, however, is complicated by Redgrave by myriad elements of the composition: the weeping brother, who dissents from his father's actions; another daughter, presumably virginal, who nevertheless intercedes for her sister; and the print on the wall, which could be either Abraham banishing Hagar and her child or Christ and the woman taken in adultery. The presence of an incriminating letter on the floor is the catalyst for the father's wrath, but the attitude of the family to this exercise of patriarchal authority interrogates it rather than confirms it. Especially with the figure of the brother, one senses Redgrave's intention to introduce with the new generation a redefined sense of sexual blame, eschewing the double standard maintained by the father. *The Outcast* juxtaposes several

masculinities: that of the patriarch, that of the sympathetic brother, and, although absent, that of the seducer. The father's back is turned on his family, demonstrating both his authority and his isolation, even his alienation. *The Outcast* in its conflicting masculinities, therefore, appears to interrogate the sexual double standard. Keith Thomas notes that during the century there was increasing 'opposition to the double standard', particularly from 'the evergrowing current of what can only be described as middle-class respectability' (204), which censured promiscuity in both sexes. In Redgrave's *The Outcast*, this opposition is construed as a conflict of masculinities across generations, reinforced by the compositional isolation of the father/patriarch.

Canvases a generation later were to present this same investigation of and even rejection of the double standard, as males exhibited increasingly sympathetic reactions to the plight of 'fallen' women. Luke Fildes's *The Return of the Penitent* of 1879, for example, depicts a woman prostrate on the doorstep of her parents' house in the early evening while the villagers gather around her. Fildes originally intended to call the canvas *The Prodigal*, but Archibald Forbes wrote him:

> *The Prodigal* is not nice. . . . I can recall no instance of its being applied to an erring woman, and it is further indissolubly linked to the association of forgiveness, and even welcome, on return to repentance. (Fildes 55)

Forbes suggested the canvas be called *The Outcast*, perhaps to re-inscribe one reading of Redgrave's canvas. Clearly the idea of 'prodigal' and its link with ideas of forgiveness applied only to errant males as far as Forbes was concerned. Fildes certainly had a different intention in mind – that women should not be condemned according to the usual double standard of sexual morality. In the canvas, it is the man leading the dray horse who appears compassionate; the woman whose elbow indicts the returned girl indicates the females' moral censure, but the male does not share their reprobation. Herkomer's pupil George Harcourt in *Forgiven* (1898–99) showed the ultimate transformation of the husband to a man who receives back his erring wife. In her gaudy dress and cloak with red lining, the woman pleads before him; the husband, with chivalric blond hair, assists her to rise. The man, of course, is imitating Christ as the Good Shepherd, as the sheepfold in the distance indicates.

The Outcast, *The Return of the Penitent* and *Forgiven* represent the reconfiguring of the sexual double standard during the century. In other paintings of males as arbiters of moral judgement, however, the situation is less progressive or at best indeterminate. In Dante Gabriel Rossetti's unfinished *Found* (1853–59), a drover from the country has discovered his former sweetheart, now a prostitute, as he takes his calf to market in the early morning. The canvas abounds with symbolic details: the man's white smock, which turns him into a chivalric male; the cowslip in the man's hat, to emphasize the contrast between rustic purity and urban depravity; the

phallic bollard, symbolic of the woman's fall and potentially the sign of her rescuer; and the female heifer, caught in the net, going to its death, obviously symbolic of the woman, whose red hair, tawdry shawl, plumed bonnet and crouching posture all signify her moral lapse. It is difficult to determine whether or not the drover will take her over the bridge to rural purity or whether he will leave her near the cemetery to face her fate. Harcourt's *Forgiven*, which appears in some details to echo Rossetti's canvas, might be the optimistic response to it, but the male in *Found*, if embodying chivalric notions of female chastity as suggested by his white smock, may be inclined to leave the woman to her destiny.

One of the most important modes of interrogating masculinity in Victorian art was the problem picture, popular during the last decades of the century and into the Edwardian period. Such canvases frequently investigated the situation of the fallen woman in the context of the family itself. The prototype of such canvases is Augustus Egg's famous triptych now called *Past and Present* (1858), which records the fall of a wife and the consequences to herself and her daughters. Casteras explains the details of the first part of the sequence (Plate 4–15), showing a husband holding an incriminating letter in his hand as the wife lies prostrate before him:

> Felled by [her husband's censure], [the wife's] body points toward the door (reflected in the window), symbolic of her outcast status and forced removal from society. Swooning, she lies literally fallen, her arms braceleted with snake motifs emblematic of her transgression. . . . The fragile house of cards being built by the two daughters simultaneously collapses as the family's stability and respectability disintegrate. . . . In addition, the book that supports their card game is entitled '*Balzac*', and this French author was perceived generally in England as being a purveyor of immoral or amoral attitudes towards adultery. . . . [There are] other allusions to Eve's disobedience. . . . The woman has been cutting an apple. . . . Egg includes the other half of the apple, which is wormy and has, like the woman, symbolically fallen to the floor. (1987, 61–62)

Even the pictures aside the mirror convey moral ideas: on the left the expulsion of Adam and Eve, on the right Clarkson Stanfield's *The Abandoned*, of a ship in a storm-tossed sea. The canvas is a particularly vivid implosion of male authority in the family: while it is clear the man will be destroyed (his portrait is under the shipwreck), the canvas repudiates the absolutism of patriarchal moral codes. The male, as much as the woman, will suffer. In the second and third canvases, respectively, the daughters are shown alone in a room in reduced circumstances, while in the third part of the triptych the errant wife, now holding another infant, is seen outcast under the Adelphi arches. The last two panels are supposed to occur simultaneously five years after the events of the first canvas. The paterfamilias in *Past and Present* can no longer assume the certainty of his moral persuasion and power.

It is this ambiguity which will reappear in the canvases of artists later in the century. John Collier painted two such problem pictures with *The Prodigal Daughter* (1903) and *A Fallen Idol* (1913). In the former, a young

woman who has left her home, returns, dressed in a gaudily splendid costume to confront her aged parents. The mother arises at the sight of the daughter, while the father, who has been reading his Bible, stares, his head haloed by the lamp. The difficulty is, however, that this halo, which endows the male with authority, and the presence of the Bible no long guarantee the man's authority in the home, as the *Art Journal* recognized:

> The setting of [Collier's] scene is plainly suburban and middle-class, a commonplace, shabby-genteel room in which the prodigal daughter, dressed in showy finery, seems strangely out of place. . . . The picture is a curious commentary on heredity; it seems almost impossible that such a type of woman as the daughter who has gone defiantly her own way, could have sprung from surroundings so conventional and narrowly respectable. The artist, indeed, suggests a problem which offers scope for wide discussion. (1903, 175).

The *Art Journal* clearly wonders about the force of authority in the family, as did *The Times*:

> This is an English Magda – the runaway daughter of a quiet old couple, returning in her finery to her simple home. The details of the dramatic moment are a little difficult to understand; has she just entered the room, or is she leaving it, repelled? Is she telling a story, or has she told it, unforgiven, and is she about to pass out again into the night? These things want explaining, for a narrative picture ought to have no ambiguity. (2 May 1903, 13)

The ambiguity of the canvas, however, is Collier's point: it is no longer possible to conceive of 'blame' or 'guilt' according to the collapsing patriarchal model of the double standard. Moral authority must be reconstructed beyond the traditional idea of the 'fallen woman' and her 'inevitable' fate. In Collier's *A Fallen Idol*, a wife leans on her husband's knee asking his forgiveness, presumably for infidelity. The location of the conversation appears to be his study or the library, filled with texts of patriarchal tradition. Caught between the warm reddish glow of the fireplace on the left and the light from the desk lamp on the right, the husband appears indecisive, except that his right hand rests over hers, possibly a sign of forgiveness. It is evident from canvases such Harcourt's *Forgiven* and Collier's *The Prodigal Daughter* and *A Fallen Idol* that the male as moral arbiter was confronting situations which required revaluation. The use of the word 'prodigal' in Collier's canvas may be a response to the hesitancy experienced by Fildes when he altered the title of *The Prodigal* to *The Return of the Penitent*. By the time Collier paints his canvas in 1903, the word 'prodigal' may be used of a woman to imply forgiveness and thus renegotiation of the male code.

From this perspective, what is one to make of the canvases which depict the male seducer? Are they interrogations of the invalidity of the double standard? Are they merely admonitory to fathers, mothers and daughters? That their moral objective exists is certain, but what was that objective? In a canvas such as Alfred Elmore's *On the Brink* of 1865, the seducer leans out the window of a gambling salon in Hamburg, offering to salvage the financial fortunes of a woman who has gambled imprudently. The woman

holds an empty purse as he fondles his bulging one, which easily signify the vagina and the scrotum. Although the male's face is in shadow, the red glare from the interior and the gas chandelier construct him as Satan from hell. The woman's face, half in light and half in shadow, emphasizes her 'falling' status, as does the passion flower (signifying vice) surmounting the drooping lily (virtue) on the right of the canvas. As Casteras observes, the woman is 'on the verge of succumbing to the greatest possible degradation, not loss of property but loss of virginity' (1987, 61). The canvas certainly warns women against such men, but equally it constructs a female proclivity for 'falling' – following the stereotype of Eve. By the 1860s, nevertheless, arguments were raised that males were as responsible as women for sexual behaviour. A clear indictment of the male exists in William Lindsay Windus's *Too Late* of 1859, in which a former lover, now stricken with remorse, encounters a past lover, who appears to be dying. It is possible that the little girl gazing into his face is his illegitimate child. The remorse exhibited by the man is unambiguous, and the onus of responsibility clearly rests with the male. The man has caused not only the 'fall' of the woman but her death from consumption. The *Magazine of Art* (1888, 122) commented: 'The expression of the dying face is quite sufficient – no other explanation is needed.'

One of the most famous seducers in British art is the man in Holman Hunt's *The Awakening Conscience* of 1853, loosely derived from the plight of Emily in Dickens's *David Copperfield*. The canvas offers the possible reclamation of the kept woman, who rises from her lover's lap with the intention of leaving and reforming, as is shown by the exterior reflected in the mirror. Myriad details present the conflict of the situation: Edward Lear's setting of *Tears, Idle Tears* on the floor; the books with papier-mâché bindings; the cat tormenting the bird under the table; the absence of the wedding band; the glove on the floor denoting prostitution; the engraving of Frank Stone's canvas *Cross Purposes*; the woman's hair unbound at midday. The canvas carries strongly anti-aristocratic over-tones, constituting an indictment of males who maintain these *maisons de convenance*. *On the Brink*, and especially *Too Late* and *The Awakening Conscience*, veer toward an accusation against patriarchal constructions of sexuality that condemn women. It is possible these three works show masculine beliefs undergoing transformation, one that will lead in 1886 to the repeal of the Contagious Diseases Acts, the most glaring example of the institutionalization and legalizing of the double standard.

The querying of masculine authority in many of these canvases involving sexual themes could also appear in other manifestations either refuting the idea of masculine infallibility or demonstrating a blurring of gender identities that imploded patriarchal dichotomies. Males, for instance, could be depicted carrying out nursing functions previously considered the domain of women. In Thomas Faed's *Worn Out* (1868), for example, an exhausted carpenter in a barren garret has watched over his son through

the night. The father has placed the mat under the door to prevent drafts; he has set the candle so it will not glare in the child's eyes; he has read from the tattered book on the floor, and he has placed his coat over the child. The snow on the windowsill indicates how harsh and cold the room must be. In the absence of a mother, the male has assumed a domestic role. This same blurring of gender appears in Fildes's *The Widower* (1876). In a dark cottage interior, a working-class father 'in work clothes and heavy boots' (Rodee *Scenes* 86) bends over his ill or dying child, pressing its palm to his lips. The eldest daughter, taking the place of her mother, registers her concern, but the three other children cavort on the floor and eat, heedless of the tragedy occurring in the room. The fact that both *Worn Out* and *The Widower* show working-class males in such situations indicates the incipient disintegration of classist constructions of masculinity, as the *Art Journal* registered about *The Widower*: 'The man kissing his dying child is but of lowly kind, but the love in that kiss and the yearning in that look, place him on a level with the lordliest on the earth' (1876, 189).

Problematizing of males in the professional class in Victorian art also registers this renegotiation of codes of masculinity, particularly towards the end of the century and perhaps as a result of women's increasing access to education and learning, which made evident that intellectual ability was not gendered. In 1891 two canvases at the Royal Academy had related themes in their concentration on the medical profession, Luke Fildes's *The Doctor* and Frank Dicksee's *The Crisis*. Such canvases may have been part of the dialogue about medicine from the 1880s, which included the publication of Elizabeth Blackwell's *The Human Element in Sex*, arguing that sex was beneficent for women and that women had a sexual life; and the 1889 *The Wife's Handbook*, on birth control. The immediate stimulus for Fildes's canvas (Plate 4–16) was the attention of a Dr Murray to his infant son Philip, who had died on Christmas Day in 1877. As his son noted, there was also a formal objective to the canvas in addition to its narrative content: 'to record how dawn and lamplight would mingle' (118) in a single canvas. Also of interest is that Fildes 'acted the part [for the principal figure] for the guidance of future models' (118). The canvas shows the physician visiting a workman's home and pondering the fate of a child, who lies on a makeshift bed of two different chairs, as the anxious parents await the outcome; from the dawn light appearing in the window, this has been an all-night vigil. The canvas is in the tradition of the Victorian problem painting, for the result remains uncertain.

As Meyer has detailed, the canvas underwent various transformations from initial study to final canvas. In the original sketch, reproduced in the *Art Annual* of 1895:

> the figure of the doctor is less clearly defined, yet we can perceive that he presents a more casual and countrified appearance than in later studies. Indeed, the careless cut of his clothes causes him to blend in much more with the unpretentious interior as opposed to the sharp contrast presented later when he

wears a better tailored suit, and his hair and beard are more fashionably trimmed. Then too, the outline of a cloak over his shoulders suggests a brief visit. This contradicts [later studies] to which details have been added implying an all-night vigil. Also, some of the paraphernalia associated with a sickroom are not present in the *Art Annual* sketch which have been added to underline the background of the story in later versions. . . . In contrast to his surroundings, the doctor's attire has grown progressively more formal. No longer the country doctor, he now appears as the eminent Victorian physician. . . . Even his hair and beard color have been changed to a more distinguished grey. (160, 164)

The changes are of considerable interest in assessing the construction of masculinity in *The Doctor*: Fildes has increased the doctor's professionalism by altering his appearance and attire. He has also transformed the class relations of the physician and the parents; in the sketch the doctor was closer to the parents, perhaps, serving such country districts, a first-generation doctor of little repute. In the second, the highly professional man visits a cottage as an act of altruism, charity, and even of democratization. In an oil study now in the United States, there is no medicine bottle as in the final canvas, indicative of the still progressing engagement of the physician with the working-class family. In the final canvas, the man's all-night attendance indicates that class distinctions are obliterated.

There are, however, two males in the painting (presuming the child is a daughter). In the oil study, the features of the father are coarser than in the final canvas, where the features have been regularized and made more distinguished; in all versions the father has his hand on the shoulder of the wife, so the concept of male as protector and guide is confirmed along patriarchal gender lines for the working-class male. For the doctor, however, a crucial detail alters this masculinity: in the final version there are scraps of paper on the floor for prescriptions which have yet to prove their efficacy. The physician is in doubt rather than certainty as he maintains his vigil. Fildes accomplishes two objectives here: he assimilates the father to standard patriarchal constructions even as he queries the certainties of professional males in his portrait of the doctor. This process occurs as the class barrier is subtly levelled from early sketch to finished canvas.

This probing of certainty is advanced in the other canvas exhibited in the same RA exhibition, Dicksee's *The Crisis* (Plate 4–17), which remains even more in the tradition of the problem painting than does *The Doctor*. In *The Crisis*, a man contemplates a woman at the decisive moment of an illness; the viewer is uncertain about the woman's fate, whether she will die or survive. The association of the female body with death and disease was a component of the patriarchal construction of female sexuality during the century. Dixon notes of *The Crisis*: 'A recurring theme of Dicksee's work was to complement an ethereal, spiritually charged woman, with a more prosaic watchful male. He liked to bathe certain areas of painting in light or shadow to contrast the two aspects of human nature' (9). Significantly, if the woman in the canvas is dying, it is only when in that state that the

female can be spiritual, a paradox of Victorian patriarchal construction. In *The Crisis*, in fact, the light falls on the male's head; the woman's is in shadow.

Interpretation of this canvas rests on the problematic relationship of the observant man to the diseased woman. Is he the father, the husband, or the attending physician? If he is the physician, then his gaze is calculated; if he is the husband, the association of death with eroticism is connoted by the bed of both mortality and sexuality; if he is the father, the canvas signifies the paternal surveillance inextricable from patriarchal authority. Dicksee's ingenuity in *The Crisis* is to make all such interpretations possible, constructing three versions of masculinity, all problematized by the male gaze. The empowered male gaze in the canvas inscribes a scopophilia verging on necrophilia while connoting male narcissistic superiority, from one perspective, that of the husband. The element of surveillance is common to all three possible masculine roles, and the idea that women were less developed on the evolutionary scale is certainly also a possible component of the canvas. Still, in *The Crisis* as in *The Doctor*, the outcome of the attendance by the male is conflicted and ambiguous: the physician's care may be unavailing; the father's monitoring may prove futile; the husband's vigil may be inconsequential. The fact that the male is in the light may still introduce a heroizing dimension, but Dicksee cannot establish this correlation with assurance. Masculinity is in a phase of negotiation by the 1890s, and both *The Doctor* and *The Crisis* attest to this transition.

The third construction of the paterfamilias figure is that of the husband, and like the constructions of the worker and of the authority figure, this paradigm of masculinity will be increasingly interrogated as the century advances. The impact of the various Matrimonial Causes Acts (1857, 1870, 1878, 1882, 1884, 1886) undoubtedly contributed to the redefinition of marital relations as through legislation women gained greater independence within the married state. Canvases at mid-century appeared to reinforce traditional patriarchal notions of the wife's submissive behaviour to the husband, but as the century progressed, such representations became muted. The canvases of George Elgar Hicks, for example, reflect the mid-century attitudes which were to be gradually superseded. In *Changing Homes* of 1862, the wedding party has returned home after the ceremony; the drawing room setting is from the 1840s, and the presence of gilded furniture and, as Allwood notes, the absence of family portraits, shows the family is nouveau riche rather than titled (29). With her gaze focused on the flowers which are her symbolic equivalent, the bride casts her eyes down before her husband, for the time solicitous, as the bride's mother ponders the future. *The Times* sneered that the picture was 'intensely vulgar' (Allwood 29) and considered it debased Frith. The title reflects the ideology of mid-century, that the bride was a commodity transported from her parents' home to that of her husband, a commodification perhaps

suggested by the tawdry vase about to be broken at the extreme right of the canvas. Hicks' *Companion of Manhood* previously examined is the logical successor to the event recorded in *Changing Homes*. The patriarchal ideologies of Ruskin in *Queens' Gardens* and of Patmore in *The Angel in the House* appear in place in *Changing Homes*.

Canvases such as *Companion of Manhood* and *Changing Homes* demonstrate that marriage or, in Goux's terms, 'the exchange of women', is a 'function of masculine initiation' which establishes male supremacy:

> The phallus would thus be the more or less cryptic symbolic attestation that the masculine subject . . . is entitled to enter as a taker into the circuit of the exchange of women. . . . Men are in the position of *agent* of the matrimonial transaction, and women are in the position of *patientes* (or passive objects) of this exchange. . . . The dissymmetry between men and women is fundamentally given from this most archaic structure of kinship. . . . If only men are supposed to maintain a relationship with the phallus in terms of *having* . . . and women in terms of *not having* . . . this dissymmetry is the very same one which presides over the nuptial economy of exchanges . . . in which the male subject . . . establishes himself as an active agent in the transition of which women are the objects. . . . The original *coup de force* is in the assignation of the roles by which a dissymmetry is instituted between that which becomes the agent and that which becomes the thing of the agent. Man is the giver, woman is the gift. Man is the exchanger, woman is the exchanged. (63–65)

For the male, marriage entails the abandonment of incest, both maternal and sororal, in exchange for which an exogamous female is the thing granted for observance of this incest prohibition. The dissymmetry of marriage is particularly reflected in the legal situation of married women in the nineteenth century, who were rendered relatively powerless in comparison with the rights of the husband over his wife's body, their children and property.

This idea of ownership of the wife remains in later canvases, such as James Charles's *Signing the Marriage Register*, c. 1896. In this canvas, the sailor groom and the bride's father watch as the bride signs the register under the eye of the minister. Most noticeable in the canvas is the constellation of vigilant male gazes around the bride, who appears circumscribed by these male eyes as she transforms her identity by enrolling in the institution of marriage. Her movement from one home to another, and her submission to male control, are signalled by the artist in the details of the father's walking stick and boots nailing her dress to the floor. In the 1890 *Happy is the Bride the Sun Shines On* by James Hayllar, this same transference of the woman from father to husband occurs in a rural church. It is difficult to fathom the gesture of the groom, who is pulling on his gloves as the bride comes down the aisle: is he nervous, disengaged, regretful? Certainly it is only the women who seem interested in the procession. The weary minister on the right is totally uninvolved. In Stanhope Forbes's *The Health of the Bride* (1889), a small wedding party is attending the reception in the 'best room' of an inn. The bride's father rises

to give a toast, which is responded to by the standing sailor on the left. The bride looks down on her flowers as she had done in Hicks's *Changing Homes*, while the groom acknowledges the toast by his uplifted gaze. In Luke Fildes's *The Village Wedding* of 1883, a rural couple returns from the ceremony, the bride looking down demurely as she passes the neighbours along the way. The best man, a soldier, struts before the admiring adulation of the women and the bridesmaids on his arms. A woman tosses a shoe at the couple, most significantly, as Casteras notes: 'Slippers remind viewers of the ancient Anglo-Saxon practice of transferring "ownership" or custody of the woman from her father to her husband, by the handing over of a woman's shoe, a custom evoked by tying old shoes on the back of a carriage' (*Images* 101). In these scenes of rural marriage, masculine roles as defined by patriarchal tradition appear entrenched.

This is not the case, however, with the images painted by artists specializing in the problem picture. Of particular interest are such canvases by William Quiller Orchardson. In *Mariage de Convenance* of 1883, set in a Victorian dining room of considerable splendour, an older husband, a former roué, sits opposite his younger and bored wife, as a butler hovers over him to pour. The *Art Journal* commented:

> At one end of the richly-appointed table sits the young wife – ambitious, disappointed, sullen, unutterably miserable. At the other end sits the husband – old, blasé, roué, bored too, and the more pitiable in that he has exhausted all his feelings and has only boredom left. (1884, 210)

In this construction, the older husband – despite riches and splendid furnishings – cannot please the wife, who is clearly ready to exit the marriage. Masculinity as constructed by power, maleness, fortune, career would appear to be under siege in *Mariage de Convenance*. Unlike the depictions of rural marriages, it would appear that the husband in Orchardson is as much a commodity and item of exchange as is the bride. In 1886, when Orchardson completed *Mariage de Convenance – After*, this impression was confirmed. In this canvas the husband is 'staring into the unswept hearth, the table behind him laid for one' (Wood 1976, 35). The man's dress shirt is rumpled, and the bitterest irony is the lavish portrait of the wife dominating the dining room. With this detail, Orchardson indicates the reversal of gender roles within this marriage, as the woman continues even after her departure to control the man's existence. Perhaps, via a settlement she has demanded, it is possible she has diminished his income as well. In this commodification, it would appear the male has now lost in the transaction, which is what such 'marriages of convenience' were in fact. It is difficult to determine the extent of Orchardson's indictment of the male, but it is clear that his promiscuous past life, recognized by reviewers, has now been punished by the wife who abandons him. What would have been transgressive behaviour for a woman a generation before is now legally possible.

Two other problem pictures by Orchardson exemplify this reinvestigation of marriage relations in late century. In *The First Cloud* (1887), a young woman exits a Victorian drawing room while her exasperated husband stands before the fireplace. 'Both are in evening dress. Words have been spoken' (Hardie no. 49). When the canvas was exhibited, it was accompanied by a quotation from Tennyson's *Idylls of the King*: 'It is the little rift within the lute/That by-and-by will make the music mute'. Since this song is sung by Vivien in the poem, the crisis in the marriage cannot be a small one; the title foretells disaster. '*The First Cloud* was caricatured in *Punch* . . . with a quatrain which the husband, dressed as a painter, addresses to the departing back of his model (the wife)' (Hardie no. 49):

> Yes, you can go; I've done with you, my dear.
> Here comes the model for the following year.
> (To himself) Luck in odd numbers – Anno Jubilee –
> This is Divorce Court Series Number Three.

While the *Punch* quatrain raises a laugh, it also places the canvas in the context of the divorce laws and Matrimonial Causes Acts which had been appearing during the 1870s and 1880s. The threat posed by the new legal rights of the wife obviously has compelled Orchardson to rethink the male role as husband in a manner strikingly different from that conceived by Hicks or by the painters of rural life. The brilliant strategy of having the wife's reflection face the viewer confirms her new estimation of herself: in the mirror she sees no husband, only her own image. She confirms for herself the validity of her exit. In *Trouble* (1896) Orchardson pursues this exploration of marital relations. A wife, having thrown her gloves on the Empire table, turns either in rebuke or contempt towards the husband, who turns his face from her. As Hadfield notes, Orchardson contended that financial troubles had led to this confrontation, with the husband no longer able to give the wife that to which she was accustomed (69). Hadfield observes:

> It is, however, by no means easy to interpret the theme of the painting. Most viewers assume that it represents a marital disaster, for which the husband is responsible, and for which she is about to leave him. . . . Orchardson was, without question, a very upright, kind and good man, devoted to his family. But it does not necessarily follow that he did not harbour in his subconscious mind the same secret fears and apprehensions that were common to a large part of the strait-laced Victorian bourgeoisie. (69)

On the evidence of *The First Cloud* and *Trouble*, both of which deal with initial confrontations that imply disastrous results, Orchardson did indeed experience anxieties about the function of males in the novel climate of advancing divorce legislation. In these canvases, and in the sequence of the *Mariage de Convenance* paintings, he reveals that the masculine paradigm within marriage was exploding under the press of new judicial formulations which males could not ignore.

Studies of endangered marriages are sequels to earlier canvases which also examined the role of the male in courtship, which often was as

hazardous as the marriage which might follow. Two contrasting versions of the male in courtship paintings illustrate this question of male control. In Philip Calderon's *Broken Vows* of 1856 (Plate 4–18), a dark-haired woman grasps her bosom as she overhears her faithless suitor flirting with the blonde woman on the other side of the fence. As Wood (1976) notes, the broken promise was 'a fate suffered by many young ladies of the period, and by young men too' (81). In this instance, the jilted woman can only endure her pain. On the ground is a bracelet, presumably a gift from the faithless lover: 'The swain's offer of an unfurling pink rosebud, symbolic of his confession of love, is in contrast to the fallen piece of jewelry. . . . In this "breach of promise" subject the ivy wilts, emblematic of the diminishing fidelity of the pair' (Casteras 1987, 90).

In contrast with the male in *Broken Vows* one might consider the suitor in Arthur Hughes's *The Long Engagement* (1859) (Plate 4–19), a curate who cannot marry his fiancée Amy (her name is carved into the tree and is already being obscured by the ivy on the trunk) because his salary is inadequate. While the ivy signifies the couple's fidelity, the force of economic circumstances will probably prevent their union. The emaciated faces of both the woman and the man, especially contrasted with 'the burgeoning fertility of nature – including that of the procreative squirrels' (Casteras 1982, 80), reveals not only emotional but physical hunger. Hughes's *Long Engagement* constructs an image of a male disempowered by economic forces as a disruptive rebuttal to the more conventional empowered suitor in *Broken Vows*. To Hughes, the man as well as the woman may be excluded from marital contentment by financial pressures. In constructing the canvas in this manner, Hughes reveals his awareness of the degree to which masculine identity was inseparable from economics in the nineteenth century.

Frederick Wedmore in 1888, at the period in which Orchardson and Dicksee were painting, discussed 'Modern Life in Modern Art' in the pages of the *Magazine of Art*. Wedmore observed that the subjects in art were inevitably influenced by cultural transformation:

> The painter cannot arrest the changes that must be wrought by time, not necessarily upon work itself, but on the minds that are to understand it. . . . All he can do is to adapt his art to the new conditions, to the new minds, and in doing so there is much that his art must leave behind. . . . Paintings that are directly, and in the accepted sense, religious, are not those which have impressed our own generation the most strongly. Is it want of inspiration in the painter, or want of faith in the spectators; or is it rather the unwillingness of the contemporary mind to have continual recourse to themes which early masters have treated perfectly a thousand times. . . . The real historical painting of our time is the record of the characteristics of our life – its labour, its pleasure, its principal personages. . . . Sometimes, in the world of the imagination, the achievements of the past become a terrible burden. (77–78)

Wedmore's declaration may be taken as a manifesto for artists of the 1880s and 1890s whose work was compelled to transform its construction of the

masculine. Wedmore continues his argument that no artist can afford to ignore the present:

> And in art, perhaps, one of the best lessons to be learnt from the past is this, that nearly all the great art of the past accepted its own time and did not try to get out of it. . . . The bastard art had its day, and it had its charm. But which do we regard the most – that school of spurious idealism, or the real Dutch school which was faithful to the inspiration of the facts which were next at hand? We need hardly answer. . . . [Some will object that] contemporary life is so ugly, a poetical person cannot endure it. Contemporary life ugly! when natural selection has beautified the race, when the gymnasium has improved your figure. (78–79)

Wedmore's statements are intriguing, especially the manner in which he incorporates Darwinian ideas into his justification for turning to contemporary forthright representations of the present. He would almost seem to be encouraging Orchardson in his enterprise:

> The artist who goes into the street, into the drawing-room, or on the lawn, without the blinding and depressing burden of a tradition that is too strong for him, sees plenty that is worthy of record in the outward aspects of the life of to-day. In recording these outward aspects that his draughtmanship can seize he fulfills an appropriate service: he teaches the rest of us to see them – those of us who never *really* saw them till they were portrayed in his art. (79)

This emphasis, Wedmore argues, on the present is also part of the literary discourse of the era:

> Literary art comes to us, as in Browning, as in Walt Whitman, in new forms, refreshed with the later experiences, renewing its youth, and being . . . an alert guide for us to-day. A novelist like Thomas Hardy . . . gets away from the conventional view of things; avoids the eternal middle-class. (80)

Wedmore concludes with a peroration/exhortation to artists to follow the practice of poets and novelists:

> Well, in its due degree . . . pictorial art must follow that lead. It may transmute that which seems vulgar and trivial into the finer forms and warmer colours of its ideal world. But the real world must be its motive. That is its one chance. It must not, by its exclusive glorification of an idyllic state we know no longer, teach us that beauty and significance were in the past alone. . . . It must paint the atmosphere that rolls over our great cities. In its character-painting does it not show already that it is not hard to be interested in the modern physician, in the man of business, in the woman of society? In its draughtmanship of the figure it may learn, I think, more and more to take heed of and to chronicle those types of force and flexibility and serviceable beauty which, in our ideals of to-day, take precedence of those old types of ascetic reticence and timid restraint which were the ideals of the childhood of art, and of the childhood of the world. (80)

In this passage, Wedmore links the focus on and the renegotiation of the contemporary world as a primary exemplum of the meliorist hypothesis that the nineteenth century was the age that most illustrated the continual advance of culture and civilization. In noting subjects such as the physician or society, Wedmore would appear to be anticipating the work of Orchardson and Dicksee very directly. It is quite possible that both men

read so popular and influential a periodical as the *Magazine of Art* and took direct encouragement from Wedmore's endorsement of the modern life subject.

The perplexities and complexities of masculinity in marriage are demonstrated in conflicted forms in three canvases by Frank Dicksee, the master of the Victorian problem picture. In his 1895 canvas *A Reverie* (Plate 4–20), the focus is on the male gaze as it contemplates two women, one a spectral female wraith and the other a woman playing a piano. The canvas is an extraordinary probing of a male's sexual life while at the same time yielding few answers. Critical reviews were sharply divided about the relationship of the male to the two women. The *Magazine of Art*, praising its 'virile handling', called it 'a modern poetic scene of a girl at the piano, while her brooding husband (?) sees the memory rise behind her, ghostlike, of a former love' (244). Claude Phillips in *The Academy* described it as 'a lamplight scene in which a young white-robed lady is seen singing at the piano, while her father . . . dreams bitter-sweet dreams of the past, visible to him only: a diaphanous vision of one who long ago sang the song now heard floats through the air' (449). Dibdin regarded the man as the young woman's husband (14). The *Art Journal* noted: 'His wife, young pretty, undistinguished, and we may hazard, rich, sits at the piano' (171). The apparition may be of the first wife, a dead beloved, possibly a dead child, even a past mistress, while the woman at the piano might be second wife, first wife, or daughter. This range of alternatives reveals the possible gamut of a man's relationships with women in all respects except with his mother. It is possible that the wraith is only a figment of the man's own imagination. The possibilities of interpretation are manifold: is this a study of male narcissism? male double standard? male assessment of the dichotomous nature of woman (mistress/wife)? male regret at marriage? male propensity to deny the existence of women's physicality? male negotiation of castration by repudiating the castrated/lacking female body? male regret at seducing a woman (the wraith's hair is unbound)? male objectification of women? Dicksee constructs the canvas to activate these and other readings of the canvas. Central to its argument is the male gaze, a repetition of a device Dicksee had used in *The Crisis* of 1891. These readings may lead one to construe the canvas as an indictment of the double standard; a repudiation of arranged marriages; a statement about the disillusionment of men in marriage; an attack on the male's commodification of women; an expression by the male of regret at past sexual indulgence; or even as an argument for the liberalization of divorce. If the man caused or provoked the death of the wraithlike woman, the guilt could range from desertion to infidelity to his being the catalyst for her suicide. All of these interpretations are possible, and their very multiplicity indicates the degree to which by the end of the century the male's role in the family and his interaction with women was becoming problematized and conflicted in a period of transitional negotiation of masculinity.

Dicksee's exploration of this conflicted masculinity is presented the following year in his canvas *The Confession* (Plate 4–21), depicting a woman in a white dress facing a man in black, who stares at her while holding his shadowed face in his right hand. Again, contemporary reviews had various interpretations. The *Art Journal* described the painting as 'a somewhat painful subject, treated in a manner which, without being realistic in the ordinary sense, accentuates the melancholy motive. A wan, emaciated woman, in the last stage apparently of illness, is telling her story to a saddened man' (171–172). Dibdin gave it an entirely different construction: 'An agonised woman, writhing like Paula Tanqueray, unfolds a terrible tale to a man who sits listening sphinx-like', noting that this was a 'drama of modern life' (14). *The Studio* wondered: 'What can this *Confession* be? An avowal, a crime, or a love secret? After all, it matters very little, for the painting suffices, apart from the subject' (111). Twentieth-century males assume the woman is confessing a sexual sin to a husband or lover; women, on the other hand, wonder whose confession is represented.

Michel Foucault has provided insight into the cultural moment represented by Dicksee's *The Confession* in his analysis of the practice at the end of the nineteenth century of 'two modes of production of truth: procedures of confession, and scientific discursivity' (65). Dicksee's canvas is a pictorial argument along the lines suggested by Foucault's approach to nineteenth-century sexuality:

> Instead of adding up the errors, naïvetés, and moralism that plagued the nineteenth century discourse of truth concerning sex, we would do better to locate the procedures by which that will to knowledge regarding sex, which characterizes the modern Occident, caused the rituals of confession to function within the norms of scientific regularity. . . . [This was a process] combining confession with examination, the personal history with the deployment of a set of decipherable signs and symptoms. (65)

While acknowledging that relationships of power were an element of the confessional situation, Foucault argues convincingly:

> If one had to confess, this was not merely because the person to whom one confessed had the power to forgive, console, and direct, but because the work of producing the truth was obliged to pass through this relationship if it was to be scientifically validated. The truth did not reside solely in the subject who, by confessing, would reveal it wholly formed. It was constituted in two stages: present but incomplete, blind to itself, in the one who spoke, it could only reach completion in the one who assimilated and recorded it. . . . The revelation of confession had to be coupled with the decipherment of what it said. The one who listened was not simply the forgiving master, the judge who condemned or acquitted; he was the master of truth. His was a hermaneutic function. With regard to the confession, his power was not only to demand it before it was made, or decide what was to follow after it, but also to constitute a discourse of truth on the basis of its decipherment. By no longer making the confession a test, but rather a sign, and by making sexuality something to be interpreted, the nineteenth century gave itself the possibility of causing the procedures

of confession to operate within the regular formation of a scientific discourse. (66–67)

In Dicksee's *The Confession*, the relations of power are represented according to the tradition of the 'problem' picture, that is, there is inscribed an ambiguity, even an indeterminacy, in its configuration. There can be no doubt, however, about one element of the painting, as Foucault's ideas demarcate: 'Sex [in the nineteenth century] became a matter that required the social body as a whole, and virtually all of its individuals, to place themselves under surveillance' (116). In *The Confession* the man and the woman are one another's observers/monitors. In addition, the artist, and especially the viewer of the canvas, become part of this construction of multiple acts of surveillance. While marking a pivotal cultural moment, however, as Foucault suggests, *The Confession* nevertheless presents this moment as conflicted, contested, challenging.

Perhaps stimulated by Wedmore's suggestion in his essay in the *Magazine of Art* in 1888, Dicksee may have appropriated a literary source, Hardy's *Tess of the d'Urbervilles* of 1891, although the woman appears rather frail for Hardy's peasant victim. Since Dicksee conspicuously includes a wedding band on the woman's finger, it appears that the male gaze may signify masculine moral superiority and judgement. On the other hand, since the woman is in white and the man in black, since his face is in shadow and hers in the light, *he* may be the one confessing. The position of the man's hand in *The Confession* recalls that of the male's hand in *A Reverie*. Is the 1895 canvas the male's silent confession, the 1896 the man's or woman's spoken one? The nervous gesture of the woman's hands, and the equally distressed position of the male's right hand, indicate the conflictive nature of the representation of sexuality in the painting. The canvas seems to inscribe a series of dichotomies (male/female, black/white, shadow/light, hands separate/hands together) encoding a harsh separation of the male from the female, everything from a misunderstanding to a *mésalliance*. Will the man forgive the woman? Will the woman forgive the man? The indeterminancy of the constructed images replicates the indeterminacy of the culture about masculinity at the end of the century.

No answer is provided by a canvas Dicksee completed in 1924, *'This for Remembrance'* (Plate 4–22), depicting an artist in a turquoise smock painting a deceased woman – presumably his wife, to judge by the focus of the light on her wedding band. The man's gaze is directed not only at the corpse but at his own constructed visualization of her both in imagination and then on canvas, as the painting is undoubtedly meta-artistic. Dicksee painted the narrative in defiance of its commercial value, as he noted in a letter of 15 December 1924: 'I am fully aware that it is not what is termed a saleable subject, but some of my friends whose judgment I value deem it one of my best, but no doubt it is better suited for a public gallery than for a private house' (Walker Art Gallery Archives). From one perspective, the canvas is a summation of patriarchal constructions, with its very title,

echoing Ophelia (*Hamlet* IV. v. 172), recalling women's potential for madness (as males believed), while evoking the patriarchal construction of the diseased woman/invalid, as in *The Crisis*. In '*This for Remembrance*' the death bed, presumably also the marriage bed, links eroticism with death (as in *A Reverie*) but also memorializes the eroticism of death in several senses: the narrative subject; the reification of the subject in the painter's canvas; and the iconography of woman as death in Dicksee's *A Reverie* or *The Crisis*. '*This for Remembrance*' epitomizes the Lacanian notion of 'the link of the sexual drive to death' (120) in a specific manner: the narcissistic, gazing, dominant male, unwilling to tolerate the otherness of woman, in a necrophilic gesture wishes/desires her dead to inscribe her into his iconographic discourse where, desexualized and disembodied, he can dominate/possess her. The painter is endowed with god-like status in granting the woman artistic immortality, 'the artist as *alter deus*' in Kris and Kurz's conception (49), while exploiting her as an object and as a potential commercial product. In the painting, the male gaze of the artist is inscribed as the quintessential subject of artistic discourse itself, subsuming both male narcissism and male scopophilia as well as female objectification and commodification, with the male thereby conquering castration anxiety.

From another perspective, however, the canvas may equally record the genuine alienation of the male because of the loss of the female. The artist's gaze, eyes benumbed and red around the edges, may reflect the fissure in a valued relationship, one which leaves him to redefine his masculinity in isolation and *in extremis*. His resort to his canvas is the finest way he knows to memorialize his love as well as transform it into a timeless form. The fact that the painting has a genuine precedent in Léon Cogniet's *Tintoretto Painting His Dead Daughter* of 1843, a canvas Dicksee could well have known, indicates that an interpretation based on genuine passion and affection may be encoded in the canvas. Rather than the woman being commodified, the artist may himself be nothing but the commodified purveyor of canvas now that his sexual life has been extinguished.

All four of Dicksee's modern life subjects, constructed as problem pictures, encode the act of the male gazing. In these constructions he is also encoding the process not only of a canvas's creation but also of the observer's act, the process not only of artistic creation but of artistic appreciation: the male gaze in the canvas constructs the male gaze of the observer of the canvas. From one direction, these canvases signify male empowerment through the gaze, both in its scopophilic and in its narcissistic functions. From another perspective, the canvases are each so conflicted, so subject to myriad interpretations, so encoded with ambiguity, that the male gaze, rather than being empowered, is being sabotaged and deconstructed. In three and possibly all of these canvases, Dicksee constructs a paterfamilias, but the male as paterfamilias has been so interrogated since mid-century that Dicksee cannot state the parameters of this paradigm nor define its representation with any certainty. As

Stearns claims, 'manhood was beginning to change even in the later decades of the nineteenth century, as a result of a number of forces, including efforts by some men themselves to find new ways to relate to family life' (157). *The Crisis*, *A Reverie*, *The Confession* and '*This for Remembrance*' constitute separate discourses about the male as paterfamilias; they do not, however, either explain their narratives or together constitute a coherent declaration or affirmation of allegiance to an uncomplicated patriarchal construction of this dimension of masculinity. Instead, they serve to demonstrate that masculinity in the nineteenth century, especially at its end, became a focus for contestation, transformation and negotiation.

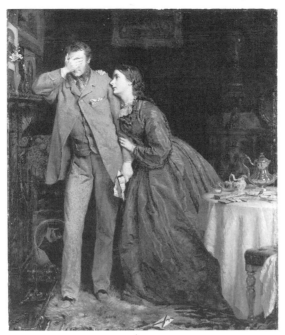

4–1. George Elgar Hicks: *Woman's Mission: Companion of Manhood*, 1863;
30 × 25¼; Tate Gallery, London.

4–2. Robert Martineau: *The Last Day in the Old Home*, 1861; 42½ × 57; Tate
Gallery, London.

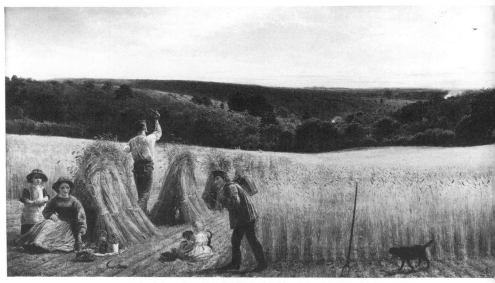

4–3. Richard Redgrave: *The Valleys also Stand Thick with Corn*, 1864; 28 × 38; Birmingham Museum and Art Gallery.

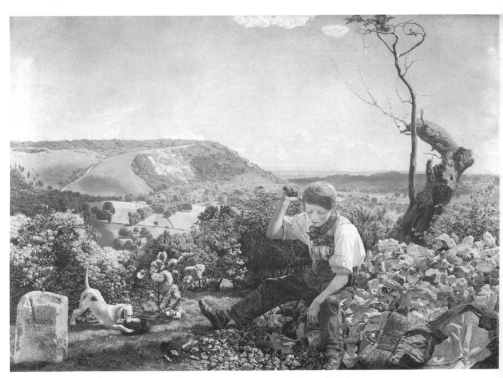

4–4. John Brett: *The Stonebreaker*, 1858; 19½ × 26⅞; National Museums and Galleries on Merseyside (Walker Art Gallery, Liverpool).

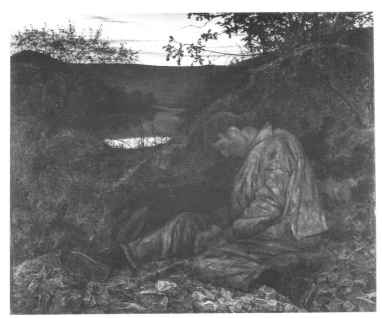

4–5. Henry Wallis: *The Stonebreaker*, 1858; 25¾ × 31; Birmingham Museum and Art Gallery.

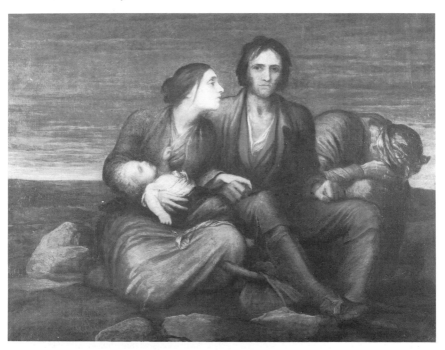

4–6. George Frederic Watts: *The Irish Famine*, 1849–50; 71 × 78; Reproduced by permission of the Trustees of the Watts Gallery.

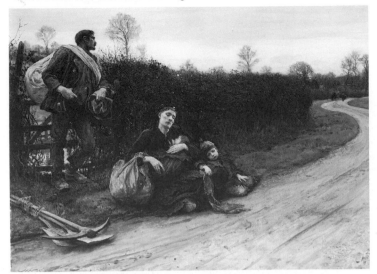

4–7. Hubert von Herkomer: *Hard Times*, 1885; 34 × 44; Manchester City Art Galleries.

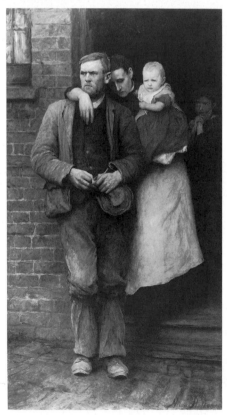

4–8. Hubert von Herkomer: *On Strike*, 1891; 89¾ × 49¾; Royal Academy of Arts, London.

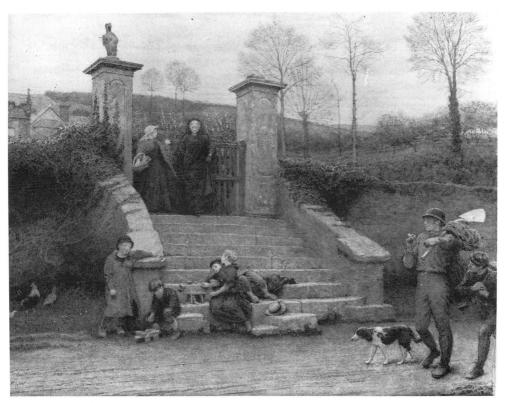

4–9. Frederick Walker: *The Old Gate*, 1869; 32 × 66; Tate Gallery, London.

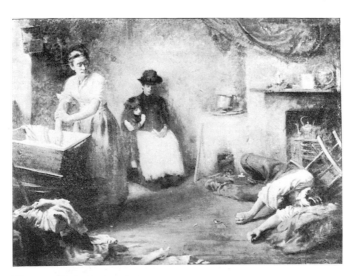

4–10. Thomas Kennington: *The Curse of the Family*, c. 1892; photo: *Art Gallery of the World's Columbian Exposition* 1893.

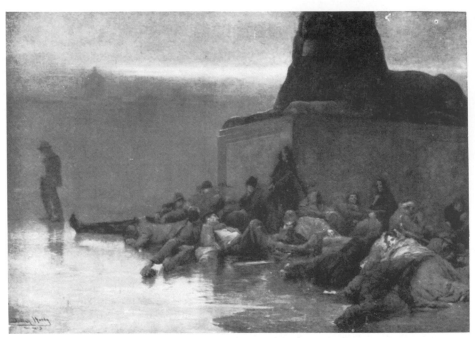

4–11. Dudley Hardy: *Sans Asile*, 1888; photo: Johnson, *Dudley Hardy* 1909.

4–12. Frank Holl: *The Lord Gave and the Lord Taketh Away*, 1869; 36 × 49;
Guildhall Art Gallery, Corporation of London.

4–13. Richard Redgrave: *The Emigrants' Last Sight of Home*, 1858; 27 × 39;
Tate Gallery, London.

4–14. Richard Redgrave: *The Outcast*, 1851; 31 × 41; Royal Academy of Arts,
London.

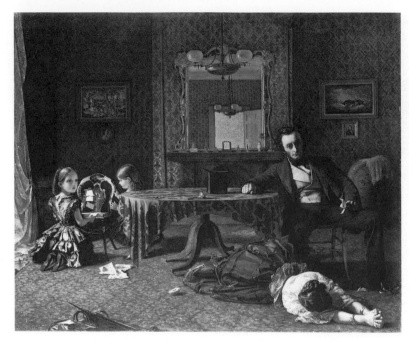

4–15. Augustus Egg: *Past and Present I*, 1858; 25 × 30; Tate Gallery, London.

4–16. Luke Fildes: *The Doctor*, 1891; 65½ × 95¼; Tate Gallery, London.

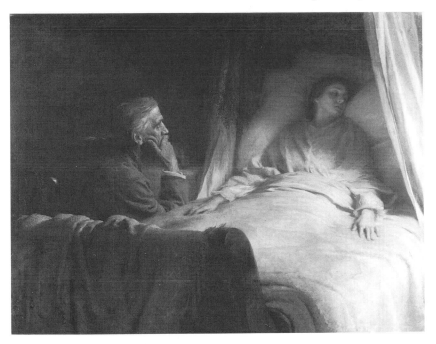

4–17. Frank Dicksee: *The Crisis*, 1891; 48 × 62; National Gallery of Victoria, Melbourne, purchased 1891.

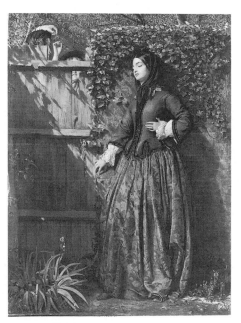

4–18. Philip Hermogenes Calderon: *Broken Vows*, 1856; 35½ × 26½; Tate Gallery, London.

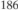

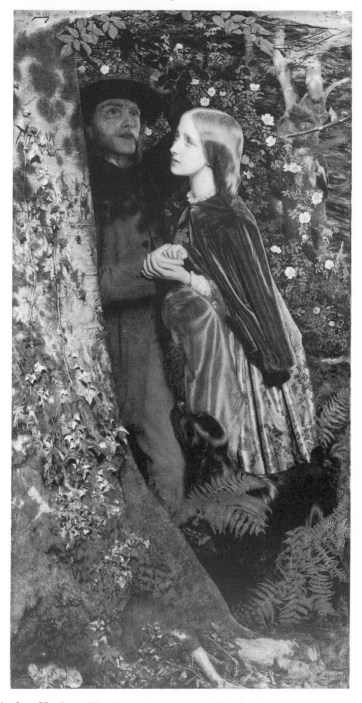

4–19. Arthur Hughes: *The Long Engagement*, 1859; 41½ × 20½; Birmingham
Museum and Art Gallery.

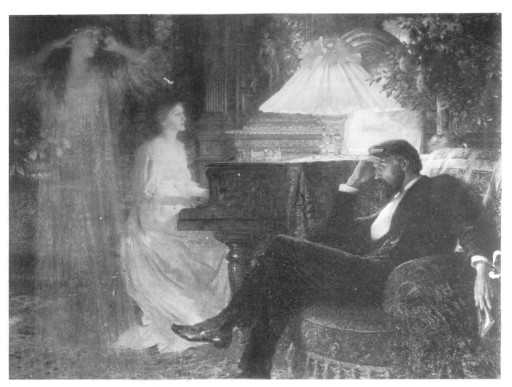

4–20. Frank Dicksee: *A Reverie*, 1895; 41 × 54; National Museums and Galleries on Merseyside (Walker Art Gallery, Liverpool).

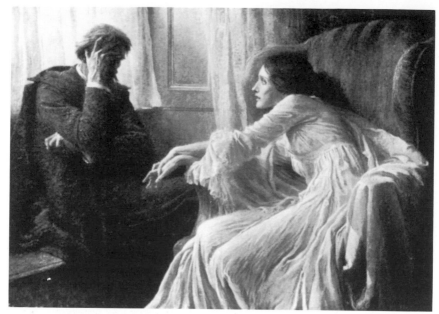

4–21. Frank Dicksee: *The Confession*, 1896; 45 × 63; Roy Miles Gallery, Bruton Street, London W1.

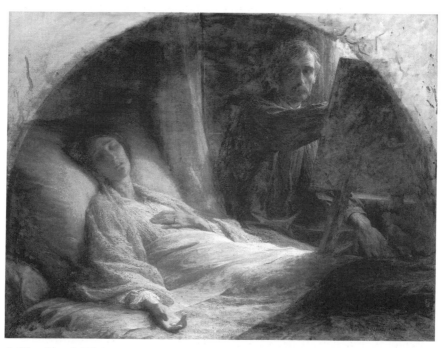

4–22. Frank Dicksee: '*This for Remembrance*', 1924; 37 × 48; National Museums and Galleries on Merseyside (Walker Art Gallery, Liverpool).

5

The Valiant Soldier

In *Be a Man! Males in Modern Society*, Peter Stearns observes that 'for men, the nineteenth century, effectively launched and ended by major wars, was a militant, indeed military century. A greater percentage of European men served in the military, even in peacetime, than ever before' (68). This militarism was part of what Stearns denominates as the 'self-conscious assertiveness about nineteenth-century masculinity' (78) manifested in myriad dimensions of the culture. The great number of campaigns cited by Brian Bond (*Victorian Military Campaigns*) and by Byron Farwell (*Queen Victoria's Little Wars*) demonstrates the degree to which warfare dominated Victorian consciousness and contributed to the formation of ideologies of masculinity, constructing paradigms of activity, aggression, dominance, endurance, heroism, comradeship, patriotism and power. These constructions advanced racist, sexist and classist agendas. As Norman Vance argues in *Sinews of the Spirit*, 'the alliance of manliness with imperialism . . . represents an extension of the mid-Victorian combination of manliness and patriotism' (195).

Michel Foucault observes in *The History of Sexuality: An Introduction*: 'The arrangement that has sustained [sexuality] . . . has been linked from the outset with an intensification of the body – with its exploitation as an object of knowledge and an element in relations of power' (107). Victorian imperial battle painting represents the intensification of the male body as the site for negotiating masculinity through empowering political, economic and racist programmes: thus *Machtpolitik* intersects with formation of ideologies of masculinity. Some of the elements negotiated in such iconography include the following: rites of initiation and investiture; the heroic male body; comradeship; the inscription of the heroic code (*andreia*, which in Greek means both manliness and courage); the reification of racist theories of polygenesis; the constructed isomorphism of masculinity and patriotism, as Vance has suggested; the construction of women and non-Caucasians as Other (thus infantilized or marginalized or atavistic); the classist depiction of men in the ranks, and the ambiguities of

the wounded male body in representations of veterans. As the nineteenth century advanced, battle iconography assumed a particularly significant function in the construction of masculinity because of the introduction of inexpensive processes for mass-market reproductions – and thus circulation – of images. Thus, those affected by such painting were not solely the observers of Royal Academy exhibitions or those readers of illustrated guidebooks (for example, *Royal Academy Pictures*, *Academy Notes*) or reviews: these images were circulated through all social ranks and in non-artistic locales.

This construction of masculinity through representations of imperial battle campaigns, however, is intensely conflicted in its negotiation of *andreia*. Stearns asserts:

> Masculinity is not simply a position of power that puts men in comfortable positions of control. . . . If we understand masculinity as a constant contradictory struggle rather than just the privileged position within a power disequilibrium, we come closer to a full definition of gender studies. (108)

The representation of Victorian imperial campaigns, therefore, not only advances codes of *andreia* but also interrogates those codes. Kaja Silverman in *Male Subjectivity at the Margins* contends that the 'dominant fiction calls upon the male subject to see himself . . . only through the mediation of images of an unimpaired masculinity . . . by believing in the commensurability of penis and phallus, actual and symbolic father' (42). Victorian imperial iconography, from one perspective, would appear to necessitate the premise of the commensurability of penis and phallus, of possession of the penis with automatic inscription into the symbolic order and the Law of the Father. However, as Serge Leclaire notes:

> The possession of the penis, which is highly cathected, serves as a screen denying the fundamental character of castration. Man comes to believe that he has not been castrated. (46)

Silverman and Leclaire suggest new strategies for assessment of imperial battle imagery. Representations of 'victories' are posited on the assumption of the commensurability of penis with phallus: depictions of battles such as Kandahar [1 September 1880, Second Afghan War], Ulundi [4 July 1879, Zulu War] and Omdurman [2 September 1898, Egyptian Campaign] reinforce the dominant fiction, as Silverman observes:

> The phallus/penis equation is promoted by the dominant fiction, and sustained by collective belief. . . . The dominant fiction offers a seemingly infinite supply of phallic sounds and images within which the male subject can find 'himself.' . . . It is imperative that belief in the penis/phallus equation be fortified . . . for it represents the most vulnerable component of the dominant fiction. (44–45, 47)

Representations of Kandahar, Ulundi or Omdurman inscribe a masculinity which reinforces the dominant fiction and the equation of penis with phallus.

However, an entire range of imperial campaign imagery exposes the fact that this dominant fiction depends upon a *méconnaissance*, 'the mis-

recognition upon which masculinity is founded' (Silverman 42). In particular, war as historical trauma implodes this equation, as Silverman contends:

> History may manifest itself in so traumatic and unassimilable a guise that it temporarily dislocates penis from phallus, or renders null and void the other elements of the dominant fiction. . . .
> The male subject's aspirations to mastery and sufficiency are undermined . . . by the traumatically unassimilable nature of certain historical events . . . [which] dramatize the vulnerability of conventional masculinity and the larger dominant fiction to . . . 'historical trauma' . . . a historically precipitated but psycho-analytically specific disruption, with ramifications extending far beyond the individual psyche. (47, 52, 53, 55)

Historical trauma, such as defeat in battle, exposes the *méconnaissance* upon which traditional masculine codes of power, aggression, superiority, activity and difference are posited. During the nineteenth century, several defeats particularly exposed this misrecognition: Gundamuck [January 1842, First Afghan War], Isandhlwana [22 January 1879, Zulu War], Majuba Hill [26–27 February 1881, First Boer War], El Teb [9 February 1884, Sudanese War] and Khartoum [26 January 1885, Sudanese War]. Such battles, disrupting the equation of penis and phallus, contest the symbolic masculine order since, as Silverman notes, 'masculinity is particularly vulnerable to the unbinding effects of the death drive because of its ideological alignment with mastery' (61). Silverman emphasizes:

> the centrality of the discourse of war to the construction of conventional masculinity . . . how pivotal that discourse is to the consolidation of the penis/phallus equation. . . . However, although the discourse of war works not only to solicit civilian belief in the dominant fiction, but to shape the subjective experience of battle, it does not always manage to fortify the soldier against an introverted death drive. (62)

So strong is the desire to enforce the equation of penis with phallus that battle imagery may extrapolate an incident from a defeat, as with Caton Woodville's *Maiwand: Saving the Guns*, in an attempt to deny the misrecognition. Of particular interest are representations of 'near defeats' which barely maintain the dominant fiction, such as Butler's depiction of Rorke's Drift [22 January 1879, Zulu War] or Giles's three representations of the battle of Tamai [13 March 1884, Sudanese War]. Rorke's Drift and Tamai expose the precarious nature of 'the construction of conventional masculinity' observed by Silverman. If paintings of military defeats acknowledge the incommensurability of phallus and penis, those extrapolating a victorious moment or commemorating a near defeat (for example, Tamai) attempt to recuperate and reaffirm a desperate commensurability. An examination of a range of battle paintings demonstrates the complexity of the construction of masculinity in representations of military campaigns.

The dominant fiction involving the military was inculcated in young boys and men during the nineteenth century by means of both literature and art. The most famous of such discourses was Henry Newbolt's *Vitaï Lampada*,

written in June 1892, with its analogy of 'the game' and war, where all are exhorted to 'Play up! play up! and play the game!', which is explicitly linked in the second stanza with imperial battle:

> The sand of the desert is sodden red, –
> Red with the wreck of a square that broke; –
> The Gatling's jammed and the Colonel dead,
> And the regiment blind with dust and smoke.
> The river of death has brimmed his banks,
> And England's far, and Honour a name,
> But the voice of a schoolboy rallies the ranks:
> 'Play up! play up! and play the game!' (38–39)

Victorian males would have recognized the specific reference in the 'wreck of a square that broke' to the battles of Tamai (13 March 1884) and Abu Klea (17 January 1885) during the Sudanese War, which were to generate Kipling's praise of the Mahdist forces in 'Fuzzy-Wuzzy'. Although the most famous of Newbolt's poems to imprint youth with military ideologies, *Vitaï Lampada* was not the sole text constructing the paradigm of the soldier. During the Boer War, Newbolt wrote *The Schoolfellow* and *The School at War*. In the former, as the lads play the game at school, a youth who had graduated but the year before dies on the battlefield:

> The self-same hour we missed him here
> He led the line that broke the foe. . . .
> Dear lad, before the word was sped,
> For evermore thy goal was won. (78)

In *The School at War*, it is as if the sixth form went in a body to the Boer conflict:

> We heard beyond the desert night
> The murmur of the fields we knew,
> And our swift souls with one delight
> Like homing swallows Northward flew. . . .
> 'O Captains unforgot', they cried,
> 'Come you again or come no more,
> Across the world you keep the pride,
> Across the world we mark the score.'

In *Clifton Chapel* Newbolt reminds the youth of England 'Of manhood and the vows of war/You made before the Lord of Hosts', invoking the 'brotherhood' of schoolfellows now soldiers as standard bearers of Caucasian supremacy: 'Henceforth the School and you are one,/And what You are, the race shall be'. Newbolt concludes that though the valiant are buried in a 'frontier-grave . . . far away' the valiant soldiers died early '*Sed miles, sed pro patria*' (63–64), the final lines a textual epitaph. *Vitaï Lampada*, *The School at War*, *The Schoolfellow* and *Clifton Chapel* construct for young men the military ideal, demonstrating a continuum between the school and the campaign, the male as *homo newboltiensis*.

Several canvases also functioned to imprint this paradigm of the soldier. Calderon's *A Son of the Empire*, previously discussed, was exhibited in

1899, during the same period as the composition of Newbolt's poems. The boy imitating the lancers riding through his country village models militaristic paradigms for male observers of the canvas. William Maw Egley's *Just as the Twig Is Bent, So Is the Tree Inclined* of 1861, while representing the contrast between two young girls, one serious, the other flirtatious, reveals both girls observing a young boy playing at soldiers, the object of their rapt gaze. As Casteras notes, the blonde girl 'has . . . temporarily forgotten the soldier doll with which she has been playing', while at the feet of the dark-haired girl 'a sheaf of paper is marked "See the Conquering Hero Comes"'; in addition, the boy is probably 'emulating an ancestor, for above the fireplace hangs the portrait of another real military man' (*Images* 42). The fact that the canvas was painted at the period of the Crimean conflict underscores its modelling function.

Painted just before the Indian Mutiny of 1857 and evoking the Crimean conflict was James Collinson's *The Siege of Sebastopol, by an Eyewitness* of 1856. An original member of the Pre-Raphaelite Brotherhood, Collinson had painted a now lost work, *A Crimean Hero*, in the same year. In *The Siege of Sebastopol*, two boys mimic military exploits, while a sketch or print inscribed 'Alma' alludes to the famous battle during the Crimean War. As Casteras notes, 'Collinson himself never traveled to the Crimea, but, like his young protagonists, is reacting to the Victorian hero worship and fantasies of bloodless war' (*Victorian Childhood* 59). Christopher Forbes claims:

> The shame, suffering, and sheer waste of men during the Crimean War nowhere surfaces in this image of the child-playing-soldier, whose naive playfulness suggests that war is a faraway thing, a matter of legend, which, like all myths, receives its due portion of childhood enactment and makes a hero out of the dullest private soldier. . . . It is difficult to accept Collinson's work as a simple childhood scene, both because of its topicality and because Collinson's religious intensity makes it unlikely that he would have reacted to the war in such a patently frivolous manner. (31–32)

Charles Hunt's *Ivanhoe* of 1871, showing two boys mimicking the action of the novel while two others read the text, similarly reveals the force of Scott's romanticism in constructing an idea of the gallant soldier for countless generations of youths. Hunt's *The Tribunal* of 1870, showing youths imitating a drum-head court martial, may be inspired, as Casteras suggests (50), by the Franco-Prussian War. Here a sheet inscribed 'War Office' warns 'Take notice any soldier that runs away will be shot'. On the drum-head is a paper labelled 'sentence of death', the penalty for desertion. Charles Spencelayh's *Dreams of Glory* of 1900, showing a small boy in bed dreaming of military glory, constructs a military paradigm appropriate for the period of the Boer War, as Casteras establishes:

> In this painting the sole subject is a sleeping boy, a 'little soldier' who presumably dreams of victory and the glamour and excitement of combat. In one hand he holds a drumstick, while near the pillow lies a drum of the sort that young drummer boys beat for the troops marching off to battle. . . . The child's

fantasies have materialized above his head in a group of soldiers with guns, and it has been suggested that the round bedstead finial looks like a small globe or world, perhaps symbolizing the global strength of the British Empire in military as well as other matters. (12)

Such canvases by Hunt, Calderon, Collinson or Spencelayh demonstrate the formation of the military ideology, assuming the commensurability of penis and phallus. Such imprinting and modelling was a primary function of battle art, which correlates with the agenda of Newbolt's poetry.

In his study of military art during the period, Roger Stearn has investigated the importance of conventions in this type of painting. Some of these painters, designated 'specials', drew their inspiration directly from events observed in the field, often imagining themselves as 'heroic adventurers' or 'swashbucklers' (14), the fictional counterpart of which is Dick Heldar in Kipling's *The Light that Failed* (1891). Battle art contributed to recruiting by constructing an imagery of war, imprinting racial superiority and the idea of masculinity, and conjoining the preferred ideologies about patriotism, martial values and imperialism. As Stearn notes, battle art was governed by conventions, which included such elements as the following: the highly selective nature of events portrayed; the emphasis on the inspirational; the minimizing of 'horror, mutilation, disfigurement, suffering and agony' (20); the omission of 'the panic of some British troops in Zululand' (20); the practice of showing 'relatively few British dead' (20); and the emphasis on what might be uplifting, heroic, dramatic or exciting. Artists such as William Simpson, Melton Prior and Frederick Villiers constructed an ideology about militarism that was crucial to ideas of masculinity both at home and abroad. The comment that battle art constituted 'an artist's victory over many a British defeat' (cited in Stearn 85), while specifically applied to Caton Woodville, could be applied to the work of other battle artists. Despite these reservations, however, the circulation of these images through prints and reproductions constructed a major component of masculinity during the era, crucial for the male both as an individual and as a citizen entrusted with the empire.

The representation of military victories is posited on the commensurability of penis and phallus. The purpose of such iconography is to advance the code of *andreia*, manliness/courage, in an empowering politicized and intensely gendered image. In particular, the male body becomes the signifier of an empowered masculinity which, in the special example of imperial iconography, can become the signifier of cultural Caucasian superiority as well, a race-inflected discourse of East/West relations. Thomas Jones Barker's *The Relief of Lucknow, 1857*, finished in 1859 (Plate 5–1), represents the generals Colin Campbell, James Outram and Henry Havelock in November 1857 after they relieved the garrison. In Barker's construction, the male rescue reaffirms the heroism of the incident without depicting the extensive and arduous combat that led to the

reunion of the three men. Of the more than 60 figures represented in the painting, many are portraits of military officers, constituting a gallery of Victorian military heroism. In particular, several of the main figures were constructed as heroes of chivalry by their compatriots. J.A. Froude wrote on 3 December 1857: 'We had been doubting, too, whether heroism was not a thing of the past: and what knight of the Round Table beat Havelock . . . ?' (Girouard 220). To Lord Curzon, the same construction was true of Outram, 'that generous and gallant spirit, the mirror of chivalry' (Girouard 220).

The cultural differences of the masculinities presented are significant. On the far left, a group of Indian natives quarrels over plunder; in the foreground, right, crouches a native servant, while on the right is a native bheesty or water carrier: natives are shown as venal or servile, while the Caucasian forces are ennobled, as with the wounded soldier of the 23rd placed strategically adjacent to the plunderers or the sunstruck 93rd Highlander on the right of the canvas juxtaposed to the native water carrier. The city of Lucknow, distinguished by the Tombs of the King and Queen on the left, the Chuter Munzil Palace in the centre, and the Residency and Motee Mahul Tower on the right, is transformed into an almost celestial city in the soft morning light. Barker conveys a sense of cultural difference in this powerful image of Caucasian male rescue during the Sepoy revolt. Signs of fighting are kept to a minimum, as around the Red Gate, to emphasize the ennobling nature of the British presence in India. The heroism of the British during the 'Mutiny' was inscribed in Newbolt's *Ballad of John Nicholson* about a hero of the Siege of Delhi who compelled Mehtab Singh to demonstrate respect to the British:

> But there within John Nicholson
> Turned him on Mehtab Singh,
> 'So long as the soul is in my body
> You shall not do this thing.

> 'Have ye served us for a hundred years
> And yet ye know not why?
> We brook no doubt of our mastery,
> We rule until we die.' (41)

The fact that Nicholson died of wounds during the conflict secured his heroism. In 1897 in Newbolt's poem *The Vigil*, previously discussed, Outram was configured to represent ideals of chivalric behaviour.

Richard Caton Woodville's *Kandahar* (1881) (Plate 5–2) depicts the 92nd Highlanders storming the village of Gundi Mullah Sahibdad during the Second Afghan War on 1 September 1880. Ayub Khan and his army were defeated, with the loss of 2,000 men while the British lost 'less than 250 men killed or wounded' (sale catalogue, Christie's, 23 October 1987, lot no. 100). Woodville completed this canvas in eight months, and the motive may well have been to reaffirm the symbolic masculine code after the defeat at Maiwand on 27 July during the same campaign. The officers

on leaping mounts derive from David's image of Bonaparte at Saint-Bernard, while the humanitarianism of the Westerners is indicated by the Red Cross supplies on the extreme left. Although the Gurkhas accompanied and assisted the Highlanders on this expedition, Woodville emphasizes the role of the Highlanders in scaling the village. Woodville's canvas of Kandahar may be usefully compared to that by Vereker Hamilton of the same incident. Hamilton, unlike Woodville, shows the Highlanders in a dramatic charge just prior to entering the village, deploying the motion of the kilts to dramatize the charge. Rather than showing the troops dispersed in the narrow passages of the village, Hamilton shows them coming in line, using the angled bayonet in the foreground to emphasize the thrust of the Highlanders' line. Subtle details contribute to this heroism: note the manner in which the clasped rifle forms a cross with the protruding bayonet, signifying the Christian force behind imperialism, and the bagpipe silhouetted farther down the line.

The victory at Ulundi on 4 July 1879 during the Zulu War was compensation for the catastrophic defeat of British forces at Isandhlwana the previous January. At Ulundi 5,000 British troops defeated 20,000 Zulus, with British losses only 15 killed and 78 wounded. B. Fayel's depiction (1880) of the battle shows the 17th Lancers who have 'charged out of the square to deliver the final blow' (Sears, ed., 229). While unquestionably a victory, Ulundi represented the triumph of artillery over ineffective native weaponry, for 'not one [Zulu] got within 30 yards of the British lines. A hail of lead from rifles and Gatling machine guns scythed down wave after wave of screaming warriors' (ibid., 229). Fayel's representation, therefore, elides the British technical superiority by emphasizing the subsequent charge of the Lancers.

The battle of Omdurman, 2 September 1898, the climax of the reconquest of the Sudan by Kitchener, constituted the last great victory for British forces during the century. Here 50,000 Dervishes under the Khalifa were defeated by Egyptian and British forces 23,000 strong. Robert Kelly's *Flight of the Khalifa, Omdurman, 1898*, completed in 1899, shows the Khalifa in rout before the British forces, reaffirming British military – and racial – superiority. Kelly's painting of this flight masks the stunning daring of the Dervishes, as recorded by Steevens:

> And the enemy? No white troops would have faced that torrent of death for five minutes, but the Baggara and the blacks came on. The torrent swept into them and hurled them down in while companies. You saw a rigid line gather itself up and rush on evenly; then before a shrapnel shell or a Maxim the line suddenly quivered and stopped. The line was yet unbroken, but it was quite still. But other lines gathered up again, again, and yet again; they went down, and yet others rushed on. . . . It was the last day of Mahdism, and the greatest. They could never get near, and they refused to hold back. By now the ground before us was all white with dead men's drapery. . . . It was not a battle, but an execution. (264)

Steevens's account of the battle does not ignore the ferocity and tenacity of

the Dervish forces, although Kelly's canvas focuses on the aftermath of the Dervish onslaught to camouflage this aspect of the battle of Omdurman.

The event at Omdurman most remembered, however, is the famous charge of the 21st Lancers, in which the young Winston Churchill participated, commemorated in canvases by Richard Caton Woodville and C.D. Rowlandson. Actually undertaken 'contrary to orders' and 'mainly prompted by the desire of its commander Lt. Colonel Rowland Hill, to gain battle honours for his Regiment' (C. Wood 1976, 244–245), the charge was in reality a foolhardy rush into an ambush laid by Osman Digna, for what appeared to be about 200 to 300 Dervishes in a *khor* turned out to be thousands hidden in a depression in the desert. The motive to prove masculinity was acute in this instance, because the Lancers was a 'regiment given the unofficial motto "Thou shalt not kill" by the rest of the army, because they possessed no battle honours' (Wilkinson–Latham 35). Steevens recorded the incident as follows:

> The trumpets sang out the order, the troops glided into squadrons, and, four squadrons in line, the 21st Lancers swung into their first charge.
> Knee to knee they swept on till they were but 200 yards from the enemy. Then suddenly – then in a flash – they saw the trap. Between them and the 300 there yawned suddenly a deep ravine; out of the ravine there sprang instantly a cloud of dark heads and a brandished lightning of swords, and a thunder of savage voices. . . . It had succeeded. Three thousand, if there was one, to a short four hundred; but it was too late to check now. Must go through with it now! The blunders of British cavalry are the fertile seed of British glory. (273)

Rowlandson's canvas accurately depicts the furious charge the Lancers had to undertake once they grasped the situation, but the rashness of the event is reconfigured into masculinizing heroism. Leaving much of the left side of the canvas blank with the *khor* accentuates the thrust of the Lancers, beset by the Dervishes beneath their mounts. Woodville's *The Charge of the 21st Lancers at Omdurman*, painted in 1898 (Plate 5–3), shows the defile into which the Lancers charged, but the heroism is reinforced through the portraiture: Colonel Martin 'without drawn sword or revolver' is painted at the right of the canvas, while 'the officer on the grey, centre, may represent Captain Kenna, who was awarded the Victoria Cross' (Barthorp 164). Woodville's depiction appears to draw its detail from Steevens:

> The colonel at their head, riding straight through everything without sword or revolver drawn, found his horse on its head, and the swords swooping about his own. He got the charger up again, and rode on straight, unarmed, through everything. The squadrons followed him down the fall. Horses plunged, blundered, recovered, fell; dervishes on the ground lay for the hamstringing cut . . . everybody went on straight, through everything (273).

Steevens recorded:

> Our men were perfect, but the Dervishes were superb – beyond perfection. It was their largest, best, and bravest army that ever fought against us for Mahdism, and it died worthily of the hugh empire that Mahdism won and kept so long. (282)

To Steevens the Dervishes were 'death-enamoured desperadoes' (283) and the total battle 'a most appalling slaughter' (285). Churchill recorded in a dispatch for the *Morning Post*:

> They were about twelve deep. It was undoubtedly a complete surprise for us. What followed probably astonished them as much. I do not myself believe they ever expected the cavalry to come on. The Lancers acknowledged the unexpected sight only by an increase of pace. A desire to have the necessary momentum to drive through so solid a line animated each man. But the whole affair was a matter of seconds (Macdonald 114–116)

Churchill's assessment essentially limns the heroism of the charge, which Steevens proceeded to criticize as one of 'three distinct mistakes' (292) in the battle of Omdurman.

Steevens recognized all the ambiguity of the event, noting that the War Office itself could not outright condemn what the public so ignorantly hailed as a triumph:

> Of these [mistakes] the charge of the 21st Lancers was the most flagrant. It is perhaps an unfortunate consequence of the modern development of war-correspondence, and the general influence of popular feeling on every branch of our Government, that what the street applauds the War Office is compelled at least to condone. The populace has glorified the charge of the 21st for its indisputable heroism; the War Office will hardly be able to condemn it for its equally indisputable folly. That being so, it is the less invidious to say that the charge was a gross blunder. For cavalry to charge unbroken infantry, of unknown strength, over unknown ground, within a mile of their own advancing infantry, was as grave a tactical crime as cavalry could possibly commit. . . . The charge implied disregard, or at least inversion, of [their] orders. . . . As it was, the British cavalry in the charge itself suffered far heavier loss than it inflicted. And by its loss in horses it practically put itself out of action for the rest of the day, when it ought to have saved itself for the pursuit. Thereby it contributed as much as any one cause to the escape of the Khalifa. (292–93)

For *The Times*, the *Illustrated London News* and the *Annual Register*, however, the emphasis was on the heroism of the charge (Stearn, 1987, 120–21). The charge of the 21st Lancers illustrates the manner in which masculinizing heroism was constructed even out of tactical blunders and vainglorious mistakes to reinforce the dominant ideology.

If victories such as those at Kandahar, Ulundi and Omdurman reinforced the dominant fiction of masculinity, other engagements when represented, even if ultimately yielding victory, could not be so easily accommodated into the dominant fiction. The defence of Rorke's Drift, 22 January 1879, during the Zulu War is one example of such an incident, in which 139 men confronted an attack by 4,000 Zulus; after 12 hours of fighting, the Zulus were routed. 'For this action 11 Victoria Crosses were awarded, the highest number for a single engagement' (*Lady Butler* 78); Butler included portraits of all the vc awardees in the canvas. However, as Jenny Spencer-Smith has noted (*Lady Butler* 79), Butler could not have been unaware of her husband's outrage at the Zulu War, embodied in his essay 'The Zulus' of 1880, where he observes that 'nothing is more natural

than that' the Zulus should 'war against us' 'from being . . . subject to frequent instances of manifest injustice' (1881, 178). Thus, the canvas is conflicted about white superiority even as it celebrates vc victors. Butler painted *Rorke's Drift* expressly for Queen Victoria, who wanted only this incident, although Butler had suggested the death of the Prince Imperial as a subject. The Queen even wanted extra Zulus depicted to underscore the heroism of the British forces and the ultimate defeat of the natives.

The battle of Rorke's Drift was particularly renowned for representing an astounding military action by British forces on the day and evening of the disaster at Isandhlwana; this victory became a means of effacing the memory of the Zulu victory earlier in the day. In *The Defence of Rorke's Drift* finished in 1880 (Plate 5–4), Butler used men from the 24th Regiment who had returned from South Africa. 'The viewpoint is roughly west to east, and the foreground figures hold the barricade opposite the front of the hospital, with the storehouse in the background' (Knight 1992, 113). Butler depicts John Chard and Gonville Bromhead in the centre of the canvas, with a number of other vc winners portrayed: Fred Hitch with bandaged shoulder carrying ammunition, on right; the surgeon Reynolds holding a wounded man; Schiess of the Natal Native Contingent shouting from the barricade. William Butler, however, could not conceive of the Zulus as savages waging capricious attacks on whites. He noted that the press had led the public to a 'frenzy of hostility against black kings as a principle,' adding:

> While the black king's dealings towards us are weighed and measured by the strictest code of civilised law and usage existing between modern states, our relations towards him are exempted from similar test rules, and the answer is ever ready for those who would preach the doctrine of a universal justice between man and man, of the impossibility of applying to savage communities the rules and maxims of ordinary life. (1881, 176–177)

This abuse of blacks, Butler contends, 'produce[s] in the native mind a deep and widespread feeling of antagonism and resentment which every now and again finds expression in open conflict' (178). The ending of slavery, Butler asserts, has not effaced the wrongs done by whites: 'All these long centuries of crime are still unpaid for. The slaves set free by us fifty years ago were not a thousandth part of those we had enslaved. . . . Notwithstanding the wide gulf which we fancy lies between us and this black man, he is singularly like us. . . . [H]e does not die out before us' (189–190). The fact that Butler completed her canvas of Rorke's Drift the same year William Butler denounced the treatment of the Zulus indicates the quality of the race-inflected nature of her subject and its celebration of a white masculinity her husband abhorred as one of the worst consequences of Britain's involvement in the scramble for Africa. The Zulu chief Cetshwayo, when he learned of his tribe's casualties at Isandhlwana and at Rorke's Drift, stated: 'An assegai has been plunged into the belly of the Zulu nation' (McBride 22).

The most conspicuous precedent for the transformation of the charge of the 21st Lancers at Omdurman from a blunder to an achievement was the Charge of the Light Brigade at Balaclava 25 October 1854, where a British force of 661 was reduced to 195 in 20 minutes, painted most notably by Woodville and by Lady Butler following the famous commemorative poem by Tennyson. Butler's *Balaclava* (Plate 5–5) was exhibited in 1876 and proved controversial for its central figure, a dazed and possibly deranged participant climbing out of the valley with bloody sword. Scenes of pathos limn the sacrifice entailed in this rashly heroic action, especially the sergeant of the 17th Regiment holding the corpse of a trumpeter and the slain lancer to the right of the pathway. The exhaustion of defeat, sacrifice, and despair are reflected in the collapsing figures in the middle distance. In Butler's *Balaclava*, the code of *andreia* is intensely conflicted as the only victory appears to be survival, a tension and disequilibrium introduced into the dominant fiction particularly by the figure of the dazed hussar. In contrast to Butler's depiction, Woodville's several representations differ considerably. In his 1894 *Charge of the Light Brigade*, Woodville shows 'horses completely airborne or crashing before exploding shells [to suggest] speed and violent activity. . . . The artist chose to depict the action's most appealing moment, before the Light Brigade disintegrated' (Lalumia 147). In this conception, Lord Cardigan leads the 17th Lancers into the valley, with no suggestion of the dismay recorded in Butler's *Balaclava*. In his 1897 *The Relief of the Light Brigade*, Woodville shows the British forces at the end of the charge, assailing the Russian artillery at the end of the valley. Woodville's two canvases, showing the commencement of the action and the best version of its conclusion, emphasize the heroism of the magnificent blunder. Woodville's final image of the Charge of the Light Brigade, *All That Was Left of Them*, however, shows the roll call after the troops emerged from the valley: clearly inspired by Butler's 1876 canvas, the Lancers form a line as the remnants of the regiment leave the valley, a riderless horse signifying the fate of many. Woodville's 'Brigade trilogy' thus presents an image of the action counter to that of the stunned despair of Butler's representation.

Although it is a matter of disagreement among scholars the extent to which Butler favoured the man in the ranks over the officer class, Woodville was strongly attracted to the depiction of officers, as the presence of Cardigan in *The Charge of the Light Brigade* indicates. A similar emphasis appears in his 1884 canvas *The Guards at Tel-el-Kebir*, painted at the request of Queen Victoria, who wanted her son, the Duke of Connaught, included in a heroic moment of the most famous battle of the 1882 Egyptian War. In Woodville's canvas, the Duke, seated on a grey mount, is shown at the head of the Guards Brigade as it awaits the results of an attack by the 1st Division. Danger is signalled by the shellburst at the top left of the canvas. Connected with the Egyptian frontier is John Evan Hodgson's image of two soldiers toasting the Queen in the Egyptian

desert, '*The Queen, God Bless Her!*' exhibited in 1885 (Plate 5–6). As Casteras notes (*Virtue Rewarded* 21) the image represents 'a chauvinistic, private moment' on the part of the two soldiers, 'who relax amid the pyramids and think of their nation's power and of their monarch'. Since news of the defeat of General Gordon reached London in February 1885, the canvas may allude to the Sudanese War as well, evoking such battles as Tamai (13 March 1884) or Abu Klea (17 January 1885). Both the Woodville and the Hodgson images juxtapose the resourceful British against the natives of the continent. The fact that Victoria wished her son to be commemorated as a hero, and that the same impulse applies to the distinctly non-aristocratic soldiers in Hodgson, demonstrates the manner in which masculinizing heroism transcended class differentiation.

Although the battle of Tamai on 13 March 1884 resulted in a British victory, the English troops barely survived against the Dervishes, whose breaking of a British square was memorialized in Kipling's 'Fuzzy-wuzzy' of 1890. Godfrey Giles completed three versions of the Battle of Tamai, two in 1885, representing different moments of the battle. One *Battle of Tamai* depicts 'the Dervishes issuing from a deep ravine in which they had concealed themselves' (*Lady Butler* 174), Osman Digna's Hadendoa 'attacking Graham's leading square' (Barthorp 90). For Hichberger this *Battle of Tamai* contains a Caucasian-empowering racist agenda:

> Giles was reworking a familiar formula for the implication of racial inferiority. By emphasising and caricaturing the features of the Dervishes, he was able to make them look ridiculous. . . . The Dervishes, in the foreground, are crouching among the rocks. The state of mind and moral qualities implied by the postures are obvious; standing straight equals bravery and crouching cowardice. . . . In the foreground . . . blood pours from the head of a dying Dervish. (112–113)

The battle had been fought in two brigade squares, one of which had been temporarily broken by the Dervishes and was only relieved when the second square moved up in support. In *The Battle of Tamai*, the reformed 2nd Brigade advances to recover the abandoned guns of the Naval Brigade. Giles juxtaposes the captured Gatling gun with the figure of a Dervish in the pose of the Deposition in the left foreground, destabilizing the image by suggesting that British heroism rested on superior artillery rather than innate *andreia*. The second *Battle of Tamai* (Plate 5–7) depicts an earlier moment of the battle, the interior of the British square as the Hadendoa attack. Hichberger notes that in this canvas 'the British wounded are depicted by polite formula, a shoulder or head neatly bandaged or a dead body lying behind a bush. The Dervishes evidently died with less dignity . . . to have shown British soldiers in pain would have offended the audience and suggested that the Dervishes were a worthy foe' (113). Indeed, on the left of the canvas one British soldier thrusts a bayonet down a man's neck, with the bloody end protruding, while the same man is being stabbed by another British soldier. Both canvases are

'cut off', like a photograph, which increases the illusion of their being documentary. Kipling's poem pays grudging respect to the blacks who broke the British square, and both paintings by Giles, which record a bare survival rather than a resounding victory, contain an element of this disequilibrium of the masculine code. Both canvases, moreover, depict a native resistance threatening to Caucasian superiority. If the Dervishes in *The Battle of Tamai* have vestiges of atavistic behaviour (for instance, crouching, 'unclothed'), they nevertheless also manifest an alternative form of *andreia* which was capable of disrupting the British square.

Both of these canvases display native resistance to British imperialism, with the result that readings of the canvases could be completely opposite, one validating British heroism, the other condemning imperialism and endorsing native defence. In 1887, Giles completed a third canvas, *An Incident at the Battle of Tamai*, depicting Lt. Percival Marling rescuing Private Morley, who had fallen. Marling is depicted putting the wounded private (who subsequently died) on his horse to return him to the British square, an action which won him the vc. Painted at the request of Marling's family, the canvas in this instance is unquestionably constructing British heroism. While one may construe these paintings as endorsing Caucasian superiority, an alternative interpretation might view them as manifestations of two different masculinities: one white, the other black, suggesting that masculinity is not essentialist or universal but rather culturally – and nationally – defined. In Giles's first two canvases, as in other representations of the square (as in Fripp's *Isandhlwana* or the remnant in Wollen's *Gundamuck*), the British square itself becomes symbolic of the dominant ideology of British masculinity and its impregnable, impenetrable authority. Hence, its irruption (as at Abu Klea) is not only a military hazard but a threatening sabotage of the gendered male code. Thus, the artist Dick Heldar returns at the end of Kipling's *The Light that Failed* to the all-male world of the square for his martyrized apotheosis.

If Giles was hesitant to display the full threat of the Dervishes at Tamai, William Barnes Wollen was the opposite in his *Battle of Abu Klea* (17 January 1885) of the next key battle of the Sudan campaign following Tamai. Wollen depicts the Mahdists breaking into the 'left rear corner of the square against the Heavy Camel Regiment' (Barthorp 106). It would appear that Wollen's canvas is a bluntly truthful response to Giles's elisions in representing Tamai: Mahdists as well as British are standing; in the centre a Mahdist and a trooper are lying on top of each other. 'The British square was broken at one corner, owing to the jamming of a Gardner gun' (Harbottle 9). The savage hand-to-hand fighting in the centre, as well as the black warrior dragging himself to help his comrade, show the precarious nature of a battle that lasted all of ten minutes. Churchill was to call Abu Klea 'the most savage and bloody action ever fought in the Sudan by British troops' (National Army Museum record). Wollen demonstrates that without superior artillery, British superiority was highly questionable

in such a contest, even though British forces were ultimately victorious at Abu Klea. It is particularly striking that Wollen should have selected the breaking of the square to represent, the one most calculated to destabilize the code of *andreia*.

Of particular interest is that even in depictions of wars not involving colonial subjects, the masculine code could be interrogated in various manners. For example, Butler's canvases of the Alma and of Inkerman evoke highly tense and even conflicting assessments of the heroic paradigm. The least ambiguous of these is *The Colours: Advance of the Scots Guards at the Alma* of 1899, showing Captain Lloyd Lindsay advancing the colours at the famous engagement of 20 September 1854. Lindsay's action is credited with bringing order to the line of the regiment after a fierce Russian onslaught had thrown it into disarray. His example won him a VC for valour. The battle of Inkerman (5 November 1854), however, evoked from Butler much more disturbing responses. In the famous *The Roll Call* of 1874 (Plate 5–8), the battalion of the Grenadier Guards is 'in formation after a winter action in the Crimea' (Lalumia 138), often construed to be Inkerman. Its innovations are noted by Lalumia:

> The artist eschewed two premises of academic doctrine pertinent to history painting on the grand scale: that fact must yield to artistic license in the creation of inspiring martial imagery on canvas, and that the most instructive subjects portray the patriotic actions of a single, high-ranking personage. . . . She depicted the common soldiers' exhaustion and suffering to the exclusion of war's glorious trappings and without reference to the commanders of the army. (Lalumia 139)

Butler emphasizes the tragic aftermath of a battle action, the calculation of the 'Butcher's Bill' of dead and wounded after an engagement. Butler had read Alexander Kinglake's *The Invasion of the Crimea* (1863–87) and, as Hichberger observes, accepted that author's belief 'that the aristocrats who commanded the army had failed their country and that only the heroism of the ordinary soldiers had won the war' (76). Of particular significance, as Spencer-Smith notes, is that details indicate the engagement has been victorious: 'the upright standards, the fleeing enemy soldiers on the distant hillside and the single Russian helmet lying in the blood-spattered snow in the foreground' (58). Its composition structure – in a horizontal line rather than in the more traditional pyramidal format – suggests its democratizing sympathies. Such a design might signal the end of classism and privilege in the military, undertaken during the 1870s with the Cardwell reforms. The varied responses of the soldiers – compassion, grief, dismay, contemplation – individualize the men of the ranks in a stirring image emphasizing the tragic aftermath of victory. Details such as the shot flags, the older man reaching to pat the hand of his young comrade, and the soldier reaching to see if his prone comrade is wounded or dead evoke the conflictory nature of masculinity *in extremis*. *The Return from Inkerman* of 1877, showing 'remnants of the Guards Brigade and the red-coated 20th Regiment'

(Lalumia 144), emphasizes Butler's focus on the ranks, for this engage-
ment was widely known as the 'Soldier's Battle' because of the 'courage
and determination of the men through hours of chaotic fighting' (Spencer-
Smith 66). As Spencer-Smith notes, details such as 'spent shot, pieces of
leather and the blood-stained shako on the road in the foreground, echo
the terrible cost of the fighting while the low rain clouds and the line of
black birds following the column add a sombre, symbolic intensity' (67).

The construction of masculinity is most conflictory, of course, in the
representation of defeat or of the *topos* of the 'last stand'. As Silverman
has argued, the historical trauma of war can disrupt conventional mascu-
line codes and the equating of penis with phallus. Representations of
defeats either recognize the incommensurability or, in the process of
heroizing the defeat, attempt to recuperate the commensurability of penis
and phallus necessary for instantiation of the masculine. It is possible that
canvases of defeats are involved in an intricate process whereby 'the
historical trauma of the war had to be registered before it could be bound'
(64), that is the recognition of incommensurability is the move that permits
the reinstantiation of commensurability: the 'temporary disintegration'
(65), at least for the nineteenth century, did not lead to the repudiation of
the dominant fiction.

Again it is Wollen with his unique and strange sensibility who confronts
this temporary disintegration. *The Last Stand of the 44th at Gundamuck,
1842*, exhibited 1898 (Plate 5–9), shows a dozen of the 80 men of the
regiment who were surrounded and annihilated. Bloodied, ragged,
exhausted, and encircled by bodies of dead comrades, the remnants of the
retreat from Kabul prepare for death. The heroic attempt to form a
'defensive four-square drill formation, a device which demonstrated their
discipline in the face of death' (Hichberger 101) is emphasized by the stark
landscape and the 'jumbled angles of the weapons' (*Lady Butler* 175). Of
all images of the nineteenth century involving besieged masculinity,
Wollen's of Gundamuck is the most harrowing: Afghanis are coming up on
right and left and, despite the Afghan standard bearer on the left having
been shot, the fate of the men in the pass of Jugdulluk is left in no doubt.
Small details, such as the soldier in the foreground getting cartridges out of
his dead comrade's box (with no. 44 on it), register poignant commentary
on their plight, perhaps stressed most emphatically by the bleak landscape
against which these haggard men face their end. This landscape, however,
is also sublime, the snow-covered mountains imaging not only the natural
landscape but also a heroic Valhalla to which the soldiers of the 44th will
ascend. A Captain Souter stands with the regimental colour tied around
his waist to save it, but he is almost the standard-bearer conducting the
heroes to the next world. If the sublime landscape arouses terror and fear,
it also endows glorification on the valiant men. The formation of a cross in
almost the centre of the canvas suggests this impending transcendence
through heroic death, while the two bayonets pointed toward the sky direct

the viewer's gaze to the next world. Similarly, the stance of the men evokes that of the men in Rembrandt's *Night Watch*, in order to align their death with heroic civic commitment to the state. The spirits of these men will be 'on guard' perpetually through this very icon of their destruction. Although the canvas might illustrate native resistance, here the Afghanis have been placed to the sides of the design, deliberately marginalized to emphasize the heroism of the British soldiers.

The inspiration for Wollen's canvas is undoubtedly Charles Fripp's terrifying 1885 *The Last Stand at Isandlhula*, now called *The Battle of Isandhlwana* (Plate 5–10). On 22 January 1879, during the Zulu War, 1,200 British troops were annihilated by 20,000 Zulus. The Zulus had 'slipped unseen into a ravine near the Isandhlwana camp' (Sears, ed. 226) while Lord Chelmsford led half his troops to verify the existence of Zulus in the foothills of the mountain. Chelmsford's miscalculation, however, was not the cause of the disaster: after successfully repelling the initial charges of the Zulus, the regiment discovered it was without additional cartridges. Bureaucratic confusion prevented a re-supply, which the Zulus recognized and exploited. In Fripp's representation, the troops are forming a small square. Spencer-Smith asserts:

> The contrast between the attitudes of the British infantry and the Zulus suggests a civilised superiority in the former, despite their being outnumbered by 'savage' hordes. (*Lady Butler* 173–174)

Fripp's painting has elements of sentimentality absent from Wollen's *Gundamuck*, such as the wounded sergeant extending his arm towards the drummer boy, a means of 'demonstrating the "cowardly" conduct of the Zulus in killing him' (Hichberger 102). It is scarcely surprising that reviewers preferred Giles's *Battle of Tamai*, as Spencer-Smith notes (*Lady Butler* 173), especially as Giles's canvas guardedly reaffirmed the dominant fiction and Fripp's decidedly did not. The savagery of the last moments is conveyed by numerous details: the soldier holding up a cartridge at the feet of the bloodied sergeant; the exulting Zulu at the extreme right background; the soldier to his left about to be stabbed; the equally exultant Zulu on the extreme left. While the presence of the regimental colours is artistic licence, it serves to limn the *topos* of the last moment. Droogleever notes 'the absence of an officer' in the canvas, which suggests a conscious critique that the 'backbone of the British army was its non-coms' (5). If so, Fripp's *Isandhlwana* of 1885 pursues the emphasis of Butler on the heroism of the rank and file. Most haunting is the face of the veteran adjacent to the drummer boy: a man who has seen it all, now sees the end.

Fripp's painting, showing the alternative of victorious black masculinity, sabotages the white dominant fiction by such devices. In his essay 'Reminiscences of the Zulu War, 1879' published in 1900, Fripp records his visit to the site of the Zulu War, including an eye-witness account of the final battle, at Ulundi. At its end, he describes the battlefield:

strewn with the weapons of the poor patriots, whose black bodies lay scattered about the trampled grass in every conceivable or inconceivable attitude. . . . That same night it might be said that the Zulu War was over, and that Cetywayo's power was a thing of the past already. The smoke of his burning kraal hung like a pall over the plain to conceal hundreds of his dead warriors from the great moon which stood calmly and gloriously in the eternal heaven above. (561–562)

Fripp then adds: 'Whatever the rights or wrongs which brought on the war, these same brave Zulus died resisting an invasion of their country and homes. . . . Naked savages as they were, let us honour them' (562). These statements would appear to be a gloss for Fripp's *Isandhlwana*, certainly indicating an awareness of the conflictory state of masculinities presented in the canvas.

If Fripp's *The Battle of Isandhlwana* conveys the heroism of the entire regiment, Richard T. Moynan's *The Last of the 24th, Isandula, 1879*, exhibited in 1883 (Plate 5–11), is the *last* of the entire regiment; the canvas is based on an account in the second edition of F.E. Colenso and E.C. Durford's *History of the Zulu War*. Ian Knight (1988) summarizes the significance of the canvas:

> Moynan's painting depicts the moment that the unknown soldier falls to Zulu fire, and is interesting for a number of reasons. . . . The man is wearing a Private's seven button tunic, with the 24th's green facings, and a 'long service and good conduct' stripe on the right sleeve. His helmet, waist belt and pouches are at his feet – his clothes are torn and bloody reflecting a prolonged fight at close quarters. More interesting, perhaps, is the fact that the Zulus in the picture are equally well-researched. . . . The painting is an interesting example of the sort of image the Victorians liked to create of their wars. The soldier's pose is stylised; he has a mystical, almost ecstatic, look on his face, and his left hand is raised as if conferring a blessing. The Zulus crouch at his feet in awe, like Roman soldiers before the crucified Christ; 'The Last of the 24th' is nobly sacrificed in the cause of the 'white man's burden'. (156)

The man dies 'as a martyr of Empire – with one hand outstretched as though in forgiveness' (Sotheby's London, 3 November 1993, p. 142). This Christ-like affiliation is marked by the tear in the left side of the private's tunic. As in Wollen's *Gundamuck*, as also in the mountain of Isandhlwana behind the square in Fripp's canvas, the landscape in Moynan's painting, a cave in the mountain, is sublime, with the sunset sky casting a glow over the dying warrior. The alignment of the soldier with Christ epitomizes the heroizing of masculinity.

Salvaging the dominant fiction in the wake of defeat is the project of Woodville's *Maiwand: Saving the Guns* of 1882 (Plate 5–12), representing a glimmer of heroism at the battle of 27 July 1880 during the Second Afghan War, which pitted 3,300 British troops against 35,000 Afghan warriors. Woodville concentrates on the withdrawal of C Battery of the Royal Horse Artillery with the enemy in pursuit. Despite the fact that Maiwand concerned a defeat, Woodville constructs the canvas – with its upraised whips, its charging steeds, and its officer pointing forward – as a

moment of heroic recovery of the dominant fiction, despite the bloodied head of the cavalryman on the right, the body being sustained to his left, and the bandaged head of the rider in the centre middle. Butler grasped at a similar remnant of valour during the same retreat in her 1905 *Rescue of Wounded: Afghanistan*, which represents men rescuing comrades from the ruthless cruelty of Afghanis, who were notorious for their treatment of captured soldiers. By emphasizing the wasteland of the Afghan landscape, Butler elevates the heroism of the comradeship. As in Wollen's *Last Stand at Gundamuck*, the landscape of Afghanistan itself constitutes the gauge of the obstacles encountered in an attempt to uphold the masculine codes.

Thomas J. Barker's *Major General Williams and His Staff Leaving Kars 28 November* 1855 [The Capitulation of Kars], completed *c*. 1860, represents the functioning of the dominant fiction in defeat. The description at the National Army Museum indicates the thrust of the canvas:

> In 1855 a Russian army sent into the Caucasus drove Turkish forces into Armenia. Major General William Fenwick Williams, British commissioner with the Turkish army, organised the defence of Kars. When the city fell after a spirited resistance, the Russians allowed Williams to march out with the honours of war.

The painting is dominated by the castle of Kars in the right distance, and shows Williams, flanked by Captain Teesdale, Lt. Col. Lake, and others exiting the defeated city. On the left, Dr Sandwith, accompanied by a Kurdish chief, draws attention to the city and to Williams. The political nature of the defeat is marked by the Turkish officer breaking his sword as he emerges from below, right. As Harrington (1991) notes: 'What was important in their eyes was that British soldiers had displayed courage against all odds in the wake of government blunderings for failing to send out reinforcements sooner' (23). A reviewer of William Simpson's version of the event noted the heroism equally applicable to Barker's canvas: '[Kars] is one of those defeats of ours which, like Corunna, is better than the victories of other nations' (Harrington 25). The location of suffering women in the foreground draws upon Delacroix's *Massacre of the Innocents at Chios* of 1824. The *Athenaeum* thus commended Barker's canvas as signifying 'English endurance and Saxon stubbornness' (Harrington 28)

A particularly important group of military paintings concerns the representation of Celts in Victorian battle imagery, a representation which reveals the conflictory nature of the dominant fiction, the equation of penis with phallus. The Irish and Scots in such canvases constitute 'the colonized in the colonies' in imperial battle art, where soldiers from groups which have lost independence (the Act of Union 1707 in the case of Scotland, the 1800 Act in the case of Ireland) fight to maintain British hegemony over other colonized groups. The depiction of the Highland soldier, in particular, was extremely popular among battle painters, for his picturesque dress in the kilt, the accompanying bagpiping [a key motif in itself at Dargai], and renowned courage made him particularly attractive in this icono-

graphic construction. No image from the nineteenth century so encapsulates this conflicted equation as Elizabeth Butler's 1879 RA exhibit *Listed for the Connaught Rangers: Recruiting in Ireland*, representing a 'sergeant, private, and two drummer boys' with two Irish recruits (Spencer-Smith 1987, 74) in the 1870s. The canvas is striking in her work for the prominence of the landscape and for the ruined cottage at the picture's left. For Butler 'the civilian peasant dress form[ed] the centre of interest' (75).

First visiting Ireland in 1878, at the time of her marriage to William Butler, the artist recorded her response to the ruined country:

> The village was deserted in the awful famine year of '47, some of the inhabitants creeping away in fruitless search for work and food, to die further afield, others simply sinking down on the home sod that could give them nothing but the grave. (Hichberger 129)

During the agricultural disasters of the 1830s and 1840s, many Scottish and Irish peasants had been forced to enlist in the army to avoid starvation and unemployment. As Spiers notes, 'In 1830 and 1840 over half of the noncommissioned officers and men came from Scotland and Ireland' (48). In 1878, the year in which Butler painted *Listed for the Connaught Rangers*, her husband William Butler, an ardent nationalist and friend of Parnell, wrote his essay 'A Plea for the Peasant', in which he indicted the British government for forcing Irish men to enlist because of the gross brutality of British policy in Ireland. Although over 50 per cent of NCOs and rankers came from Ireland and Scotland in the 1830s, and although their proportion decreased as the century progressed, the Irish contingent still 'kept pace with Ireland's share of the United Kingdom population' (Skelley 131) although the Scottish did not. Butler's indictment of 1878 is therefore directed at pervasive discriminatory policies of the British government which transcend but still affect the military.

The private soldier, he wrote, was 'thrown to our service by the hazard of his social condition, that social condition being poverty or disgrace' (284), concealing 'the great secret that the cradle of an army is the cottage of the peasant' (288; on recruiting, see Skelley, chapter 5). About the victories in the Napoleonic Wars or the Crimea or the colonial campaigns, Butler asserts 'that it was only through the assistance of our Celtic peasants, Irish and Scotch, that our armies were able to achieve victory' (291). Recruits were automatically commodified since 'recruiting officials received a fee for every man they enlisted' (Skelley 240), already a manifestation of *méconnaissance*.

About these Scottish and Irish troopers, Butler asks, 'Were they men on whom the nation had lavished the benefits of civil law, the blessings of good government, the privilege of a free faith? Alas! the answer must be, No' (300). He continues:

> This poor Celt found voice and strength and space, at last, upon these Spanish battle-fields. Room for the hunted peasant! . . . While abroad over the earth

Highlanders were thus first in assault and last in retreat, their lowly homes in far-away glens were being dragged down . . . by the cold malignity of a civilised law. . . . A dreadful famine came to aid the cause of peasant clearers in Ireland. It became easier to throw down a cottage while its inmates were weakened by hunger; the Irish peasant could be starved into the capitulation of the hovel which, fully potato fed, he would have resisted to the death. Yet that long period of peace had its military glories, and Celtic blood had freely flowed to extend the boundaries of our Indian Empire (300–301; 302, 305–306)

Listed for the Connaught Rangers therefore demonstrates Silverman's contention about 'the centrality of the discourse of war to the construction of conventional masculinity . . . how pivotal that discourse is to the consolidation of the penis/phallus equation. . . . However, although the discourse of war works not only to solicit civilian belief in the dominant fiction, but to shape the subjective experience of battle, it does not always manage to fortify the soldier against an introverted death drive' (62).

In Butler's canvas, the juxtaposition of ruined cottage with remote mountain and especially the contrast of the two recruits, one looking back with regret on the historical circumstances which have driven him to enlist, presents the conflicted construction of masculinity present in the Celtic subject in battle iconography. This incommensurability was given particular point in the 1860s and 1870s when Scottish regiments were posted in Ireland to counter Fenian revolt. It must be noted also, as Cecil Woodham-Smith observes, that the Connaught Rangers evoke the horrendous severity of the treatment of Connaught during the Elizabethan period and later under Cromwell, who forced 'native Irish' into the region, 'turned loose to starve in a ruined country' (111). Butler constructs not only contemporary but distant history in the canvas.

It was, however, Scottish troops which drew the focus of Victorian battle artists, especially because of their exotic dress – from mid-century the kilt – and their haunting bagpipe music. However, by the nineteenth century Scotland had undergone a metamorphosis in the public imagination. The visit of George IV to Edinburgh in 1822; the Eglinton tournament in 1839; the impact of Scott's novels; the visit of Queen Victoria there in 1842; her purchase of Balmoral in 1847; and her close relationship with Napolean III's wife, Eugénie, who had a Scottish grandfather (see Wood, *Scottish Soldier* 76; Hichberger 108–109) all influenced this change of view. More overt political events included the formation of the National Association for the Vindication of Scottish Rights in 1853, the creation of a Secretary for Scotland in 1885, and the growing cult of Mary Queen of Scots from the 1850s onward (see *The Queen's Image, passim*; Strong 162–163; Trevor-Roper; Hanham).

Butler painted a number of canvases of Scottish regiments, but nearly always in the context of global rather than small/colonial/imperial wars. These canvases become conflictory constructions of masculinity through their configuration of the incommensurability of penis and phallus by representing the sacrifice of Scottish rankers for British military supremacy.

Thus, in a canvas such as *Scotland for Ever!* (1881), showing the Scots Greys at Waterloo in the famous charge of the Union Brigade, the representation of what appears a victory (only two men are shown shot) is in fact equivocal; although Sergeant Ewart managed to capture the French eagle, 'a counter-attack by French cavalry while [the Greys] were returning from this mad-cap venture led to their being cut to pieces and reduced to little more than a squadron in number' (Spencer-Smith 82), in Wood's terms a 'Pyrrhic achievement' (50).

Butler's 1895 exhibit *The Dawn of Waterloo* shows the Irish members of the Scots Greys at reveille prior to the charge in *Scotland for Ever!*, but again this representation of Celts is intensely conflicted if one recalls William Butler's 1878 essay. The very colonized circumstance of the Scottish and Irish troopers explodes the penis/phallus equation. A similarly conflictory circumstance appears in *The Colours: Advance of the Scots Guards at the Alma* of 1899 and especially in *A Lament in the Desert: Cameron Highlanders 1885*, painted only in 1925.

In the latter, set during the Sudanese War of 1883–85, the colonized Scots bury one of their own in the campaign against the Dervishes or what Kipling in 1890 called the Fuzzie-Wuzzies. In his 1880 essay 'The Zulus' in which he attacks the British government for its abuse of this nation, Butler had said that 'nothing is more natural' than that blacks should revolt against British white occupation and conquest. In *A Lament in the Desert*, Scottish troopers, themselves driven to enlist because of the 'clearance' and other abuses, become the oppressed oppressing the oppressed. At the same time, the desert in Butler's canvas becomes a vast, democratizing levelling ground of the races. The sharp diagonal of the line of mourning soldiers confronts the viewer directly in the foreground. William Butler's assertion that the blacks were singularly like the British themselves became literally true, as his wife recalled:

> The Upper Nile had these graves of British officers and men all along its banks during that terrible toll taken in the course of the Gordon Expedition and after, some in single loneliness, far apart, and some in twos and threes. These graves had to be made exactly in the same way as those of the enemy, lest a cross or some other Christian mark should invite desecration. (*Lady Butler* 92)

The Union Jack draped over the corpse is consecrated by the moonlight. Kipling's death in the desert used in the alternative conclusion to *The Light that Failed* is the literary analogue of Butler's canvas.

One of the greatest battle artists of the nineteenth century was the Scottish painter Robert Gibb, whose works epitomize the conflicted nature of masculinity in his subjects of Scots in global and colonial wars. In his most famous canvas, *The Thin Red Line* of 1881 (Plate 5–13), Gibb depicts the 93rd (Sutherland) Highlanders receiving the charge of Russian cavalry at Balaclava on 25 October 1854, an 'action immortalized by William Howard Russell's phrase "that thin red streak topped with a line of steel" ' (Spencer-Smith 1987, 171). If Gibb's title remained indelibly one

of the paradigmatic signifiers of masculinity for the remainder of the century, it was more to Alexander Kinglake's *Invasion of the Crimea* that Gibb owed his inspiration, in particular the following sections which construct Scottish masculinity as imperial model:

> The 93rd Highlanders, now augmented to a strength of about 550 men . . . were drawn up in a line two deep, upon that rising ground in front of the village of Kadikoi which was afterward called the 'Dunrobin' or 'Sutherland' hillock. . . . When these horsemen [the Russian cavalry] were within about a thousand yards of him, [Sir Colin] Campbell gave a brisk order to his little body of men on foot, directing them at once to advance, and again, crown the top of the hillock. . . . At the critical moment, two battalions of Turkish troops turned and fled, leaving Campbell's small force of Highlanders to face the enemy. [Campbell] could not help seeing how much was to depend upon the steadfastness of the few hundred men who remained with him on the hill. . . . He rode down the line and said, 'Remember, there is no retreat from here, men! You must die where you stand!' The men cheerily answered his appeal saying, 'Aye, aye, Sir Colin; we'll do that'. (Harrington 1989, 589–590)

Kinglake's account already contained the elements requisite for the construction of the legend: the desertion by the Turks, the small force, the line, the 'last stand' or 'backs to the wall' *topos*. Although it is disputed whether there were two or four lines of troops, Gibb selects the former to emphasize the heroism of the rankers. *The Thin Red Line*, which in the diversity of faces of the Scottish soldiers derives from Butler's line in *The Roll Call*, is noteworthy for elements that became signatures of Gibb's style, especially his preference for infantry rather than cavalry, which lends his constructions a restraint alien to the work of Woodville or even Butler, who grasped at the charging horse as a means of injecting dynamism into the canvas. Gibb, in contrast, concentrates on the psychologically tense situation of the combatants, here reflected in the diversity of responses to the Russian charge, which has brought down one hussar. The canvas also elevates Colin Campbell to heroic status. Another signature of Gibb's technique is to emphasize the line rather than represent soldiers in the defensive square, which was the usual formation to repel cavalry. In fact, the Russians withdrew after two volleys were fired because they thought the line of Highlanders had to be supported, which was not true.

The same line formation appears in *The Alma: Forward the 42nd* of 1889 (Plate 5–14), showing Sir Colin Campbell leading the Black Watch to scale the Russian fortifications. A Russian officer recorded later: 'This was the most extraordinary thing to us, as we had never before seen troops fight in lines two deep' (Harrington 1989, 590). The Scots at the Alma, according to Kinglake, were living embodiments of Victorian masculinity:

> These young soldiers, distinguished to the vulgar eye by their tall stature, their tartan uniforms, and the plumes of their Highland bonnets, were yet more marked in the eyes of those who know what soldiers are by the warlike carriage of the men, and their strong lithesome, resolute step. (ibid., 590)

In Gibb's canvas, the 42nd (Highland) Regiment advances 'in double

formation towards the seemingly impregnable Russian positions on the slopes about the south bank of the River Alma' (file, Glasgow Art Gallery). Kinglake again provided Gibb with the operative text:

> When Sir Colin rode up to the Corps which awaited his signal, he only gave two words, 'Forward 42nd' and 'as a steed that knows its rider' the great heart of the battalion bounded proudly to his touch – smoothly, easily, swiftly, the Black Watch seemed to glide up the hill. (file)

Gibb emphasizes the heroism of Campbell, who directs the advance with his sword in front of his troops. The battle of the Alma is particularly conflicted in its results because, while successful in itself, the British and French did not pursue the retreating Russians, who 'headed, unmolested, towards Sevastopol. . . . Sevastopol at that time was poorly fortified, and if an attack had followed this Allied victory, the port would have very likely fallen and the Crimean War could well have ended then' (Woosnam-Savage 3).

Gibb's final Crimean canvas, *Saving the Colours: The Guards at Inkerman* (painted 1894–98; exhibited 1900) (Plate 5–15) concentrates on the heroism of Lt. H.W. Verschoyle of the Guards, who carries the flag of the regiment after the engagement at Inkerman, a group the *Art Journal* called a 'band of heroes' (Gilbert 28), albeit not a Celtic regiment. The Duke of Cambridge is shown on the right welcoming the victorious survivors. Bonnets on the ends of bayonets celebrate the victory. Because Gibb is not painting a line here, the interaction among the participants is noteworthy, rather than the forward-looking gazes of *The Thin Red Line* and *The Alma*: one man has his eyes on the colours; another looks with concern at Verschoyle, whose head is bandaged under his bonnet; the drummer boy in the left corner focuses his blue eyes on the heroic action, imprinted by this heroic masculinity. The battle honour CORUNNA (16 January 1809) is under the Union Jack, evoking a heroic encounter of the Peninsular War. In this interaction of the participants, Gibb signals the importance of comradeship, an element of the masculine code particularly significant in *Saving the Colours*.

Gibb's images of comrades are among the most famous in battle art. In the 1885 *Letters from Home*, two men sit in a cold tent exchanging confidences about domestic circumstances recorded in their letters. In his first battle picture, the 1878 *Comrades*, Gibb made comradeship the basis of the painting, showing 'a young soldier, dying amid a snowstorm' (Gilbert 27) during the Crimea. The emphasis on comradeship is crucial for the maintenance of the dominant fiction, as Silverman notes:

> The fiction of a phallic masculinity generally remains intact only for the duration of the war. As long as the soldier remains on the battlefield, he is fortified to some degree by his comrades; the 'binding' which can no longer take place at the level of the ego occurs instead at the level of the group. (63)

Gibb's three soldiers of the Black Watch have left their column as one of their number has collapsed in the snow. Gibb constructs a military pietà as

the dying confidences are exchanged. As Lalumia observes, '*Comrades* demonstrated that Lady Butler's anti-heroic conception of battle did not represent a phenomenon unique to her' (145), as Gibb shows the ordinary ranker capable of extreme loyalty in combat. John Luard's *The Welcome Arrival* of 1857 is set in the Crimea and shows as its central figure his brother Major Richard Luard of the 77th Regiment. The comradeship of the canvas is linked by the sharing of a gift box, 'a newly opened crate of preserved foods and tobacco from England' (Lalumia 102). The figure on the right may be a self-portrait of the artist. Of particular interest is the great number of wood engravings on the walls of the small hut, signifying the manner in which the events themselves unite the comrades, one of whom appears to study a miniature.

The legacy of this comradeship during the nineteenth century was the formation of 'pals' battalions' during recruitment for the First World War, as Reader notes: 'Municipalities or private individuals were encouraged to advance money, later to be repaid, for clothing, feeding and housing battalions raised in their locality, which groups of "pals" would join from motives of local as well as national patriotism' (108–109). The death of one soldier was noted thus: 'In the morning of his youth he hastened to rejoin his friends and comrades by a swift and noble death' (131–132), a perfect illustration of the importance of comradeship for maintaining the dominant fiction. Easthope stresses that comradeship is one of the essential components of war:

> The four elements of the war genre – defeat, combat, victory, comradeship – are not just a series but a structure. Defeat and combat, castration and narcissistic disavowal, are clearly organized in relation to each other, but so is comradeship. In the dominant versions of men at war, men are permitted to behave towards each other in ways that would not be allowed elsewhere, caressing and holding each other, comforting and weeping together, admitting their love. The pain of war is the price paid for the way it expresses the male bond. . . . In this special form the male bond is fully legitimated. (66)

The role of Kipling's *The Light that Failed* in emphasizing this comradeship among soldiers and 'specials' supports the ideology constructed in Gibb's *Letters from Home* and *Comrades*.

The comradeship of Scottish forces is particularly important in two of the most famous representations of the Gordon Highlanders scaling the heights at Dargai on 20 October 1897 during the Tirah Expeditionary Force campaign against the Afridis in northwest India. In Gibb's *Dargai* of 1909 (Plate 5–16), again a famous command was the germ of the action: 'Colonel Mathias commanding the Gordons said to his men, "Highlanders, the General says the position must be taken at all costs. The Gordons will take it" ' (Harrington 593). Gibb, like Wollen, uses the landscape to suggest the brutal circumstances in which the charge occurred, during which the regiment lost three officers and 30 men. The rough terrain magnifies the achievement. Woodville's *The Storming of Dargai Heights* of

1898 deploys landscape for the same purposes, but it also includes the most famous element of the charge, Piper George Findlater continuing to play even though both his legs were wounded. Woodville places him in the foreground to link the anecdote with the canvas, unlike Gibb, who chooses to ignore this element of the legend of Dargai. In his poem commemorating the battle at Dargai, *The Gay Gordons*, Henry Newbolt focused on Findlater's action:

> But the Gordons know what the Gordons dare
> When they hear the pipers playing! . . .
> Rising, roaring, rushing like the tide,
> (*Gay goes the Gordon to a fight*)
> They're up through the fire-zone, not to be denied;
> (*Bayonets! and charge! by the right!*)
> Thirty bullets straight where the rest went wide,
> And thirty lads are lying on the bare hillside;
> But they passed in the hour of the Gordon's pride,
> To the skirl of the pipers' playing. (60)

Findlater's action is a supreme marker of comradeship, but Gibb's representation, in its emphasis on sheer bravery, concentrates the observer's attention on the action by omitting the anecdote. The motif of the 'charge up a height' which unites Gibb's *Dargai* with his *Alma*, draws a correlation between Scottish Highlanders and terrain that yields a powerful psychological nexus of masculine defiance. This imagery of Scots abroad eliminates the stigma of their ethnicity which would be felt in England: the penis/phallus equation abroad could be maintained as ethnicity was subsumed into racial superiority and national identity.

The Scots as heroic rescuers is a focus of Joseph Noel Paton's *In Memoriam* of 1858, which has a history both combat- and race-inflected. As the picture exists today, it represents a group of English women, one of whom holds a Bible, praying for divine intervention at the moment the Highlanders enter to effect their rescue during the Indian Mutiny, probably a scene at Cawnpore. As Hichberger observes, Paton constructs his figures in a manner 'reminiscent of Christian martyrdom scenes . . . in the tradition of High Art representations of saints' (*Images* 175). When first exhibited, the picture had in fact depicted a group 'of maddened Sepoys, hot after blood', according to *The Times* (*The Raj* 241). In its original version, the canvas aroused fervid controversy. The *Illustrated London News* declared the subject was 'too revolting for further description' (15 May 1858, 498), although *The Critic* regarded the canvas as one 'to solemnly meditate. We feel it almost a profanation to hang this picture in a show-room, it should have a chapel to itself' (15 May 1858, 235). The picture was engraved not with murderous Sepoys but with the revised Highlanders, demonstrating – and circulating – the idea of British Caucasian superiority over the lustful dark natives. As Hichberger observes, 'the depiction of ladies in the power of black soldiers was deeply offensive' (*Images* 175) and for Paton ultimately intolerable. A canvas therefore that

originally contested the heroic code of white male militarism by *not* showing a rescue – and thereby exposing the incommensurability of the penis/phallus equation – was reconfigured to affirm that equation.

This incommensurability, however, is not camouflaged in Frank Holl's *A Deserter* of 1874 (Plate 5–17), in which Highlanders have caught a deserter/labourer, his 'heavy, split boots and ragged attire . . . in obvious contrast to the brilliant red clothing of the Highlanders' (Casteras, *Virtue Rewarded* 51). When one considers Butler's essay on the factors driving men to enlist – famine, the 'clearances', unemployment, starvation (the last signalled by the loaf in the man's hand) – the issues of class, ethnicity and imperialism are conjoined, especially since in the 1870s the recruit would be destined for a colonial campaign. The act of desertion itself, also appearing in Richard Redgrave's *The Deserter's Home* (1847), enacts a repudiation of the masculinizing norm, with a clear acknowledgement of its irrelevance to those marginalized by ethnicity, poverty or classism. Particularly because of its setting, questions of incommensurability and the misrecognition underlying the dominant fiction also destabilize Robert G. Hutchinson's *Under Orders* of 1883, depicting the Black Watch in a barrack room of Edinburgh Castle prior to embarking for the Egyptian War which led to Tel-el-Kebir. Hutchinson shows the families gathered with their individual loved ones, with elderly relatives counselling the young soldiers. In the background of the painting, a reproduction of Millais's *Cherry Ripe* (1879) symbolizes the reason why the troops are fighting: it is to preserve white womanhood. Thus the canvas has a strange affiliation with Paton's *In Memoriam*, as Scots become defenders of Caucasian racial superiority whether that be in Africa or India.

This racial superiority, emphasized by the ethnicity of the Scot, appears in George Joy's *The Last Stand of General Gordon* of 1893 (Plate 5–18), commemorating the death of Gordon at Khartoum on 26 January 1885, when the Sudanese capital fell to the Mahdi's forces. Although born in Woolwich, commentators stressed Gordon's Scottish heritage, including William Butler, who described Gordon in *The Campaign of the Cataracts* as 'the solitary figure of the great Celtic soldier' (84) at his death. Surmounting blacks for the last time, Gordon epitomizes the Scot caught at the very moment exposing the *méconnaissance* upon which the dominant fiction of the commensurability of penis and phallus rests. In this representation, the Celt in Victorian battle imagery, himself colonized, confronts another Other in the form of an alternative, non-Caucasian masculinity, as in Giles's *Battle of Tamai* or Fripp's *Isandhlwana*. In *The River War*, Churchill had speculated that Gordon 'saw himself facing that savage circle with a fanaticism equal to, and a courage greater than, their own' when he confronted these 'wild, harlequin figures' (quoted in Johnson 285). Churchill associates Gordon with racist myths of blacks (especially Sudanese with their patched jibbahs) as savage clowns, and even Gordon admitted that 'one black face looked like another to him' (D.H. Johnson 301).

Johnson notes that a 'saint cult' (304) was built around the figure of the Celtic Gordon, the motive of which was to justify the imperial idea:

> The vast majority of Gordon literature is important not for the study of Sudanese history but . . . for the study of western psychology, more particulary the psychology behind British imperial sentiment. . . . A man without imperfection, [Gordon] justified the winning of an empire by men of more mortal stature. (307)

Thus, this ultimate example of Celtic valour constructs white masculinity in imperial contexts.

In his *Autobiographical Sketch* published in 1904, Joy left an account of the generation of *The Last Stand of General Gordon* which demonstrates the manner in which military art constructed masculinity for cultural purposes:

> In this picture of Gordon I was desperately in earnest. On no historical or political event have I felt so strongly as on this momentous one. I cannot bring myself to look at it from any point of view but that of betrayal of all that was highest and best in our national instincts, life, and traditions. A betrayal of one of the greatest men we ever possessed; of the anti-slavery cause in the Soudan; as well as of the doomed inhabitants of Khartoum, who had trusted to us, and to our plighted word, to help and protect them.
>
> It was therefore in the genuine hope of doing something, however insignificant, to help on that awakening of the conscience of the nation, that I undertook, will all due reverence, this great subject. (20–21)

Joy records how he changed his canvas as it evolved 'to give more accurately the direction of the slanting light of dawn . . . mainly with a view to secure the absolute fidelity and truth of my representation' (21–22). He continued:

> That small dark figure, standing out against the whitewashed wall, in the dim morning light, with the white-clad ragged dervishes eager for their prey surging up from below, is truly one of the most pathetic sights in all history. Stern determination, not unmixed with scorn, is in his whole bearing. One cannot help being reminded of that other scene in dark Gethesemane, the most momentous and tragic the world has ever witnessed, and of the words: – 'Whom seek ye?' (22)

Joy conjoins Gordon to exalted paradigms, here to Christ in his self-sacrifice. In his concern with light, however, he also associated Gordon with Apollo and male rationalism/enlightenment, given particular point by the African location. He wanted 'the effect just before sunrise . . . that fateful moment between dawn and sunrise . . . In the grey morning light, stands the dark figure of the general, alone against a multitude! . . . On the broad forehead of the hero the light of morn strikes for the last time' (23, 48). Even Lytton Strachey's debunking with 'The End of General Gordon' in *Eminent Victorians* (1918) did not dislodge Gordon from this Apollonian pre-eminence.

Caton Woodville's *The Gordon Memorial Service at Khartoum* of 1899 (Plate 5–19), painted expressly for the Queen, is the iconographic memorial

to this construction of Gordon. The Catholic, Anglican, Presbyterian and Methodist chaplains are shown before the ruins of the palace. Steevens recorded the event as follows:

> Thus with Maxim-Nordenfeldt and Bible we buried Gordon after the manner of his race. . . . He was an Englishman doing his duty, alone and at the peril of his life. . . . We came with a sigh of shame: we went away with a sigh of relief. . . . We left Gordon alone again – but alone in majesty under the conquering ensign of his own people. (314–316)

Steevens summarizes that 'the vindication of our self-respect was the great treasure we won at Khartoum, and it was worth the price we paid for it' (318).

For Steevens, the imperial conquest was justified by the nature of the natives. In his conclusion to his book, he reveals he accepts the white Western construction of African masculinity as something Other and inferior:

> Take the native Egyptian official even to-day. No words can express his ineptitude, his laziness, his helplessness, his dread of responsibility, his maddening red-tape formalism. . . . To put Egyptians, corrupt, lazy, timid, often rank cowards, to rule the Sudan, would be to invite another Mahdi as soon as the country had grown up enough to make him formidable.
>
> The Sudan must be ruled by military law strong enough to be feared, administered by British officers just enough to be respected. . . . [The Sudan] is not a country; it has nothing that makes a country. Some brutish institutions it has, and some bloodthirsty chivalry. But it is not a country: it has neither nationality, nor history, nor arts, nor even natural features. . . . Its people are naked and dirty, ignorant and besotted. It is a quarter of a continent of sheer squalor. . . . The Sudan is a God-accursed wilderness. (321–325)

The most startling passage in Steevens's record, however, is its famous penultimate paragraph, when he considers a savage norm of masculinity resulting from the Sudan campaign and the Gordon relief expedition:

> Perhaps to Englishmen – half-savage still on the pinnacle of their civilisation – the very charm of the land lies in its empty barbarism. There is space in the Sudan. There is the fine, purified desert air, and the long stretching gallops over its sand. There are the things at the very back of life, and no other to posture in front of them, – hunger and thirst to assuage, distance to win through, pain to bear, life to defend, and death to face. You have gone back to the spring water of your infancy. You are a savage again. . . . You are unprejudiced, simple, free. You are a naked man, facing naked nature.
>
> I do not think that any of us who come home whole will think, from our easy-chairs, unkindly of the Sudan. (325–26)

Here the norms of masculinity are exposed as savage and liberating simultaneously. Elements of both *Heart of Darkness* (1899) and *The Light that Failed* are suggested in Steevens's paean to masculinity in the desert.

The attempt to reassert the dominant fiction of masculinity is most difficult in the representation of the wounded male body, particularly in the case of the returned veteran. It is striking that representations of

veterans from imperial campaigns were relatively few after mid-century. Silverman offers an explanation of this anomaly:

> Once removed from the battlefront, the traumatized veteran no longer enjoys the support of his comrades-in-arms. All that stands between him and the abyss is the paternal imago, within which he can no longer recognize himself. For the society to which he returns, moreover, he represents a sorry travesty of 'our fighting men and boys,' a living proof of the incommensurability of penis and phallus. (63)

Hichberger notes that 40 paintings of veterans were exhibited at the Royal Academy between 1815 and 1914, 18 of which involved Chelsea pensioners (141). This small number is not surprising if one considers that the wounded body of the male becomes the signifier not of masculinity but of the Other, the resourceless, passive, non-aggressive paradigm associated with the feminine or the colonized. Few of these veteran depictions were of imperial war campaigns. Rather, the best known involve the Crimea. In Joseph Noel Paton's *Home: The Return from the Crimea* exhibited in 1859 (Plate 5–20), a corporal in the Scots Fusilier Guards is embraced by his kneeling wife as his aged mother hovers over him. He has lost his left arm and is still bandaged about the head. As Christopher Lloyd notes, 'the painting can . . . be interpreted as an implied criticism of the war', the 'anti-heroic sentiments' of which disturbed reviewers (202). There can be no doubt that to observers the wounded and incapacitated male body exposed the fragility of the penis/phallus equation. The disabled veteran, in fact, guaranteed that the prevailing order was *not* sabotaged. Hichberger (in *Patriotism*, ed. Samuel) notes that disabled veterans were depicted 'to minimise any sense of physical threat from the veterans and to make them into recognizably suitable cases for pity' (63). Hichberger observes that the public feared 'the dangers of radicals "subverting" soldiers and veterans' ('Old Soldiers' in *Patriotism* 62). Located in a domestic setting, and disabled as well 'the veteran of the Crimea became an unthreatening patriot' (55).

The artist C.M. Hodges revealed in his canvases the preferred construction of the veteran. In his *Home Sweet Home* of *c.* 1890, a corporal of the 11th Hussars is shown home on leave, an image much in contrast with the broken veteran of Paton's *Home*. Here the domestic setting, the attentive wife, the loyal dog, the table laden with food, and the clean surroundings reveal the situation of a man unwounded and thus still within the dominant fiction. Painted in 1898, the veteran in *Of Balaclava and '54*, narrating the tale of the Charge of the Light Brigade in the Crimea, transmits the masculine code to a young ranker, who listens respectfully. This veteran conveys to a later generation the empowering ideology of the dominant fiction. Hodges' *Balaclava and '54* thus epitomizes the construction of masculinity in Victorian military painting, especially its function of imprinting the future generation of young men.

The best-known representation of the veteran of an imperial campaign is

Henry O'Neil's *Home Again, 1858*, exhibited in 1859 (Plate 5–21). Writing about another version, Spencer-Smith observes in her essay that the canvas represents a range of types of veterans returning from the Indian Mutiny. While most of the returnees are happily received by wife or mother, 'a highlander of the 93rd (Highlanders) with his arm round his daughter looks away in distress from the letter that he has just read. The words "deceive . . . wife . . . who loved you" can just be traced' (30). This detail is especially trenchant, suggesting that the wife rejects the man as sexual partner, provider and guide, clearly recognizing his new marginalized status. The *Athenaeum* in its review (30 April 1859, 587) indicted the falsity of O'Neil's optimistic construction: 'The crowding down of relatives and friends to greet [the veteran] on the land, is too generally a myth . . . broken health and penury, to be endured in obscurity, are all that remain'. The disabled veteran was too evident a marker of the disintegration of the dominant fiction of masculinity.

The social realist artists of the Victorian period were especially aware of this disintegration as marked by the veteran. In Thomas Faed's *From Hand to Mouth* of 1879, a veteran, accompanied by his son and daughter, stands in front of a shop counter reaching for money to pay for the goods on the counter before the suspicious shop proprietor. A pointed constrast with the well-dressed woman on the left emphasizes the plight of the veteran, the feared image of the unemployed, poor, migrant, dispossessed male. Here Faed records the total collapse of the dominant fiction. As Treuherz records: 'Unemployment had caused them to enlist, but after discharge only a few were entitled to pensions and most were thrown onto the casual labour market. Unskilled, they became beggars or vagrants' (*Hard Times* 45). In the long line of the dispossessed in Luke Fildes's *Applicants for Admission to a Casual Ward* of 1874, a veteran leaning on a crutch appears to the far right of the canvas. Probably a survivor of the Crimea, he is a terrifying remnant of the campaign. As Hichberger notes, the only review to record his presence called him a 'professional beggar', suggesting he was a fraud (*Images* 148). The destitute nature of the man exposes the falsity of the dominant fiction and the devaluation of the male body once wounded and impoverished. Since the casual ward was the last step before the work-house, the veteran's plight is acute, linked as he is with an unemployed mechanic, a drunkard, a stowaway and various outcast women.

Two other social realist artists, Holl and Herkomer, also were attracted to the veteran. In his *Home from the Front* of 1881, soldiers of the McKenzie Highlanders are shown returning from one of the wars of the late 1870s, such as the Second Afghan War. Unlike the situation of the veterans in Faed's or Fildes's canvases, the welcoming citizenry accord the veteran acceptance and status in a civic ceremony, even when he may be wounded. Wives, sweethearts, and drummer boys enliven the canvas and camouflage the much more certain social neglect experienced by most veterans. Holl had exhibited *Ordered to the Front* the previous year, and its

sequel *Home from the Front* echoes the same personages. He may well have felt compelled to sustain a valiant attitude for this 'diptych'. In Herkomer's *The Last Muster* of 1875 (Plate 5–22), a group of veterans is shown at the Royal Hospital Chelsea attending a service in the chapel, during which the man at the end of the second row has died. His friend reaches to take his pulse. As Edwards notes, 'the inmates of the Chelsea Hospital were seasoned war veterans who qualified for residence because of their indigence' (*Hard Times* 92). The flags hanging over the group evoke glories long forgotten by an ungrateful public. In contrast to *The Last Muster*, however, Herkomer's veterans of the Crimea in *The Guards' Cheer* of 1898 stand beneath the Crimean War memorial to celebrate the Queen's diamond jubilee. The Union Jack and the presence of the young girl (as in Hutchinson's *Under Orders*) remind the observer of the reasons for military service. In both of Herkomer's canvases, however, the veterans are aged, too old or penurious to pose any threat to the culture or become involved in radical politics.

The plight of a veteran's family after his death is signified by the neglect the public accorded his widow and family. In Thomas Brooks's *Relenting* of 1855, 'a landlord and his agent prepare to evict a widow and her children from their garret chambers. From the portrait on the wall, the black-edged letter behind its frame, and the sword hanging nearby, it is apparent that the husband was a soldier, killed perhaps in the Crimea' (Casteras, *The Substance or the Shadow* 63). As Casteras notes, details such as the curtainless windows, the meagre room furnishings, and the medicine bottles alluding to the illness of the eldest daughter denote a situation of the poverty all too often awaiting both the veteran and his family. In *Relenting*, the callous neglect of the veteran is transferred to his survivors, representing the unwillingness of the culture to deal with those exposing the falsity of the dominant fiction. Probably painted during 1854–56, Frederic George Stephens's *Mother and Child* (Plate 5–23) is a Pre-Raphaelite response to the Crimean War. A woman holding a letter has reacted so intensely to its message that her young daughter has turned to her. The letter may convey the father's death or evoke a longing for him if he still lives. Stephens has placed a number of significant toys on the table: a carved lion (symbolizing Britain) and a 'rolling cylinder from which hangs a miniature of a hussar' (Lalumia 1984, 99), which indicates Russia. In Stephens's and Brooks's canvases, the role of the soldier is associated with that of the paterfamilias. By his absence, and the suffering it causes, each artist exposes the fallacy of the myth of female domesticity and of the security of a wife/queen in her Ruskinian 'garden'. Instead, the woman's dependence on the male is demarcated by the distress his absence generates. The valour exhibited by the absent husbands in these two canvases will not be rewarded by the very culture endorsing such masculine behaviour.

John Springhall contends that battle artists:

supplied the British public on a regular basis with the visual imagery for the great imperial events of their times. Popular art was thus instrumental in defining the public image of warfare in Victorian Britain [especially through] popularised reproductions [in which could] be found all the qualities – hero worship, sensational glory, adventure and the sporting spirit [through which] the age of imperialism saw itself. (68–69)

Lalumia asserts that in the 1880s and 1890s there was a 'contemporary mood of confidence in the army's invincibility' (148). Imperial battle iconography, however, suggests that such attitudes were not universal. In fact, with the exception of the representations of indisputable victories, battle painting interrogated as much as it constructed the dominant fiction of masculinity, particularly because as MacKenzie observes such imagery revealed the connection 'between imperialism and sexual separation' (179). The all-male world of imperial battle imagery is the extreme example of the intensification of the male body, which became a site for negotiation and contestation of masculinity.

This contestation was stimulated by the debate about battle art itself, which included a pacifist critique that such imagery was marked by misrepresentation and reticence. Roger Stearn notes:

> Decorous selection and omission was the norm in pre-1914 portrayal of war, in the illustrated press as at the Royal Academy. Yet while its practitioners saw it as proper and beneficial, to their pacifist critics it was deliberate lying, the hiding of the real horror of war. While battle painting was accepted by the art establishment and popular with the public, a minority of critics condemned it, asserting that its subject and necessity of omission invalidated it as true art. (*War Images* 125)

Two responses to this criticism may be in order. First, all art is necessarily selective and reticent by the very nature of its exclusion of material in construction of the canvas. Even more significantly, the pacifist critique overlooked the degree to which the role of the soldier and the nature of combat were in fact represented with considerable fidelity. Stearn observes, '[battle artists] portrayed death and wounds, but in a style that omitted the horror, mutilation, disfigurement, suffering and agony, and showed relatively few British dead' (*War Images* 20). He adds: 'Victorian battle painting followed self-censoring conventions: no ugliness or squalor; minimised, conventionalised wounds; few British dying or dead; and no cruelty, horror or agony' (*War Images* 116). Such statements, however, contain only a part of the truth. On the contrary, it is the case that squalor, agony, cruelty and horror are not absent or omitted from military painting; see for example Fripp's *Isandhlwana* or Butler's *The Roll Call* or *Inkerman*. Gibb's *Saving the Colours* is memorable for its squalor, mud, torn and dirty uniforms, and bandaged heads; Wollen's *Gundamuck* epitomizes the horror of the 'last stand'. In fact, the battle artist, by showing wounding, death, abandonment, stabbing or collapse in a few carefully calculated details of a canvas increased its horror by this very selectivity, which caused such incidents to emerge from the mass with

startling clarity and indelible precision. To indict military art for falsification overlooks the extraordinary advantage gained by artistic selection and construction.

Military painting, by the very nature of its enterprise, transcends the mere glorification of hero-worship and adventure. The fact that artists could focus on defeats such as Gundamuck or Isandlhwana or marginal victories like Tamai, demonstrates their willingness to examine masculinities beyond the comfortable formulations possible if they only painted unqualified victories or attended to superficial heroics. The extent of the suffering depicted by Butler, Fripp, Giles, Wollen, and other artists reveals that the model of Woodville's dashing manner was far from common. The very de-emphasis on the officer class in much of this painting represents not the adulation of but the dethroning of Carlylean-inspired hero-worship and its attendant glorifications. For this very reason, military painting becomes a prime site for the negotiation of masculinity in its conflicted composition. The circulation of such images is also key to their value as sites of such negotiation. Stearn notes: 'They were extensively disseminated through a variety of media including periodicals, prints, postcards, advertisement, encyclopedias, popular histories and textbooks. They complemented and reinforced the writings of the war correspondents, and contributed to increased popular imperialism and support for imperial wars and to the increased popularity of the army' (128). The versions of masculinity circulated by such means meant that they constituted a common discourse about its formation throughout the culture.

Klaus Theweleit observes in *Male Fantasies* the basis for this negotiation of masculinity in military painting: for the male 'the army, high culture, race, nation – all of these appear to function as . . . extensions of himself' (2.84). Representations of disasters such as in *Gundamuck* or *Isandhlwana*, or of cliff-hanging conquests as in *Rorke's Drift* or *Tamai*, or of disabled veterans depict the conflicted and fragile nature of the dominant fiction, even as representations of victory, as at Ulundi or Omdurman, exhibit the tense triumph of artillery as much as of *andreia*. The iconography of imperial campaigns constructs an ideology 'central to the maintenance of classic masculinity . . . through the alignment of [the phallus] with the male sexual organ' as Silverman contends (16). Battle iconography, however, under the press of historical trauma, could prove transgressive and expose the *méconnaissance* upon which the dominant fiction rests. For artists of imperial campaigns, the potential for disintegration of masculinity constituted the ultimate challenging conflict. The nineteenth century, so marked by the presence of wars large and small, deployed military art to interrogate as much as to construct a masculinity taut from the press of history and conflicted by such elements as race, Social Darwinism, ethnicity, poverty and wounding. For these reasons, masculinity in military iconography becomes decisive in an investigation of the construction of male subjectivity during the era.

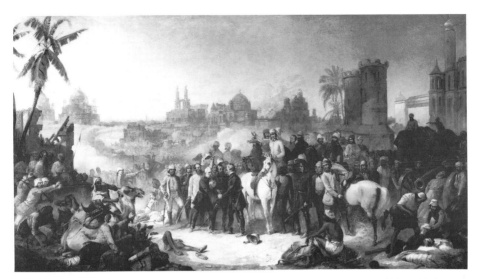

5–1. Thomas Jones Barker: *The Relief of Lucknow, 1857*, 1859; 41½ × 71⅜;
National Portrait Gallery, London.

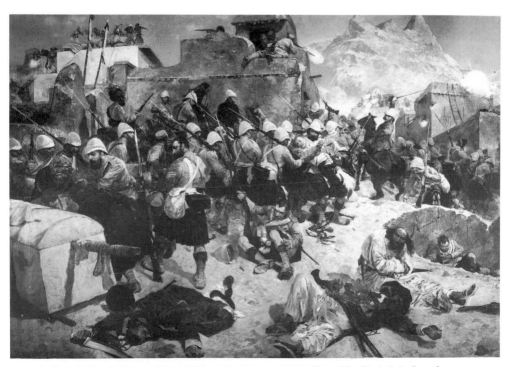

5–2. Richard Caton Woodville: *Kandahar*, 1881; 52 × 73; Christie's London.

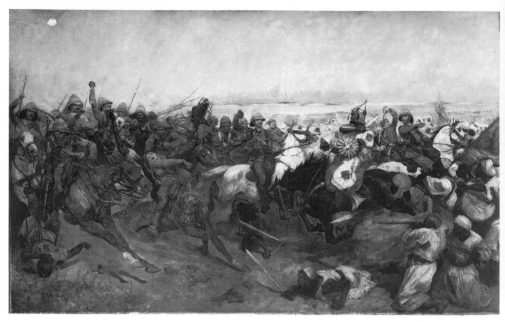

5–3. Richard Caton Woodville: *The Charge of the 21st Lancers at Omdurman*, 1898; 60 × 98; National Museums and Galleries on Merseyside (Walker Art Gallery, Liverpool).

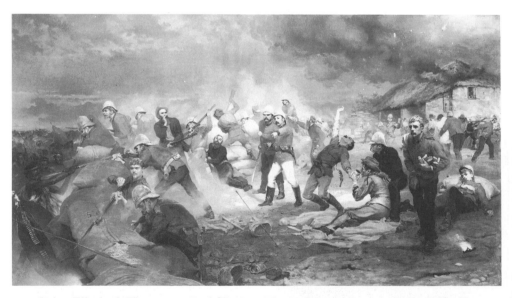

5–4. Elizabeth Thompson, Lady Butler: *The Defence of Rorke's Drift*, 1880; 47 × 83¼; The Royal Collection © 1994 Her Majesty Queen Elizabeth II.

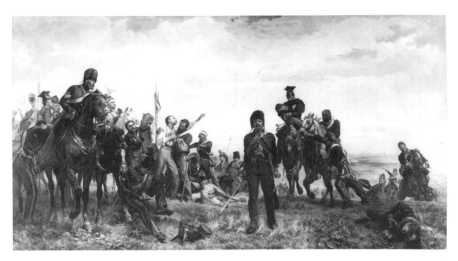

5–5. Elizabeth Thompson, Lady Butler: *Balaclava*, 1876; 40 × 73; Manchester City Art Galleries.

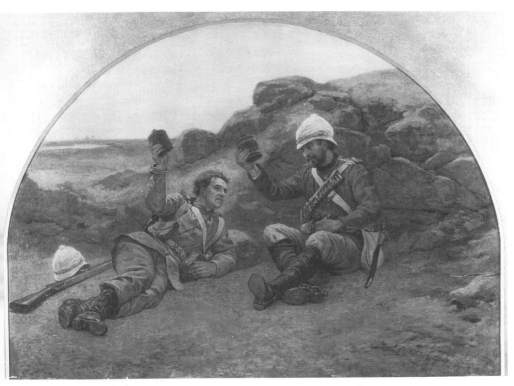

5–6. John Evan Hodgson: *'The Queen, God Bless Her!'*, 1880; 26 × 36; The FORBES Magazine Collection, New York.

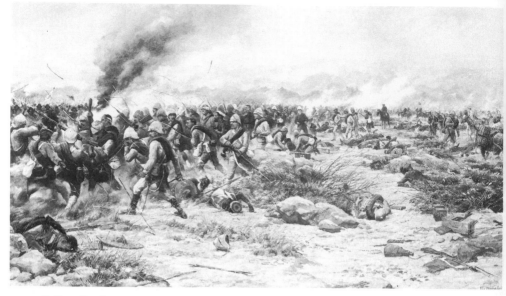

5–7. Godfrey Douglas Giles: *The Battle of Tamai*, 1885; 41 × 72; Regimental Trustees of the York and Lancaster Regiment.

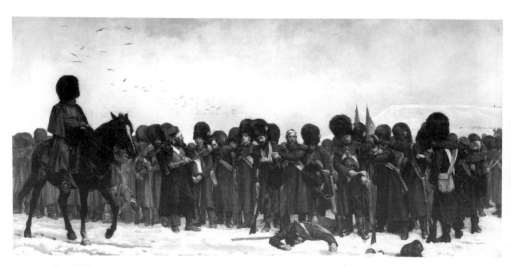

5–8. Elizabeth Thompson, Lady Butler: *The Roll Call*, 1874; 36½ × 72⅜; The Royal Collection © 1994 Her Majesty Queen Elizabeth II.

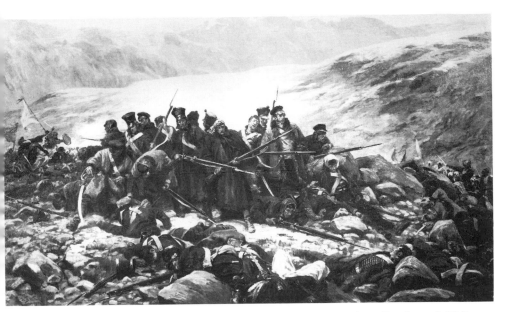

5–9. William Barnes Wollen: *The Last Stand of the 44th at Gundamuck 1842*, 1898; The Trustees of the Essex Regiment Association, The Royal Anglian Regiment.

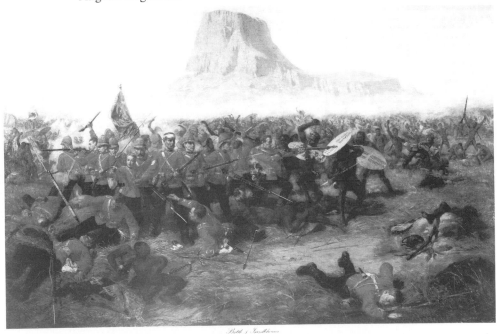

5–10. Charles Edwin Fripp: *The Battle of Isandhlwana*, 1885; 57 × 88½; Courtesy of the Director, National Army Museum, London.

5–11. Richard T. Moynan: *The Last of the 24th, Isandula, 1879*, 1883; 50 × 40; Sotheby's London.

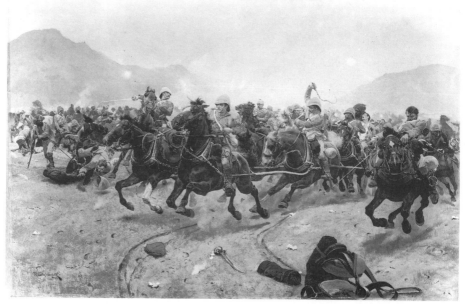

5–12. Richard Caton Woodville: *Maiwand: Saving the Guns*, 1882; 51 × 78; National Museums and Galleries on Merseyside (Walker Art Gallery, Liverpool).

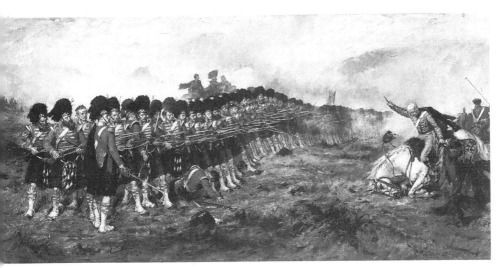

5–13. Robert Gibb: *The Thin Red Line*, 1881; 42 × 83¾; by permission of
United Distillers, Edinburgh, Scotland.

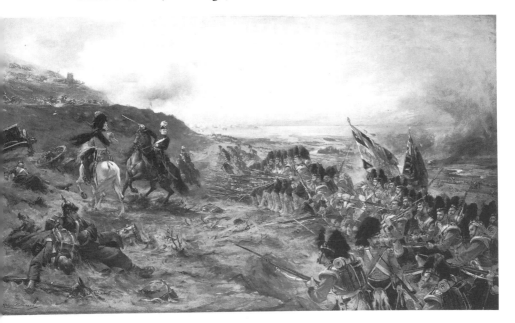

5–14. Robert Gibb: *The Alma: Forward the 42nd*, 1889; 50 × 86; Glasgow
Museums: Art Gallery and Museum, Kelvingrove.

5–15. Robert Gibb: *Saving the Colours: The Guards at Inkerman*, 1900; 110 ×
71; Naval and Military Club, London.

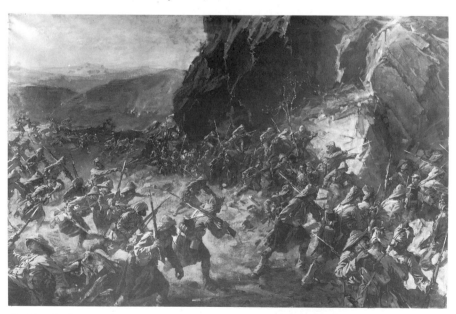

5–16. Robert Gibb: *The Dargai*, 1909; 61 × 91; Sotheby's London.

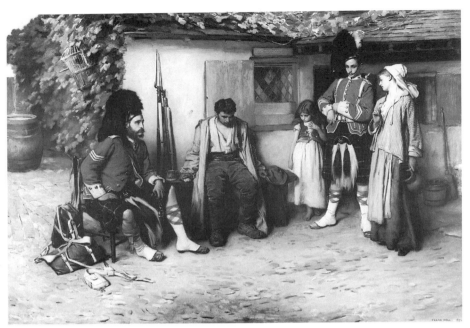

5–17. Frank Holl: *A Deserter*, 1874; 36¾ × 53½; The FORBES Magazine Collection, New York.

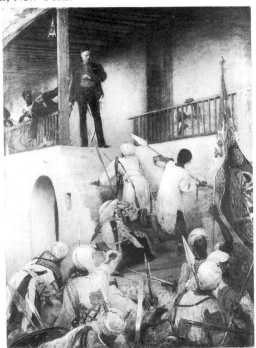

5–18. George Joy: *The Last Stand of General Gordon*, 1893; 120 × 84; Leeds City Art Galleries.

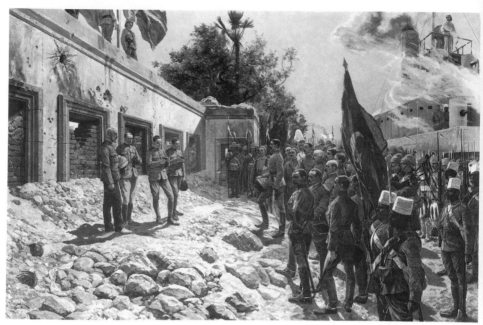

5–19. Richard Caton Woodville: *The Gordon Memorial Service at Khartoum*, 1899; 52¼ × 78⅜; The Royal Collection © 1994 Her Majesty Queen Elizabeth II.

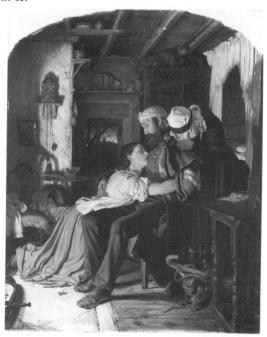

5–20. Joseph Noel Paton: *Home: The Return from the Crimea*, 1859; 27¹⁵⁄₁₆ × 22⅝; The Royal Collection © 1994 Her Majesty Queen Elizabeth II.

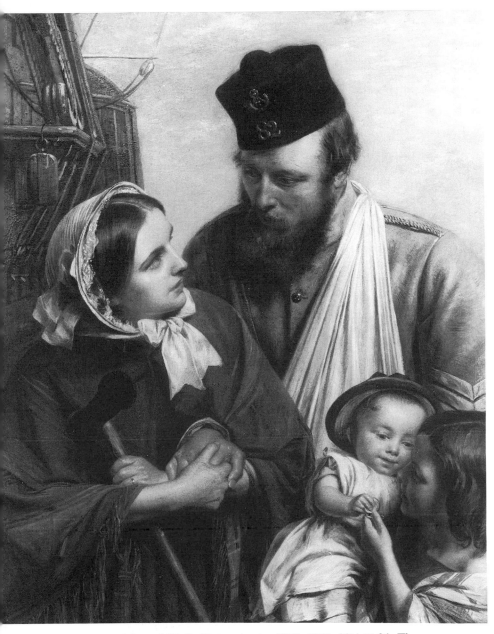

5–21. Henry Nelson O'Neil: *Home Again, 1858*, 1859; 20½ × 34; The
FORBES Magazine Collection, New York.

5–22. Hubert von Herkomer: *The Last Muster*, 1875; 82 × 62; National
Museums and Galleries on Merseyside (Lady Lever Art Gallery, Port
Sunlight).

5–23. Frederic George Stephens: *Mother and Child*, 1854–56; 18½ × 25¼;
Tate Gallery, London.

6

The Male Nude

In previous chapters it has been possible to map major forms of represen-
tation of masculinity in the nineteenth century. The mythical hero, the
chivalric knight, the valiant soldier, the diligent labourer constitute some
of the most significant and signifying ideographs in the history of art during
the period. All of these images are marked by one common denominator –
they are clothed or costumed and perforce conceal the male body. (Of
course, some of this costuming, such as armour, may be a representation of
the male body aggrandized and magnified.)

The male nude, however, is the site for the negotiation of the most
intense signifier of masculinity, for it is the most powerful marker of
difference. It is also the most conflictory and the most problematical and
problematized delineator of sexuality. Gill Saunders has defined a number
of elements concerning the male nude that merit serious consideration. She
observes that in representing the nude:

> There is an imbalance between the sexes, for the male nude is seen much less
> often either in fine art or in other visual media [suggesting] that men are equally
> threatened, psychically if not physically, by images of themselves naked. . . .
> 'Nude' is synonymous with 'female nude' because nakedness connotes passivity,
> vulnerability; it is powerless and anonymous. . . . For the Greeks, the nude,
> apart from its celebration of physical beauty, expressed the nobility and
> potential of the human spirit, but in Christian theology nakedness became a
> symbol of shame and guilt. (7, 9)

For the Greeks, of course, the male nude represented not merely the
beauty of hoplite athletic/political masculinity but also a spiritual ideal
made concrete. The effect of this construction was enduring, as Saunders
observes, including a marked repercussion for the study of fine art:

> The life model was himself often posed after an antique figure. The male nude
> was the main subject of academic study until the late eighteenth and early
> nineteenth century. There were a number of reasons for this, the first being that
> the male represented physical perfection and that woman was physically as well
> as morally inferior. (17)

The result is that 'the nude as a subject of art has been an obvious site for

235

the construction of sexual difference' (21); moreover, 'as the pattern of excellence and physical perfection the male body was symbolic of spiritual and cultural aspiration' (26):

> The male body, while not constructed as the site of sexual pleasure, is often symbolic of phallic power. The whole body, muscular, potent, active, may come to represent the phallus. Where softness, curves, smoothness are celebrated in a woman's body, strength and muscular development are the prerequisites of the male. Like its female counterpart, the male nude is evidence of the way patriarchy has imposed, and continues to reinforce through a proliferation of visual imagery, a series of opposites to define sexuality: masculine versus feminine, active versus passive, sexual drive versus sexual receptiveness. (26)

The male body is intricately linked with patriarchy, as Rob Powell argues: 'An understanding of the male nude . . . necessitates a perception of our society as a patriarchal system. . . . The representation of the male body . . . continues to be a battleground precisely because, within it, patriarchal power is at stake' (5). It is crucial to recognize that although representations of maleness in association with armour clearly signify an empowered masculinity, 'through institutional discourse [images] are put to work on a variety of representational tasks which mark even the naked body with specific meanings', as Roberta McGrath contends (58). The male nude in nineteenth-century British culture, therefore, was made to bear representational meaning as much as an armoured knight or an armed ranker. Barker-Benfield notes during the nineteenth century 'the somatic basis of the mind: the intellect depended on the material body for "vigor and power" ' (338). Walters comments about the naked Greek *kouroi* that in such constructs 'the body is an ideogram, asserting masculine strength' (37). In Victorian England, the male nude could represent such strength as well as much else in the domain of political and sexual empowerment.

Discussing nineteenth-century America and its conception of the black male body, Hatt notes a cultural element equally applicable to Britain:

> The body increasingly became the medium of masculinity. Masculinity was increasingly understood as literally embodied. Manliness, like racial inferiority, could simply be read off the body, and just as the apparent physical defects of the negro signalled a moral absence, so, in the white body, the moral and the muscular were conflated and conceived as mutually reducible. (1992, 27)

It has already been seen that in battle art, for example in Giles's paintings of *The Battle of Tamai*, the masculine body of the Other has a marked racist inflection. The challenge for artists depicting the male nude is summarized by Hatt as he continues:

> The male nude is strangely ambivalent. It is a traditional sign of masculinity, of strength and courage. Classical and classicising sculpture from Phidias to Thorwaldsen and beyond takes the male nude as a central subject; indeed it is this tradition that makes nudity heroic. Yet, at the same time, and perhaps in spite of the cultural encoding of the unclothed male body, to be nude is to be vulnerable and exposed. The male nude needs to be supported by traditions of masculine representation, narratives of inviolability, and media that can offer

concrete analogues for the inviolability of the heroic flesh. The nude provides
these analogues by careful attention to the organisation of the body and its
surfaces: proportion, physical perfection as ruled by antique or pseudo-antique
canons; pose, as a science of balance, the poised, relaxed body *after* exertion;
the surface of the body rendered as smooth and as unblemished as new armour.
All these present a body that is symbolic of moral perfection. . . . The
distinctions that the nude creates, and its location in a larger taxonomy of
corporeal morphology, make it clear that there is a tension between any appeal
to the general nude as the unimpeachable icon of aesthetics, and any given nude
as a specific representation of the body. In order to understand what is at stake
here we need to think of the nude as a set of bodies, a system of corporeal
classification that can distinguish the acceptable, controlled body from the
excessive and indecent one. The nude is not simply a representation of the body,
but a measure of corporeal decorum. This decorum also applies to other bodies;
the nude becomes the yardstick not only in art, but within a broader
representational field. (27–28)

The nudity of the classical hero, discussed in Chapter two, is sustained by
its alignment with heroic myths. The black bodies in battle art, whether
naked or clothed in native garb in their difference can appear indecorous in
Hatt's sense. The white male body, particularly the nude, during the later
nineteenth century becomes the signifier of the masculine in all its
connotations: moral, muscular, sexual, political, racial, patriarchal, and
imperial.

In this consideration, however, there are two elements which conflict
and problematize the analysis of the male nude in nineteenth-century
British art: one is the relative scarcity of such imagery when compared to
representations of the female nude; the other is the unwillingness to depict
the penis itself even when the male nude is represented. 'The relative
invisibility of the male nude in our culture is attributable to the fact that in
a patriarchal society men have the power to define, and to define is to
control' (Saunders 26). The relatively small number of depictions of the
male nude must rest on this power, particularly if one considers the
authority of the Hanging Committee at the Royal Academy. It is possible,
therefore, as Saunders suggests, that the scarcity of such imagery is linked
with the unwillingness to depict the penis:

> It remains true that images of the male body are relatively rare in mainstream
> culture and those images that do appear are almost always celebrations of
> physical power – the vulnerability of nudity is screened out of representations of
> the male (to the extent that the erect penis – unable to match up visually to its
> role as symbol of phallic power – is forbidden even in so-called 'soft'
> pornographic publications). (27)

The link between nudity and passivity/vulnerability must account for the
scarcity of such images in the nineteenth century. Alasdair Foster emphasizes
the reluctance to depict the penis:

> Never can that most mutable of organs measure up to the panoply of phallic
> aspiration behind which it lurks. Patriarchy, wary of this contradiction, reacts by
> making the representation of the penis in general, and the erection in particular,
> taboo. (46–47)

McGrath expands Foster's insight in her commentary about the depiction of the penis:

> If, as I suggested . . . phallic power is veiled, covert; and if it rests precisely on witholding the male body from scrutiny, then we have to ask ourselves what is at stake in exhibiting not only the naked body of the male, but particularly that visible marker of difference, the penis, on which so much power rests?
>
> For within the myth that upholds male power (and since it is a myth it must be kept secret) the anatomical penis can never live up to the great expectations of symbolic phallic power. In short, this power rests on very little. (59)

As both Foster and McGrath contend, the withdrawal of the male body from scrutiny is implicated in the necessity to maintain patriarchal authority; stripped and mutilated bodies of dead soldiers never appeared in military painting although correspondents were familiar with such actualities. The masculine world, as well, perceived the potential weakness and impotence of the penis, therefore necessitating its concealment in fine art during the era. Lehman (1993) underscores the basis of this practice of concealment, declaring: 'In a patriarchal culture, when the penis is hidden, it is centered. To show, write, or talk about the penis creates the potential to demystify it and thus decenter it. Indeed, the awe surrounding the penis in a patriarchal culture depends on keeping it hidden from sight . . . or carefully regulating its representation. . . . Since the penis bears a crucial, if frequently unacknowledged, relation to the phallus, understanding this paradox is all the more critical. . . . Representations of phallic masculinity . . . depend on keeping the male body and the genitals out of the critical spotlight' (28). However this practice may even disadvantage males, as Lehman comments, 'since a male's development through the mirror stage establishes a powerful mechanism for pleasure in looking at the male body' (21). Consequently 'men under patriarchy are not just empowered by their privileged position through the penis-phallus; they are also profoundly alienated from their own bodies' (36). An additional factor is the anxiety on the part of males of becoming objectified and hence powerless. McGrath writes:

> Moreover, for the heterosexual male viewer gazing upon his like can arouse not only the fear that he is looking at another man with the repressed eye of desire but that he himself may be being looked at with that same eye. This latter aspect can arouse a fear of being objectified, of being passive, of being less than male, and consequently like a woman: powerless. (59)

As a result, images of males clothe and conceal and arm the male body: 'the badge of masculinity must be worn as a shield, a protective armour against all that is castrating; against all that is considered to be most feminine' (59). Thus, fear of being objectified, anxiety about exposing the penis to scrutiny, and concern about the vulnerability of the male body may all account for its relative scarcity in nineteenth-century British art. 'The male nude,' Saunders argues, 'continues to be conspicuous by its absence' (132), but it is that very absence that makes it so crucial a site for

constructing difference, negotiating maleness, and problematizing masculinity in nineteenth-century culture. It is important, nonetheless, to note Gill's claim that 'total masculine nakedness seems to be permissible in Western art only in times of radical change, such as the Renaissance, the early nineteenth century, and this [the twentieth] century' (230). If one considers that the most important practitioner of painting the male nude, Henry Scott Tuke, worked in the latter part of the nineteenth and into the twentieth century, it may well be that the slowly increasing representation of the male nude in the last few decades of the nineteenth century indicated what was in fact the case, that the final decades were a period of 'radical' change (considering, for example, social reform and the rise of the New Woman) which continued into the twentieth century.

If finished oils generally avoid the male nude during the era, however, there is no denying that the study of the male nude in the life class, the tradition of the *académie* or male nude as a stage of a student's training in drawing, was crucial to art education prior to and during the nineteenth century. 'The art academy institutionalized a closed environment where men studied men. The drawing academy was the *sanctum sanctorum*, an all-male enclave for the study of the nude male model' (Martocci n.p.). As Edward Lucie-Smith observes:

> Throughout the 17th and 18th centuries artists continued to draw and paint from the life, using chiefly the nude male model. The models were male because painting was largely a man's profession. . . . Artists continued to be interested in drawing the male nude, even when the current of taste was turning towards a lighter and more feminine style of painting. . . . There seems to have been no awkwardness among the models about total nudity, despite the notorious prudishness of 19th-century society, especially in England. The reason was that art schools remained sexually segregated. . . . The influx of women into the traditional art schools . . .weakened the hitherto unchallenged authority of the life-class, by introducing sexual overtones which had hitherto been absent. (1989, 5, 6, 10–11)

Even in studies of the nude male, however, as Saunders observes, the presence of a 'phallic stave' (111) often marks an intensification of maleness and masculinity. For example, in an *académie* by John Everett Millais, completed when he was seventeen, a standing male figure with genitals depicted is represented with a stave, a doubling of the valence of masculinity as well as a potentially heroizing of maleness by the artist. Thus if artists in the nineteenth century did not depict the nude male body it was not for inability; it was therefore a conscious decision on their part to avoid its representation. Patriarchally encoded belief about masculine authority and anxieties about male sexuality led to the erasure of the male body in order to reinforce this very empowerment.

Not all artists, however, subscribed to this prohibition or acceded to the restrictions about the representation of the male nude. Strange as it may seem, therefore, the representation of the male nude in art by male artists during the era must be viewed as daring and even transgressive by the

codes of patriarchy itself. This paradox illuminates the degree to which males as well as females were prevented from full expression of gendered selves. Just as medical manuals advising against masturbation and playing on the terrors of nocturnal emissions alienated males from their bodies and their sexuality, so too did silent prohibitions against the exhibition of the male nude (especially of the frontal male nude with its penis) regulate the exhibition of the male nude body on canvas. The artists who chose to ignore this prohibition are, therefore, of particular interest.

Early in Victoria's reign, one artist in particular took great pleasure in depicting nudes both male and female. The work of William Etty is most frequently cited as an early mark of preoccupation with female beauty in the century, but in fact Etty was equally interested in nudes of his own sex. 'In his drawings of the male nude, unlike his successors like Burne-Jones, Etty depicts men with fully developed genitals, as in his study for *The Bowman*' (Kestner 1989, 71). Etty's life studies of males are insightful and individual rather than idealized. Gaunt and Roe note that Etty 'could render the nude male figure with an equivalent intensity and power' to that of his representations of the female (68). Etty often achieves this intensity by a sense of mystery in the life study of the nude male. In Gaunt/Roe number 48, for example, a male is viewed from the side, with the suggestion of a leopard skin over his right leg, gazing into the distance as he ties his sandal. Although the image is an *académie*, Etty suggests potential narratives of masculinity in the study. Another life study, Gaunt/Roe number 57, shows a posed male nude, but Etty signifies his masculinity by showing the upper edges of his pubic hair. Some of Etty's life studies introduce a tormented or disturbing potential in the pose. In Farr number 36b, for example, a nude of a male with upstretched arms, the figure appears helpless rather than heroic. In Farr number 85b, two male nudes are depicted: one a back view of a standing male nude, the other a smaller study of a seated male nude in the background. The two nudes, however, present temperamental alternative masculinities. The male in the foreground holds a sword, possibly connoting martial prowess; the male in the background is seated, signifying contemplation or discouragement. Often in Etty's *académies*, the stave held by the model intensifies his masculinity, as in Farr numbers 5a and 5b: 'the male nude often hides his penis while implying virility by means of displacement' (Kent 91).

Etty's finished canvases similarly engage the male nude. In *The Good Samaritan* of 1838, the nude male victim, with only genitals draped, is stretched along the entire foreground of the canvas, with the ministering Samaritan squatting over him. If the victim has been beaten, the body gives no evidence of it: the nude male remains a signifier of power even in this victimized state; no blood or wounding is evident. In *The Parting of Hero and Leander* of 1827, Leander is leaving his beloved and is naked save for a drape around his genitals; since the point of the narrative is the sexuality of the male body, this nude display warrants the construction of a powerful

yet rash swimmer with the glistening fleshtones of the male contrasted with the draped female. In the 1829 depiction *Hero, Having Thrown Herself from the Tower at the Sight of Leander Drowned, Dies on His Body*, the male's corpse lies stretched on the shore in a cruciform posture. As Saunders notes, the dead male body cannot be linked with weakness. The suffering male body 'must be allied to courage, sacrifice, a cause transcending the individual. For men, "victim" status is seen as something that is chosen, rather than being "innate" as it appears to be in women' (63). The contrast of flesh tones, and the contrast of Hero's black cape and Leander's green loincloth, with the sun beginning to rise in the background, signify heroic pathos and effort on the part of the male. Etty's *Prometheus* of 1825–30 (Plate 6–1) 'shows the man inverted, spread-eagled, and crucified, with an arrow piercing his side, a picture of sadistic violence but also of male heroism' (Kestner *Mythology and Misogyny* 71). Etty's Prometheus is analogized to Christ, with the nudity conveying the heroism of Prometheus's defiance. The arrow in the side aligns the image, as well, with that of the martyred St Sebastian. An equally heroic nude is *A Standard Bearer* of 1849, 'almost a direct copy of the standard bearer who appears in Titian's *Madonna of the Pesaro Family* . . . Venice' (Farr 162). Not only does the canvas pay homage to a famous predecessor: Etty glorifies the nude body by the standard, enhancing the phallic supremacy connoted by the resplendent nude and the dark pubic hair. The banner curling in front of the genitals conceals them only to enhance them by the stronger phallicism of the standard. In this painting, the nude male becomes the signifier of civic idealism and heroic militarism.

The heroism of Prometheus as represented by Etty induced his artistic successors to deploy the nude male as the site for the construction of gendered heroism. A particularly strong example of this practice is Edward Poynter's *The Catapult* of 1868 (Plate 6–2). The subject of the canvas is the siege of Carthage by the Romans in 146 BC. Cato's famous injunction, 'Delenda est Carthago', appears on the left upright support of the catapult, facing the observer and demanding to be read. The focus of the canvas is on the resplendent nude male technocrat manipulating the levers of the device, preparatory to hurling the javelin with its flaming tip against the walls of Carthage. The implications of this nude are extensive. First, it epitomizes the all-male world of *The Catapult*, which is, after all, a combat painting. This is to say that it is not only an exclusively male world, but a hypermasculine world, a depiction of an event that even for males is not ordinary or conventional: it is masculinity in excess and *in extremis*. It is not only a partriarchal event, in both its civic goal and its male exclusivity, but a superpatriarchal record. Within this context, therefore, the nude male celebrates the civic objective in a highly charged situation of sexual politics.

The painting encapsulates the Victorian doctrine of separate spheres for men and women. It is a world of power, force, civic responsibility, all

associated with Victorian constructions of male gender. The phallic javelin with its inflamed head reifies this patriarchal conception. Pierre Vidal-Naquet notes that knowledge of the catapult was one of the skills learned by ephebes in Athens during their two-year segregation prior to becoming hoplites, that is, citizen-warriors, so the civic association of the catapult, and its inscription of a masculine civic ideology, is constructed in Poynter's canvas.

The male technocrat, whose nudity is implausible in this context, since he is defenceless against the Carthiginians' arrows, exists as a gender marker. His strength is the glorification of industry, where the nobility of the man merges with the nobility of the deed, as with Pindar's athletes. Poynter's technocrat derives from Michelangelo, and the nudity of the figure becomes associated not only with historical but also with art historical grandeur. As Etty suggests the power of the concealed penis by the model's stave, so does Poynter allude to phallic empowerment by the javelin, far more impressive than would be the exposure of the hero's penis.

In 1876 Poynter exhibited *Atalanta's Race* (Plate 6–3), showing the woman stooping to pick up the second golden apple as Melanion/Hippomanes rushes past her. Poynter's sources for this canvas were William Morris's *The Earthly Paradise* and more distantly Ovid's *Metamorphoses*. The naked Melanion behind Atalanta, inspired like the technocrat in *The Catapult* by Michelangelo, celebrates the young man's Pindaric racing skill. As in *The Catapult*, Poynter includes the male's heroic action within a political context by the civic tableau of the picture's right-hand side, signifying the formulation of partriarchal ideology in the context of marriage. The nudity, civic context and marital teleology of *Atalanta's Race* are particularly necessary for this subject. Whether the Atalanta of the Arcadian version, in which she is a huntress who first strikes the boar of the Calydonian hunt; or whether the Atalanta of the Boeotian version, in which Atalanta outraces potential suitors who then are executed, the legend is a powerful configuration of a female who repudiates patriarchal constructions of the feminine. In the Arcadian version preserved in the *Library* of Apollodorus, Atalanta repudiates the construction of women, probably because she was exposed by her father, who wanted a male child.

In order to conquer Atalanta, Melanion, who may partake of the qualities of the beardless ephebe, must resort to a key ephebic quality, *apatê*, that is, deception or cunning, represented here by the strategem of throwing Aphrodite's apples in Atalanta's path. For both the man and the woman, marriage is an initiation rite, but for the one it marks citizenship, for the other consignment to the interior space of the house or *oikos*. Atalanta had resisted marriage in order to be a male, outside in the *polis*, the city, or free to wander in the wilds or frontier, the *agros*, which is the locale of the ephebic male during training. Enacted in the legend, and represented by Poynter, is the deception of Atalanta to insure her enforced

submission to the patriarchal code she has heretofore resisted. Atalanta becomes the commodified prize, seized not in an equal contest but by deception. Poynter's *Atalanta's Race* shows the unequal results for men and women resulting from this transition state to adulthood. The inclusion of the civic tableau, along with the male hero's nudity, marks the supremacy of patriarchal ideology. It is significant that Poynter had wanted to continue the story of Atalanta by doing a mural-sized canvas of the marriage procession following her defeat. Had this programme been completed, the representation of Atalanta's defeat would have been followed by that of her civic subjugation. Here Poynter strategized the nude male to be the site of a constellation of male empowerment and masculine grandeur. *Atalanta's Race* was destined to become another of the murals decorating the billiard room of the Earl of Wharncliffe, along with *Perseus and Andromeda* and *The Fight between More of More Hall and the Dragon of Wantley*. As with its two predecessors, *Atalanta's Race* participates in the configuration of male supremacy on the walls of an all-male, domestic interior. The male nudes in both *The Catapult* and *Atalanta's Race*, furthermore, are also polemic refutations of Ruskin's strictures about the nude and about Michelangelo, as Kestner (1989b) has explored. In his lecture 'Professor Ruskin on Michelangelo' of 1875, Poynter invoked the examples of the Greeks and of Michelangelo to legitimate the depiction of the nude in art. Poynter's nude males consecrate masculinity and the male body by their evocation of Michelangelo and the Greeks.

Paralleling Poynter's use of the nude to invest the body with heroism is the work of Frederic Leighton, who had already deployed the male nude in the 1871 canvas *Hercules Wrestling with Death for the Body of Alcestis*, previously discussed. The legend of Alcestis has a relationship to the larger corpus of tales involving the god Apollo, for Apollo once fell in love with Alcestis's husband Admetus, and even served him as a shepherd; Apollo bargained with the Fates that someone else die in Admetus's place, so Apollo's homoerotic attraction to Admetus led to the sacrifice of Alcestis. Leighton was to resort to another Apollonian dimension in his bronze sculpture *An Athlete Struggling with a Python* of 1877, the work which inaugurated the movement known as the New Sculpture, which emphasized a detailed grasp of anatomical structure. In Leighton's *Athlete*, the meticulous depiction of muscles, tendons and joints, with the exact rendering of the athlete's breathing, signifies a new standard for sculpture in Britain, advancing beyond the smooth contours of Canova or even of the *Apollo Belvedere*. This new attention to anatomy transforms the male nude into a higher valence of intensity, as in the *Athlete*. The title of the statue indicates its mythic source, the story of Apollo and the serpent Python. This serpent was sent by the goddess Hera to destroy Leto, Apollo's mother, at the moment of his birth, an attempt foiled by Poseidon. The most striking element of the legend is that the Python was female. When

Apollo had slain the creature, he condemned it to 'rot', from the Greek verb *pytho*. The location of this struggle was called Pytho, later Delphi.

Leighton's *Athlete* embodies the triumph of the masculine sun/Apollo. The large cylinder of the snake functions in two ways: it reflects the hypermasculine fantasy of the hugh phallus while simultaneously reflecting male anxiety that the female may have or appropriate phallic power. The injunction to 'rot' or 'decay' exhibits contempt for the female body. As with the figure of Hercules in 1871, the *Athlete* draws on a range of predecessors to intensify its construction of the heroic male through nudity: Polykleitos in his *Doryphoros* and *Diadumenos*, which both celebrate male heroism via heroic nudity; Michelangelo and the *David* for the head; and the *Laocoön* for the left arm and the prominent buttocks. The conjunction of the large cylindrical serpent next to the comparatively small penis demonstrates the over-compensatory sexual aggrandizement of Leighton's statue.

The influence of Michelangelo is also conspicuous in the nudes painted by Edward Burne-Jones in the course of his career. Here, however, the male nude becomes problematized and conflictory. If Leighton's and Poynter's male nudes constitute an encoded masculine heroism and empowerment, in Burne-Jones's nude males an uncertainty about power becomes manifest. The nude male comes to represent not the conviction of authority but the indeterminacy, and even loss, of control. In *Phyllis and Demophoön* of 1870, Burne-Jones drew on Ovid's *Heroides* and Chaucer's *Legend of Good Women*, which concern the story of Phyllis, the queen of Thrace, who falls in love with Theseus's son Demophoön, who abandons her. When he returns to the country, he learns she has been transformed into an olive tree. In Burne-Jones's canvas, Phyllis's face is a portrait of his beloved Maria Zambaco, who is shown leaning from the tree, embracing a reluctant Demophoön; she is draped and he is nude. On its exhibition in 1870 at the Old Water-Colour Society the picture caused an outcry because of the nudity of the male figure. A study for the canvas shows a much more aggressive Phyllis embracing a diminutive Demophoön, more accurately expressing Burne-Jones's fears of domination. The penis of Demophoön is minuscule, and Burne-Jones could well be asserting that the male nude, once the marker of control and empowerment, is no longer either in command or dominant. Walters notes: 'His genitals *are* disturbing, simply because they are so diminutive, as if they had withered to nothing under the woman's onslaught' (243–244). The male nude in this canvas is renegotiated from its empowered position in Leighton and Poynter: heroic nudity avails little against the transgressive embrace of the female. In *The Tree of Forgiveness* of 1882 (Plate 6–4), a later reworking of the legend, Phyllis is totally nude leaning out of the tree, embracing a Demophoön clearly inspired by Michelangelo. In this later version, however, the woman's nudity is now triumphant; the male's genitals have been concealed, so vulnerable is the male nude conceived, despite the musculature

derived from Michelangelo. The faces of both men betray an anxiety about their sexual power which conflicts with the conventional signification of power by male nudity.

This querying of the construction of the male body as intrinsically empowered is carried over to two other canvases in Burne-Jones's oeuvre. In *The Depths of the Sea* (oil 1886, gouache 1887) (Plate 6–5), a mermaid is dragging a doomed sailor into the ocean. A result of the artist's visits to Italy in 1871 and 1873, the Leonardo smile of the maid is one of the artist's enigmas, the face of the Mona Lisa as described by Pater in the essay on Leonardo in 1869. The *Athenaeum* reviewed the canvas as follows: 'She, with wicked triumph gleaming in her eyes, smiles over her victory. . . . Delight in evil gleams in her witchlike face. . . . Her delighted clutch will not relax its hold of the human toy that perishes' (561). The drowning exhibited in *The Depths of the Sea* indicates the self-destructive nature of male narcissistic empowerment. The mermaid's tail and the arm over the sailor's genitals reflect the castration fear prevalent in the culture. As in *The Tree of Forgiveness*, the well-muscled body of the sailor has not availed against the wicked and predatory female body, here linked via its tail to evolutionary atavism. Barker-Benfield underscores the nineteenth-century male anxiety reflected in *The Depths of the Sea*:

> Dying or sticking in mud doubly evoked the dangers of sexual intercourse. . . .
> An underlying meaning was the fear of finding oneself held under, being absorbed by a vagina. The image of not getting out of the depths into which one plunged also conjured up the fear of not passing through the dangers of being born, of not being distinguished from woman, from the mass. (346)

At the same time, anxiety about castration also had another significance: 'The other side of castration's meaning, in its projective dimension [was] that men desired to be beyond the anxiety and responsibility to which they were committed by the existence of their penes and testicles' (361). That a contemporary review could confront the male body as being a ruined 'toy' indicates the extent of the anxiety about the male body and the male genitals.

The 1886 gouache *The Wheel of Fortune* (Plate 6–6) carries the triumph of the female body over the nude male to its furthest extent in Burne-Jones's work. Here the goddess Fortune has chained to her wheel three nude males: a slave, a king and a poet. The males are modelled after Michelangelo's *Dying Slave* in the Louvre, of which Burne-Jones possessed a plaster version, and the *Captives* in Florence. The males' powerful torsos cannot avail against the woman, here clothed and prevented from being the object of male desire. The difference in scale between the figure of Fortune and the three males further conveys this concept. Burne-Jones is too terrified to depict the males without their meagre loin cloths. Sarah Kent contends: 'The penis, symbol of masculine virility, a source of sexual pleasure and focus of male pride, is also the most vulnerable piece of human flesh. Those few inches that should epitomise male strength and

potency need more protection than any other part of the male or female anatomy. The sight of the limp penis sparks off the anxiety and ambivalence that men feel about their own sexuality' (72–73). The artist conveys that even the powerfully muscled male body guarantees nothing about power, authority or dominance. Walters observes: 'Despite their massive torsos and muscular legs . . . the men are effete, langorous, masochistic' (244).

Other artists did not share Burne-Jones's sense of the futility of empowerment through the male body. William Blake Richmond painted several nudes, all of mythical figures whose nudity conveys their superior stature, as in the previously discussed *Orpheus Returning from the Shades*. In *Hermes* (1886) (Plate 6–7), Richmond shows the god between white temple columns, fastening his sandal as he prepares for flight. The musculature of the dark body combined with the swirl of drapery conveys the youthful force of Hermes. The god is confident; the *Athenaeum* characterized Hermes as having a 'beautiful face in shadow and lit up by a cunning smile' (592), the cunning of the ephebic Melanion who deluded Atalanta. Richmond's *Hermes* uses the nude male body alone to signify masculine supremacy, whereas Leighton in *The Return of Persephone* a few years later (discussed in Chapter Two) depicts the god in a specific function. In both instances, nevertheless, the phallic superiority of Hermes is constructed. That this canvas appeared in the same year as the oil version of Burne-Jones's *The Depths of the Sea* reveals the conflictory nature of the construction of masculinity during the latter part of the century: debilitating colonial wars and crippling economic depression made it difficult to sustain the idea of patriarchal supremacy without reservation.

Richmond's emphasis on the male nude was triumphantly expressed in his bronze sculpture *Greek Runner* of 1879, also called *An Athlete*, of a naked youth in a racing contest or in the attitude of a messenger. The young man rests his weight lightly on the toes of his left foot, but the sense of vitality and confidence is unquestionably signalled, especially by the full and undraped frontal nudity of the sculpture, the sculptural equivalent of the athletes celebrated by Pindar or the messenger who brought the news of the victory at Marathon to Athens. For Richmond, whether the hero be Hermes or an athlete, the empowerment of the male nude is unquestioned. The same idea pervades the work of Briton Riviere. In his *Prometheus* of 1889 (Plate 6–8), Riviere shows the hero suspended over an abyss, crucified and enchained in a painful manner to exemplify the hero's endurance, defiance and sacrifice. Bathed in moonlight to emphasize his solitude, Riviere's hero displays his nudity as a marker of distinction. In the 1892 *Dead Hector* (Plate 6–9), Riviere commemorates the heroism of the Trojan prince. On the shore of a blue ocean, resting on greyish earth, Hector's body, with no mark on it, is bathed in cream-coloured light. Riviere draws on a significant detail of the legend, that Apollo kept the sun's rays from the body and Aphrodite preserved it from fierce dogs.

Riviere strips the body and retains its perfection to show the power of the male nude even after death. That Hector died in defence of his state aligns nudity with civic commitment, as in Etty's *Standard Bearer*.

Frank Dicksee's *The Ideal* of 1905 (Plate 6–10) advanced this conviction about male nudity into the twentieth century. A naked red-haired youth reaches to a female shape in the clouds. The deliberate emphasis on the penis is clarified by the history of the canvas. At its initial exhibition, the swirling drapery of the wraith concealed the naked man's genitals, but in 1927 Dicksee altered the painting, showing the genitals and thereby giving the figure a more phallic, triumphant construction. In this repainting, Dicksee reveals the suppressed meaning of the original. In the final version, the visibility of the penis reasserts the male supremacy already connoted by placing the youth on a promontory. The masculine solipsism of the goal is evident because the ideal is actually the male's narcissistic creation through patriarchal empowerment. The male is the pursuer of the quest, the projector of the ideal, and the empowerer of the vision of moral idealism. Dicksee's *The Ideal* transmits for the twentieth century the ideology of late-Victorian thought about masculinity. In his address to the students of Clifton College, for example, Thomas Hughes discussed the 'gospel of work' and the necessity of idealism, telling the students the two aspects were not incompatible but exhorting them to embrace idealism:

> Even in our materialist age, I must urge you all, as you would do good work in the world, to take your stand resolutely and once for all, at school and all your lives through, on the side of the idealists. . . . In the stress of the great battle of life it will trouble no soldier who keeps his eye in his head and a sound heart in his bosom. For he who has the clearest and intensest vision of what is at issue in that battle, and who quits himself in it most manfully, will be the first to acknowledge that for him there has been no approach to victory except by the faithful doing day by day of the work which lay at his own threshold. . . . No, there is no victory possible for boy or man without humility and magnanimity; and no humility or magnanimity possible without an ideal. I have been pleading with you, boys, to take sides with the idealists at once and through life. (80, 82)

In Dicksee's *The Ideal* the male body encodes this idealism. Vance notes that in the nineteenth century, 'physical manliness is not only attractive and useful . . . the basis at least for a higher manliness: it is also an index and a condition of psychological, moral and spiritual health' (110). Dicksee's true beliefs about the power of the male body are evident in the 1891 *The Mountain of the Winds* (Plate 6–11), showing three male nudes with a female in classical garb. The female draped figure in the centre, representing the South Wind, reclines, while the men encircling her are full of energy as the other three winds. Thus, the South Wind, representing continental luxuriousness as opposed to male northern British force, is a reclining woman. The most prominent male is the East Wind, a fierce dynamic male, flying through the air on an eagle, the bird of Zeus. Male nudity, as suggested by that of Orpheus or Hermes or Prometheus, is encoded with divinity in *The Mountain of the Winds*.

If the nude male juxtaposed with a clothed or naked female emphasized sexual difference and the incommensurability of the male and female bodies, a particular legend deploying the nude male and even more aggressively marking this incommensurability was that of the Sphinx. In this construction, the female body is partially bestial, having the head and torso of a woman but the body of a lion with wings. While infrequently a subject of painting in England during the nineteenth century, the juxta-position of a nude male body with a Sphinx's semi-human one limned sexual difference and male superiority. In his 1875 pencil drawing *The Question*, Dante Gabriel Rossetti depicts figures representing Youth, Manhood and Old Age ascending a summit to query the Sphinx, presumably about the meaning of existence, as the title of the drawing evokes Hamlet's famous question. Rossetti's two sonnets on the subject describe the naked Youth as dead or dying; all three receive no reply from the Sphinx. If the nude young man represents Oliver Madox Brown, the question may be the reason for untimely death. The *Art Journal* in 1902 (18) commented: 'As an almost unique study of the nude this one is very interesting'. However, one might contest this reading of the drawing by aligning the depiction with the classical sources, where the man-devouring Sphinx was finally con-quered by Oedipus. In terms of Darwinian influence, the emphasis on the male nude contrasts with the atavistic bestiality of the Sphinx, which underscores the incommensurability of the male body and the female. In 1887 Walter Crane sent *The Riddle of the Sphinx* (Plate 6–12) to the Grosvenor Gallery. Here a naked man, presumably Oedipus, kneels before a monstrous female with dark wings. Crane's male points towards the city walls, associating Oedipus's question with the salvation of the terrorized city and the male with civic commitment. The juxtaposition of nude male with bestial female underscores somatic incommensurability.

The representation of the male nude during the nineteenth century intersected with other paradigms, especially those derived from Greek culture. One of the most important of these was the model of the ephebe from ancient Greece, especially from the city-state of Sparta. The function of the ephebe in Greek society has been extensively studied, most notably by Vidal-Naquet and Vernant, and their analyses illuminate dimensions of canvases involving the male nude during the Victorian period. The ephebe involved two specific age classifications, that of the civic ephebe being aged 18 to 20 and 'traditional puberty, which was recognized at the age of sixteen within the framework of the phratry' (Vidal-Naquet 99). Vidal-Naquet summarizes other elements of the ephebiate: it was 'initiation into a warrior's life' (99); it involved the practice of *apatê*, 'wile, deception' (110); some city-states practised 'ritual nudity before the conferring of hoplite arms' (117); the ephebe inhabited for the two-year period of the ephebia 'the frontier area . . . the *eschatia*' (120); and the ephebe represented 'the young man on the threshold of adult life' (120), that is, his position was transitional from adolescence to adulthood and his state was

liminal. Part of ephebic skills was knowledge of the javelin and of the catapult (104) already seen in Poynter's *The Catapult*, and the cunning or *apatê* exhibited in Poynter's *Atalanta's Race*, for as Vidal-Naquet notes, one tradition recorded that 'Melanion beat Atalanta and won her for life by means of a feminine apatê – dropping Aphrodite's three golden apples' (120). The function of this specific period of Greek training for adulthood citizenship involved the isolation of the ephebes from home and from women as they learned the codes of manliness or *andreia*. The ephebia was thus an *agōgē*, a course of training or education, a process of guiding the adolescent male from ephebic to hoplite status. These involved 'the common meals [*sussitia*], the physical exercises [*gumnasia*], and the hunt' as well as 'that marvelous exercise of endurance, the *krypteia*, in which [the ephebes] march barefoot in winter, sleep on the bare ground . . . wandering by day and night all over the whole territory' (224). It is clear from the above that such institutions as the Victorian public school had elements strongly echoing the ephebia of ancient Greece: the common mess, the physical gamesmanship, the all-male world, the sequestration from women, the cult of manliness, all in the name of training or guidance during the transition from adolescence to adulthood. British painting of the male nude was to evoke the elements of exercise, liminality, sequestration endurance and nudity from the tradition of the ephebiate.

An additional element added to this representation was that of the older male lover (perhaps around 25 years of age) and the younger male (16 or older and beardless), the construction of formal erotic relations codified in the relationship of the *erastēs* (lover) to the *erōmenos* (beloved), one of the basic elements of Plato's *Symposium*. What the Victorians denominated as 'Greek love' was derived from this paradigm of *erastēs/erōmenos*, which in fact was governed by strict practices. Like the practices in the ephebia, this relationship had 'pedagogic overtones' (Keuls 275) and followed 'the scenario of initiation rites' (276). The *erastēs* was required to give gifts to the beloved youth and was to receive sexual gratification only if his merit warranted such a concession from the young man. The form of sexual encounter as well was regulated to be intercrural, permitting neither anal nor oral penetration. It was not expected that the young man would respond sexually to the *erastēs* if the evidence of Greek vases is to be trusted. From the idea of the *erōmenos* derived the concept of 'The Radiant Youth' marked in the 'Artist's Preface' to Wilde's *The Picture of Dorian Gray*, the title of which marks its orientation towards 'the Hellenic ideal' praised by Lord Henry Wotton (16) and admired by the pederastic contingent of the Uranian poets in the latter part of the century. Their construction of the beloved boy, however, in the strictest sense embraced practices (anal and oral sexual intercourse) which would not have been sanctioned in the ancient Greek model except with male prostitutes, as Halperin (1990) and Winkler (1990) have demonstrated. Intercrural sex is also a gender marker, as Dover observes: 'the intercrural mode is normal when the

sexual object is male but unknown when it is female' (99). Even the posture of intercourse was mandated, never supine and 'the *erōmenos* stands bolt upright, and it is the *erastēs* who bows his head and shoulders' (101); it is 'the *erōmenos* who stares ahead while the face of the *erastēs* is hidden from him' (102); the *erōmenos* 'never permits penetration of any orifice in his body' (103). Violation of these rules 'of legitimate eros' meant that a man 'detaches himself from the ranks of male citizenry and classifies himself with women and foreigners' (103).

For British Victorian paintings of the male nude, a nexus of ideas formed around the tradition of the ephebia and of the *erastēs*/*erōmenos* relation, the latter marked by an older man and a youth in the canvas, the former by elements such as sequestration, liminality and nudity. The male nude in such canvases appropriates the inherent dignity of the representations of the male nude in the Greek world, where nudity is linked to initiation rituals like the *gymnopaidiai* of Sparta. Male beauty was the highest form of physical splendour for the Greeks, where the youth embodied *aretē* or glory/excellence, himself being *kaloskagathos* or 'beautiful and noble'. Nudity also served to distinguish males from three other groups, especially as 'it is the small penis which was admired' (Dover 126): from slaves, who were represented with large penises; from barbarians/foreigners, who disliked nudity; and from women, who were always represented as draped or clothed, with the exception of slave girls and whores. The nakedness of the youth, therefore, distinguished him as a potential citizen, linking the male body with political incorporation and inclusion, again defining the male against women, slaves, and foreigners, none of whom could qualify for citizenship. This politicizing of the male body, and especially of the nude male, in nineteenth-century British art reveals that such art strategizes the privileging of the masculine over the feminine in patriarchal culture. The Victorian male nudes of *Dead Hector*, *A Standard Bearer* and *Atalanta's Race* all partake of thus nudity as signifier of the citizen-warrior derived from Greek history.

The element of ephebic education, with possible strong homoerotic elements, appears in several representations of the male nude by Frederic Leighton. Leonée and Richard Ormond discuss Leighton's sexuality as follows:

> There can be no doubt that Leighton fulfilled some part of himself in the company of younger men, and that he was attracted by physical beauty. His male models, like his protégés, were all noticeably good-looking. It is also true that in the Sartoris circle there were several narcissists with pronounced homosexual leanings, chief among them Henry Greville and Hamilton Aïdé. . . . The truth seems to be that Leighton . . . found a fulfillment as much emotional as purely sexual [in the young of both sexes]. (48)

As Cooper observes, however, this statement does 'not recognise the difficulties homosexual men face in expressing feelings for younger men' in a society far more tolerant of heterosexual attractions (1986, 26). The

letters addressed from Greville to Leighton certainly indicate a strongly erotic element to the relationship, as Cooper comments (26), and Leighton often took upon himself to be the guide of younger artists such as George Mason or John Hanson Walker, leading them into the fraternity of artists in a manner similar to an aesthetic *agōgē*. Leighton's drawing *A Contrast* exhibited at the Hogarth Club in 1859 shows a crippled old man gazing at a statue of a naked youth, for which he was the model as a young man. Without its title and without the explanation, it would represent an aging Greek male's admiration for naked Hellenic youth, similar to the admiration accorded the photographs of naked Sicilian boys taken later in the century by Wilhelm von Gloeden. On the evidence, there can be no doubt that Leighton was thoroughly conversant with Greek erotic practices, and in several canvases alluded to the pedagogic and potentially erotic elements of the relationship of an older male to a youth.

One of the most significant of these constructions is Leighton's 1869 *Daedalus and Icarus* (Plate 6–13). In the canvas, Leighton follows the model of the *Apollo Belvedere* and the raised foot established by Polykleitos, an appropriate prototype for a legend concerning worship of the sun. The contrast between the dark-hued flesh tones of the father and the white skin of the son is carried through by the dark blue robe behind Icarus, the pink sash covering his genitals, and the red handle he grasps on the wing. Icarus's body is typical of the 'masculine idealised bodies' noted by Cooper (28), although the effete nature of Icarus was noted in *The Times*, which observed that Icarus's torso exhibited 'the soft, rounded contour of a feminine breast' (15 May 1869, p. 12). Leighton's Icarus is indeed the 'radiant youth' admired by both ancient Greeks and later Uranians, with the classical curls and head silhouetted by the drapery. The story links Icarus with the sun and thus with Apollo, introducing a homoerotic element into the canvas despite the fact that Daedalus and Icarus were father and son. Daedalus was supposed to have been the inventor of a bronze male named Talos, whose *erastēs* was the hero Rhadamanthus. The pedagogic element rests on the fact that Talos was also Daedalus's pupil.

An additional component of the legend, as Sergent notes, is that Talos is 'a Cretan and Dorian solar hero' (200), thereby having affinities with the Apollonian legend and with the construction of Apollo as the embodiment of male heroism, for example in Ruskin's *The Queen of the Air* in 1869:

It may be easy to prove that the ascent of Apollo in his chariot signifies nothing but the rising of the sun. But what does the sunrise itself signify to us? If only languid return to frivolous amusement, or fruitless labour, it will, indeed, not be easy for us to conceive the power, over a Greek, of the name of Apollo. But if, for us also, as for the Greek, the sunrise means daily restoration to the sense of passionate gladness, and of perfect life – if it means the thrilling of new strength through every nerve, – the shedding over us of a better peace than the peace of night, in the power of the dawn, – and the purging of evil vision and fear by the baptism of its dew; if the sun itself is an influence, to us also, of spiritual good – and becomes thus in reality, not in imagination, to us also, a spiritual power, –

we may then soon over-pass the narrow limit of conception which kept that power impersonal, and rise with the Greek to the thought of an angel who rejoiced as a strong man to run his course, whose voice, calling to life and to labour, rang round the earth, and whose going forth was to the ends of heaven. (19.302–303)

Leighton's *Daedalus and Icarus* demonstrates that in the same year as this passage was expressed, the Apollonian male ideal had appeared on canvas.

Also behind Leighton's canvas, and that of other artists who painted the male nude in the sunlight, was the solar theory of mythology, embodied in the ideas of Friedrich Max Müller. Müller contended that all myth was a disease of language and that the primary subject of myth was the conquest of night by day, of the nocturnal by the solar. It was an easy step to associate the conquest of night by day with the supremacy of the male over the female: Apollo pursuing Daphne signifies this process. (The Apollonian solar hero most familiar from Victorian fiction is Will Ladislaw of *Middlemarch*.) For the Victorians, solar power is both phallic and fertile. In Leighton's *Daedalus and Icarus*, the sunlight not only illuminates but also deifies Icarus's ephebic, hairless body. The lack of body hair transforms the youthful body into a super-phallus, as Alasdair Foster notes:

> Body builder and actor shaved their chest and abdomen removing one of the more obvious secondary sexual characteristics, sanitizing the body of its more overt aspects of hormonal maleness while inferring a quality of genital maleness (body as super-phallus) and underscoring the fine art associations (flesh as marble). (28)

The fact that Icarus is destroyed in his attempt to fly and that the sun melts his wings only adds to his incorporation into the masculine pantheon, for this death grants him heroism for aspiring to be like/near the sun, the appropriate aspiration for all solar-identified males, even if this leads to destruction.

The theme of Icarus permitted artists to make heroes of aspirant ephebic males, especially after Leighton's success with his *Daedalus and Icarus*. In 1887 William Blake Richmond, for example, exhibited his now lost *Icarus, Starting on His Flight* at the Grosvenor Gallery. At 99 × 57 inches, the scale of the canvas was designed to overwhelm the viewer with an icon of male dauntlessness. Nude except for the meagrest of drapery, the figure was described thus in *Grosvenor Notes*:

> Nearly nude, with light yellow hair and pink wings; the figure standing out against the shimmer of sunlight on rocks and sea; sea-gulls flying. (29)

In the surviving sketch in *Grosvenor Notes*, Icarus stands on a promontory, actually *above* the gulls flying in the abyss in order to bring him closer to the sun's rays. Henry Blackburn, writing the commentary, recognizes this element of the composition by noting the 'yellow hair' and the 'shimmer of sunlight', which align Icarus with nineteenth-century masculinist solarism. Thus, with the *Hermes* of 1886 and the *Icarus* of 1887, Richmond deploys the male nude to celebrate the male body. (There can be little doubt that

Riviere's *Prometheus* of 1889 suspended over a promontory was inspired by Richmond's *Icarus*.) The theme of Icarus was particularly appropriate for representing male nudity, as the scarcity of clothing was justified by the necessity in the legend itself of being as light as possible in order to fly. In Herbert Draper's *The Lament for Icarus* of 1898 (Plate 6–14), the ephebic body, now with darker skin from his fatal flight too near the sun, is the object of concern and admiration by the nymphs who surround him. In the foreground a wreath with a red ribbon floats, symbolizing the link between art and solar aspiration, further signalled by the lyre held by one of the nymphs. In such a construction, art becomes a male preserve or guild, similar to the Royal Academy of Arts itself. Icarus in such canvases is the liminal, daring ephebe, exhibiting courage at the very threshold of creation. Apollo's oppression of females, such as Clytie or Daphne, as well as his famous declaration at the end of Aeschylus's *Eumenides* marking his misogyny and male-privileging, align him with patriarchal societies in an intense manner, clearly evident in the canvases of Draper, Richmond or Leighton. Behind this solarism is Plato's observation in the speech of Aristophanes in *The Symposium* that 'originally the male sprang from the sun' (59–60). Significantly, Aristophanes observes that men who are lovers of other men 'are the best of their generation, because they are the most manly' (62).

The pedagogic relationship of the older male to the youth, with potentially strong erotic elements, reappeared in Leighton's *Hit!* of 1893 (Plate 6–15), a canvas of a youth teaching a boy to hold a bow and shoot at a target. The Ormonds contend this is 'a father teaching his son to shoot with a bow and arrow' (128), but as Cooper (1986) observes it is 'a youth with a laurel wreath being shown by an older man how to handle a bow and arrow' (28). The ephebic nature of the canvas is clear in the sense that weapons training would be part of the *agōgē*. The presence of bow and arrow also eroticizes the canvas via the tales involving the youthful Eros. The erotic nature of Leighton's canvas is confirmed by preparatory drawings for *Hit!*: in two drawings, the young man is nuzzling the youth; in one drawing the nude boy stands beside the seated youth; in the other he stands between his legs, with the outline of the bow all but disappeared, making the sketch highly erotic in the tradition of the *erastēs* and the *erōmenos*. Attempts to claim that this is father and son, as in the notice from the *Athenaeum*, deflect the homoeroticism of the drawings and are refuted by the age of the instructor. The aspect of ephebic training also appears in Leighton's *Jonathan's Token to David* exhibited in 1868, showing Jonathan accompanied by a young lad as he prepares to shoot the arrow warning his beloved friend David that Saul intends to have him slain. As the Ormonds note in the catalogue *Victorian High Renaissance* (1978), the canvas 'celebrates male beauty in a consciously statuesque and formal style' (110), with the figure of Jonathan evoking Michelangelo's *David*. The erotic element is connoted by the legend itself, of the love between

David and Jonathan, and also by the relationship of the young lad to Jonathan. Swinburne recognized the erotic component of the canvas in his review:

> The majestic figure and noble head of Jonathan are worthy of the warrior whose love was wonderful, passing the love of woman; the features resolute, solicitous, heroic. The boy beside him is worthy to stand so near; his action has all the grace of mere nature, as he stoops slightly from the shoulder to sustain the heavy quiver. (361–362)

The presence in the canvas of bows, arrows and quivers eroticizes it as they had done in *Hit!*, all these also being accoutrements of the god Apollo.

The imagery of Apollo and its link with Victorian solarism were reinforced during the nineteenth century by the theories of Victorian Aryanism. Hersey notes that Leighton advocated 'a recurring Phidian racial type' as the model for his students (108), while Jones notes the 'racial characteristics' (36) of Leighton's theories, which revere Greek art. Worship of the sun and Aryanism are associated because the Aryans were thought to have followed the path of the sun, migrating westward from central Asia. Such works as Robert Knox's *The Races of Men*, Edward A. Freeman's *The Origin of the English Nation* and Francis Galton's *Hereditary Genius* celebrated the Aryan/Teutonic male. The ideas of the American Samuel G. Morton reinforced British Aryanism. Morton, for instance, believed that races had innate capacities and that the Aryan exemplified the finest in mental, moral and physical ability. Thomas Carlyle and Charles Kingsley, the latter particularly in *The Roman and the Teuton*, confirmed this superiority to many Victorians. It was Kingsley who celebrated specifically masculine Aryanism. In the Preface to *Hypatia* in 1853, Kingsley describes how the 'effeminate' and degenerate Latin, Egyptian and Syrian races were conquered by the Nordic/Germanic tribes. It was the solar mythologist Max Müller who wrote a Preface to the reissue of Kingsley's rapidly Aryan *Roman and the Teuton* in 1881, praising Kingsley's 'manly' features in the first sentence as 'calm, grand, sublime' (v), all Apollonian traits, as Hersey notes.

The link between Apollo and Aryanism was made explicit by Benjamin Disraeli in his novel *Lothair* of 1870, published the year following the exhibition of *Daedalus and Icarus*, the latter embodying the ideal of Aryan male beauty. Disraeli had attempted in his earlier novels *Coningsby* and *Sybil* to align the Jews with Aryan Saxons. Many, however, were not willing to include the Jews in this configuration. In 1870, therefore, Disraeli sabotaged the Aryan thesis in *Lothair* by his satirical study of the Aryanist artist Gaston Phoebus, that is, Apollo. Mr Phoebus believes that art flourished from the age of Pericles to that of Hadrian, when 'Semitism began to prevail, and ultimately triumphed. Semitism has destroyed art,' he declares. To Phoebus, all art should be constructed according to the principles established by the Greeks, who were Aryan, 'but nothing can be done until the Aryan races are extricated from Semitism' (136, 139). Of

particular interest is that Disraeli's Phoebus is a satire of Leighton. In his identification of Leighton/Apollo/Aryan, Disraeli was prophetic. In his lectures to the students of the Royal Academy, of which he became president in 1878, Leighton declared that race was a key index to the quality of art produced in a society. He affirmed that the Semitic nations (for him Chaldeans and Assyrians as well as Jews) were hostile to art, Jews being 'void of the artistic impulse'. Noting the greatness of the Phidian, proto-Aryan type, Leighton observed that this nature is 'sometimes found in the women of another Aryan race – your own' (89). This linkage of Apollonian and Aryan ideas is unquestionably male-privileging and aggrandizing. As Léon Poliakov has observed about such ideas: 'On close inspection the true Aryan appeared to be a Westerner of the male sex, belonging to the upper or middle classes, who could be defined equally by reference to coloured men, proletarians or women' (272). *Daedalus and Icarus*, *Hit!* and even *Jonathan's Token to David* (despite its Hebraic subject) form a constellation of ideas of masculinity around the idea of the nude: Apollonian, ephebic, Aryan, phallocentric, heroizing, homocrotic.

A key painting in the tradition of representing the male nude, replete with many of these associations, is Frederick Walker's *The Bathers*, exhibited at the Royal Academy in 1867 (Plate 6–16). Claude Phillips locates the canvas in a classical tradition:

> It is in many respects the best of Walker's productions on this large scale . . . of a classicality sounder because arising more naturally out of the subject depicted. In an evening landscape . . . appear, under one of the painter's favourite warm evening skies, a company of naked youths and boys, some stripping themselves for the bath, some dressing again, some larking with the smaller fry . . . Many delightful episodes arrest the eye by their truth and plastic beauty. . . . The central figure of a nude youth half kneeling jars, on the other hand, in the midst of all this nature, though the head is beautiful as that of a Greek ephebus on the painter's favourite frieze of the Parthenon. Here the element of studied classicality imported *quand même* into the subject is felt to be an intrusion as it is also in the erect figure of the nude bather who stands dreaming a moment, as he strips off his last garment and braces himself for the plunge. The too deliberately sculptural character of these and one or two other elements of the design harmonizes but imperfectly with the undistorted truth, with the genuine spontaneity of the rest. There is, no doubt, in the unshamed nakedness of youth, so supple and free in movement, a kind of classicality of its own, but in these particular figures, thought not elsewhere in the picture, it is carried too far, and obtained too much at the expense of the life and sincerity of characterization which are of the very essence of the subject. . . . The method followed in suggesting ancient Greece under modern England was Walker's own. (*Frederick* 32–33)

In *The Bathers*, Walker draws on the practices of the ephebia in several ways: the ritual nudity; the exercising in the nude; the homosocial sequestration of the young male; the differing ages of the youths; the affectionate comradeship, especially featured in the central group; the

location of the youths in an Arcadian, liminal landscape; the absence of females; and the idea of ritual bathing associated with initiation into chivalric cults and groups. The nudity is especially emphasized as one passes from the left group, preparing to undress, to the central group, all but undressed, to the two running boys at the right, completely naked. The classicism of Walker's canvas is reinforced by the new construction of swimming and bathing early in the century:

> The first Swimming Society in England, formed by a group of Old Etonians in 1828, was inspired by the classical example. It was divided into two sections: 'philolutes' (lovers of bathing) and 'psychrolutes' (lovers of cold water). They adopted as their motto the opening lines of Pindar's Olympian odes – 'ariston men hudor' – water is best – and their records in the college library reveal the rivers, lakes, and streams of Europe bathed in by various members, with their comments, often classical. (Sprawson 82–83)

The Romantic poets had inspired this renewed interest in swimming: Byron swimming the Hellespont in 1810 and Shelley, who 'would translate Plato's *Symposium* in the morning, then in the middle of the day "bathe in a pool or fountain. . . . My custom is to undress and sit on the rocks, reading Herodotus" ' (79). In his canvas, Walker evokes classical sculpture, as Phillips perceived: the standing central figure has the bent left leg of the *Doryphoros* and *Diadoumenos* of Polykleitos; his stance echoes the *Apollo Belvedere*; the raised arm recalls that of *Aristogeiton* (Naples), one of a pair with the *Harmodios*, the two lovers who resisted tyranny; the raised arm as well recalls the upraised arms of the *Diadoumenos*. The other major central figure, the youth on one knee with left leg extended, equally evokes classical prototypes: distantly, the squatting warriors of the pediments of the Temple of Aegina (Munich); the *Youth from Subiaco* in the Terme, Rome; and the *Warrior from Delos* (Athens); Pigalle's *Mercury Attaching His Sandal* is also suggested in this stance. The concealment of the penis in all the figures elevates its mystery and allows Walker, via the hairless bodies of his youths, to suggest the entire body as a phallus. The nude bathing subject was not new with Walker, for in 1862 he did at least one illustration, *Summer*, for a magazine, showing one boy beginning to undress on the bank of a stream as another naked youth awaited him in the water.

The all-male preserve of *The Bathers* is a component of its composition. Walker reveals a strong gender bias even in its creation, as he wrote on 10 August 1865: 'As I told her, beginning a picture [*The Bathers*] is like taking a wife; one must cleave to it, leaving one's relations and everything, to work when one can' (Marks 61). It would appear that Walker painted in the figures before the water, for he records on 28 March 1866: 'I have arranged to go next week to paint the water in my picture. I shall take one of my boy models with me' (75). The two figures on the right were reworked: 'I . . . put them in again smaller, and somewhat differently; the improvement is very striking. . . . I mean the bigger boy's leg to be right off the ground,

and his face *not* turned towards the small boy' (90). Press responses when the canvas was re-exhibited in 1876 recognized in classicism:

> The composition from one end to the other is complete and altogether excellent, even if measured by the highest standard of excellence we know – the sculptures of Phidias [on the Parthenon]. (103)

The painting had great repercussions for English literature and subsequent art.

One of the primary reasons for this influence was that *The Bathers* enunciated an association of the young man with water, which has its source in art history, in the work of Winckelmann. In his *History of Ancient Art*, Winckelmann 'compared "the beautiful form of a youth" to "the unity of the surface of the sea, which from a distance appears smooth and still, like a mirror, although constantly in movement" ' (Kemp 269). In addition, as Berman observes:

> The image of the strong male body was . . . commonly used to promote bathing, a sport that gained increasing attention in the 1880s and 90s as a form of public health and hygiene throughout the North. . . . For the male, contact with the sea acted as a restorative of confidence and masculinity. . . . It also assured a greater sense of community through the fluid contact that bathing created between individuals. . . . This image of an intact masculinity was conditioned by broader discourses as well. Nudism, *Nacktkultur*, emerged concomitantly as a mechanism of moral enhancement through physical release. Central to the culture of nudism – originally called the 'culture of sun and light' . . . were athletic development, the enhancement of physical strength through exposure to the sun and a sublimation of libidinal energy into collectivity and camaraderie. This camaraderie served as an affirmation of manliness. (77–78)

Thus, canvases evoking the association of youths and bathing had established contexts, both historical and art-historical.

Robert Martin comments about Gerard Manley Hopkins: 'Another poem written in Dublin and owing a great deal to Frederick Walker is the evocation of a happier past in "Epithalamion" ' (390), which was inspired by *The Bathers*. Hopkins, as Bump has demonstrated, was greatly influenced by several of Walker's canvases, and these lines from *Epithalamion*, written for his brother Everard in April 1888, celebrate male comradeship and nudity in what purports to be a commemoration of a heterosexual alliance:

> We are there, when we hear a shout
> That the hanging honeysuck, the dogeared hazels in the cover
> Makes dither, makes hover
> And the riot of a rout
> Of, it must be, boys from the town
> Bathing: it is summer's sovereign good.

A male comes upon them and decides himself to bathe in isolation:

> By there comes a listless stranger: beckoned by the noise
> He drops towards the river: unseen
> Sees the bevy of them, how the boys
> With dare and with downdolphinry and bellbright bodies huddling out

> Are earthworld, airworld, waterworld thorough hurled, all by turn
> and turn about. . . .
> He hies to a pool neighbouring; sees it is the best
> There;
> . . . No more, off with – down the dings
> His bleached both and woolwoven wear:
> . . . last he offwrings
> Till walk the world he can with bare his feet . . .
> . . . Here he will then, here he will the fleet
> Flinty kindcold element let break across his limbs
> Long. Where we leave him, froliclavish, while he looks about him,
> laughs, swims. (85–86)

As Martin notes, the poem 'is a pure hymn to physical beauty, to the
celebration of bodily exultation' (391). The poem ends with fragmentary
references that water is spousal love, but the erotic/ephebic/masculine
world is the one privileged in Hopkins as in Walker. As Pronger notes,
'sport is an initiation into manhood, a forum in which [boys] can realize
their place in the orthodoxy of gender culture' (19). Swimming nude,
predominantly still a single-sex activity, echoes the ephebic, hoplite para-
digm, even as Walker's youths are of different ages in their sequestered
realm. Hopkins was to dwell on the beautiful youth in other poems, often
associated with water, as in *The Loss of the Eurydice*, albeit 'the
homoerotic impulses of Hopkins were largely subdued by his conversion in
1866' (Fussell 281). Fussell notes, as well, the link with Apollo, in that
'blonds are preferred throughout' (281) Hopkins's work, including *Harry
Ploughman*, itself derived from another Walker canvas, *The Plough* of
1870. Walker's canvas inaugurated the cult of the Apollonian/ephebic/
Aryan/blond/bather/swimmer that reached a climax in Uranian literature
in the 1880s and 1890s and continued through the First World War, where
the motif of soldiers bathing became a *topos* of war poetry.

At the end of the century, a major impetus to depict the naked youth
was Pater's essay 'The Age of Athletic Prizemen' published in February
1894 and then incorporated into his *Greek Studies*. Pater's 'prizemen' are
the naked males celebrated in the odes of Pindar and immortalized in
classical sculptures like the *Diadumenos*, the *Jason* (in the Louvre) or
the *Discobolus*. Pater notes the connection between sculpture and the
gymnasium:

> We are with Pindar, you see, in this athletic age of Greek sculpture. . . .
> Olympia was in truth, as Pindar says again, a *mother* of gold-crowned contests,
> the mother of a large offspring. All over Greece the enthusiasm for gymnastic
> [*sic*], for the life of the *gymnasia* prevailed. It was a gymnastic which, under the
> happy conditions of that time, was already surely what Plato pleads for . . . a
> matter, partly of character and of the soul, of the fair proportion between soul
> and body, of the soul with itself. . . . Now, this predominance of youth, of the
> youthful form, in art, of bodily gymnastic promoting natural advantages to the
> utmost, of the physical perfection thereby, is a sign that essential mastery has
> been achieved by the artist – the power, that is to say, of a full and free
> realisation. (297, 299–300)

Pater praises what he denominates as 'the fairness of the bodily soul' (305), that is, the physical perfection of the male body which encodes its spiritual superiority. Pater clearly perceives, as well, the transitional state connoted by the young male body in its progress from ephebe to hoplite:

> As to the *Jason* of the Louvre, one asks at first sight of him, as he stoops to make fast the sandal on his foot, whether the young man can be already so marked a personage. Is he already the approved hero, bent on some great act of his famous *epopée*; or mere youth only, again, arraying itself mechanically, but alert in eye and soul, prompt to be roused to any great action whatever? The vaguely opened lips certainly suggest the latter view. (315)

Then, Pater aligns the young men in the *Discobolus*, *Diadumenos* or *Jason* with undergraduates at Oxford, granting a virtual charter to his culture for depicting the male youth:

> Set here also, however, to the end in a congruous atmosphere, in a real perspective, they may assume their full moral and aesthetic expression, whatever of like spirit you may come upon in Greek or any other work, remembering that in England also, in Oxford, we have still, for any master of such art that may be given us, subjects truly 'made to his hand'. . . . As with these, so with their prototypes at Olympia, or at the Isthmus, above all perhaps in the *Diadumenus* of Polycleitus, a certain melancholy (a pagan melancholy, it may be rightly called, even when we detect it in our English youth) is blent with the final impression we retain of them. (316)

Pater's recognition of the ephebic male as the proper subject of art summarizes movements in painting from Walker to Poynter and anticipates the flourishing of the nude male body on canvas at the end of the century.

All of these elements – aquatic, ephebic, youthful, blond, Aryan – coalesce in the canvases of the greatest painter of the male nude in Victorian art, Henry Scott Tuke. Tuke studied under Poynter at the Slade School, and he could not have been unaffected by such canvases as *The Catapult* or *Atalanta's Race*, where he saw the male nude as expressive of patriarchal ideologies of power and masculinity. Tuke's career spanned the pre- and post-war periods even into the Georgian era. For an artist whose themes were explicitly those involving naked youths, he achieved great fame and acceptance, although some of his canvases caused intermittent controversy. His painting *All Hands to the Pumps!* (1889) was purchased by the Chantrey Bequest even as was the later *August Blue* of 1893, the latter a picture of naked young men bathing in a harbour. Becoming a full Academician in 1914, he had previously been made a member of the Royal Watercolour Society in 1911. Cooper (1986) notes that John Addington Symonds, the author of *A Problem in Greek Ethics* (1883) and *A Problem in Modern Ethics* (1891), was a 'regular visitor' to Tuke's studio (42). A great admirer of Walt Whitman, it is probable that Symonds introduced Tuke to Whitman's poetry, and particularly to the famous bathing passage in the eleventh part of *Song of Myself*:

Twenty-eight young men bathe by the shore,
Twenty-eight young men and all so friendly. . . .
The beards of the young men glisten'd with wet, it ran from their long hair
Little streams pass'd over their bodies. . . .
The young men float on their backs, their white bellies bulge to the sun, they do
 not ask who seizes fast to them,
They do not know who puffs and declines with pendant and bending arch,
They do not think whom they souse with spray. (no. 11)

Tuke's allegiance to the male nude was enduring, having been formed from various European excursions and his own predilections. On a journey to Rome, Tuke had admired above all other sculpture the naked *Apoxyomenos*, the athlete with a scraper, and his early canvases often drew on mythological subjects as a justification for the nude. His visit to Greece, Italy and the Mediterranean in 1892 influenced him to combine classicism with *pleinairisme*, and gradually he concentrated on youths in the open air, under sunlight, often rendered with impressionistic effects. The presence of the sunlight invoked the Apollonian association of male nudity with Apollo which Tuke made evident in two canvases in the early twentieth century. In *The Coming of Day* (1901) (Plate 6–17), a naked youth with arms outstretched comes upon a group of semi-naked men and women in a glade. The youth is crowned with vine leaves, and behind his head a solar nimbus indicates his Apollonian status. The naked youth embodies Apollo, artistic creativity and supremacy, male radiance and divinity. This solarism is made even clearer in *To the Morning Sun [A Sun Worshipper]* of 1904 (Plate 6–18). A youth clad only in a loincloth raises his hands in homage to the sun, which glistens and highlights his hairless body. The cult of the sequestered ephebe, the youthful hairless body as phallus, and the Arcadian pastoral seclusion all reinforce the canvas as an ideograph of solar masculinity. The youth becomes a young priest of Apollo. Wainwright and Dinn emphasize how prominent was 'the theme of the sun as a life-giving force and an object of worship' (80) in Tuke's oeuvre.

Several of Tuke's early mythical canvases deploy the nude male body to construct paradigms of male heroism. In such a manner, the nude male body begins to be associated not only with history, as in Poynter's *Catapult*, but also with mythical precedent that endows it with grandeur and force. Also given the marginalized status of homosexuals in the latter part of the century, so cogently explored by Jeffrey Weeks in various studies, the male nude on canvas, even if excluded in life, was not marginalized but revered. In *Perseus and Andromeda* of 1890, Tuke shows a nude male hero with a small sword raised as he extends the Medusa head before him to petrify the creature in the water; Andromeda, chained to a rock, stands mutely awaiting her rescue. Symonds wrote to Tuke about the *Perseus*: 'The feeling for the nude in it seems to me as delicate as it is vigorous'. Later, in 1903, Symonds advised Tuke to paint his nudes as studies of 'nature's beauty': 'Unless you are inflamed with the mythus, the poetical motive, I do not think you will bring your mastery to bear upon the work in hand if it

be mythological' (Sainsbury 106–107). Tuke, however, retained a vestige of allegiance to the mythical in his canvases with their Apollonian sunlight. In the *Registers* of his paintings, Tuke recorded that a boy modelled for the figure of Andromeda in the *Perseus*. The homoerotic intention suggested by this detail is confirmed in a sonnet from *The Artist* which Tuke pasted on the same page as this entry in his *Registers*; it is possible the sonnet is by Tuke himself. In it, the body of the youth is admired with 'All freshness of the day and all the light/Of morn on thy white limbs, firm, bared and bright/For conflict, and assured of victory,/Youth, make one conquest more; and take again/Thy rightful crown, in lovers' hearts to reign!' (Price ed. *Registers*, Appendix I). Tuke asserts that Perseus's final conquest will be his instantiation of male love. *The Artist* was edited for a period by Charles Kains-Jackson, who accepted 'discreetly, sentimentally pederastic verse' (Taylor 24) in the journal; Kains-Jackson wrote a profile of Tuke for the *Magazine of Art* in 1902, so Tuke was decidedly aware of the erotic adulation of young men. This poem was to be included in an anthology of Uranian homosexual poetry compiled by S.E. Cottam in the 1930s. In the *Hermes at the Pool* of 1900 (Plate 6–19), Tuke shows a male nude resting beside a cove, the cap, wings and caduceus signifying the god's identity. Although the wand conceals the man's genitals, it becomes the displaced marker of the phallus. It is probable that Tuke's *Hermes* was inspired by that of Richmond in 1886. The presence of the pool signals Tuke's allegiance to marine subjects.

Tuke's canvases often evoke the all-male group and particularly the pedagogic element of it, echoing the Spartan *agōgē* in a marine context. In the famous *All Hands to the Pumps!*, albeit not a nude subject, the canvas depicts men of various ages in a gale so fierce the sails have ripped and the ensign, reversed to indicate the extreme danger, has been torn. Here the combination of bearded older sailors and unbearded youths – note the young sailor in the shrouds – indicates the element of guidance constituting the ephebiate *agōgē* This guiding function is made clear in *The Steering Lesson* of 1892, showing an older sailor instructing a young lad. *The Run Home* of 1901 uses Tuke's 'one-rate – *Red Heart*' (Wainwright 84) with its crew of two youths and a moustached older man to depict a rapid passage through a harbour; significantly, the older man has the tiller, the youths handling the sail. Likewise, the all-male isolation of a ship's crew is reflected in *The Midday Rest* of 1905, which shows a group of men of various ages resting on deck, sails furled in the background. These canvases evoke the male world of shipboard training so encapsulated in 1897 when Kipling published *Captains Courageous* and its account of the passage of Harvey Cheyne to manhood.

Tuke's career painting young men and youths in marine settings began with *The Bathers* of 1885, the title of which echoes that of Walker's canvas. Three naked boys are on deck, one of whom points to a figure emerging on the left. As Taylor notes, however, the bodies, although creamy under the

glaring sunlight, are not idealized as classical sculpture (23), as had been the overt intention in Walker's *The Bathers*. To cognoscenti such as Kains-Jackson, Tuke's paintings were celebrations of the youthful male body, as he recorded in 'Sonnet on a Picture by Tuke' in *The Artist*, 1 May 1889, where he praises 'The cameo's self, the boyish faces free/From care, the beauty and the delicacy/Of young slim frames not yet to labour put' (Reade 225–226). Inspired by Tuke and perhaps by Walker, Frederick Rolfe published his *Ballade of Boys Bathing* in *The Art Review* in April 1890, praising 'Deep blue water as blue can be' and 'Boys of the colour of ivory' (Reade 226–227), lines which not only commemorate Tuke but also anticipate Tuke's *August Blue* of 1894 (Plate 6–20), the title of which may echo Rolfe's text.

August Blue derived its title from Swinburne's poem *Sundew* but also very probably from Rolfe's text. As Cooper notes in his study of Tuke, the canvas by its title is aligned with Whistler's canvases with their emphasis on abstract values rather than narrative anecdote. It depicts 'healthy young bodies enjoying exercise, sport and play' (1987, 29). The fact that the canvas was purchased by the Chantrey Bequest for the national collections made Tuke famous as well as made legitimate the male nude as a subject for painting. The homoerotic significance of *August Blue* was not lost on contemporaries. Alan Stanley published his Uranian poem *August Blue* in his collection *Love Lyrics* of 1894, inspired by the play of light on flesh as Tuke intended, addressing the poem to the standing youth:

> Silver mists on a silver sea,
> And white clouds overhead
> Sailing the grey sky speedily
> To where the east turns red.
> And one lone boat her sails has spread,
> Sails of the whitest lawn,
> That seem to listen for the tread
> Of the tender feet of dawn.
>
> The risen sun now makes the sky
> An arching roof of gold.
> Amber the clouds turn as they fly
> Uncurling fold on fold;
> The sun a goblet seems to hold
> A draught of fervid wine,
> And the young day no longer cold
> Glows with a fire divine.
>
> Stripped for the sea your tender form
> Seems all of ivory white.
> Through which the blue veins wander warm
> O'er throat and bosom slight,
> And as you stand, so slim, upright
> The glad waves grow and yearn
> To clasp you circling in their might,
> To kiss with lips that burn.

Flashing limbs in the waters blue
And gold curls floating free;
Say, does it thrill you through and through
With ardent love, the sea?
A very nymph you seem to be
As you glide and dive and swim,
While the mad waves clasp you fervently
Possessing every limb.

King of the Sea, triumphant boy,
Nature itself made thrall
To God's white work without alloy
On whom no stain doth fall.
Gaze on him, slender, fair, and tall,
And on the yearning sea
Who deigns to creep and cling, and crawl,
His worshipper to be.

(Reade 347–348)

Stanley's poem celebrates the radiant youth praised by Wilde and others, but the canvas does not ignore the *agōgē* component of the ephebia, for the large ships in the background foretell the time when these bathers will become sailors, losing the independence of a younger period but also progressing to an institutionalized manhood in the manner of Kipling's Harvey Cheyne in *Captains Courageous*. This ephebic element is emphasized in Tuke's *Ruby, Gold and Malachite* of 1901 (Plate 6–21). Rather than being in the commercial traffic of the young men in the harbour of *August Blue*, the youths are sequestered in a cove, a genuine ephebic isolation. The young men are noticeably blond and with individualized rather than classicized faces. The title echoes the formalist objective of Whistler, but the subject itself is strongly in the tradition of the representation of the masculine ephebia. It is not surprising that Tuke was to describe one of his models, Bert White, using the Greek word *kalos* in his diaries (Cooper 1987, 33), for the assimilation of harbour lads to Greek ephebes in training was a mode of aligning the masculine – and more importantly the homoerotically masculine – with enduring paradigms of maleness.

Not all Tuke's male nudes were so amenable to formal abstractness, however. In some of these marines, the figures contain an erotic element implicit or even explicit. In *The Diver* of 1899 (Plate 6–22), Tuke shows an Aryan/Apollonian youth preparing to dive. The canvas contains a typical Tuke feature in the voyeur(s) who contemplate the naked youth from the front, thus permitting the observers *in* the canvas a view of the penis which the observer *of* the canvas must transform to the whole body of the young man. The raised left foot of the diver introduces a classicizing element in its evocation of Polykleitos and his athletes/warriors. When *The Diver* was exhibited in 1899, its erotic component was clear to reviewers:

It is one of those daring studies which would daunt the majority of painters, yet Mr Tuke seems to find nothing so congenial to his mind as to tackle a subject

everybody else would shrink from. . . . Masterly as is Mr Tuke's work, one cannot help feeling regret that he does not give his attention to a more acceptable subject. (Wainwright and Dinn 61)

Following in the wake of the Wilde trials of 1895, one can detect here not only an awareness of the homoeroticism of *The Diver* but also an anxiety about the nude male body. Oftentimes, the titles of Tuke's canvases introduced an implicit erotic element. In *Noonday Heat* of 1903 (Plate 6–23), two youths exchange glances in a secluded inlet, one of the models being the *kalos* Bert White. 'The two youths who relax and rest on the beach are totally engrossed in their private world: neither of them addresses the viewer: their relationship is at once intimate, exclusive and ambiguous' (Cooper 1987, 34). As Cooper observes, the 'homoerotic element is present but not overt'. However, in 1911 Tuke painted a watercolour version of the canvas in which the youth clothed in trousers in the 1903 oil is now nude, making both young men naked. Unquestionably this increases the eroticism of the canvas and makes the title of the painting more ambiguous than it is in the trousered version. Both canvases are masterful studies of texture and light, with the golden sheen conferring on the men in the watercolour an Apollonian element.

In *The Diving Place* of 1907 (Plate 6–24), Tuke shows a solitary naked youth in a cove at Newporth Beach; he is self-absorbed as he gazes into the water, a naked worshiper of Apollo and an Edwardian Narcissus. According to *Tuke Reminiscences* (21), the canvas was originally exhibited without the genital detail; subsequently, a purchaser requested that the genitals be defined; later, it was altered again, prompting Tuke to call it 'Love in a Mist'. The reproduction in *Royal Academy Pictures*, however, clearly shows testicles and an uncircumcised penis, increasing even more the Greek, ephebic quality of the canvas, given the Greek aversion to circumcision; the canvas appears with the title *The Pool*, also indicating more clearly the narcissistic component of the painting. Tuke's *Playmates* of 1909, depicting two naked youths in a rowboat and their pet dog, by its very title emphasizes the eroticism of these males. Additional canvases of young men on the shore as liminal ephebes in the sun include *A Sun Bather* of 1912 and *July Sun* of 1914, both studies of solitary nude youths; and *Under the Western Sun* of 1917 and *Facing South* of 1920, showing two nude males together, the latter category emphasizing idealized comradeship. Tuke had painted a portrait of Lord Ronald Gower, the model for Sir Henry Wooton in *The Picture of Dorian Gray*, in 1897, again indicative of Tuke's awareness of the homosexual world of late nineteenth-century London. Canvases such as *Playmates* or *Noonday Heat*, therefore, reflect the artist's consciousness of Uranian culture. After the War, Tuke's canvases, such as *Morning Splendour* of 1921 (once at Baden-Powell House), a group of naked youths bathing in a cove, appropriated an elegiac cast because of the thousands of golden lads slain in Europe. In the event,

the training as ephebic youths preparing for warrior status became all too actualized.

The intention of Tuke's last great male nude, the lost *Sunburn* of 1929, is both celebratory and elegiac. A young man, viewed from the back, stares into the water from a rock on which he sits. The canvas recalls all the lads destroyed in the Great War but links them via the title and sunlight with the solarism associated with Apollo. The pose also echoes in reverse that of a youth, a frontal nude, painted by the gay artist Glyn Philpot in *Melampus and the Centaur* of 1919, which in turn was the basis for Montague Glover's photograph of his lover Ralph Hall. Glover had been a captain in the British Army in the First World War; Hall, whom he met in 1930, was 'a tall, fair and strikingly good-looking East End lad in his teens' (Gardiner 11). Gardiner emphasizes that Hall was 'a blond, teenage labourer' (90), whose appearance recalled the youths in Tuke's canvases which, directly or indirectly, inspired Glover to photograph youths bathing at 'the Thames in Dockland, the Serpentine in Hyde Park, and especially . . . the public bathing lakes at Victoria Park in East London' (66). The blondness of some of the men in Tuke's canvases is part of the cult of solarism which was basic to 'the equation of blondness with special beauty and value [explaining] the frantic popularity of Rupert Brooke' (Fussell 276). 'The Sun was too supreme' Wilfred Owen recorded on his last day in England, when he went bathing and saw:

> issu[ing] from the sea distraction, in the shape . . . of a Harrow boy, of superb intellect and refinement: intellect because he hates war more than Germans; refinement because of the way he spoke of my Going, and of the Sun, and of the Sea there. (Fussell 277)

Fussell locates Tuke in this tradition, but one might claim that Tuke, along with artists like Walker, invented it. The relationship of Glover with Hall indicates that Tuke's canvases could be actualized: Gardiner cites one of Glover's photographs as a 'translation' (67) of Tuke's *August Blue*. In this metier, solarism, the all-male world, the military and the male nude coalesce in an evocation of Apollo's relationship with Hyacinthus.

O'Flaherty has noted the 'phallic/seminal nature of the sun' as being well-established; it 'may be extrapolated from the solar nature of seed' (205). The emphasis on the solar in Tuke aligns his canvases with other discourses of an empowered masculinity. Tuke's canvases, especially if connected with the advocacy of new theories of homosexuality as advanced by Symonds and Edward Carpenter, become heroic in their defence of heretofore marginalized masculinities, supporting an idea of homosexuality not along the lines of gender inversion but that of gender separation, constituting the exclusion of characteristics of the opposite sex in favour of Greek love or male bonding or comradeship. In his work, Weeks has examined the nature of the restrictions placed on homosexuals at the end of the century, albeit 'the death penalty for buggery . . . was finally abolished in England and Wales in 1861' (1977, 14):

> By section 11 (the 'Labouchere Amendment') of the 1885 Criminal Law Amend-
> ment Act, *all* male homosexual acts short of buggery, whether committed in
> public or private, were made illegal. . . . And thirteen years later, the Vagrancy
> Act of 1898 clamped down on homosexual 'soliciting'. (14–15)

For Symonds and others, the constellation of sun and ephebe and Grecian associations dignified homosexuality at a time when blackmail and violence jeopardized freedom of sexual expression. Symonds was to publish a study of Whitman in 1893, also to increase acceptance of male–male love. The nudity in Tuke's canvases also eliminated elements of classism that prevailed when working-class youths or Guardsmen, both often engaged in homosexual prostitution, became linked with upper-class or aristocratic males (Weeks 1991, 55–56).

The link between solarism and masculinity, adumbrated in so many of Tuke's canvases, has become central to both analysis and Men's Studies, particularly in the work of Eugene Monick. In his 1987 study *Phallos*, Monick discusses Erich Neumann's distinction, derived from Bachofen, of 'solar' from 'chthonic' masculinity, the former being associated with light and spirituality, the latter with darkness and sexuality; Monick contends that this distinction is artificial and that both masculinities are equivalent in their significance (60). In Jung, the 'solar masculine principle' is *logos* (85), and in Monick's extrapolation, 'solar phallos is in fact word, logos. . . . Solar men love institutionalization; it is their narcissism' (102). The link between representations of the male body and the solar in Victorian art are premonitory of Monick's belief, enunciated in his later *Castration and Male Rage*, that 'it is incorrect to value solar phallos and devalue chthonic phallos' (10). In this linking of the body with the solar, Victorian art affected gendered culture in two ways: the male body, *per se*, was recognized as more evolved and perfect than the female body (thus too rare and precious to be widely depicted); and the link with the solar – *logos*, institution, civic responsibility – meant that possession of the penis granted a privileged status in patriarchal culture. As Pronger notes, 'The myth of masculinity hangs on the penis. It is by the myth that a dangling tissue becomes a phallus' (159). Victorian culture valued both the cult of the male body (as in games, warfare, evolutionary theory) and the practice of emphasizing the Apollonian component of masculinity, anticipating Neumann's 'insistence upon solar masculine qualities as the goal of masculine development. . . . In this transformation, the energy nature pours forth in concrete sexual capacity and appetite is substantially converted into allegorical phallic activity. This is Freud's concept of sublimation' (Monick, 1991, 30–31). Males seek 'metonymic equivalences of phallos. . . . Attainment for a man is parallel to erection and insemination' (31). The result for those unable or unwilling to embrace the solar is conflict, alienation, exclusion: 'Patriarchy does indeed castrate males who cannot or will not move into the fraternity of the solar establishment' (91). The powerful constellation of the Aryan race, ephebia, nudity, the solar,

and Apollonianism in Victorian artistic representations of the male body was a stunning ideograph of masculine ideology. In the discourse constructed by this art, even marginalized masculinities such as homosexuality could be included in an inclusive paradigm privileging biological maleness and gendered masculinity.

Tuke's canvases appeared at a time when the male body was also a focus for other artists. Robert Goodman in 1900 exhibited his *The Diver*, the title of which echoes Tuke's 1899 canvas. Here a group of youths is shown in a forest glade surrounding a pool in which several young men are already standing; one, in the foreground, points to a place where he intends to dive. The circular design of the pool and the circular arrangement of the young men symbolizes their sequestration and the nature of their all-male *agōgē*. Sculptors as well during the end of the century used the nude male in a commemorative or ideological manner. In Alfred Gilbert's *Perseus Arming* (1882) and *Icarus* (1884), the bodies of the young men telegraph their heroism, again by their full frontal nudity. G.F. Watts's *Physical Energy*, conceived around 1883 but not cast until 1906, showed a naked male astride a powerful horse, shading his eyes against the sun towards which he advances with all the confidence of an Apollonian, solar adherent. Eventually the work was cast as a memorial to the ruthless imperialist Cecil Rhodes, linking the male nude with the British imperialist project and showing the dominance of white, Aryan races over 'inferior' blacks or foreigners. As Read observes, 'the rider looks out for the next thing to do. The incline of the plinth is slightly symbolic of a rising wave' (285). P. Bryant Baker's *Beyond* of 1910 shows a naked male, holding a skull behind him, raising his head towards the sky, evidence of his developed evolutionary status as well as his transcendent progressive attitude. Hamo Thornycroft did sculptures of nude boys in *The Bather* of 1898 and *After the Bathe* of 1910. His *Putting the Stone*, a half-size nude in bronze of 1880, showed a naked youth whose raised left foot, quoting both Leighton and Polykleitos, was modelled by one of the preferred Italian models, Orazio Cervi, so favoured by nineteenth-century artists. The motive of the statue is Paterian: 'Hamo had it in mind to make a series of bronze statues illustrating English games, since they gave an opportunity for modelling from the nude' (Manning 79). Tuke's canvases, therefore, are part of a cultural project involving the encoding of masculinity, Pater, gamesmanship, the Aryan race, the solar and imperialism.

Representations of the male nude in nineteenth-century British painting constitute the inscription of the ultimate signifier of masculinity. The consequences of this representation for the culture are myriad. As Laqueur has noted, the emphasis on the incommensurability of the male and female bodies begun in the eighteenth century may be said to achieve a climax in such depictions, which are part of 'a biology of incommensurability' (19). The nude male in art becomes the visible/visual epitome of male subjectivity. The male gaze directed at canvases of nude males was at once erotic,

scopophilic and narcissistic. As Neale has claimed, 'the narcissistic male image – the image of authority and omnipotence' (13) might be aligned with masochism, but this narcissistic drive was paramount in constructing the masculine during the nineteenth century. In representations of the mythical hero, the chivalric knight, the bourgeois paterfamilias, the military ranker, as well as in the depictions of male nudes, the male saw configured an ideology empowering and privileging. Representations of masculinities during the nineteenth century comprised much of the spectrum of men's homosocial relations, including, as Sedgwick has argued in *Between Men*, 'male friendship, mentorship, entitlement, rivalry and hetero- and homosexuality' (1). This iconography constructed for the era the dominant fiction by which men became acculturated and gendered. The nude hairless male body epitomized the penis/phallus equation of the dominant fiction by which males lived. As Sedgwick has contended, 'the politics of male homosociality' anchored 'the distinctive relation of the male homosocial spectrum to the transmission of unequally distributed power' in Victorian society, including 'the enforcement of women's relegation within the framework of male homosocial exchange' (17, 18, 120). Even if the dominant fiction was founded on a misrecognition, the penis/phallus equation was legitimated along a large range of the homo-social continuum. As London has argued, 'masculinity . . . is created by cultural negotiations and contestations. . . . It brings to light the constitution and distribution of the male body in the making of cultural identity. . . . Male spectacle is an integral part of masculinity' (261). The representation of the male in art, and above all the male nude, constructed masculinity during the Victorian period and for much of the twentieth century. To reiterate Graham Dawson's observation, 'masculine identities are lived out in the flesh, but fashioned in the imagination. . . . An *imagined identity* . . . has real effects in the world of everyday relationships' (118). Of the forms of imagined identity, the imaged construction of masculinity in art constituted a formidable type. If as Roper contends 'masculinity is never fully possessed, but must perpetually be achieved, asserted, and renegotiated' (*Manful* 18), the iconography of masculinity was a major part of this assertion and renegotiation.

This male alliance was an empowering force in patriarchal culture. The nude male body and its constellation of elements permitted the dominant fiction of patriarchal ideology (investigated by Silverman *passim*) to remain in authority, despite the potential castration awaiting males who might repudiate incorporation into the model. The epitome of this discourse is constructed in George Wetherbee's *Adventurers* of 1908. Wetherbee had previously elevated the male nude in his canvas *Orpheus* of 1901 (Plate 6–25), in which a nude ephebic poet is playing a lyre while two water nymphs pause to listen at the base of a waterfall. Loosely cloaked in a leopard skin, the youth glances at the two women. His elevated situation on a promontory overlooking the water and the two women emphasizes his

gendered as well as artistic superiority. In *Adventurers* (Plate 6–26) this heroism has been constructed devoid of explicit mythological reference, although much ideology about the nude male clarifies the artist's intention. In this celebration of Aryan Apollo worship, three youths set off daringly into the ocean. The time of the canvas is sunrise, the appearance of Apollo/light/*logos* as conqueror of female night. These males are a variant of Tuke's *To the Morning Sun*, especially as they raise their arms to hail the sun and pay it homage, almost as if they are acolytes of Apollo. Wetherbee's three youths are the phallocentric response to the Three Fates or the Three Graces, which have been supplanted by a new male trio. Supporting an imperialist, colonizing agenda, emerging manhood in this most liminal of locations is equated with new worlds to conquer. The young men become the iconographic analogues of Ruskin's pronouncement about Apollo in *The Queen of the Air*. Their nude bodies not only catch but also absorb the rays of the rising sun/deity in a catalysing icon of Aryan, Apollonian, ephebic, liminal empowerment.

This objective is made clearer when *Adventurers* is compared with the artist's *Frolic Spring*, shown at the Royal Academy the same year as *Adventurers* was exhibited at the New Gallery. In *Frolic Spring*, three young women are shown skipping along the grass path on a cliff overlooking the sea. The three women represent Ruskin's 'frivolous amusement', while the Apollonian males of *Adventurers* follow Ruskin's injunction to set out 'to the ends of heaven'. The Reverend Francis Kilvert recorded in his diary in 1872:

> There was a delicious feeling of freedom in stripping in the open air and running down naked to the sea, where . . . the red morning sunshine [was] glowing upon the naked limbs of the bathers. (Ableman 68)

Early in the nineteenth century, the nude male body was invariably linked to a mythological figure, as with Richard Westmacott's *Achilles* memorial to the Duke of Wellington of 1822. In mid-century, Poynter deployed the nude male in a canvas such as *The Catapult* in a civic context to align the nude male body with the political power of patriarchy. By the end of the century, however, the nude male body could exist as its own justification, the definitive sign of the masculine and its codes. Despite the relative scarcity of representation of the male nude in Victorian art, its affiliations with the ideologies of the solar, the Aryan race, the ephebia, and liminality in the canvases of these artists transformed them into the ultimate representations of maleness, the quintessential constructions of masculinity in nineteenth-century British culture.

David Gilmore's recent examination of the cultural conceptualization of masculinity stresses the importance of 'imaging' in this process:

> Most societies hold consensual ideals – guiding or admonitory images – for conventional masculinity. . . . The one regularity . . . here is the often dramatic ways in which cultures construct an appropriate manhood – the presentation or 'imaging' of the male role. In particular, there is a constantly recurring notion

that real manhood is different from simple anatomical maleness. . . . This recurrent notion that manhood is problematic . . . is found at all levels of sociocultural development. . . . The question of continuities in gender imaging must go beyond genetic endowment to encompass cultural norms and moral scripts. If there are archetypes in the male image . . . they must be largely culturally constructed as symbolic systems. (10, 11, 23)

Such symbolic systems or imaging is necessary for, as Stearns stresses, 'manhood . . . is not purely natural . . . it has to be taught' (248) or, as Gilmore observes, 'male gender is "created" rather than "natural" ' (106). Gilmore notes that there is even a tradition 'that identifies masculinity with the act of artistic creation, the process that forges beauty from an unyielding raw material' (113). Walter Pater in *Plato and Platonism* describes masculinity in art as 'the spirit of construction' (280–281), while Gerard Manley Hopkins in his letters believed: 'Masterly execution is a kind of male gift, and especially marks off men from women' (133). Both Pater's and Hopkins' statements are a charter for men to engage in art *and* to construct their male subjectivity through art. In fact, it is male artists only who could engage in this enterprise:

> Manhood is a kind of male procreation; its heroic quality lies in its self-direction and discipline, its absolute self-reliance – in a word, its agential autonomy. (Gilmore 223)

Construction of masculinity by artistic representation constructs and legitimizes maleness: 'Gender ideologies are . . . collective representations. . . . We can characterize manhood . . . as a mythic confabulation that sanctifies male constructivity. . . . Manliness is a symbolic script' (224, 226, 230). The construction of masculinity by art, therefore, not only constructs male gender but also demonstrates as a meta-artistic function male constructivity itself, a dimension of the inscription of art as male, revealed by the maleness of the art establishment of the nineteenth century (Hanging Committee , membership in the Royal Academy, exhibition and book reviewing, book publishing, admission to the life class, engraving).

During the nineteenth century, Stearns contends, there was a 'basic change in the canons of manhood during the nineteenth century' (11–12). Mangan and Walvin summarize this transition as follows:

> 'Manliness' [embraced] qualities of physical courage, chivalric ideals, virtuous fortitude with additional connotations of military and patriotic virtue. In the second half of the nineteenth century . . . the concept underwent a metamorphosis. To the early Victorian it represented a concern with a successful transition from Christian immaturity to maturity, demonstrated by earnestness, selflessness and integrity; to the late Victorian it stood for neo-Spartan virility as exemplified by stoicism, hardiness and endurance – the pre-eminent qualities of the famous English public school system, without doubt one of the most influential education systems the world has witnessed. . . . [The] adherents [of manliness] were audacious in their aspirations. Their task was teleological. . . . 'Manliness' symbolised an attempt at a metaphysical comprehension of the universe. It represented an effort to achieve a *Weltanschauung* with an internal coherence and external validity which determined ideals, forged

identity and defined reality. . . . After its inception in the mid and late nineteenth-century English public schools, a neo-Spartan ideal of masculinity was diffused throughout the English speaking world with the unreflecting and ethnocentric confidence of an imperial race. (1, 3)

This transition, however, might more accurately be construed as a gradual alteration of emphases, a process of accretion and consolidation. It was not possible to separate, for example, integrity from endurance, even if one were more Christian and the other Spartan. As Hatt notes, 'while these different masculinities were widespread, none of them was stable. This is evident from the way in which they were mutually inflecting, different discourses overlapping. . . . A broad pattern of normative definition does emerge' (58). Newbolt's *Vitaï Lampada*, written in 1892, for instance, seems to embody the classical idea of its title (from Lucretius), the comradeship and gamesmanship of the school ideology, the militarism of the imperial ethos, and the strength of the male body, an amalgam of discourses. As cited earlier, discussing the American artist Thomas Eakins' *Salutat* (1898), Hatt continues:

Masculinity . . . can be deployed as a unified field rather than as a set of diverse gender positions. But although at any given historical moment we are dealing with the issue of masculin*ies* – of male gender as a field of difference – certain definitions may predominate, being cited more frequently as that masculine exemplar. (1993, 57)

During the nineteenth century in Britain, the classical hero, the chivalric knight, and the valiant soldier constituted some of these predominating exemplifications. Hatt emphasizes 'the importance of men watching men', for:

it is in the homosocial realm that young men are inculcated with the ideals of their gender roles: in gymnasia, colleges, workshops, saloons, and so on. (62)

For males during the nineteenth century, furthermore, canvases representing male homosociality became themselves homosocial spaces accessible to the male gaze. These constructions of masculinity 'allowed the scrutiny of the male body by the male gaze' (68), a necessary element in the construction of masculinity. As Hatt contends:

The stability of masculinity depends upon the visibility of the male body; to be learnt or consolidated, masculinity requires a visual exchange between men. (63)

Artistic configurations of males during the nineteenth century, whether classical, chivalric, bourgeois or militaristic, enabled this 'visual exchange' by which men perceived and conceived male subjectivity.

This consolidated discourse of masculinity was to endure into the twentieth century and influence its renegotiations of masculinity. Of this process of reconfiguration, Peter Stearns writes:

For the last seventy years, with fluctuating intensities, men in Western society have been reshaping the definition of manhood inherited from the nineteenth century, adjusting to a reduction of the significance of gender identification

> while, in the main, insisting in some identification still. . . . [For example,] men
> without work are not so sure of themselves. . . . For most adult men, work
> remained [in the 1960s and 1970s] the clearest defining identity, even the
> clearest obligation in family life. . . . Male family styles also displayed
> considerable continuity from nineteenth-century forms. . . . For men, the
> twentieth century has witnessed a complex juggling act designed to preserve
> certain masculine personality traits inherited from the nineteenth century or
> before, while at the same time adapting to important new pressures. . . . The
> new male standards touched base with Victorian traditions in urging restraint in
> normal emotional expression. . . . Male traditions did shift, but they maintained
> contact with reactions that had seemingly worked well in the nineteenth century.
> (176, 190, 220–221, 224, 232)

Artistic representation has continued to be part of this process of
configuring masculinity in the twentieth century.

In the exhibition 'Visualising Masculinities' with which this study began,
for example, Robert Longo's *Sword of the Pig* of 1983 (Plate 6–27)
particularly demonstrated this renegotiation, as Andrew Stephenson dis-
cussed:

> Longo's piece exposes Western culture's identification of strength with male
> heterosexual authority. The sword format is an obvious reference to violence
> and power. The precise drawing of a hard, muscle-bound physique explicitly
> freeze-frames the penis. The right-hand section with its screen printed photo-
> graphic image of missile silos printed on an aluminium sheet, alludes to military
> aggression. The phallic columns of the silos ally this symbolically to sexual
> power. Yet Longo is critical of equating masculinity with machoism. The nude
> male body, encased under layers of plexi-glass, is a collage of close-ups of ageing
> male body-builders. The silos are marked INERT: a description that undermines
> the authority of the work's apparently heroic, male postures. (n.p.)

The wall placard accompanying this picture elaborated that 'pig' was a man
with an aggressive sense of maleness and that 'pork sword' was a slang term
for penis. It noted that the handle refers to the phallic shapes of skyscraper
and church steeple and that the naked male body is 'distorted' by muscles
and thus a parody of the macho man. The 'inert' might apply to the macho
mentality, which denies its actual impotence.

On the other hand, if one examines the picture in the context of the
construction of masculinity in the nineteenth century, a number of
elements appear which demonstrate its dialogue with the discourses of
masculinity examined in this book. The prismatic tip of the sword recalls
the flaming tip of the war engine in Edward Poynter's *The Catapult*. The
sword evokes the discourse of chivalry even as the silos with missiles echo
the military paradigm constructed by battle art. The naked male body is
hypermasculine in its exaggerated musculature but at the same time, since
it is coloured in yellow gold, it exalts as much as mocks male nudity: this
alignment with the solar/Apollonian ideologies links the naked male body
with divinity. In addition, it evokes such extraordinary examples of male
nudity as the *Belvedere Torso* of the mid first century BC, not only in its
musculature but also in its *contrapposto* attitude. With the exception of

pubic hair, the body is hairless, transforming the entire figure into the phallus, suggesting myths of Hercules. The exposed glans evokes 'the new mania for circumcision among the upper and professional classes of Britain and America in the 1890s' (Weeks 1981, 51), which Wallerstein links with the prevention of masturbation as a means of assuring the self-control necessary for imperial domination 'over the poor and "inferior" peoples' (35).

Goux has argued that circumcision is part of a sequence of rituals initiating the male to manhood. Circumcision was 'probably originally a puberty rite' but in the form of infant circumcision 'has been as it were "pre-dated" to mark a precocious, almost immediate, allegiance with the fathers. The child thereby finds himself symbolically severed from the mother shortly after birth' (74). His remarks suggest that the increase of female independence with civil rights at the end of the nineteenth century and the practice of infant male circumcision are connected. As women gained a degree of power and control, men enrolled their sons in the male ranks by this practice, a physical and symbolic inscription of the masculine, the marking of the penis as phallus. As Bernheimer has argued, refuting Lacan, the phallus cannot be separated from the actual penis: 'For Lacan, the phallus . . . refers to no body. But he is wrong: the link between the signifier and signified cannot be severed' (120–121). Longo's painting interrogates the penis/phallus equation of the dominant fiction, but it does so by demonstrating that the phallus cannot be completely separated from the penis. Jane Gallop has contended:

> Of course, the signifier *phallus* functions in distinction from the signifier *penis*. . . . But it *also* always refers to *penis*. . . . The penis is what men have and women do not; the phallus is the attribute of power which neither men nor women have [according to Lacan]. But as long as the attribute of power is a phallus which can only have meaning by referring to and being confused with a penis, this confusion will support a structure in which it seems reasonable that men have power and women do not. . . . I believe it to be a symptom of the impossibility, at this moment in our history, to think a masculine that is not phallic. . . . *Phallus*, the signifier in its specificity . . . is always a reference to *penis*. *Phallus* cannot function as a signifier in ignorance of *penis*. (126–128)

Longo's *Sword of the Pig* engages the equation of penis with phallus upon which the concepts of male dominance and masculinity were constructed, represented and established in/for/during the nineteenth century. The predominantly male-exclusive metiers of the classical hero, the chivalric knight or the combat soldier equate penis with phallus to construct an order of dominance. Thus the penis in Longo's canvas consolidates militaristic, sexual, classist, chivalric, racist and imperialist discourses. If *Sword of the Pig* were exhibited without its title, it would be as valid to construe it as a perpetuation of nineteenth-century discourses as much as it may be a way of sabotaging them. As Stephenson argues, the size of the work 'is essential to understanding the phallic power which the male body symbolically has within Western culture' (n.p.). In fact, the projecting

horizontal of the entire composition could be an erection. *Sword of the Pig* in its very title contains both the elevation and denigration of phallic identity. 'To unveil the penis is to unveil the phallus is to unveil the social construction of masculinity' (de Genevieve 4).

Robert Longo's painting *Sword of the Pig* constructs both the penis and phallus, both physical maleness and symbolic system. In this process of representation, it indisputably engages nineteenth-century constructions even as it might contest and challenge them. As such, it demonstrates an element Schwenger denominates as 'the masculine mode':

> The masculine mode is above all an attempt to render a certain *maleness of experience*. . . . This maleness of experience . . . must mean the infusion of a particular sense of the body into the attitudes and encounters of a life. (102)

Whether representing the classical hero, the gallant knight, the challenged paterfamilias, the valiant soldier, or the male nude, Victorian male artists rendered the maleness of experience by imaging the male body, whether it was clothed, armoured, uniformed, or naked. Their canvases establish, as does Longo's, that phallus, even functioning in distinction from penis, could not signify without recognition of penis. Schwenger observes that the penis is 'a subject peculiar to the masculine mode':

> *Sine qua non* of maleness, instrument of the adolescent's awakening virility, center and symbol of his manhood to the adult – the penis has enormous importance in the life of the male. (106–107)

In constructing their canvases, these artists sought to 'express the dynamics of manhood' (111) by imaging the male body. Writing in 1928, Virginia Woolf commented in *A Room of One's Own* that 'virility has now become self-conscious' (105). It was during the nineteenth century that this process became evident, however, above all in the construction of masculinity by artists, because, as Schwenger emphasizes, 'the male gauges his own masculinity not by women but by other men' (109). Gazing at these representations of masculinity produced by males, men negotiated their own identities as males. Armoured, uniformed, or naked, the male body in art always acknowledged the penis while representing the phallus in its symbolic drive. The legacy of these Victorian representations of masculinities, as Longo's canvas reveals, has been enduring. Painting the male body was to paint ideologies, behaviours, practices, and codes. These constructions of masculinities remain to challenge and engage succeeding codes and practices and constructions. Stearns contends that still 'Western manhood wars with manly moderation. . . . No man can consistently fulfill all the requirements of his gender' (249). Such an estimate parallels Poovey's conclusion about nineteenth-century manhood: 'For the Victorians, "normal" masculinity was more difficult to achieve than to describe' (226). Endowed with both penis and gaze, males of the twentieth century were and are implicated through the discursive construction of masculinities and male subjectivity by artistic representation during the nineteenth century.

6–1. William Etty: *Prometheus*, 1825–30; 27¾ × 30½; National Museums and Galleries on Merseyside (Lady Lever Art Gallery, Port Sunlight).

6–2. Edward J. Poynter: *The Catapult*, 1868; 61 × 72¼; Laing Art Gallery, Newcastle upon Tyne, England (Tyne and Wear Museums).

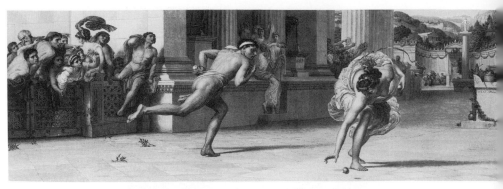

6–3. Edward J. Poynter: *Atalanta's Race*, 1876; 58 × 174; photo: Christopher Wood Gallery, London.

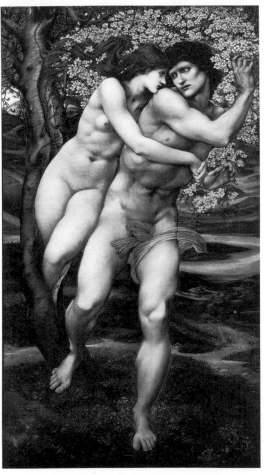

6–4. Edward Burne-Jones: *The Tree of Forgiveness*, 1882; National Museums and Galleries on Merseyside (Lady Lever Art Gallery, Port Sunlight).

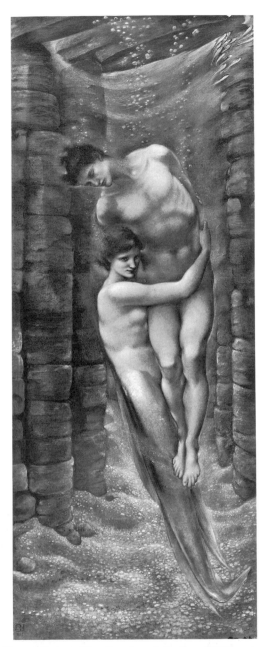

6–5. Edward Burne-Jones: *The Depths of the Sea*, 1887; watercolour and
gouache on paper mounted on panel; 77 × 30; Fogg Art Museum,
Harvard University Art Museums, Bequest of Grenville L. Winthrop.

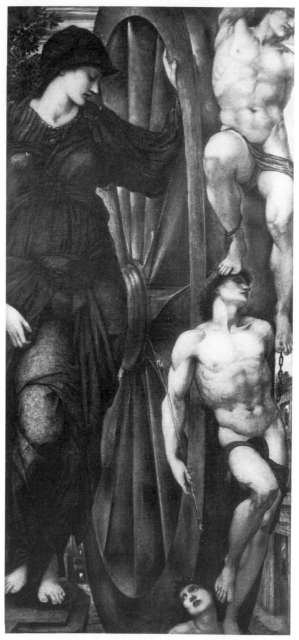

6–6. Edward Burne-Jones: *The Wheel of Fortune*, 1886; gouache on canvas; 45 × 21; Cecil French Bequest, London Borough of Hammersmith and Fulham, on loan to Leighton House Museum, London.

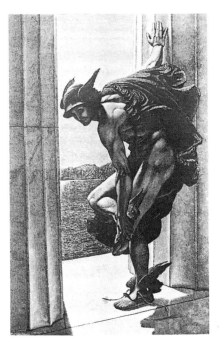

6–7. William Blake Richmond: *Hermes*, 1886; 58 × 36; photo: Kestner from
reproduction in The Witt Library, Courtauld Institute of Art, Somerset
House, London.

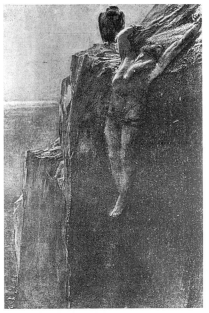

6–8. Briton Riviere: *Prometheus*, 1889; 35 × 23; photo: *Pall Mall Pictures of
1889*.

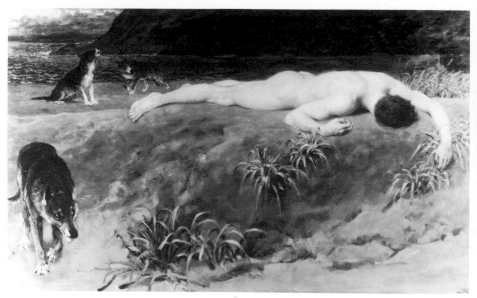

6–9. Briton Riviere: *Dead Hector*, 1892; 30¼ × 48¼; Manchester City Art Galleries.

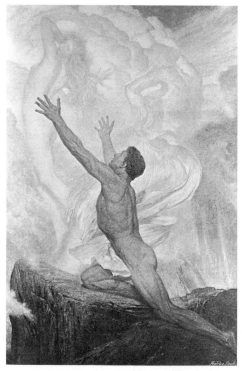

6–10. Frank Dicksee; *The Ideal*, 1905; 90 × 58; photo: *RAP* 1905.

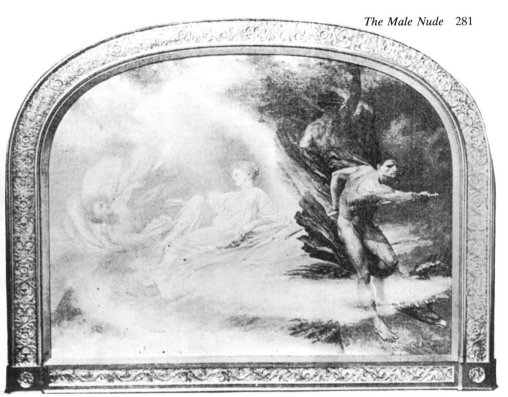

6–11. Frank Dicksee: *The Mountain of the Winds*, 1891; photo: *Pall Mall Pictures of 1891*.

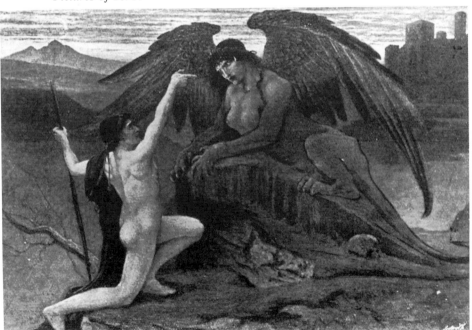

6–12. Walter Crane: *The Riddle of the Sphinx*, 1887; gouache sketch; photo: *Pearson's Magazine* 1906.

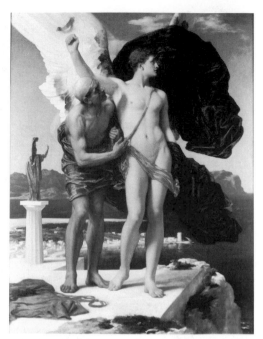

6–13. Frederic Leighton: *Daedalus and Icarus*, 1869; 53½ × 40½; The National Trust, Buscot Park.

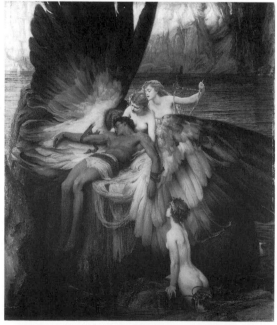

6–14. Herbert James Draper: *The Lament for Icarus*, 1898; 72 × 61; Tate Gallery, London.

6–15. Frederic Leighton: *Hit!*, 1893; 29 × 22. The FORBES Magazine
Collection, New York.

6–16. Frederick Walker: *The Bathers*, 1867; 37 × 84; National Museums and
Galleries on Merseyside (Lady Lever Art Gallery, Port Sunlight).

6–17. Henry Scott Tuke: *The Coming of Day*, 1901; 72 × 54; photo: *RAP*
1901.

6–18. Henry Scott Tuke: *To the Morning Sun [A Sun Worshipper]*, 1904; 40 ×
30; Hugh Lane Municipal Gallery of Modern Art, Dublin.

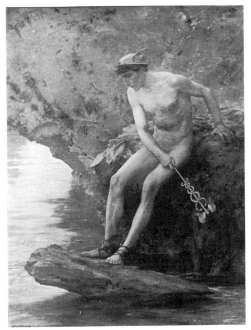

6–19. Henry Scott Tuke: *Hermes at the Pool*, 1900; 60 × 45; photo: *RAP* 1900.

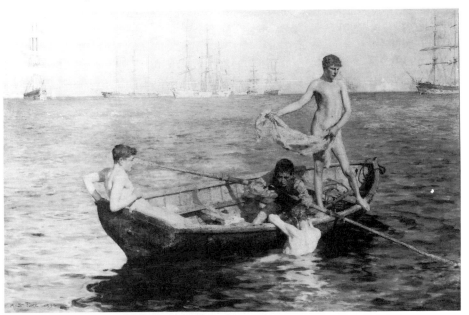

6–20. Henry Scott Tuke: *August Blue*, 1894; 48 × 72; Tate Gallery, London.

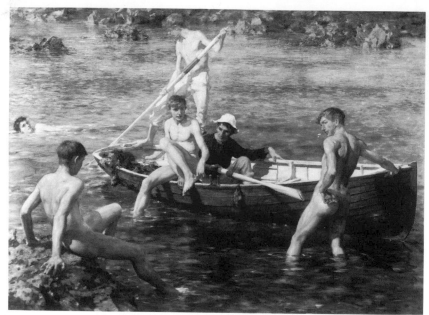

6–21. Henry Scott Tuke: *Ruby, Gold and Malachite*, 1901; 46 × 62½;
Guildhall Art Gallery, Corporation of London.

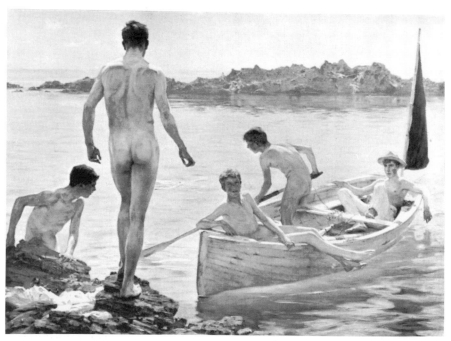

6–22. Henry Scott Tuke: *The Diver*, 1899; 50 × 70; photo: *RAP* 1899.

6–23. Henry Scott Tuke: *Noonday Heat*, 1903; 32 × 52; photo: *RAP* 1903.

6–24. Henry Scott Tuke; *The Diving Place*, 1907; 56 × 32; photo: *RAP* 1907.

6–25. George Wetherbee: *Orpheus*, 1901; 50 × 30; photo: *RAP* 1901.

6–26. George Wetherbee: *Adventurers*, 1908; photo: *Pall Mall Pictures of 1908*.

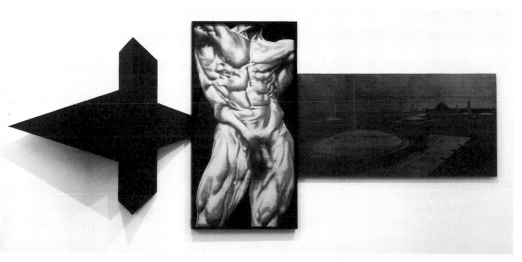

6–27. Robert Longo: *Sword of the Pig*, 1983; mixed media on wood relief, paper and aluminium; 97 × 231 × 19; Tate Gallery, London.

Bibliography

Note: Reviews from the *Art Journal*, *Athenaeum*, *Magazine of Art*, *Illustrated London News*, *Studio*, and *The Times* are cited parenthetically to page number in the text; the year is always given.

Abbott, Franklin, ed. *New Men, New Minds*. Freedom, California: Crossing Press, 1987.

Abbott, Franklin, ed. *Men and Intimacy*. Freedom, California: Crossing Press, 1990.

Ableman, Paul. *Beyond Nakedness*. Los Angeles: Elysium Growth Press, 1982.

Academy Notes. London: Chatto and Windus, 1875–1894.

Acton, William. *The Functions and Disorders of the Reproductive Organs*. Philadelphia: Lindsay and Blakiston, 1875.

Adams, James Eli. 'Gentleman, Dandy, Priest: Manliness and Social Authority in Pater's Aestheticism.' *ELH* 59 (1992), 441–466.

Adams, James Eli. 'The Banality of Transgression?: Recent Works on Masculinity', *Victorian Studies* **26** (Winter 1993), 207–213.

Aldrich, Robert. *The Seduction of the Mediterranean: Writing, Art and Homosexual Fantasy*. London: Routledge, 1993.

All the Banners Wave. Providence, Rhode Island: Brown University, 1982. [exhibition catalogue]

Allwood, Rosemary. *George Elgar Hicks*. London: Geffrye Museum, 1982. [exhibition catalogue]

Aristotle. *The Politics*. Trans. Benjamin Jowett. Oxford: Clarendon, 1885.

Armstrong, Walter. *Briton Riviere: His Life and Work*. London: Art Journal Office, 1891.

Arnold, Matthew. *Culture and Anarchy*. Cambridge: Cambridge University Press, 1960.

Arnold, Matthew. *Poetry and Criticism*. Boston: Houghton Mifflin, 1961.

The Art and Mind of Victorian England. Minneapolis: University of Minnesota, 1974. [exhibition catalogue]

Ash, Russell. *James Tissot*. New York: Abrams, 1992.

August, Eugene R. ' "Modern Men", or, Men's Studies in the 80s', *College English* **44** (October 1982), 583–597.

Baden-Powell, Robert. *Rovering to Success*. London: Herbert Jenkins, 1922.

Baden-Powell, Robert. *Scouting for Boys* (1908). London: Pearson, 1928.

Baden-Powell, Robert. *Aids to Scoutmastership* (1920). London: Jenkins, 1949.

Baker, Malcolm. 'A Victorian Collector of Armour: Sir Joseph Noel Paton', *Country Life*, 25 January 1973, 323–336.

Baldry, A.L. *Hubert von Herkomer*. London: Bell, 1901.

Banham, Joanna and Jennifer Harris, eds. *William Morris and the Middle Ages*. Manchester: University of Manchester Press, 1984.

Bann, Stephen. 'Image, Text, and Object in the Formation of Historial Consciousness', in *The New Historicism*, ed. H. Aram Veeser. New York: Routledge, 1989, 102–115.

Barker–Benfield, Ben. 'The Spermatic Economy: A Nineteenth-Century View of Sexuality', in *The American Family in Social-Historical Perspective*, ed. Michael Gordon. New York: St. Martin's, 1973, 336–421.

Barrington, Emilie. *The Life, Letters and Work of Frederic Leighton*. 2 vols. New York: Macmillan, 1906.

Barthes, Roland. *The Fashion System [Système de la Mode]*. Trans. by Matthew Ward and Richard Howard. New York: Farrar, Strauss and Giroux, 1983.

Barthorp, Michael. *War on the Nile*. London: Blandford Press, 1984.

Baumli, Francis, ed. *Men Freeing Men*. Jersey City: New Atlantis Press, 1985.

Beattie, Susan. *The New Sculpture*. New Haven: Yale University Press, 1983.

Bell, Donald H. 'Up from Patriarchy: The Male Role in Historical Perspective', in *Men in Difficult Times*, ed. Robert A. Lewis. Englewood Cliffs, New Jersey: Prentice-Hall, 1981.

Berger, John. *Ways of Seeing*. Harmondsworth: Penguin, 1972.

Berman, Patricia G. 'Body and body politic in Edvard Munch's *Bathing Men*', in *The Body Imaged*, ed. Kathleen Adler. Cambridge: Cambridge University Press, 1993, 71–83.

Bernheimer, Charles. 'Penile Reference in Phallic Theory', *differences* 4 (Spring 1992), 116–132.

Best, Geoffrey. 'Militarism and the Victorian Public School', in *The Victorian Public School*, eds. Brian Simon *et al*. Dublin: Gill and Macmillan, 1975, 129–146.

Bhabha, Homi K. 'The Other Question: The Stereotype and Colonial Discourse', *Screen* 23 (December 1983), 18–36.

Biddiss, Michael D., ed. *Images of Race*. Leicester: Leicester University Press, 1979.

Black, Clementina. *Frederick Walker*. London: Duckworth, 1902.

Blackburn, Henry. *Academy Notes*. London: Chatto and Windus, 1875–1894.

Blackburn, Henry. *Grosvenor Notes*. London: Chatto and Windus, 1880–1889.

Bloom, Lisa. *Gender on Ice*. Minneapolis: University of Minnesota Press, 1993.

Board, Marilyn L. 'Art's Moral Mission: Reading G.F. Watts' *Sir Galahad*.' In *The Arthurian Revival*, ed. Debra N. Mancoff. New York: Garland, 1992, pp. 132–154.

Bond, Brian, ed. *Victorian Military Campaigns*. London: Hutchinson, 1967.

Brantlinger, Patrick. *Rule of Darkness*. Ithaca: Cornell University Press, 1988.

Bristow, Joseph. *Empire Boys*. London: HarperCollins, 1991.

Brittan, Arthur. *Masculinity and Power*. Oxford, England: Blackwell, 1989.

Brod, Harry, ed. *The Making of Masculinities*. Boston: Allen and Unwin, 1987.

Brod, Harry. 'The New Men's Studies: From Feminist Theory to Gender Scholarship', *Hypatia* 2 (Winter 1987), 179–196.

Brontë, Emily. *Wuthering Heights*, eds. Hilda Marsden and Ian Jack. Oxford: Clarendon, 1976.

Brown, Ted. 'Casting a Little More Light upon Isandlwana', *Soldiers of the Queen* 56/57 (June 1989), 13–15.

Bullen, J.B., ed. *The Sun Is God*. New York: Oxford, 1989.

Bump, Jerome. 'Hopkins' Drawings', in *All My Eyes See*, ed. R.K.R. Thornton. Sunderland: Sunderland Arts Centre, 1975. [exhibition catalogue]

Burne-Jones, Georgiana. *Memorials of Edward Burne-Jones.* 2 vols. London: Macmillan, 1904.

Burne-Jones and His Followers. Tokyo: Isetan Museum of Art, 1987. [exhibition catalogue]

Butler, William F. *Far Out: Rovings Retold.* London: Isbister, 1881.

Butler, William F. *The Campaign of the Cataracts.* London: Sampson Low, 1887.

Carlyle, Thomas. *On Heroes, Hero-Worship, and the Heroic in History.* London: Dent, 1967.

Carlyle, Thomas. *The Nigger Question.* New York: Appleton-Century-Crofts, 1971.

Carrigan, Tim, Bob Connell and John Lee. 'Toward a New Sociology of Masculinity', in *The Making of Masculinities*, ed. Harry Brod. Boston: Allen and Unwin, 1987, 63–100.

Casteras, Susan P., *The Substance or the Shadow.* New Haven: Yale Center for British Art, 1982. [exhibition catalogue]

Casteras, Susan P. 'Victorian Images of Emigration Themes', *Journal of Pre-Raphaelite Studies* **6** (1985), 1–24.

Casteras, Susan P. *Victorian Childhood.* New York: Abrams, 1986.

Casteras, Susan P. *Images of Victorian Womanhood in English Art.* Rutherford, New Jersey: Fairleigh Dickinson University Press, 1987.

Casteras, Susan P. and Ronald Parkinson. *Richard Redgrave.* New Haven: Yale University Press, 1988a. [exhibition catalogue]

Casteras, Susan P. *Virtue Rewarded.* Louisville: Speed Art Museum, 1988b. [exhibition catalogue]

Casteras, Susan P. 'Excluding Women: The Cult of the Male Genius in Victorian Painting', in *Rewriting the Victorians*, ed. Linda M. Shires. London: Routledge, 1992, 116–146.

Chapman, David. *Adonis: The Male Physique Pin-up 1870–1940.* London: Gay Men's Press, 1989.

Chesney, Kellow. *The Victorian Underworld.* New York: Schocken, 1972.

Christ, Carol. 'Victorian Masculinity and the Angel in the House', in *A Widening Sphere*, ed. Martha Vicinus. Bloomington: Indiana University Press, 1977, 146–162.

Cohan, Steven and Ina Rae Hark, eds. *Screening the Male.* London: Routledge, 1993.

Cohen, Ed. 'The Double Lives of Man', *Victorian Studies* **36** (Spring 1993), 353–376.

Cohen, Ed. 'Ma(r)king Men', *Victorian Studies* **36** (Winter 1993), 215–221.

Coleman, D.C. 'Gentlemen and Players', *Economic History Review* **26** (1973), 92–116.

Cominos, Peter T. 'Late-Victorian Sexual Respectability and the Social System', *International Review of Social History* 8 (1962), 18–48, 216–250.

Connell, R.W. *Gender and Power.* Oxford: Polity Press, 1987.

Cook, Pam. 'Masculinity in Crisis?' *Screen* **23** (1982), 39–46.

Cooper, Emmanuel. *The Sexual Perspective: Homosexuality and Art in the Last 100 Years in the West.* London: Routledge and Kegan Paul, 1986.

Cooper, Emmanuel. *The Life and Work of Henry Scott Tuke.* London: Gay Men's Press, 1987.

Cordingly, David. 'The Stonebreaker: An Examination of the Landscape in a Painting by John Brett'. *Burlington Magazine* **125** (1982), 141–145.

Courtney, W.L. *Hubert Herkomer.* London: Art Journal Office, 1892.

Craig, Steve, ed. *Men, Masculinity and the Media.* London: Sage, 1992.

Crane, Walter. *An Artist's Reminiscences.* New York: Macmillan, 1907.

Crompton, Louis. *Byron and Greek Love*. Berkeley: University of California Press, 1985.

Crow, Thomas. 'A Male Republic: Bonds Between Men in the Art and Life of Jacques-Louis David', in *Femininity and Masculinity in Eighteenth-century Art and Culture*, ed. Gill Perry and Michael Rossington. Manchester: Manchester University Press, 1994, 204–218.

Dafforne, James. 'The Works of Edward J. Poynter', *The Art Journal* (1877), 17–19.

Darby, Elisabeth and Nicola Smith. *The Cult of the Prince Consort*. New Haven: Yale University Press, 1983.

Dawson, Graham. 'The Blond Bedouin', in *Manful Assertions*, eds. Michael Roper and John Tosh. London: Routledge, 1991, 113–144.

De Cosson, E.A. *Fighting the Fuzzy-Wuzzy* [1886]. London: Greenhill, 1990.

de Genevieve, Barbara. 'Masculinity and its Discontents'. *Camerawork* 18 (Summer/Fall 1991) 3–5.

Dellamora, Richard. 'Male Relations in Thomas Hardy's *Jude the Obscure*', *Papers on Language and Literature* 27 (Fall 1991), 453–472.

Dibdin, E. Rimbault. *Frank Dicksee: His Life and Work*. London: Virtue, 1905.

Dicksee, Frank. *Discourse . . . to the Students of the Royal Academy on the Distribution of the Prizes*. London: Clowes, 1925.

Dicksee, Frank. *Discourse . . . to the Students of the Royal Academy on the Distribution of the Prizes*. London: Clowes, 1927.

Dicksee, Frank. 'Letters', Manchester: City Art Gallery Archives. [unpublished]

Disraeli, Benjamin. *Tancred*. London: Longman, 1906.

Dixon, Annette. '*The Crisis* by Sir Frank Dicksee'. *Gallery Society Bulletin of the National Gallery of Victoria* (September 1987), 8–9.

Dollimore, Jonathan. 'Homophobia and Sexual Difference', *Oxford Literary Review* 8 (1986), 5–12.

Dover, Kenneth J. *Greek Homosexuality*. Cambridge, Massachusetts: Harvard University Press, 1978.

Doyle, James A. *The Male Experience*. Dubuque, Iowa: Wm C. Brown, 1989.

Droogleever, R.W.F. 'Charles Fripp and "the Battle of Isandhlwana" ', *Soldiers of the Queen* 70 (September 1992), 5.

Dyer, Richard. 'Don't Look Now', *Screen* 23 (1982), 61–73.

Dyer, Richard. *The Matter of Images*. London: Routledge, 1993.

Easthope, Anthony. *What a Man's Gotta Do*. Boston: Unwin Hyman, 1990.

Edelstein, Teri J. 'But Who Shall Paint the Griefs of Those Oppress'd?' The Social Theme in Victorian Painting. Diss., University of Pennsylvania, 1979.

Edelstein, Teri J. 'They Sang "The Song of the Shirt": The Visual Iconology of the Victorian Seamstress', *Victorian Studies* 23 (Winter 1980), 183–210.

Edwards, Lee M. 'The Heroic Worker and Hubert von Herkomer's *On Strike*', *Arts Magazine* (September 1987), 29–35.

Eliade, Mircea. *Rites and Symbols of Initiation*. New York: Harper, 1958.

Ellenzweig, Allen. *The Homoerotic Photograph*. New York: Columbia University Press, 1992.

Empires Restored, Elysium Revisited: The Art of Sir Lawrence Alma-Tadema. Williamstown, Massachusetts: Clark Art Institute, 1991. [exhibition catalogue]

England, Raimond M. and Andrew S. Gardiner. 'Isandlwana, 22nd January 1879: Further Observations on Colonel Durnford's No 2 Column', *Soldiers of the Queen* 65 (June 1991), 24–27.

Farr, Dennis. *William Etty*. London: Routledge and Kegan Paul, 1958.

Farrell, Warren. *The Liberated Man*. New York: Random House, 1973.

Farwell, Byron. *Queen Victoria's Little Wars*. New York: Norton, 1973.

Fasteau, Marc Feigen. *The Male Machine*. New York: McGraw-Hill, 1974.

Faverty, Frederic E. *Matthew Arnold the Ethnologist*. New York: AMS, 1968.

Fee, Elizabeth. 'The Sexual Politics of Victorian Social Anthropology', *Feminist Studies* **1** (1973), 23–39.

Fildes, L. V. *Luke Fildes, R. A.* London: Michael Joseph, 1968.

Forbes, Christopher. *The Art and Mind of Victorian England*. Minneapolis: University of Minnesota Gallery, 1974. [exhibition catalogue]

Forbes, Christopher. *The Royal Academy Revisited*. New York: White Brothers, 1975. [exhibition catalogue]

Ford Madox Brown. Liverpool, Walker Art Gallery, 1964. [exhibition catalogue]

Foster, Alasdair and Roberta McGrath. *Behold the Man: The Male Nude in Photography*. Edinburgh: Stills Gallery, 1988.

Foster, Hal, ed. *Vision and Visuality*. Seattle: Bay Press, 1988.

Foucault, Michel. *The History of Sexuality: An Introduction*. New York: Vintage, 1990.

Fox, Greer L. ' "Nice Girl": Social Control of Women through a Value Construct', *Signs* **2** (Summer 1977), 805–817.

Free, Renée. *Victorian Social Conscience*. Art Gallery of New South Wales, 1976. [exhibition catalogue]

Freud, Sigmund. 'A Special Type of Choice of Object Made by Men', in *The Standard Edition*, Vol. 11. London: Hogarth Press, 1957a.

Freud, Sigmund. 'Medusa's Head', in *The Standard Edition*, Vol. 18. London: Hogarth Press, 1957b.

Fripp, Charles E. 'Reminiscences of the Zulu War, 1879', *Pall Mall Magazine* **20** (1900), 547–562.

Fussell, Paul. *The Great War and Modern Memory*. New York: Oxford University Press, 1975.

Gallop, Jane. *Thinking Through the Body*. New York: Columbia University Press, 1988.

Gardiner, James. *A Class Apart*. London: Serpent's Tail Press, 1992.

Gates, Henry Louis, ed. *'Race,' Writing, and Difference*. Chicago: University of Chicago Press, 1986.

Gaunt, William and F. Gordon Roe. *Etty and the Nude*. Leigh-on-Sea, Essex: F. Lewis, 1943.

Gerdts, William H. *The Great American Nude*. New York: Praeger, 1974.

Gerzon, Mark. *A Choice of Heroes*. Boston: Houghton Mifflin, 1982.

Gilbert, W. Matthews. 'Robert Gibb', *The Art Journal* (1897), 25–28.

Gillett, Paula. *Worlds of Art*. New Brunswick: Rutgers University Press, 1990.

Gill, Michael. *Image of the Body: Aspects of the Nude*. New York, Doubleday, 1989.

Gilmore, David D. *Manhood in the Making: Cultural Concepts of Masculinity*. New Haven: Yale University Press, 1990.

Girouard, Mark. *The Return to Camelot: Chivalry and the English Gentlemen*. New Haven: Yale University Press, 1981.

Gitter, Elisabeth G. 'The Power of Women's Hair in the Victorian Imagination', *PMLA* **99** (October 1984), 936–954.

Goldberg, Herb. *The Hazards of Being Male*. New York: New American Library, 1976.

Goldberg, Herb. *The New Male*. New York: Signet, 1980.

Gordon, Michael. 'The Ideal Husband as Depicted in the Nineteenth Century Marriage Manual', *Family Coordinator* (July 1969), 226–231.

Goux, Jean-Joseph. 'The Phallus: Masculine Identity and the "Exchange of Women" ', *differences* **4** (Spring 1992), 40–75.

Graves, Algernon. *The Royal Academy of Arts*. 8 vols. New York: Burt Franklin, 1972. [originally 1905–1906]

Graves, Robert. *The Greek Myths*. 2 vols. Baltimore: Penguin, 1955.

Greg, William R. 'Why Are Women Redundant?' *Literary and Social Judgments*. Boston: Osgood, 1873.

Grosvenor Notes. London: Chatto and Windus, 1880–1889.

Guttman, Jon. 'Proud Regiments Routed', *Military History* **9** (October 1992), 58–65.

Hadfield, John. *Every Picture Tells a Story*. London: Herbert Press, 1985.

Haggard, H. Rider. *King Solomon's Mines* (1885). New York: Oxford, 1989.

Hall, Lesley A. *Hidden Anxieties: Male Sexuality, 1900–1950*. Cambridge: Polity Press, 1991.

Haller, John S. and Robin M. *The Physician and Sexuality in Victorian America*. New York: Norton, 1974.

Halperin, David M. *One Hundred Years of Homosexuality*. New York: Routledge, 1990.

Hamilton-Paterson, James. *The Great Deep*. New York: Random House, 1992.

Hanham, H.J. 'Mid-century Scottish Nationalism: Romantic and Radical', in *Ideas and Institutions of Victorian Britain*, ed. Robert Robson. London: Bell, 1967.

Hantover, Jeffrey P. 'The Social Construction of Masculine Anxiety', in *Men in Difficult Times*, ed. Robert A. Lewis. Englewood Cliffs, New Jersey: Prentice-Hall, 1981, 87–97.

Harbottle, T.B. *Dictionary of Battles*. New York: Van Nostrand, 1971.

Hard Times: Social Realism in Victorian Art. Catalogue by Julian Treuherz *et al*. Manchester City Art Gallery/Yale Center for British Art, 1987–1988. [exhibition catalogue]

Hardie, Martin. *John Pettie*. London: Adam and Charles Black, 1908.

Hardie, William. *Sir William Quiller Orchardson*. Edinburgh: Royal Scottish Academy, 1972. [exhibition catalogue]

Hardy, Thomas. *Jude the Obscure*, ed. Irving Howe. Boston: Houghton Mifflin, 1965.

Harrington, Peter. 'The Man Who Painted *The Thin Red Line*', *The Scots Magazine* **130** (March 1989), 587–595.

Harrington, Peter. 'The Defence of Kars', *Journal of the Society for Army Historical Research* **69** (Spring 1991), 22–28.

Harrington, Peter. *British Artists and War: The Face of Battle in Paintings and Prints, 1700–1914*. London: Greenhill Books, 1993.

Harrison, Brian. 'Underneath the Victorians', *Victorian Studies* **10** (March 1967), 239–262.

Harrison, Martin and Bill Waters. *Burne-Jones*. London: Barrie and Jenkins, 1973.

Hatt, Michael. ' "Making a Man of Him": Masculinity and the Black Body in Mid-Nineteenth-Century American Sculpture', *Oxford Art Journal* **15**, No. 1 (1992), 21–35.

Hatt, Michael. 'The Male Body in Another Frame: Thomas Eakins' *The Swimming Hole* as a Homoerotic Image', in *The Body*, ed. Andrew Benjamin. London: Academy, 1993a, 8–21.

Hatt, Michael. 'Muscles, Morals, Mind: The Male Body in Thomas Eakins' *Salutat*', in *The Body Imaged*, ed. Kathleen Adler and Marcia Pointon. Cambridge: Cambridge University Press, 1993b, 57–69.

Hays H.R. *The Dangerous Sex: The Myth of Feminine Evil*. New York: Putnam, 1964.

Hearn, Jeff and David Morgan, eds. *Men, Masculinities and Social Theory*. London: Unwin Hyman, 1990.

Sir Hubert von Herkomer. Landsberg: Neues Stadtmuseum, 1988. [exhibition catalogue]

Hersey, G.L. 'Aryanism in Victorian England', *Yale Review* **66** (Autumn 1976), 104–113.

Hichberger, J.W.M. *Images of the Army*. Manchester: Manchester University Press, 1988.

Hichberger, J.W.M. 'Old Soldiers', in *Patriotism*, vol. III, ed. Raphael Samuel. London: Routledge, 1989, 50–63.

Hobson, Anthony. *The Art and Life of J.W. Waterhouse*. London: Studio Vista, 1980.

Hobson, Anthony. *J.W. Waterhouse*. Oxford: Phaidon-Christie's, 1989.

Hodgson, Pat. *The War Illustrators*. New York: Macmillan, 1977.

Honey, J.R. *Tom Brown's Universe*. New York: Quadrangle, 1977.

Hopkins, Gerard Manley. *The Correspondence of G. Manley Hopkins and Richard Watson Dixon*, ed. C.G. Abbot. London: Oxford University Press, 1935.

Hopkins, Gerard Manley. *Poems and Prose*, ed. W.H. Gardner. Harmondsworth: Penguin, 1953.

Horsman, Reginald. 'Origins of Racial Anglo-Saxonism in Great Britain before 1850', *Journal of the History of Ideas* **37** (July–September 1976), 387–410.

Houghton, Walter E. *The Victorian Frame of Mind*. New Haven: Yale University Press, 1957.

Hughes, Thomas. *The Manliness of Christ*, with 'An Address, Delivered at Clifton College'. New York: Alden, 1879.

Hunt, John Dixon. *The Pre-Raphaelite Imagination*. London: Routledge and Kegan Paul, 1968.

Inglis, Alison. 'Sir Edward Poynter and the Earl of Wharncliffe's Billiard Room', *Apollo* (October 1987), 249–255.

Jackson, David. *Unmasking Masculinity*. London: Unwin Hyman, 1990.

Jackson, Graham. *The Secret Lore of Gardening: Patterns of Male Intimacy*. Toronto: Inner City Books, 1991.

James, Louis. 'Tom Brown's Imperialist Sons', *Victorian Studies* **17** (September 1973), 89–99.

Jeal, Tim. *Baden-Powell*. London: Hutchinson, 1989.

Jeffords, Susan. 'Can Masculinity be Terminated?' in *Screening the Male*, eds. Steven Cohan and Ina Rae Hark. London: Routledge, 1993, 245–262.

Jenkyns, Richard. *The Victorians and Ancient Greece*. Cambridge, Massachusetts: Harvard University Press, 1980.

Jenkyns, Richard. *Dignity and Decadence: Victorian Art and the Classical Inheritance*. London: HarperCollins, 1991.

Johnson, A.E. *Dudley Hardy*. London: Adam and Charles Black, 1909.

Johnson, D.H. 'The Death of Gordon: A Victorian Myth', *Journal of Imperial and Commonwealth History* **10** (May 1982), 285–310.

Johnson, Don. 'The Loneliness of the Male Body', *American Health* (January/February 1989), 62–63.

Jones, Stephen. 'Attic Attitudes'. *History Today* **37** (June 1987), 31–37.

Joy, George W. *Autobiographical Sketch*, in *The Work of George W. Joy*. London: Cassell, 1904.

Jung, C.G. *Aspects of the Masculine*. London: Routledge, 1989.

Kains-Jackson, Charles. 'H.S. Tuke', *Magazine of Art* **26** (1902), 337–343.

Kaplan, E. Ann. *Women and Film: Both Sides of the Camera*. New York: Methuen, 1983.

Keen, Maurice. *Chivalry*. New Haven: Yale University Press, 1984.

Kemp, Martin. 'Some Reflections on Watery Metaphors in Winckelmann, David and Ingres', *Burlington Magazine* **110** (May 1968), 268–270.

Kent, Sarah and J. Morreau, eds. *Women's Images of Men*. London: Writers and Readers Publishing, 1985.

Kershner, R. Brandon. 'The World's Strongest Man: Joyce or Sandow?' *James Joyce Quarterly* **31** (Fall 1993), 667–693.

Kestner, Joseph A. 'Romantic Rebel: Wagner's Tannhäuser', *Opera News* **47** (January 1983), 16–19.

Kestner, Joseph A. 'Edward Burne-Jones and Nineteenth-Century Fear of Women', *Biography* **7** (Spring 1984), 95–122.

Kestner, Joseph A. 'The Perseus Legend and the Mythology of "Rescue" in Nineteenth-Century British Art', *Victorians Institute Journal* **15** (1987), 55–70.

Kestner, Joseph A. *Mythology and Misogyny: The Social Discourse of Nineteenth Century British Classical-Subject Painting*. Madison: University of Wisconsin Press, 1989a.

Kestner, Joseph A. 'Poynter and Leighton as Aestheticians', *Journal of Pre-Raphaelite and Aesthetic Studies* **2** (Spring 1989), 108–120.

Kestner, Joseph A. 'The Solar Theory and Female Oppression in Nineteenth-Century British Art', *Victorians Institute Journal* **17** (1989b), 105–124.

Kestner, Joseph A. 'The Male Gaze in the Art of Frank Dicksee', *Annals of Scholarship* **7** (1990), 181–202.

Kestner, Joseph A. 'Before *Ulysses*: Victorian Iconography of the Odysseus Myth', *James Joyce Quarterly* **28** (Spring 1991), 565–594.

Kestner, Joseph A. 'The Dark Side of Chivalry', *Opera News* (March 3 1991), 18–21, 44.

Kestner, Joseph A. 'Constructing the Renaissance: Leighton and Pater', *Journal of Pre-Raphaelite and Aesthetic Studies* NS II (Spring 1993), 1–15.

Kestner, Joseph A. 'The Representation of Armour and the Construction of Masculinity in Victorian Painting', *Nineteenth Century Studies* **7** (1993), 1–28.

Kestner, Joseph A. 'Youth by the Sea: the Ephebe in *Portrait* and *Ulysses*', *James Joyce Quarterly* **31** (Spring 1994), 233–276.

Kestner, Joseph A. 'The Pre-Raphaelites and Imperialism: John Everett Millais's *Pizarro, The Boyhood of Raleigh* and *The North-West Passage*', *Journal of Pre-Raphaelite Studies* NS IV (Spring 1995).

Keuls, Eva C. *The Reign of the Phallus*. New York: Harper & Row, 1985.

Kimmel, Michael S. *Changing Men: New Directions in Research on Men and Masculinity*. Newbury Park, California: Sage, 1987.

Kimmel, Michael S. and Michael A. Messner. *Men's Lives*. New York: Macmillan, 1992.

Kingsley, Charles. *The Heroes*. London: Blackie and Son, 1855.

Kingsley, Charles. *The Roman and the Teuton*. London: Macmillan, 1881.

Kinsey, Alfred C. *Sexual Behavior in the Human Male*. Philadelphia: Saunders, 1948.

Kipnis, Aaron R. *Knights Without Armor*. New York: Putnam, 1991.

Knight, Ian. J. 'R.T. Moynan's Painting "The Last of the 24th Isandlwana"', *Journal of the Society for Army Historical Research* (Autumn 1988), 155–156.

Knight, Ian J. ed. *There Will Be an Awful Row at Home about This*. Shoreham-by-Sea, Sussex: Zulu Study Group, Victorian Military Society, 1987.

Knight, Ian J. *Zulu*. London: Windrow & Greene, 1992.

Knight, Vivien *et al.*, eds. *The City's Pictures*. London: Barbican Art Gallery, 1984. [exhibition catalogue]

Komarovsky, Mirra. *Dilemmas of Masculinity*. New York: Norton, 1976.

Kris, Ernst and Otto Kurz. *Legend, Myth, and Magic in the Image of the Artist*. New Haven: Yale University Press, 1979.

Krutnik, Frank. *In a Lonely Street: Film Noir, Genre, Masculinity*. London: Routledge, 1991.

Lacan, Jacques. *The Four Fundamental Concepts of Psycho-Analysis*. New York: Norton, 1978.

Lacan, Jacques. *Feminine Sexuality*. New York: Norton, 1985.

Ladies of Shalott: A Victorian Masterpiece and Its Contexts. Providence, Rhode Island: Brown University, 1985. [exhibition catalogue]

Lady Butler, Battle Artist. London: National Army Museum, 1987. [exhibition catalogue]

Lago, Mary. *Burne-Jones Talking*. Columbia: University of Missouri Press, 1981.

Lalumia, Matthew P. 'Realism and Anti-Aristocratic Sentiment in Victorian Depictions of the Crimean War', *Victorian Studies* **27** (Autumn, 1983), 25–51.

Lalumia, Matthew P. *Realism and Politics in Victorian Art of the Crimea War*. Ann Arbor, Michigan: UMI Reasearch Press, 1984.

Lambourne, Lionel. 'Sir Edward Landseer's *The Stonebreaker and His Daughter*', *Masterpieces No. 17*. London: Victoria and Albert Museum, 1978.

Laqueur, Thomas. 'Orgasm, Generation, and the Politics of Reproductive Biology', in *The Making of the Modern Body*, eds. Catherine Gallagher and Thomas Laqueur. Berkeley: University of California Press, 1987, 1–41.

Laqueur, Thomas. *Making Sex: Body and Gender from the Greeks to Freud*. Cambridge, Massachusetts: Harvard University Press, 1990.

Laqueur, Thomas W. 'Sexual Desire and the Market Economy During the Industrial Revolution', in *Discourses of Sexuality*, ed. Domna C. Stanton. Ann Arbor: University of Michigan Press, 1992, 185–215.

Lascelles, Helen. *Sir William B. Richmond*. London: Art Journal Office, 1902.

Leclaire, Serge. 'Sexuality: A Fact of Discourse', in *Homosexualities and French Literature*, ed. George Stambolian. Ithaca: Cornell University Press, 1979, 42–55.

Lehman, Peter. '*In the Realm of the Senses*: Desire, Power, and the Representation of the Male Body', *Genders* **2** (Summer 1988), 91–110.

Lehman, Peter. 'Penis-size Jokes and Their Relation to Hollywood's Unconscious', in *Comedy/Cinema/Theory*, ed. Andrew S. Horton. Berkeley: University of California Press, 1991, 43–59.

Lehman, Peter. *Running Scared: Masculinity and Representation of the Male Body*. Philadelphia: Temple University Press, 1993.

Leighton, Frederic. *Addresses Delivered to the Students of the Royal Academy*. London: Kegan Paul, Trench, 1896.

Leiris, Michel. *Manhood*. Chicago: University of Chicago Press, 1984.

Lenfest, David. *Men Speak Out*. Deerfield Beach, Florida: Health Communications, Inc., 1991.

Levinson, Daniel J. *The Seasons of a Man's Life*. New York: Ballantine, 1978.

Lewis, Robert A., ed. *Men in Difficult Times: Masculinity Today and Tomorrow*. Englewood Cliffs, New Jersey: Prentice-Hall, 1981.

Lloyd, Christopher, ed. *The Queen's Pictures*. London: National Gallery, 1991. [exhibition catalogue]

Löcher, Kurt. *Der Perseus-Zyklus von Edward Burne-Jones*. Stuttgart: Staatsgalerie Stuttgart, 1973.

London, Bette. 'Mary Shelley, *Frankenstein*, and the Spectacle of Masculinity', *PMLA* **108** (March 1993), 253–266.

Lucie-Smith, Edward. *Eroticism in Western Art*. London: Thames and Hudson, 1972.

Lucie-Smith, Edward. *The Body*. London: Thames and Hudson, 1981.

Lucie-Smith, Edward. *Fully Exposed: The Male in Nude Photography*. London: Unwin, Hyman, 1989a.

Lucie-Smith, Edward. *Life Class: The Academic Male Nude*. London: Gay Men's Press, 1989b.

Macdonald, John. *Great Battlefields of the World*. New York: Macmillan, 1984.

MacKenzie, John M. 'The Imperial Pioneer and Hunter and the British Masculine

Stereotype in late Victorian and Edwardian Times', in *Manliness and Morality*, eds. J.A. Mangan and James Walvin. New York: St. Martin's, 1987, 176–198.

MacKenzie, John. ed. *Popular Imperialism and the Military 1850–1950*. Manchester: Manchester University Press, 1992.

The Male Nude. Hempstead, New York: The Emily Lowe Gallery, 1973. [exhibition catalogue]

The Male Nude: A Modern View. ed. Edward Lucie-Smith. New York: Rizzoli, 1985. [exhibition catalogue]

The Male Nude: A Survey in Photography. New York: Marcuse Pfeifer Gallery, 1978. [exhibition catalogue]

The Male Nude: Women Regard Men. New York: Hudson Center Galleries, 1986. [exhibition catalogue]

'Male Subjectivity', *differences* 1 (Fall 1989). [special issue]

Malory, Thomas. *Le Morte D'Arthur*. 2 vols. London: Dent, 1906.

Mancoff, Debra N. *The Arthurian Revival in Victorian Art*. New York: Garland, 1990.

Mancoff, Debra N. ' "Albert the Good": Public Image and Private Iconography', *Biography* 15 (Spring 1992), 140–164.

Mancoff, Debra N., ed. *The Arthurian Revival*. New York: Garland, 1992.

Mangan, J.A. and James Walvin, eds. *Manliness and Morality*. Manchester: Manchester University Press, 1987.

Mann, Anthony. 'Looking at the Male', *Framework* **15–17** (1981), 16–20.

Manning, Elfrida. *Marble and Bronze: The Art and Life of Hamo Thornycroft*. London: Trefoil, 1982.

Marcus, Steven. *The Other Victorians*. New York: New American Library, 1964.

Marks, John G. *Life and Letters of Frederick Walker*. London: Macmillan, 1896.

Marriner, Gerald L. 'A Victorian in the Modern World: The "Liberated" Male's Adjustment to the New Woman and the New Morality', *South Atlantic Quarterly* **76** (Spring 1977), 190–203.

The Martial Face. Providence, Rhode Island: Brown University, 1991 [exhibition catalogue]

Martin, Robert B. *Gerard Manley Hopkins*. New York: Putnam, 1991.

Martocci, David, ed. *The Male Nude*. Williamstown, Massachusetts: Sterling and Francine Clark Institute, 1980. [exhibition catalogue]

May, Larry and Robert A. Strikwerda, eds. *Rethinking Masculinity*. Lanham, Maryland: Littlefield Adams, 1992.

McBride, Angus. *The Zulu War*. London: Osprey, 1976.

McGrath, Roberta. 'Looking Hard: The Male Body under Patriarchy', in *Behold the Man: The Male Nude in Photography* by Alasdair Foster. Edinburgh: Sills Gallery, 1988. [exhibition catalogue]

McKerrow, Mary. *The Faeds*. Edinburgh: Canongate, 1982.

Metcalfe, Andy and Martin Humphries, eds. *The Sexuality of Men*. London: Pluto Press, 1985.

Metcalfe, Andy, ed. *The Sexuality of Men*. London: Pluto Books, 1990.

Meyer, Alice. '*The Doctor* by Luke Fildes', *Guthrie Bulletin* **43** (April 1974), 155–169.

Meynall, Wilfrid. 'Frank Holl'. *Magazine of Art* (1880), 187–190.

Middleton, Peter. *The Inward Gaze: Masculinity and Subjectivity in Modern Culture*. London: Routledge, 1992.

Mill, John Stuart. *The Works of John Stuart Mill*. Toronto: University of Toronto Press, 1963.

Mill, John Stuart. *Mill's Ethical Writings*. New York: Collier, 1965.

Mill, John Stuart. *The Subjection of Women*. ed. Alice Rossi. Chicago: University of Chicago Press, 1970.

Mill, John Stuart. *On Liberty*. New York: Norton, 1975.

Millais, John Guille. *The Life and Letters of Sir John Everett Millais*. 2 vols. London: Methuen, 1899.

Millar, Oliver. *The Victorian Pictures in the Collection of Her Majesty the Queen*. 2 vols., Cambridge: Cambridge University Press, 1992.

Mills, J. Saxon. *Life and Letters of Sir Hubert Herkomer*. London: Hutchinson, 1923.

'Modern Man-Haters'. *Saturday Review*, 29 April 1871, 528–529.

Monick, Eugene. *Phallos: Sacred Image of the Masculine*. Toronto: Inner City Books, 1987.

Monick, Eugene. *Castration and Male Rage*. Toronto: Inner City Books, 1991.

Monkhouse, Cosmo. 'Sir Edward John Poynter.' *Art Annual* (1897), 1–32.

Moore, David and Fred Leafgren, eds. *Men in Conflict*. Alexandria, Virginia: American Association for Counseling and Development, 1990.

Morgan, David. *Discovering Men*. London: Routledge, 1991.

Morgan, David. 'Reflection on the Male Body and Masculinities', in *Body Matters: Essays on the Sociology of the Body*, eds. Sue Scott and David Morgan. London: Falmer Press, 1993, 69–88.

Morgan, Thais. 'Reimagining Masculinity in Victorian Criticism: Swinburne and Pater', *Victorian Studies* **36** (Spring 1993), 315–332.

Morris, Donald, R. *The Washing of the Spears*. New York: Simon and Schuster, 1965.

Morris, Edward and Frank Milner. *'And When Did You Last See Your Father?'* Liverpool: Walker Art Gallery, 1992–1993. [exhibition catalogue]

Müller, Max. *Comparative Mythology*. London: Routledge and Sons, 1909.

Mulvey, Laura. 'Afterthoughts', *Framework* **15–17** (1981), 12–15.

Mulvey, Laura. 'Visual Pleasure and Narrative Cinema', in *Film Theory and Criticism*, ed. Gerald Mast. New York: Oxford University Press, 1985, 803–816.

Munich, Adrienne. *Andromeda's Chains*. New York: Columbia University Press, 1989.

Murray, Janet, ed. *Strong-Minded Women*. New York: Pantheon, 1982.

Myers, Bernard. 'Studies for *Houseless and Hungry* and the *Casual Ward* by Luke Fildes', *Apollo* 9 (July 1982), 36–43.

Nardi, Peter M., ed. *Men's Friendships*. London: Sage, 1992.

Nead, Lynda. 'Woman as Temptress', *Leeds Arts Calendar*, no. 91 (1982), 5–20.

Nead, Lynda. *Myths of Sexuality*. Oxford: Basil Blackwell, 1988.

Neale, Steve. 'Masculinity as Spectacle', in *Screening the Male*, eds. Steven Cohan and Ina Rae Hark. London: Routledge, 1993, 9–20.

Nelson, Claudia. 'Sex and the Single Boy: Ideals of Manliness and Sexuality in Victorian Literature for Boys.' *Victorian Studies* **32**. (Summer 1989), 526–550.

Newall, Christopher. *The Art of Lord Leighton*. Oxford: Phaidon, 1990.

Newbolt, Henry. *Selected Poems*, ed. Patric Dickinson. London: Hodder & Stoughton, 1981.

Newsome, David. *Godliness and Good Learning*. London: John Murray, 1961.

Nickel, Helmut. 'Armour in the Italian Renaissance', in *Gloria dell'Arte*. Tulsa, Oklahoma: Philbrook Art Center, 1979, 9–13.

Nochlin, Linda. 'Lost and *Found*: Once More the Fallen Woman', *Art Bulletin* **58** (March 1978), 140–153.

Norris-Newman, Charles L. *In Zululand* [1880]. London: Greenhill, 1988.

'The Nude in Photography', *The Studio* **1** (1893), 104–108.

O'Flaherty, Wendy D. *Women, Androgynes, and Other Mythical Beasts*. Chicago: University of Chicago Press, 1980.

Ogilvie, R.M. *Latin and Greek*. Hamden, Connecticut: Archon, 1969.

Ormond, Leonée and Richard. *Lord Leighton*. New Haven: Yale University Press, 1975.

Orwell, George. 'Such, such were the Joys . . .' and 'Boys' Weeklies', *A Collection of Essays*. New York: Doubleday, 1954.

A Passion for Work: Sir Hubert von Herkomer, Essays by David Setford, Rosemary Treble and Lee Edwards. London: Watford Museum, 1982. [exhibition catalogue]

Pater, Walter. *Greek Studies*. London: Macmillan, 1895.

Pater, Walter. *Plato and Platonism*. London: Macmillan, 1910.

Pater, Walter. *The Renaissance*, ed. Donald Hill. Berkeley: University of California Press, 1980.

Payne, Christiana. *Toil and Plenty*. New Haven: Yale University Press, 1993. [exhibition catalogue]

Pearsall, Ronald. *The Worm in the Bud*. Harmondsworth: Penguin, 1971.

Penley, Constance and Sharon Willis, eds. *Male Trouble*. Minneapolis: University of Minnesota Press, 1993.

Peterson, M. Jeanne. 'Dr. Acton's Enemy: Medicine, Sex, and Society in Victorian England', *Victorian Studies* **29** (Summer 1986), 569–590.

'The Phallus Issue', *differences* **4** (Spring 1992). [special issue]

Phillips, Claude. 'The R. A. Exhibition', *The Academy* (25 May 1895), 449.

Phillips, Claude. *Frederick Walker and His Works*. London: Seeley, 1897.

Phillips, Olga S. *Solomon J. Solomon*. London: Herbert Joseph, 1933.

Plato. *The Symposium*. Trans. W. Hamilton. Baltimore: Penguin, 1951.

Plato. *Timaeus*. Trans. H.D. Lee. Baltimore: Penguin, 1971.

Pleck, Joseph and Jack Sawyer, eds. *Men and Masculinity*. Englewood Cliffs: Prentice-Hall, 1974.

Pleck, Joseph H. *The Myth of Masculinity*. Cambridge, Massachusetts: MIT Press, 1981.

Poliakov, Léon. *The Aryan Myth*. New York: Basic Books, 1971.

Poovey, Mary. 'Exploring Masculinities', *Victorian Studies* **36** (Winter 1993), 223–226.

Porter, David, ed. *Between Men and Feminism*. London: Routledge, 1992.

Powell, Rob. 'Introduction'. *Behold the Man*. Edinburgh: Stills Gallery, 1988.

Poynter, Edward J. *Ten Lectures on Art*. London: Chapman and Hall, 1880.

Praz, Mario. *The Romantic Agony*. New York: Meridian, 1956.

The Pre-Raphaelites. Cambridge, Massachusetts: Fogg Art Museum, 1946. [exhibition catalogue]

The Pre-Raphaelites. London: Tate Gallery/Allen Lane, 1984. [exhibition catalogue]

Pre-Raphaelites: Painters and Patrons in the North East. Newcastle: Laing Art Gallery, 1989. [exhibition catalogue]

Price, Brian D., ed. *The Diary of Henry Scott Tuke*. Falmouth: Royal Cornwall Polytechnic Society, n.d.

Price, Brian D., ed. *Registers of Henry Scott Tuke*. Falmouth: Royal Cornwall Polytechnic Society, 1983a.

Price, Brian D., ed. *Tuke Reminiscences*. Falmouth: Royal Cornwall Polytechnic Society, 1983b.

Pronger, Brian. *The Arena of Masculinity: Sports, Homosexuality, and the Meaning of Sex*. New York: St. Martin's, 1990.

The Queen's Image, ed. Helen Smailes. Edinburgh: Scottish National Portrait Gallery, 1987. [exhibition catalogue]

The Raj, ed. C.A. Bayly. London: National Portrait Gallery, 1990 [exhibition catalogue]

Rancour-Lafarriere, Daniel. *Signs of the Flesh*. Bloomington: Indiana University Press, 1985.

Read, Benedict, *Victorian Sculpture*. New Haven: Yale University Press, 1982.

Reade, Brian, ed. *Sexual Heretics: Male Homosexuality in English Literature from 1850 to 1900*. New York: Coward-McCann, 1970.

Reader, W.J. *'At Duty's Call': A Study in Obsolete Patriotism*. Manchester: Manchester University Press, 1988.

Rees, A.L. and Frances Borzello, eds. *The New Art History*. London: Camden Press, 1986.

Reynolds, A.M. *The Life and Work of Frank Holl*. London: Methuen, 1912.

Richards, Jeffrey. ' "Passing the love of women': manly love and Victorian society', in *Manliness and Morality*, ed. J.A. Mangan and James Walvin. New York: St. Martin's, 1987, 92–122.

Roberts, David. 'The Paterfamilias of the Victorian Governing Classes', in *The Victorian Family*, ed. Anthony Wohl. New York: St. Martin's, 1978, 59–81.

Rodee, Howard D. *Scenes of Rural and Urban Poverty in Victorian Painting and Their Development, 1850 to 1890*. Diss., Columbia University, 1975.

Rodee, Howard D. 'The "Dreary Landscape" as Background for Scenes of Rural Poverty in Victorian Paintings', *Art Journal* 37 (1977), 303–315.

Romanes, George J. 'Mental Differences between Men and Women', *Nineteenth Century* 21(May 1887), 654–672.

Roper, Michael. 'Introduction: Recent Books on Masculinity', *History Workshop* 29 (Spring 1990), 184–187.

Roper, Michael and John Tosh, eds. *Manful Assertions: Masculinities in Britain since 1800*. London: Routledge, 1991.

Rosenthal, Michael. 'Recruiting for the Empire: Baden-Powell's Scout Law', *Raritan* 4 (Summer 1984), 27–47.

Roskill, Mark. *The Interpretation of Pictures*. Amherst: University of Massachusetts Press, 1989.

Ross, Marlon B. 'Romancing the Nation-State: The Poetics of Romantic Nationalism', in *Macropolitics of Nineteenth-Century Literature*, eds. Jonathan Arac and Harriet Ritvo. Philadelphia: University of Pennsylvania Press, 1991, 56–85.

Rossetti, William Michael, ed. *Ruskin: Rossetti: Preraphaelitism*. London: George Allen, 1899.

Rowbotham, Sheila. ' "Commanding the Heart": Edward Carpenter and Friends', *History Today* (September 1987), 41–46.

Royal Academy Pictures. London: Cassell, 1888–1915.

Rural and Urban Naturalism. Santa Fe: Museum of Fine Arts, 1987. [exhibition catalogue]

Ruskin, John. *The Works of John Ruskin*, eds. E.T. Cook and Alexander Wedderburn. 39 vols. London: Allen, 1902–1912.

Rutherford, Jonathan. *Men's Silences: Predicaments in Masculinity*. London: Routledge, 1992.

Said, Edward. *Culture and Imperialism*. New York: Knopf, 1993.

Sainsbury, Maria T. *Henry Scott Tuke*. London: Secker, 1933.

Schindler, Richard A. 'Sir Noel Paton and the Grail Quest: The Arthurian Mythos as Christian Art.' In *The Arthurian Revival*, ed. Debra N. Mancoff. New York: Garland, 1992, 115–121

Schwenger, Peter. 'The Masculine Mode.' In *Speaking of Gender*. Ed. Elaine Showalter. London: Routledge, 1989, 101–112.

Sears, Stephen W., ed. *The Horizon History of the British Empire*. New York: McGraw-Hill, 1973.

Saunders, Gill. *The Nude: A New Perspective*. London: Herbert Press, 1989.

Sebeok, Thomas, ed. *Myth: A Symposium*. Bloomington: Indiana University Press, 1958.

Sedgwick, Eve. *Between Men: English Literature and Male Homosocial Desire*. New York: Columbia University Press, 1985.

Sedgwick, Eve. *Epistemology of the Closet*. Berkeley: University of California Press, 1990.

Seidler, Victor J. *Rediscovering Masculinity*. London: Routledge, 1989.

Seidler, Victor J. *Recreating Sexual Politics*. London: Routledge, 1991.

Seidler, Victor J., ed. *The Achilles Heel Reader*. London: Routledge, 1991.

Seidler, Victor J., ed. *Men, Sex and Relationships*. London: Routledge, 1992.

Seidler, Victor J. *Unreasonable Men: Masculinity and Social Theory*. London: Routledge, 1994.

Sergent, Bernard. *Homosexuality in Greek Myth*. Boston: Beacon Press, 1984.

'Sexuality in Greek and Roman Society', *differences* **2** (Spring 1990). [special issue]

Shelley, Percy Bysshe *The Complete Poetical Works*. London: Oxford, 1961.

Silverman, Kaja. 'The Lacanian Phallus', *differences* **4** (Spring 1992), 84–115.

Silverman, Kaja. *Male Subjectivity at the Margins*. London: Routledge, 1992.

Simon, Brian and Ian Bradley, eds. *The Victorian Public School*. Dublin: Gill and Macmillan, 1975.

Skelley, Alan Ramsay. *The Victorian Army at Home*. Montreal: Queen's University Press, 1977.

Smith, F. Barry. 'Sexuality in Britain, 1800–1900: Some Suggested Revisions', in *A Widening Sphere*, ed. Martha Vicinus. Bloomington: Indiana University Press, 1977, 182–198.

Smith, Paul. 'Vas', *Camera Obscura* **17** (1988), 89–111.

Smith, Timothy d'Arch. *Love in Earnest*. London: Routledge and Kegan Paul, 1970.

Snow, Edward. 'Theorizing the Male Gaze: Some Problems', *Representations* **25** (1989), 30–41.

Sons & Others: Women Artists See Men. Flushing Meadow, New York: The Queens Museum, 1975. [exhibition catalogue]

Spencer, Herbert. *The Study of Sociology*. Ann Arbor: University of Michigan Press, 1961.

Spencer-Smith, Jenny and Paul Usherwood. *Lady Butler: Battle Artist*. London: Alan Sutton/National Army Museum, 1987. [exhibition catalogue]

Spencer-Smith, Jenny. 'Henry Nelson O'Neil's *Home Again*', *National Army Museum Year Book* **1** (1991), 29–30.

Spiers, Edward M. *The Army and Society 1815–1914*. London: Longman, 1980.

Sprawson, Charles. *Haunts of the Black Masseur: The Swimmer as Hero*. New York: Pantheon, 1992.

Springhall, John. ' "Up Guards and at Them!": British Imperialism and Popular Art, 1880–1914.' In *Imperialism and Popular Culture*, ed. John M. MacKenzie. Manchester: Manchester University Press, 1986, pp. 49–72.

Stall, Sylvanus. *What a Young Man Ought to Know*. London: Vir Publishing Company, 1904.

Stanton, Domna C., ed. *Discourses of Sexuality*. Ann Arbor: University of Michigan Press, 1992.

Stearn, Roger T. 'War and the Media in the 19th Century', *RUSI* **131** (September 1986), 55–61.

Stearn, Roger T. *War Images and Image Makers in the Victorian Era*. London: King's College, University of London, 1987. [unpublished PhD thesis]

Stearns, Peter N. *Be a Man! Males in Modern Society*. New York: Holmes & Meier, 1990.

Steevens, G.W. *With Kitchener to Khartoum* [1898]. London: Greenhill Books, 1990.

Stephenson, Andrew. 'Visualising Masculinities', introduction to *Visualising Masculinities*. London: The Tate Gallery, December 1992–June 1993, n.p. [exhibition brochure]

Stirling, A.M.W. *The Richmond Papers*. London: Heinemann, 1926.

Stone, Brian. 'Models of Kingship: Arthur in Medieval Romance', *History Today* **37** (November 1987), 32–38.

Storey, Gladys. *All Sorts of People*. London: Methuen, 1929.

Strage, Mark. *The Durable Fig Leaf*. New York: Morrow, 1980.

Strong, Roy. *Recreating the Past: British History and the Victorian Painter*. London: Thames and Hudson, 1978.

The Substance or the Shadow: Images of Victorian Womanhood. Catalogue by Susan P. Casteras. Yale Center for British Art, 1982. [exhibition catalogue]

Sussman, Herbert. 'Robert Browning's "Fra Lippo Lippi" and the Problematic of a Male Poetic', *Victorian Studies* **35** (Winter 1992), 185–200.

Sussman, Herbert. 'The Study of Victorian Masculinities'. *Victorian Literature and Culture* 20 (1992), 366–377.

Swinburne, Algernon. *Essays and Studies*. London: Chatto and Windus, 1876.

Taylor, John R. 'H.S. Tuke – Grand Old Man of the Sea.' *Art & Antiques Weekly* (July 25–31, 1980), pp. 23–24.

Theweleit, Klaus. *Male Fantasies*, volume 1. Trans. by Stephen Conway. Minneapolis: University of Minnesota Press, 1987.

Theweleit, Klaus. *Male Fantasies*, volume 2. Trans. by Erica Carter and Chris Turner. Minneapolis: University of Minnesota Press, 1989.

Thomas, Keith. 'The Double Standard', *Journal of the History of Ideas* **20** (1959), 195–216.

Thompson, Keith, ed. *To Be a Man*. Los Angeles: Tarcher, 1991.

Thomson, David C. *Life and Work of Luke Fildes*. London: Art Journal Office, 1895.

Tiger, Lionel. *Men in Groups*. New York: Random House, 1969.

Toilers of the Fields: Nineteenth-Century Paintings of Rural Life in Britain. Wolverhampton: Wolverhampton Art Gallery, 1979.

Tolson, Andrew. *The Limits of Masculinity*. New York: Harper, 1977.

Tosh, John. 'Domesticity and Manliness in the Victorian Middle Class', in *Manful Assertions*, eds. Michael Roper and John Tosh. London: Routledge, 1991, 44–73.

Tremain, Rose. 'Votes for Women', *British History Illustrated* **4** (November 1977, January, March 1978), 8–22, 16–29, 40–53.

Treuherz, Julian. *Hard Times*. London: Lund Humphries, 1987. [exhibition catalogue]

Trevor-Roper, Hugh. 'The Invention of Tradition: The Highland Tradition of Scotland', in *The Invention of Tradition*, ed. Eric Hobsbawm. Cambridge: Cambridge University Press, 1983.

Usherwood, Paul. 'William Bell Scott's *Iron and Coal*: Northern Readings', in *Pre-Raphaelites: Painters and Patrons in the North East*. Newcastle: Laing Art Gallery, 1989, 39–56.

Usherwood, Paul. 'Officer material: Representations of leadership in late nineteenth-century British battle painting', in *Popular Imperialism and the Military*, ed. John M. Mackenzie. Manchester: Manchester University Press, 1992, 162–175.

Vale, Juliet and Malcolm. 'Knightly Codes and Piety', *History Today* **37** (November 1987), 12–17.

Vance, Norman. 'The Ideal of Manliness', in *The Victorian Public School*, Brian Simon *et al.*, eds. Dublin: Gill and Macmillan, 1975, 115–128.

Vance, Norman. *The Sinews of the Spirit: The Ideal of Christian Manliness in Victorian Literature and Religious Thought*. Cambridge: Cambridge University Press, 1985.

Vernant, Jean Pierre. *Mortals and Immortals*. Princeton, New Jersey: Princeton University Press, 1991.

Victorian Dreamers. Tokyo: The Tokyo Shimbun, 1989. [exhibition catalogue]

Victorian High Renaissance. Manchester: Manchester City Art Gallery, 1978. [exhibition catalogue]

Victorian Oil Paintings. Southport: Atkinson Art Gallery, 1978. [exhibition catalogue]

Victorian Parnassus. Bradford: Cartwright Hall, 1987. [exhibition catalogue]

Victorian Pictures. Sotheby's London (3 November 1993). [sale catalogue]

Victorian Taste. London: A. Zwemmer, 1982. [catalogue]

Vidal-Naquet, Pierre. *The Black Hunter*. Baltimore: Johns Hopkins University Press, 1896.

Wainwright, David and Catherine Dinn. *Henry Scott Tuke: Under Canvas*. London: Sarema Press, 1989.

Wallerstein, Edward. *Circumcision: An American Health Fallacy*. New York: Springer, 1980.

Walters, Margaret. *The Nude Male*. New York: Penguin, 1978.

Warner, Marina. *Monuments and Maidens*. New York: Atheneum, 1985.

Warren, Allen. 'Citizens of the Empire: Baden-Powell, Scouts and Guides and an Imperial Ideal, 1900–1940', in *Imperialism and Popular Culture*, ed. John M. MacKenzie. Manchester: Manchester University Press, 1986, 232–255.

John William Waterhouse. Sheffield: Mappin Art Gallery, 1978. [exhibition catalogue]

G.F. Watts. Introduction by Chris Mullen. London: The Whitechapel Gallery, 1974. [exhibition catalogue]

Wayne, June. 'The Male Artist as Stereotypical Female', in *Art Studies for an Editor*. New York: Abrams, 1975, 269–275.

Webb, Peter. *The Erotic Arts*. London: Secker and Warburg, 1983.

Wedmore, Frederick. 'Modern Life in Modern Art', *Magazine of Art* (1888), 77–80.

Weeks, Jeffrey. *Coming Out: Homosexual Politics in Britain, from the Nineteenth Century to the Present*. London: Quartet Books, 1977.

Weeks, Jeffrey. *Sex, Politics and Society: The Regulation of Sexuality since 1800*. London: Longman, 1981.

Weeks, Jeffrey. 'The Idea of Sexual Minorities', in *Patriotism*, Vol. II, ed. Raphael Samuel. London: Routledge, 1989, 256–269.

Weeks, Jeffrey. *Against Nature: Essays on History, Sexuality and Identity*. London: Rivers Oram, 1991.

Weeks, Jeffrey. 'The Late Victorian Stew of Sexualities', *Victorian Studies* **35** (Summer 1992), 409–415.

Weiermair, Peter. *The Hidden Image*. Cambridge, Massachusetts: MIT Press, 1988.

Wharncliffe Muniments. Sheffield: Sheffield City Archives. [unpublished]

Whitaker, Muriel. *The Legends of King Arthur in Art*. Woodbridge, Suffolk: Boydell and Brewer, 1990.

White, Kevin. *The First Sexual Revolution*. New York: New York University Press, 1993.

White, Norman. 'Hopkins as Art Critic', in *All My Eyes See: The Visual World of Gerard Manley Hopkins*. Sunderland: Ceolfrith Press, 1975.

White, S.P. 'Modern Mannish Maidens', *Blackwood's* **147** (February 1890), 252–264.

Whitman, Walt. *Complete Poetry*, ed. James Miller. Boston: Houghton Mifflin, 1959.

Wilde, Oscar. *The Picture of Dorian Gray*, ed. Isobel Murray. New York: Oxford, 1981.

Wilkinson-Latham, C. 'The Defence of Rorke's Drift', *Tradition* 55 (1970), 6–8.

Wilton, Andrew. *The Swagger Portrait*. London: Tate Gallery, 1992. [exhibition catalogue]

Winkler, John J. 'Phallos Politikos: Representing the Body Politic in Athens', *differences* 2 (Spring 1990), 29–45.

Winkler, John J. *The Constraints of Desire*. New York: Routledge, 1990.

Wohl, Anthony S., ed. *The Victorian Family: Structure and Stresses*. New York: St. Martin's, 1978.

Wollen, William B. 'War Pictures: How They are Painted', *The Regiment* (15 February 1902), 308–309.

Wood, Christopher. *Victorian Panorama*. London: Faber and Faber, 1976.

Wood, Christopher. *The Pre-Raphaelites*. New York: Viking, 1981.

Wood, Christopher. *Olympian Dreamers*. London: Constable, 1983.

Wood, Christopher. *Paradise Lost: Paintings of English Country Life and Landscape 1850–1914*. London: Barrie & Jenkins, 1988.

Wood, Evelyn. *British Battles on Land and Sea*. London: Cassell, 1915.

Wood, Stephen. *The Scottish Soldier*. Manchester: Archive Publications, 1987.

Woodham-Smith, Cecil. *The Reason Why*. London: Constable, 1953.

Woosnam-Savage, Robert C. 'Gibb's *Alma*', Glasgow: Glasgow Art Gallery, n.d. [record information]

Worth, George J. 'Of Muscles and Manliness: Some Reflections on Thomas Hughes', in *Victorian Literature and Society*, eds. James R. Kincaid and Albert J. Kuhn. Columbus: Ohio State University Press, 1984, 300–314.

Wyly, James. *The Phallic Quest: Priapus and Masculine Inflation*. Toronto: Inner City Books, 1989.

Zeitlin, Froma I. 'Cultic Models of the Female: Rites of Dionysus and Demeter', *Arethusa* 15 (1982), 129–157.

Zilbergeld, Bernie. *Male Sexuality*. Boston: Little Brown, 1978.

Index